KU-638-016

SHAKESPEARE IN ART

SHAKESPEARE IN ART

Jane Martineau *et al.*

MERRELL
LONDON · NEW YORK

LIVERPOOL JOHN MOORES

First published 2003 by Merrell Publishers Limited

Head office
42 Southwark Street
London SE1 1UN

New York office
49 West 24th Street
New York, NY 10010

www.merrellpublishers.com

in association with

Dulwich Picture Gallery
Gallery Road
London SE21 7AD

Jacket front: Sir John Everett Millais, P.R.A., *Ferdinand lured
 by Ariel*, 1849–50, detail (pl. 82, p. 109)
Jacket back: Henry Fuseli, *Titania embracing Bottom*, 1792–93
 (pl. 27, p. 233)
Page 1: William Blake, *Imaginary Portrait of Shakespeare*,
 1800–03 (pl. 73, p. 209)
Pages 2–3: Henry Fuseli, *The Weird Sisters*, c. 1783, detail
 (pl. 12, p. 79)

Published on the occasion of the exhibition

Shakespeare in Art

organized by Dulwich Picture Gallery, London,
in collaboration with Ferrara Arte Spa

EXHIBITION ITINERARY

Palazzo dei Diamanti, Ferrara
16 February – 15 June 2003

Dulwich Picture Gallery, London
16 July – 19 October 2003

The exhibition is sponsored by
Baring Asset Management

Baring Asset
Management
Member of ING Group

with support from the Timothy Franey Charitable Foundation
and the Friends of Dulwich Picture Gallery

EXHIBITION CURATORS
Jane Martineau
Maria Grazia Messina

STEERING COMMITTEE
Brian Allen
John Baskett
Martin Butlin
Andrea Buzzoni
John Christian
James Fowler
Charlotte Gere
Lionel Lambourne
Jane Martineau
Maria Grazia Messina
Desmond Shawe-Taylor

Copyright © 2003 Dulwich Picture Gallery

All rights reserved. No part of this publication may be
reproduced, stored in a retrieval system or transmitted, in
any form or by any means, electronic, mechanical,
photocopying, recording or otherwise, without the prior
permission in writing from the publishers.

British Library Cataloguing-in-Publication Data:
Shakespeare in Art
1.Shakespeare, William, 1564–1616 – Influence 2.Art,
Modern – 18th century 3.Art, Modern – 19th century
I.Martineau, Jane II.Dulwich Picture Gallery
709'.033

ISBN 1 85894 229 2

Edited by Jane Martineau and Desmond Shawe-Taylor
Translations from the Italian by Desmond Shawe-Taylor

Produced by Merrell Publishers
Designed by Matt Hervey
Copy-edited by Mary Scott with Kirsty Seymour-Ure
Indexed by Hilary Bird
Printed and bound in Italy

AUTHORS OF ENTRIES
BA Brian Allen
CB Christopher Baugh
MB Martin Butlin
JC John Christian
EE Elizabeth Einberg
RH Robin Hamlyn
LL Lionel Lambourne
JTM Jane Martineau
MGM Maria Grazia Messina
DST Desmond Shawe-Taylor

NOTE ON THE TEXT
Quotations from Shakespeare are from *The Complete Works
of William Shakespeare*, ed. Peter Alexander, London 1951

CONTENTS

FOREWORD

Nobody has ever said that Shakespeare was perfect. Ben Jonson thought him unlettered; Milton rustic; Pope slapdash; Voltaire savage; Samuel Johnson indecorous; and Tolstoy immoral. At the same time few poets have so comprehensively got under the skin of future writers, composers, artists and thinkers throughout the world. This exhibition deals with the period – from *c.* 1730 to 1860 – during which Shakespeare began to obsess the British (who had known about him for a while) and the Continentals (who were just discovering him). Shakespeare's impact in all the arts during the Romantic period is incalculable. The old Prince of Denmark became the archetypal modern hero – the play was still a model for Chekhov's ironic anti-romantic comedy *The Seagull* in the 1890s.

To some extent Hamlet is Everyman and each culture and age discovers its *own* Shakespeare. So is there something specifically Shakespearean, some common ground between the works of art in this exhibition? This question is probably best answered in the comments book of the exhibition rather than in the preface to its catalogue, but two possibilities suggest themselves. Shakespeare seems to have struck all generations as the poet of copiousness, who celebrates the fecundity and variety of Nature and a parallel universe of elves, ghosts, dreams and monsters. At either end of the show images from *The Tempest* – by Hogarth and Millais (cat. 2, 82) – convey natural and supernatural prodigality. Shakespeare also appeared to the Romantic generation as the poet of 'common humanity'. Recent literary criticism has derided this idea as a convenient myth for a paternalist generation; and indeed the way Shakespeare has sometimes been presented as a kind of benign therapist, with a gift for well-written case-notes, is slightly absurd. Though Shakespeare may not have given all men his sympathy, he certainly gives them a voice, and the eloquence with which the good and the bad assert themselves and their feelings comes over in almost every painting in this exhibition.

This is the first exhibition in London since 1964 devoted to Shakespeare's impact on the visual arts. It is appropriate that it should take place at Dulwich, as the College (our parent institution) was founded by the Elizabethan actor, Edward Alleyn (1566–1626). Alleyn was Marlowe's leading actor; Shakespeare probably had him

in mind when Hamlet is explaining how *not* to act (*Hamlet* III. ii). The Dulwich collection however includes the only known portrait of Shakespeare's favourite actor, Richard Burbage (*c.* 1568–1619; DPG, no. 395), the world's first Hamlet (and the first Richard III, Lear and Othello). Dulwich College remains the institution with the strongest historical link to Shakespeare and his world.

This exhibition was conceived by Andrea Buzzoni of Ferrara Arte, and it is a monument to his international vision and boundless energy that it has come about. We at Dulwich are most grateful to be able to participate in the project and have been privileged to have worked with Andrea and his colleagues in Ferrara. I would particularly like to thank Maria Luisa Pacelli, Manuel Mortari, Alessandra Cavallaroni, Tiziana Giuberti, Barbara Guidi and Caterina Azzini for their patience, and their enthusiasm for and dedication to the show.

The exhibition was curated by Jane Martineau and Maria Grazia Messina, who have conceived the intellectual form of the show, planned the sections, selected the works and assembled the team of scholars involved. Whilst congratulating them on their achievement I would also like also to thank the Steering Committee and the authors of the catalogue, all of whom are listed above.

We have been very fortunate in the magnificent response of lenders to this exhibition, which has made possible such a full survey of the subject. Almost all of the individuals and institutions, listed above, have agreed to be without some of their most popular works for the duration of the exhibition. The National Trust, the Garrick Club and Birmingham Museums have been particularly accommodating; Tate has an especially rich collection of Shakespearean subjects and has been especially generous in lending. We are also very mindful that exhibitions of this kind can only happen through the enlightened philanthropy of private collectors agreeing to share their treasures with the public.

The exhibition has been brought 'home' to Shakespeare's own Southwark through the generosity of our sponsors. Our exclusive corporate sponsors are Baring Asset Management, whose enthusiastic support allowed us to 'snap up' this opportunity. We are also most grateful to the Timothy Franey Charitable Foundation, long-standing supporters of our education work, for stepping in to close the gap in

funding with a most generous donation. As with all our exhibitions, the Friends of Dulwich Picture Gallery have provided a vital contribution. We would like once again to acknowledge and thank the team led by Gregory Eades of Re:source for their support and assistance, enabling us to take advantage of the Government Indemnity Scheme.

I would also like to take this opportunity to congratulate the curatorial department here at Dulwich on a brilliantly displayed and efficiently managed exhibition. As always the success is due to our Curator, Ian Dejardin, and his team. The contribution of Eloise Stewart should be especially singled out.

On behalf of the curators and authors of the catalogue we would like to thank the following people who have provided invaluable scholarly insights and have gone out of their way to help in the preparation of this exhibition:

Julia Alexander, Sarah Allard, Graham Allen, Irene Amadei, Robert G.W. Anderson, Erika Angelini, Melvyn Barnes, John Baskett, Christoph Becker, Martin Beisly, Margaret Benton, Maria Ida Biggi, Silvia Bordini, Perla Boschetti, Louise Bythell, Luisa Capodieci, Margie Christian, Alessandro Cicogna Mozzoni, Michael Clarke, Constance Clement, Claudia Corti, Jean Pierre Cuzin, Robert Dalgliesh, Lynn Davies, Ann Donnelly, Ann Dumas, The Earl of Iveagh, Richard Eddington, Anne-Marie Ehrlich, Lisa Etheridge, Judith Etherton, Oliver Fairclough, Jane Farrington, Alun Ford, Marie-Cécile Forest, Melissa Fournier, James Fowler, Simonetta Fraquelli, David Fraser, Charlotte Gere, Antony Griffiths, Renzo Guardenti, Stan Guichard, Audrey W. Hall, Iain J. Harrison, Ernst Haverkamp, John Hayes, David Howells, Diane Hudson, Hanna-Sabine Hummel, Joel Huthwohl, Daniel Jeffreys, Mark Jones, Edward King, Dick Kingzett, Andrew Kirk, Christian Klemm, Vivien Knight, Généviève Lacambre, Alastair Laing, David Landau, Marit Lange, Ken Lee, Isabelle L'Hoir, Alastair Laing, Christopher Lloyd, Julia Lloyd Williams, Dominique Lobstein, Stéphane Loire, Anne Lyons, Adrian Lyttelton, Antonia Maas, Rupert Maas, Iain Mackintosh, Christopher Makins, Danielle M.

Mann, Krystyna Matyjaskiewicz, Giuseppe Mazzitello, Fernando Mazzocca, Joni McArthur, Marianne McElwee, Menna McGregor, Beth McIntyre, Amy Meyers, Alison Miles, Mauro Minardi, Julian Mitchell, Marie Andrée Mondini, Giuseppe Mongini, William Montgomery, David Moore-Gwyn, Giovanni Morelli, William Mostyn-Owen, Roy Moxham, Sir Philip Naylor-Leyland Bt, Hannah Neale, Paul Norris, Jenny Page, Mattia Patti, Vittorio Pellizzola, Sibylle Pieyre de Mandiargues, Roger Pringle, Michael Raeburn, Patrick Ramade, Janice Reading, Christine Riding, Duncan Robinson, Cinthia Roman, Amanda Russell, Francis Russell, Michael Scott, David Scrase, Kate M. Sellers, Nicholas Serota, Robin Simon, Janet Skidmore, Helen Smailes, Howard Smith, Michael Smurfit, Anna Southall, the staff of the Paul Mellon Centre for Studies in British Art, London, Christopher Stephens, MaryAnne Stevens, Virginia Tandy, Victoria Tear, Simona Tosini Pizzetti, Julian Treuherz, Jody Trowbridge, Luisa Vertova, Michael Wade, Tracey Walker, Stanislaw Waltos, David Weinglass, Louise Wellemeyer, Pamela White Trimpe and Christine Wise.

Maria Grazia Messina thanks the Paul Mellon Centre for Studies in British Art, London, and in particular its Director, Brian Allen, for its support in funding her research in London.

Desmond Shawe-Taylor
DIRECTOR, DULWICH PICTURE GALLERY

LIVERPOOL JOHN MOORES UNIVERSITY
LEARNING SERVICES

Mr. WILLIAM

SHAKESPEARES

COMEDIES,
HISTORIES, &
TRAGEDIES.

Published according to the True Originall Copies.

put,
e cut;
e
life:
wit
hit
surpasse
asse.
ooke
Booke.

B. I.

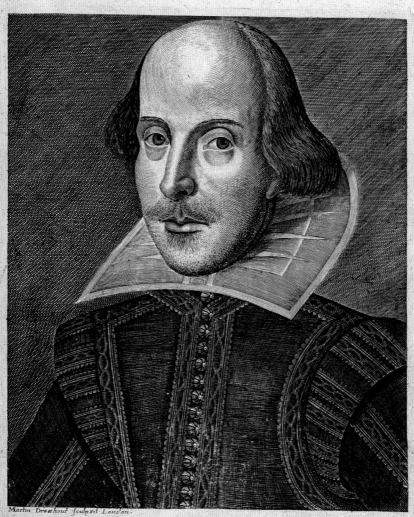

Martin Droeshout sculpsit London.

LONDON

Printed by Isaac Iaggard, and Ed. Blount. 1623.

THE SHAKESPEARE PHENOMENON

JONATHAN BATE

In 1612, around the time of William Shakespeare's retirement to Stratford-upon-Avon, the young dramatist John Webster wrote a preface to his tragedy *The White Devil* in which he expressed his "good opinion" of the "worthy labours" of his peers in the art of playmaking: the grandiose style of George Chapman, the learning of Ben Jonson, the collaborative enterprise of Francis Beaumont and John Fletcher, and "the right happy and copious industry of Mr Shakespeare, Mr Decker [*sic*], and Mr Heywood". Shakespeare's plays are thus praised for being plentiful in number and well judged in execution. He is placed in the company of Thomas Dekker and Thomas Heywood, two other prolific and highly professional writers who made their living from the stage. But he is mentioned after four writers who, whilst equally professional and industrious, were better connected to the court and the gentry – Chapman, Jonson, Beaumont and Fletcher.

Four years later, in the spring of 1616, Beaumont and Shakespeare died within a few weeks of each other. Beaumont became the first dramatist to be honoured with burial in the national shrine of Westminster Abbey, beside the tombs of Geoffrey Chaucer (the father of English verse) and Edmund Spenser (the greatest poet of the Elizabethan era). Shakespeare was laid to rest in the obscurity of provincial Stratford-upon-Avon (fig. 2). That same year, Ben Jonson became the first English dramatist to publish a collected edition of his own plays. He was much mocked for his presumption in doing so, especially under the title of *Works*, suggestive of an edition of a Classical author such as Virgil.

Webster learned many of the tricks of his trade from Shakespeare, but if he had been asked which of his contemporaries would achieve immortality and come to be regarded as the greatest playmaker since the ancient Greek tragedians, he could equally well have plumped for either Jonson or the team of Beaumont and Fletcher. Or possibly even Chapman. We now think of Shakespeare as a unique genius, the embodiment indeed of the very idea of artistic genius, but in his own time, though widely admired, he was but

OPPOSITE Fig. 1 Martin Droeshout the Younger (born 1601), *Portrait of William Shakespeare from the First Folio*, 1623, engraving, 19.1 × 15.9 cm (17½ × 6¼ in.), The British Library, London

one of a constellation of theatrical stars. How is it, then, that when we reach the eighteenth and nineteenth century Shakespeare's fame has outstripped that of all his peers? Why was he the sole dramatist of the age who would eventually have a genuinely international – ultimately a worldwide – impact? What is the wider cultural story behind the emergence of Shakespearean painting and engraving? Artistic representations of scenes from the works of Chapman, Jonson, Beaumont and Fletcher, Dekker and Heywood are, it has to be admitted, somewhat thin on the ground.

FROM THE FIRST FOLIO TO THE RESTORATION

Shakespeare's plays were first and foremost commodities: scripts for performance, translatable into cash by way of box-office receipts. His own (considerable) income from them derived from his shareholding in the acting company that produced them. After his death, it was in the interest of that company, the King's Men, to retain its exclusive right to perform the plays. Dissemination in print could have led to rival productions. So there was no immediate move to produce a Jonson-style edition of Shakespeare's *Works*.

Then in 1619, three years after Shakespeare's death, there appeared unauthorized new editions of ten of the plays. With the assistance of the Earl of Pembroke, who was Lord Chamberlain and a good friend to the actors, the King's Men obtained a blocking order against further productions of a similar kind. Soon after, they began the work of gathering *Mr William Shakespeares Comedies, Histories, & Tragedies Published according to the True Originall Copies*. The great book appeared in 1623, in large double-columned 'folio' format, adorned with Martin Droeshout's engraving of Shakespeare (fig. 1) and an array of preliminary matter, including Ben Jonson's commendatory poem praising his fellow playwright as "Soul of the Age", as a rival even to Sophocles, and as a dramatic artist whose works were "for all time". Without the First Folio, half of Shakespeare's output would have been lost forever, and much of the rest would only have remained available in error-strewn texts. It was a book cherished by readers as various as King Charles I and the radical republican John Milton.

One of the ways in which writers endure is through their influence on later writers. Jonson intuited this in his dedicatory poem, describing

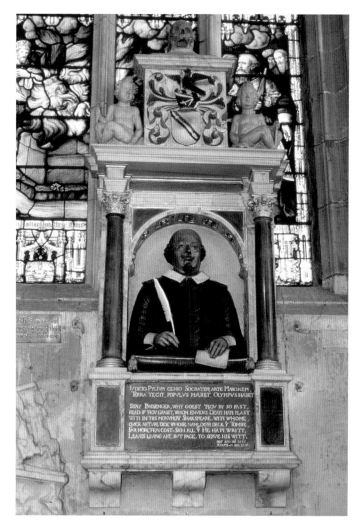

Fig. 2 Gerard Johnson the Younger, funerary monument to William Shakespeare, *c.* 1616, painted marble, Holy Trinity Church, Stratford-upon-Avon

The London theatres were closed during the years of civil war and republican government in the middle of the seventeenth century. The years after the Restoration of the monarchy in 1660 were characterized by a somewhat schizophrenic attitude to Shakespeare. On the positive side, he was invoked for his inspirational native genius, used to support claims for English naturalness as opposed to French artifice and for the moderns against the ancients. In a sweeping *Essay of Dramatic Poesy* (1668), Dryden described Shakespeare as "the man who of all Modern, and perhaps Ancient Poets, had the largest and most comprehensive soul". He brushed off charges of Shakespeare's lack of learning with the memorable judgement that "he needed not the spectacles of Books to read Nature". Contemporaneously with Dryden, the learned Margaret Cavendish, Duchess of Newcastle, praised Shakespeare for his extraordinary ability to enter into his vast array of characters, to "express the divers and different humours, or natures, or several passions in mankind".

Yet at the same time, the courtly élite had spent their years of exile in France and come under the influence of a highly refined Neo-classical theory of artistic decorum, according to which tragedy should be kept apart from comedy and high style from low, whilst dramatic 'unity' demanded obedience to strict laws. For this reason, Dryden and his contemporaries took considerable liberties in polishing and 'improving' Shakespeare's plays for performance. According to the law of poetic justice, wholly innocent characters should not be allowed to die: Nahum Tate accordingly rewrote *King Lear* (1681) with a happy ending in which Cordelia marries Edgar (he also omitted the character of the Fool, on the grounds that such a figure was beneath the dignity of high tragedy; see pl. 30). The more formal Classicism of Jonson and the courtly romances of Beaumont and Fletcher answered more readily to the Frenchified standards of the Restoration theatre.

Actors, though, were demonstrating that the most rewarding roles in the repertoire were the Shakespearean ones. Thomas Betterton (1635–1710), the greatest player of the age, had enormous success as Hamlet (fig. 13), Sir Toby Belch in *Twelfth Night*, Henry VIII, Macbeth, Timon of Athens, Lear, Falstaff, Angelo in *Measure for Measure*, and Othello (some of these in versions close to the original texts, others in heavily adapted reworkings). Playhouse scripts of individual plays found their way into print, while the Folio went through its third and fourth printings. By the end of the century, Shakespeare was well entrenched in English cultural life. But he was not yet the unique genius.

From the First Biography to Garrick's Jubilee

Thomas Betterton's veneration for the memory of Shakespeare was such that late in his life he travelled to Warwickshire in order to find out what he could about the dramatist's origins. He passed a store of anecdotes to the poet, playwright and eventual Poet Laureate

Shakespeare as a "star" whose "influence" would "chide or cheer" the future course of British drama. Once the Folio was available to, in the words of its editors, "the great Variety of Readers", the plays began to influence not just the theatre but poetry more generally. The works of Milton, notably his masque *Comus* (1634), were steeped in Shakespearean language. Indeed, the young Milton's first published poem was a sonnet prefixed to the second edition of the Folio, in which Shakespeare was said to have built himself "a live-long Monument" in the form of his plays. Shakespeare was Milton's key precedent for the writing of his epic *Paradise Lost* (1667) in blank verse rather than rhyme. Even later seventeenth-century poets who were committed to rhyme, such as Charles II's Poet Laureate John Dryden, acknowledged the power of his dramatic blank verse – it was as an act of homage to "the Divine Shakespeare" that Dryden abandoned rhyme in *All for Love* (1678), his reworking of the Antony and Cleopatra story.

Nicholas Rowe, who wrote *Some Account of the Life of Mr William Shakespeare*, a biographical sketch published in 1709 in the first of the six volumes of his *Works of Shakespeare* (1709) – a collection usually regarded as the first modern edition of the plays (spelling and punctuation were modernized, and for the first time all the plays were divided into numbered acts and scenes).

Rowe's life offered a mixture of truth and myth, calculated to represent Shakespeare as a man of the people. It tells of how young Will was withdrawn from school when his father fell on hard times, how he then got into bad company and stole deer from the park of local grandee Sir Thomas Lucy. The resultant prosecution forced him to leave for London, where he became an actor and then a dramatist. There is no documentary warrant for the deer-stealing story. Rowe's account is a symptom of how every age reinvents Shakespeare in its own image. The road from the provinces to London was a familiar one in the eighteenth century – Samuel Johnson and David Garrick walked it in fact, Henry Fielding's Tom Jones in fiction. Shakespeare served as exemplar of the writer who achieved success, and an unprecedented degree of financial reward, from his pen alone. The Earl of Southampton may have helped him on his way in his early years, but he was essentially a self-made man rather than a beneficiary of court and aristocratic patronage. For writers such as Alexander Pope and Samuel Johnson, struggling in the transition from the age of patronage to that of Grub Street professionalism, Shakespeare offered not only a body of poetic invention and a gallery of living characters but also an inspirational career trajectory.

In addition, the increasing demand for printed copies of his plays gave both Pope and Johnson the opportunity to edit the plays and write in prefatory praise of them. Johnson's preface to his edition of Shakespeare (1765) sounded the death knell of Neo-classicism by extolling Shakespeare for his truth to the variety of life in denial of the stultifying restrictions of regimented precept. "Shakespeare's plays", Johnson wrote, magnificently, "are not in the rigorous and critical sense either tragedies or comedies, but compositions of a distinct kind; exhibiting the real state of sublunary nature, which partakes of good and evil, joy and sorrow, mingled with endless variety of proportion and innumerable modes of combination". Defences of this kind were reiterated throughout the eighteenth century, usually as part of an explicit or implicit argument for the superiority of English empiricism over French theory.

If we had to identify a single decade in which the 'cult of Shakespeare' took root – in which his celebrity and influence came to outstrip that of his contemporaries once and for all – it would probably be the 1730s. At that time, there was a proliferation of cheap mass-market editions of his plays, while in the theatre the plays came to constitute about a quarter of the entire repertoire of the London stage, twice what they had been hitherto. The promotion of Shakespeare was driven by a number of forces, ranging from the censorship of new plays to a taste for the shapely legs of actresses in the cross-dressed 'breeches parts' of the comedies. After the passing of the Licensing Act of 1737 it became easier to stage political drama indirectly by way of Shakespeare than to satirize the government of Sir Robert Walpole directly, as John Gay had done in his *Beggar's Opera* a decade before. Around the same time, a Shakespeare Ladies Club was formed under the leadership of Susanna, Countess of Shaftesbury, with the aim of persuading the London theatre managers to stage more Shakespeare and less in the way of Harlequinades (the prototype of the modern pantomine) and other such vulgar spectacles. The plays were becoming synonymous with decency and Englishness, even as the institution of the theatre was still poised between respectability and disrepute.

David Garrick (1717–1779) arrived in London at a propitious moment. Shakespeare was growing into big business and the time was ripe for a new star to cash in on the name of the Bard. As in all good theatre stories, Garrick's first break came when he stepped in as an understudy and outshone the actor who normally took the part. This was followed by a more formal début, again of a kind that established a pattern for later generations: the revolutionary new reading of a major Shakespearean part. For Garrick, as for Edmund Kean in the following century, it was Richard III. After this, there was no looking back. Garrick did all the things we have come to expect of a major star: he took on the full gamut of Shakespeare, he had an affair with his leading lady (the gorgeous and talented Peg Woffington), and he managed his own acting company, supervising the scripts and directing plays whilst also starring in them. It was because of Garrick's extraordinary energy in all these departments that he not only gave unprecedented respectability to the profession of actor, but also effectively invented the modern theatre. The 'actor–manager' tradition that he inaugurated has stretched down to Laurence Olivier and beyond.

Garrick was admired for the extreme naturalism of his acting style. On seeing his Richard III, James Quin (1693–1766), leading player of the older generation, remarked that "if the young fellow was right, he, and the rest of the players, had been all wrong". It is, however, part of the Garrick myth that he was a lone pioneer of 'modern' Shakespeare. Quin's style had been elevated and rhetorical. "His action", wrote Tobias Smollett in the comic novel *The Adventures of Peregrine Pickle* (1751), "resembles that of heaving ballast into the hold of a ship". The new naturalism that reacted against such 'ranting' began not with Garrick but with Charles Macklin's rendition of Shylock, a role he first played in 1741 (see pl. 33), in which an inward and psychological approach was taken to a part that had hitherto been mere caricature. It is another myth that Garrick restored Shakespeare's original texts: he owned a fine collection of early quartos (which were of assistance to Dr Johnson in his editorial work) and he removed some of the additions of the Restoration adapters, but his

LIVERPOOL JOHN MOORES UNIVERSITY
LEARNING SERVICES

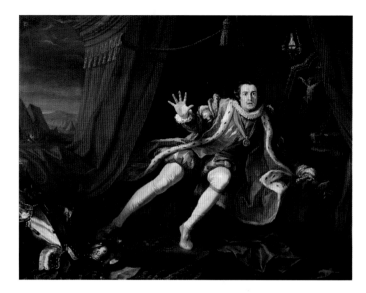

Fig. 3 William Hogarth (1697–1764), *Garrick as Richard III* (V. iii), *c.* 1745, oil on canvas, 190.5 × 250.1 cm (75 × 98½ in.), Walker Art Gallery, Liverpool

And till ETERNITY with power sublime,
Shall mark the mortal hour of hoary TIME,
SHAKSPEARE and GARRICK like twin stars shall shine,
And earth irradiate with a beam divine.

Lamb dismissed these verses as a "farrago of false thoughts and non-sense". He considered it ludicrously presumptuous that Garrick should have set himself up as Shakespeare's equal. In an essay called 'On the Tragedies of Shakspeare, considered with reference to their fitness for stage representation' (1811), Lamb argued, to the contrary, that the greatness of Shakespeare lay in his "knowledge of the inner structure and workings of mind in a character", something that could never be adequately reproduced by the externalized posturing of a mere actor. When we read *King Lear* we enter into the mind of Lear, in all its grandeur and derangement, whereas in the theatre all we see is "an old man tottering about the stage with a walking-stick". Lamb is of course exaggerating, trying to turn the plays into novels or poetic meditations of the kind that were being written at this time by his friends William Wordsworth and Samuel Taylor Coleridge. But the very strength of his reaction against the stage is testimony to the extraordinary influence of Garrick on the perception of Shakespeare.

scripts were still heavily cut and reworked, often with the aim of giving extra prominence to whichever character he was playing himself.

It was in the art of self-promotion that Garrick was unique. His public image was secured by William Hogarth's vibrant painting of him in the role of Richard III (fig. 3), confronted with his nightmares on the eve of the Battle of Bosworth. The most frequently engraved and widely disseminated theatrical portrait of the eighteenth century, this iconic image simultaneously established Garrick as the quintessential tragedian and inaugurated the whole tradition of large-scale Shakespearean painting. Hitherto, the elevated genre of 'history painting' had concentrated on biblical and Classical subjects. With Hogarth's image – created in the studio, though influenced by Garrick's stage performance – Shakespearean drama joined this august company.

Some years after Garrick's death, the Romantic essayist Charles Lamb was taking a turn in Westminster Abbey, when he was "struck with the affected attitude" of a figure that he had not seen before. Upon examination it proved to be a full-length sculpted representation of "the celebrated Mr Garrick", adorned with the following lines by the minor poet Samuel Jackson Pratt:

To paint fair Nature, by divine command,
Her magic pencil in his glowing hand,
A Shakspeare rose: then to expand his fame
Wide o'er this breathing world, a Garrick came.
Though sunk in death the forms the Poet drew,
The Actor's genius bade them breathe anew;
Though, like the bard himself, in night they lay,
Immortal Garrick call'd them back to day:

The climax of Garrick's career in Bardolatry was the Jubilee in commemoration of the bicentenary of Shakespeare's birth. The event took place in Stratford-upon-Avon in 1769, on the occasion of the opening of a new town hall, a mere five years later than the anniversary it was supposed to mark. It lasted for three days, during which the '*ton*' – scores of fashionable Londoners – descended on the hitherto obscure provincial town where Shakespeare had been born. The literary tourist industry began here: local entrepreneurs did good business in the sale of Shakespearean relics, such as souvenirs supposedly cut from the wood of the great Bard's mulberry tree. Not since the marketing in medieval times of fragments of the True Cross had a single tree yielded so much wood.

The Jubilee programme included a grand procession of Shakespearean characters, a masked ball, a horse race and a firework display. In true English fashion, the outdoor events were washed out by torrential rain. At the climax of the festivities Garrick performed his own poem, *An Ode upon dedicating a building and erecting a statue to Shakespeare at Stratford-upon-Avon*, set to music by the leading composer Thomas Arne (fig. 4). In the manner of a staged theatrical 'happening', Garrick had arranged for a member of the audience (a fellow actor), dressed as a French fop, to complain – as French connoisseurs of literary taste had complained for generations – that Shakespeare was vulgar, provincial and over-rated. This gave Garrick the opportunity to speak a defence of Shakespeare in a style to which he had become long accustomed. Back in the metropolis after the event, Garrick re-enacted some parts of the Jubilee in his theatre at Drury Lane. Though the whole business was much mocked in newspaper

reports, caricatures and stage farces, it generated enormous publicity for both Garrick and Shakespeare across Britain and the Continent.

"The whole will conclude with the apotheosis of Shakespeare", the *Gentleman's Magazine* had reported in advance of the event. The jubilee itself was a curious apotheosis in that Garrick's words were a great deal more prominent than those of the Bard himself (none of the plays was actually performed), but in retrospect it may be seen as the point at which Shakespeare was finally transformed from *primus inter pares* (first among equals) to "god of our idolatry". Garrick's own role as high priest at the shrine – as, indeed, the divine Shakespeare's self-proclaimed representative on earth – was summed up a few years later in book six of William Cowper's immensely popular poem, *The Task* (1785):

> For Garrick was a worshipper himself;
> He drew the liturgy, and framed the rites
> And solemn ceremonial of the day,
> And call'd the world to worship on the banks
> Of Avon famed in song. Ah! Pleasant proof
> That piety has still in human hearts
> Some place, a spark or two not yet extinct.

THE GERMAN NATIONAL POET

The Jubilee incident involving the mock-Frenchman reveals that, even a century after Dryden had defended Shakespeare from the strictures of Neo-classicism, there was still a perception among the English that sophisticated Europeans, nurtured on a diet of Sophocles and Seneca, Racine and Corneille, looked down on Shakespeare. Given that Britain went to war with France in the early, middle and late years of the eighteenth century, there was inevitably a good deal of national rivalry at work in the argument over what made a good play. Equally inevitably, there was a good deal of caricature in the charges laid by each of the rival positions. Nowhere was this more apparent than in the different perceptions in England and France of the position held by the foremost intellectual of the age, François-Marie Arouet, better known as Voltaire (1694–1778).

In the light of French drama's adherence in the seventeenth century to the supposed tenets of Aristotle's *Poetics* – the 'unities' of time, place and action, whereby the action of a play was confined to one day, one location and one plot; and the prohibition against vulgarity and on-stage violence in tragedy – it was hardly surprising that Shakespeare had no influence on the Parisian stage. But in 1726 the free-thinking Voltaire was exiled to England. This happened to be exactly the time when Shakespeare's plays were being properly edited for the first time and taking their position of dominance in the English theatre. Voltaire read and saw the tragedies, and became

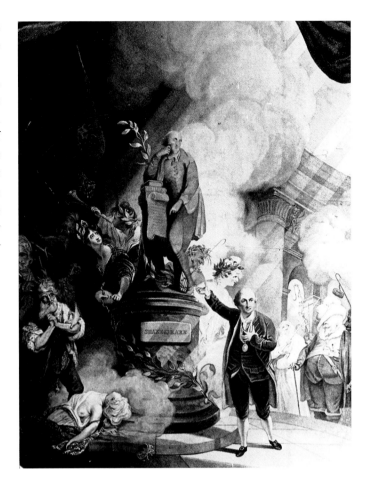

Fig. 4 Caroline Watson (1760–1814) after Robert Edge Pine, *Garrick Speaking the Jubilee Ode*, dated 1782, stipple engraving, 61.6 × 44.5 cm (24¼ × 17½ in.), Shakespeare Birthplace Trust, Stratford-upon-Avon

convinced that they had an energy and a life, a responsiveness to the many dimensions of the human condition, that was lacking in the increasingly sterile and formulaic Classicism into which the French theatre had declined. He made this case in his *Lettres philosophiques* (sometimes known as *Letters from England*) of 1733. His high praise of Shakespeare's "force and fecundity ... naturalness and sublimity" scandalized the French academic establishment. He was condemned as a renegade, despite (or because of) achieving notable success in some Shakespeare-influenced tragedies of his own, such as *Zaïre* (1732) and *Sémiramis* (1748), indebted, respectively, to *Othello* and *Hamlet*. English readers and critics, by contrast, were blind to the praise bestowed by Voltaire and alighted instead on the criticisms with which he had tempered his plaudits, such as his condemnation of the presence of joking gravediggers in *Hamlet*.

In later life, partly in reaction against the dreary prose of the first French translation of Shakespeare (1776–83) by Pierre Le Tourneur, Voltaire hardened his opinions and took to describing the plays as a heap of dung ("*ordure*"). Patriotic Englishmen such as Garrick and

Dr Johnson felt compelled to enter the lists in defence of their national Bard – as did Elizabeth Montagu, Queen of the Bluestockings, who in the year of Garrick's Jubilee published a forcefully argued *Essay on the Writings and Genius of Shakespear, compared with the Greek and French Dramatic Poets. With some Remarks on the Misrepresentations of Mons. de Voltaire.* Elsewhere in Europe, meanwhile, the equation of French cultural snobbery with anti-Shakespearean sentiment opened up new possibilities.

The two principal features of German political and cultural life in the middle of the eighteenth century were that the language of the nobility was French and that a unified nation did not exist, since the German-speaking territories were divided into an array of independent sovereignties. Faced with these divisions, men and women of letters began to argue for the forging of a 'polite literature' in the German language. Potentially, this was a means of both breaking free from francophone domination and unifying the nation. Even if the different states retained political autonomy, it would become possible to speak of a German national culture.

In the 1730s and 1740s, a manifesto for a new German literature was set down by the playwright and critic Johann Christoph Gottsched. He argued that a national culture must be based on a national theatre and that the best model for a German theatre would be French Neo-classical drama. This position was contested by Johann Elias Schlegel (uncle of the Romantic theorist and translator of Shakespeare, Auguste Wilhelm Schlegel, and the literary historian Friedrich Schlegel), in his *Vergleichung Shakespears und Andreas Gryphs* (A Comparison of Shakespeare and Andreas Gryphius), the first extended German treatise on Shakespeare, published in 1741 in the wake of the first translation of a complete Shakespearean play, a version of *Julius Caesar*, into the German language. J.E. Schlegel argued that Shakespeare had to be judged by different standards from those of Neo-classical drama; he thus opened up the possibility that the model for a new German literature might not be the French one.

The desire of the emergent German bourgeoisie to cut free from the francophone aristocracy and forge their own cultural identity meant that Johann Schlegel's position came to look more attractive than Gottsched's. So it was that a group of critical theorists based in Berlin was able to press home the case for Shakespeare. In the seventeenth of his *Literaturbriefe* (Literary Letters), published in 1759, the playwright and critic G.E. Lessing argued that Gottsched's reliance on French models was misguided because it emphasized the pretty, the tender and the amorous, whereas the German temperament was more suited to the characteristics of the English, and in particular the Shakespearean, drama: the grand, the terrible, the melancholy. Shakespeare thus became the presiding genius – in theory, though not initially in terms of actual stage repertoire – of the attempt to establish a German national theatre in Hamburg, and indeed of the *Sturm und Drang* period more broadly. In Lessing's manifesto, the

Hamburgische Dramaturgie (1767–79), the ghost in *Hamlet* was praised above that in Voltaire's *Sémiramis*. This analysis marked Germany's decisive break from the most influential literary figure of the French Enlightenment.

Following on from Lessing, Johann Gottfried Herder argued, in his *Von deutscher Art und Kunst* (Of German Art) of 1773, that foreign models, and especially French ones, should be thrown off. The ground would then be clear for native genius to grow, as it had done in Shakespeare's England. This native genius would be characterized by spontaneity and enthusiasm, allowing for the regeneration of German culture. The new culture would share in the spirit of Shakespeare, but be distinctively national in its identity. Herder was expressing these ideas contemporaneously with the young Goethe's discovery of Shakespeare, which was again characterized – as in his 'Shakespeare's Birthday' oration of 1771 – by praise of the English poet's truth to nature as opposed to the restrictions of French art.

Herder wrote that the aim of his essay on Shakespeare was "to explain him, feel him as he is, use him, and – if possible – make him alive for us in Germany". For Herder and his successors, Shakespeare's creation of a drama that showed no concern for the so-called rules of Aristotle served as the prime precedent for their own artistic principles and practice. The drama of Elizabethan England was exemplary, Herder stated, because it was created out of the nation's "own history, the spirit of its age, customs, views, language, national attitudes, traditions, and pastimes". A programme for a new national drama was raised upon the claim that Shakespeare's plays were deeply rooted in the traditions of the people (*das Volk*) and the argument that history was the true substance of all good drama ("every play is History in the widest sense"). Herder's hopes for German culture were amply realized in the next thirty years, principally through the great historical tragedies of Goethe and Friedrich Schiller. And the complete translation of Shakespeare's plays, begun by A.W. Schlegel (whose versions appeared between 1797 and 1810), and completed in 1833 by the playwright Ludwig Tieck (see fig. 21) and his daughter, Dorothea, played a crucial role in the flowering of European Romanticism. It was not unknown for enthusiasts to claim that the German versions were better than the original.

Shakespeare had for some time been established as the English national poet; now he was the German one too. For both nationalities he served as a weapon against the hegemonic tendencies of French Neo-classical culture. This was the most significant sense in which he was 'used' and 'made alive' in the eighteenth and nineteenth centuries. What is now regarded as the 'Classical' period of German literature, we may then say, had its origins in a combination of anti-French sentiment, Shakespearean inspiration, Herder's theory of national culture expressing itself in untrammelled poetry, and the innate genius of Goethe and Schiller.

In the following century, German writers turned again and again to Shakespeare for inspiration. They found a perfect mirror of themselves in the character of Hamlet. Did he not attend a German university at Wittenburg? Is not his problem that German intellectual life has not prepared him for the great political task that has been laid upon his shoulders? This reading of *Hamlet* had its origins in Goethe's *Wilhelm Meister* (1795–96): "the effects of a great action laid upon a soul unfit for the performance of it … . There is an oak-tree planted in a costly jar, which should have borne only pleasant flowers in its bosom; the roots expand, the jar is shivered." In 1844 the ardently democratic and nationalist poet Ferdinand Freiligrath began a poem with the words *"Deutschland ist Hamlet"* (Germany is Hamlet): when will it stop agonizing and philosophizing, when will it rouse itself to action? The poem proceeds to an allegorical reading of the play in which the ghost of Hamlet's father symbolizes the Freedom that Germany lacks; he summons Hamlet, at once a representative of both the diseased body-politic and the paralysed intellectual, to bring revolution, freedom from French influence, and new national vigour.

ROMANTICISM AND NATIONALISM

In one of the few contemporary attempts to isolate the quintessence of the literary revolution in England that has become known as Romanticism, the critic and controversialist Leigh Hunt pointed to three things. First there were the "political convulsions" of the last years of the eighteenth century; then the coming together of Wordsworth, Coleridge and Charles Lamb (author, with his sister Mary, of the hugely influential *Tales from Shakespeare* of 1807 for children); and, thirdly, "the revived inclination for our older and great school of poetry, chiefly produced, I have no doubt, by the commentators on Shakspeare, though they were certainly not aware what fine countries they were laying open". Similarly, Thomas Babington Macaulay argued that the Romantic revolution consisted of the dethroning of the Augustan poetical dynasty (who had themselves dethroned the successors of Shakespeare and Spenser) by "a race who represented themselves as heirs of the ancient line, so long dispossessed by usurpers"; the seeds of the revolution, he contended, lay in the revival of "our fine ancient ballads" and the fact that "the plays of Shakspeare were better acted, better edited, and better known than they had ever been". Macaulay was thinking here of the scholarly work of such men as Edmond Malone (whose 1790 edition took Shakespearean textual bibliography to new heights) and the acting of Garrick's successors – first the poise of the highly Classical John Philip Kemble (see fig. 40, p. 114) and the sublimity of his sister, Sarah Siddons (see pl. 45; fig. 43, p. 118), then latterly the Romantic energy and excess of Edmund Kean (pl. 44).

As Leigh Hunt and Macaulay indicate, the rise of Romanticism and the growth of Shakespeare idolatry were parallel and connected phenomena. If we had to pick out a single aesthetic belief at the core of Romanticism, it would be the ascription of a central place to the force of the creative imagination. Those critics and aestheticians of the second half of the eighteenth century who laid the groundwork for the Romantics by exploring the creative power of imagination turned again and again to Shakespeare for examples of that power.

In Dr Johnson's writings, for all his deep emotional engagement with the plays, there were still vestiges of the old argument that Shakespeare was the great exception, the genius who broke the rules, the *lusus naturae* (prodigy of nature) who snatched a grace beyond the reach of art. The shift from Johnson to Coleridge and the Romantics was not a matter of condemnation giving way to commendation, but of the great exception becoming the great exemplar. The Johnsonian idea of truth to 'general nature' was superseded by a fascination with the creative forces that generate nature. A.W. Schlegel argued, in his highly influential *Über dramatisches Kunst und Literatur* (A Course of Lectures on Dramatic Art and Literature) of 1809–11 that poetry, especially when it addressed itself to the supernatural, was intimately associated with the organic principle of "the inward life of nature": "In general we find in *A Midsummer Night's Dream,* in *The Tempest,* in the magical part of *Macbeth,* and wherever Shakspeare avails himself of the popular belief in the invisible presence of spirits, and the possibility of coming in contact with them, a profound view of the inward life of nature and her mysterious springs, which, it is true, can never be altogether unknown to the genuine poet, as poetry is altogether incompatible with mechanic physics."

Many eighteenth-century critics had seen the supernatural plays as Shakespeare's special achievement, and recognized their close connection with the art of imagination. But the imagination was often treated as slightly suspect; Johnson called it "a licentious and vagrant faculty, unsusceptible of limitations, and impatient of restraint". For Schlegel and Coleridge, by contrast, the supernatural and the Sublime led not to the fringes of experience, away from general nature, but to the imaginative principle without which nature could not be perceived and organized. It is no coincidence that Shakespeare's supernatural subjects – the weird sisters in *Macbeth,* the fairies in *A Midsummer Night's Dream,* the ghost in *Hamlet,* Prospero's magical spirits – were among the most frequently painted in this period. The art of William Blake (pls. 17–22) and Henry Fuseli (who was especially compelled by *Macbeth,* see pl. 12) was of a piece with this revolution in aesthetic theory.

Central to Schlegel's Shakespearean criticism in Germany and Coleridge's in England was the idea that the plays had an organic unity: they did not conform to the Neo-Aristotelian 'unities', but had a more profound inner unity of imaginative conception and linguistic execution. Organicism was a political theory as well as an aesthetic one. In the preface to his *Über dramatisches Kunst und Literatur,* Schlegel, building on the ideas of Herder, argued that "in the mental dominion

of thought and poetry, inaccessible to worldly power, the Germans, who are separated in so many ways from each other, still feel their unity". Germany's prospects were clouded as a result of internal divisions and above all the worldly power of Napoleon, but unity could be achieved through art.

Schlegel viewed the history of drama in terms of a distinction, which he developed from the theories of his brother Friedrich, between the Classical and Romantic forms. The division mirrored the European war that was being fought as the Schlegels wrote and lectured: the French (Classical) against the British and the Germanic (Romantic, Gothic, northern). Schlegel vigorously rejected what he saw as French culture's presumptuous attempt to set itself up as the only arbiter of taste. It was a rejection born of indignation at the wider sense in which France was imposing its laws beyond its own borders. To speak of France's assault on "the dramatic liberties of other nations" was implicitly to evoke the extinction of other kinds of national liberty.

In the face of the march of Napoleon, Schlegel comforted himself and his audience by evoking the Middle Ages, a time when the Germanic races were conquerors, not conquered. He ended his introductory account of the history of European drama by making explicit the parallel between the military and the cultural realms, suggesting that to list every writer in literary history would be like listing the names of every soldier who fights in the ranks; therefore, just as history only speaks of the generals, so his lectures would concentrate on the true intellectual heroes. This was as much as to say: we may not have a general to compare with Napoleon, but I will give you a literary general, an intellectual hero. They may have Napoleon, but we have Shakespeare.

For Schlegel, dramatic art was determined by national characteristics. He saw the theatre as a public forum in which a nation came together and explored its own history and identity. Art, he proposed, is influenced by its social and even geographical environment: the drama of the misty north will be very different from that of the sunny south. According to this argument, there is a symbiotic relationship between literary taste and national identity: "The Germans are a speculative people; in other words, they wish to discover by reflection and meditation, the principle of whatever they engage in. On that very account they are not sufficiently practical". This is not only an analysis of German intellectual life in the age of Kant and Hegel, but also a reading of Hamlet in the tradition of Goethe's *Wilhelm Meister*.

French national culture was said to be in thrall to theoretical mechanisms and the outward regularity of form. Schlegel's famous passage, taken up by Coleridge, in which he praised Shakespeare's plays for having "organic" as opposed to "mechanical" form was an attack not only on Neo-classicism's mechanistic obedience to predetermined rules, but also on such systematic formulations as the Declaration of the Rights of Man, the Civil Constitution of the Clergy

and, pre-eminently, the Napoleonic Civil Code. Schlegel's commitment to an organic form that was "innate", that unfolded itself from within, that acted "according to laws flowing from its own essence", was intimately bound up with the ideal of an imagined community of German peoples. For Schlegel, the hidden essence of Germany derived from language, culture and national character. The counter-model to France was England, with its freedom from prescriptive artistic rules and its evolving constitution, which Edmund Burke in his *Reflections on the Revolution in France* (1790) had praised in the language of organicism, using the English oak tree as a metaphor for the stability and longevity of the British state. Shakespeare thus became central to what may be called 'Romantic nationalism', that flowering of national and folk identities that was the inevitable counter-current to the Napoleonic dream of a united Europe under French hegemony. The history plays in particular became a model for the creation of new national literatures in many different countries.

For instance: *Hamlet* reached Hungary at the end of the eighteenth century, and in the next thirty to forty years there were twin movements to establish a Hungarian National Theatre and to translate Shakespeare's plays. The act of translation helped to reform and standardize the vernacular, a development that played a major part in the emergence of a sense of the nation. So, too, in what is now the Czech Republic: the translation and staging of Shakespeare's plays, their influence on creative artists and their celebration in the context of an emergent concept of the nation, all went hand in hand. In 1864, there were festivities in Prague to mark the tercentenary of Shakespeare's birth, with the nationalist composer Bedřich Smetana composing a special Festival March. And in Italy, the appearance of Schlegel's lectures in translation was swiftly followed by critical appreciations of Shakespeare from such major figures in the emergent *Risorgimento* as Alessandro Manzoni and Giuseppe Mazzini. Later in the nineteenth century, Ernesto Rossi and Tommaso Salvini demonstrated that the tragedies could be acted in the high style by non-Englishmen with every bit as much force as that of the spectacular London stage productions of Charles Kean and Henry Irving. It was Salvini's performance as Othello that led Verdi and Arrigo Boito to collaborate on their operatic version of the play (1887), which remains among the pre-eminent examples of the power of a great work of art to inspire other great works in different media.

Shakespeare eventually triumphed over his peers for a number of reasons. Actors found his roles more compelling than those of the other Elizabethan and Jacobean dramatists. The variety and psychological complexity of his characters invited endless analysis and speculation in accordance with the eighteenth- and nineteenth-century fascination with individuality and the human mind; the rise of Bardolatry coincided with the rise of the novel and the birth of the science of psychology. The fecundity, the difficulty indeed, of Shakespeare's language made his plays especially rewarding for

philologists and textual scholars, who were an abundant breed in the Age of Enlightenment. His self-conscious interest in the force of imagination, in the capacity of the poet to create a world on the empty stage of a theatre, to give to airy nothings a local habitation and a name, was an inspiration to Romanticism in every branch of the arts all across Europe. His cycle of plays on his own nation's history was also an inspiration to later nationalists.

And what of Ben Jonson, his nearest rival in terms of sheer dramatic inventiveness? Given that the English tradition was valued and renewed because of its gloriously eclectic anti-Classicism – in effect, because it was so different from the French – the very Classicism of Jonson's accomplishment meant that he never stood a chance of becoming a major international figure. More often than not, he was denigrated precisely so that Shakespeare could be praised.

France's Shakespearean Revolution

We have seen that the eighteenth-century deification of Shakespeare was premised upon a demonization of Classical French culture. Romanticism and Shakespeare idolatry were the two sides of the same anti-Gallic coin. For that reason, both phenomena came late to France itself.

In July 1822 a performance of *Othello* in Paris was curtailed amid cries from the audience of "*à bas Shakespeare! C'est un aide-de-camp de Wellington!*", denouncing Shakespeare as part of the Duke of Wellington's military campaign against the French. A cavalry charge was needed to disperse the anti-Shakespearean crowd. But that October, scandalized by the treatment of the English actors, Stendhal published an article in the English-language journal, the *Paris Monthly Review*. The following year it was reprinted as the first chapter of his polemical pamphlet, *Racine et Shakespeare*. Stendhal asks: "To write tragedies which can interest the public in 1823, is it necessary to follow the ways of Racine or those of Shakespeare?" He came down on the side of the flexibility and modernity of Shakespeare. In a deeply subversive move, he had produced a Romantic manifesto in Paris, the very capital of Classicism. "What is romanticism?" he asks: it is the art that gives people most pleasure. "What is classicism?": it is the art that gave most pleasure to their great-grandparents. The clear implication is that contemporary drama must reject the traditions of Racine and model itself on the romanticism of Shakespeare, with his disregard for the unities and his energetic combination of verse and prose, of the heroic and the quotidian. Stendhal went on to write historical novels on the Shakespearean model of Sir Walter Scott: in *Le Rouge et Le Noir* (1830) and *La Chartreuse de Parme* (1839), fictional stories of ordinary people's lives and loves are played out against the backdrop of real historical events.

In 1827 Victor Hugo pushed Stendhal's argument home in the preface to his historical drama *Cromwell*, and attempted to put it into practice in that play itself: "Shakespeare *is* drama; and drama, which

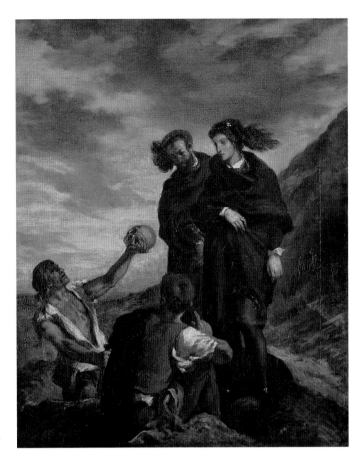

Fig. 5 Eugène Delacroix (1798–1863), *Hamlet and Horatio at the Cemetery* (*Hamlet*, V), 1839, oil on canvas, 81 × 65 cm (31⅞ × 25½ in.), Musée du Louvre, Paris

is based on the grotesque and the sublime in the same breath, tragedy and comedy, such drama is the appropriate form for the third period of poetry, the literature of the present." "*Shakespeare, c'est le Drame*": to the French Academy, the effrontery of this was nothing short of revolutionary. Hugo did not merely claim that Shakespeare rather than Racine represented the summit of modern poetry, he praised and set up as models precisely those aspects of Shakespeare that French Neo-classicism had condemned: the mixed genre, the indecorous but realistic mingling of high and low, tragedy and comedy, sublime and grotesque. He especially commended the gravediggers whose presence in *Hamlet* had provoked some of Voltaire's most excoriating remarks. Among the "*Personnages*" of *Cromwell* were numbered Trick, Giraff, Gramadoch and Elespuru, "the four Fools of Lord Protector Cromwell" – it was as if French high drama had gone so long without Fools that Hugo decided to make up for lost time by including four of them in one play.

Parisians in late 1827 not only had the opportunity to read Hugo's homage to Shakespeare in *Cromwell*. They were also given the chance to revise their opinions of the plays in the theatre. Charles Kemble

and Harriet Smithson played in *Hamlet* and *Romeo and Juliet* at the Odéon (see fig. 22, p. 42). Reactions were as positive as those to the *Othello* of 1822 had been negative. These performances – cried up by an extraordinary circle of young artists including Eugène Delacroix (fig. 5), Alexandre Dumas, Théophile Gautier, Hugo, Charles Sainte-Beuve and Alfred de Vigny – were the trigger for the explosion of French Romanticism. The eventual success of Hugo's Romantic historical tragedy, *Hernani*, in 1830 was a direct consequence of the transformation of the aesthetics of the Parisian theatre brought about by the English company in 1827. The first performance of *Hernani* was marked by violent disputes between traditionalists and the new Romantic faction in the auditorium; the triumph of the Romantics demonstrated that an aesthetic revolution was possible, that the barricades of the Academy could be stormed. This was a precedent for the political revolution later in 1830: that July, rioting in a theatre spread to the streets and, as a result of the ensuing three days of violence, Charles X abdicated and fled the country. Whereas Shakespeare had been used in England and Germany as a bulwark against French revolutionary and Napoleonic influence, when he eventually reached France he was in the vanguard of a republican and Bonapartist revolution.

A famous passage from the *Mémoires* (1870) of Hector Berlioz brings the advent of Shakespeare marvellously to life:

> I come now to the supreme drama of my life. I shall not recount all its sad vicissitudes. I will say only this: an English company came over to Paris to give a season of Shakespeare at the Odéon, with a repertory of plays then quite unknown in France. I was at the first night of *Hamlet*. In the role of Ophelia I saw Henriette Smithson, who five years later became my wife. The impression made on my heart and mind by her extraordinary talent, nay her dramatic genius, was equalled only by the havoc wrought in me by the poet she so nobly interpreted. That is all I can say. Shakespeare, coming upon me unawares, struck me like a thunderbolt. The lightning flash of that discovery revealed to me at a stroke the whole heaven of art, illuminating it to its remotest corners. I recognized the meaning of grandeur, beauty, dramatic truth, and I could measure the utter absurdity of the French view of Shakespeare which derives from Voltaire – "That ape of genius, sent/ By Satan among men to do his work" – and the pitiful narrowness of our own worn-out academic, cloistered traditions of poetry. I saw, I understood, I felt ... that I was alive and that I must arise and walk.

That final image casts the young artist as someone who has been miraculously brought to fullness of life by Shakespeare's Christ-like intervention. Berlioz's exaggerations – *Hamlet* was not "quite unknown" in France – are part and parcel of his Romantic rhetoric.

The language closely echoes that of Goethe's oration of 1771, on his discovery of Shakespeare nearly sixty years earlier:

> The first page of his that I read made me his for life; and when I had finished a single play, I stood like one born blind, on whom a miraculous hand bestows sight in a moment. I saw, I felt, in the most vivid manner, that my existence was infinitely expanded I did not hesitate for a moment about renouncing the Classical drama. The unity of place seemed to me irksome as a prison, the unities of action and of time burthensome fetters to our imagination; I sprang into the open air, and felt for the first time that I had hands and feet.

In France in the 1820s, as in Germany in the 1770s, Shakespeare is imagined not just as an antidote to the prescriptions of Voltaire's Classicism, but as a saviour of the artistic spirit, a bringer of sight, feeling and freedom – a freedom that is linked to political emancipation. He was the instigator of a sustained artistic revolution in France: his form of history-writing exercised a powerful influence on the novels of Hugo and Stendhal, while his plays inspired not only the drama of Alfred de Vigny but also much of Berlioz's best musical work, most notably the *Roméo et Juliette* symphony (1839).

His political force was felt on a wider stage later in the century. Asked who was the great French writer of the nineteenth century, André Gide (1860–1951) replied: "*Victor Hugo, hélas*". We tend to endorse that "*hélas*", forgetting the extraordinarily high regard in which Hugo was held by the end of his life. When he returned to France in 1870 after the fall of the Second Empire, Hugo was greeted as a national hero. André Maurois reminds us of his funeral fifteen years later: "For the first time in the history of mankind a whole nation was rendering to a poet the honours usually reserved for sovereigns and military leaders."

As we have seen, Hugo's first encounter with Shakespeare, albeit an indirect one since he knew no English, was in the 1820s. It led to his Romantic manifesto, the preface to *Cromwell*. After 1850, having been exiled by Louis Napoleon, he again made Shakespeare the pretext for a manifesto that was at once aesthetic and political. According to his own recollection, when he took up residence on the Channel Island of Guernsey, his son asked him how he would spend his exile. He replied that he would gaze at the ocean, and asked his son what he would do. "I," said the son, "I shall translate Shakespeare". To which Hugo added that the two activities are one and the same, for there are indeed men "whose souls are like the sea". Hugo's Shakespeare is like the sea, a force of nature transcending national boundaries.

He originally intended to contribute a preface to his son's translation, but it grew into a book called *William Shakespeare*, which summed up his thoughts on genius, on art, and on politics. It was published in 1864, three hundred years after Shakespeare's birth and

two years after the other *chef d'œuvre* of Hugo's exile, *Les Misérables*. "In contemplating Shakespeare," wrote Hugo in his preface, "all the questions relating to art have arisen in the Author's mind. To deal with these questions is to set forth the mission of art; to deal with these questions is to set forth the duty of human thought toward man". The book's political effect was immediate. Hugo was invited to a banquet in Paris to celebrate both its publication and the ter-centenary of Shakespeare's birth. The event was promptly banned by the authorities out of fear at the mere prospect of the exiled writer setting foot on French soil. Most reviews of the book were highly partisan, with pro-government journals condemning it and opposi-tional ones praising it to the skies. Always for Hugo the literary rev-olution and the political revolution were one and the same; he made a virtue of his enemies' accusation that Romanticism was dangerous because it was the same thing as socialism.

For Hugo, whereas Classical French literature had been polished and élite, the plays of Shakespeare were characterized by their excess, their impropriety, their drunkenness, all those qualities that Classicism and moralism abhorred. His attack on the literary estab-lishment, the Academy with its obsessive regulation, was inextrica-ble from his political position. He argued that, in the face of the liberty of genius, official culture sometimes resorted to banishment (Aeschylus, Voltaire, implicitly Hugo himself), but sometimes it relied on a lighter weapon, namely "a state criticism" written by "literary policemen". The Neo-classical writer Jean-François de la Harpe had accused Shakespeare of pandering to the mob, describing him as "*Ce courtisan grossier du profane vulgaire*" (this gross courtier of the ungodly masses), but for Hugo the Shakespearean drama was the supreme embodiment of the force of the people.

Shakespeare, wrote Hugo, had been policed for too long in France, reined in not least by Pierre Le Tourneur's wholly prose translation, the only complete rendering of the plays into French. The new version by Hugo's son would, his father claimed, bring to France "Shakespeare without a muzzle". The translation would educate and thus liberate the masses. Would the people prove capable of understanding the literature they are taught? Of course they would, Hugo replies:

> The soul of the people is great. Have you ever gone, of a holiday, to a theatre open gratuitously to all? What do you think of that audience? Do you know of any other more spontaneous and intelligent? Do you know, even in the forest, a vibration more profound? … The multitude – and in this lies their grandeur – are profoundly open to the ideal. When they come in contact with lofty art they are pleased, they palpitate. Not a detail escapes them. The crowd is one liquid and living expanse capable of vibration. A mob is a sensitive plant. Contact with the beautiful stirs ecstatically the surface of multitudes, – a sure sign that the deeps are sounded.

The forest, the deeps of the sea, the sensitive plant, Shakespeare, the crowd in Hugo's own novels: all are inexorable forces that will triumph over petty state power. Whereas many eighteenth- and nineteenth-century readers and critics found in Shakespeare a precedent for their conservative politics, Hugo discovered in the plays a demagogic art that was his own. "He drops his eyes and looks at the people. There in the depths of shadow, well nigh invisible by reason of its submersion in darkness, is that fatal crowd, that vast and mournful heap of suffering, that venerable populace of the tattered and of the ignorant, – a chaos of souls": such passages as this have the uncanny effect of making Shakespeare sound as though he were the author of *Les Misérables*.

Like Sir Walter Scott, Hugo valued Shakespeare for writing history from below as well as above, and thus paving the way for a new kind of historical novel that overturned the many centuries dur-ing which "history has been a courtier". But Hugo went much further than Scott, who revealed his fear of the mob in the dramatic opening scene of his most Shakespearean novel, *The Heart of Midlothian* (1818). Hugo was wresting Shakespeare away from the dominant critical tra-dition, which proposed that he held the mob in contempt for its fick-leness. This had been the position of the leading Romantic critics of the earlier nineteenth century, A.W. Schlegel and Coleridge; even the liberal-minded William Hazlitt had reluctantly concluded that Shakespeare ultimately admired Coriolanus more than the citizens. Hugo's view was closer to that of the working-class Chartist agitators in Victorian England, who made Shakespeare one of their own.

Hugo's *William Shakespeare* is a book of slogans as much as an act of literary criticism. Perhaps the most memorable of all its arresting claims is the following: "A little more, and Shakespeare would be European." Hugo was a passionate advocate of a United States of Europe, conceived in socialist and republican terms, not imperial and Napoleonic ones. In his will he left his books to the Bibliothèque Nationale in Paris, which he said would one day be the library of those United States. If he had been asked who would be the poet of all Europe, he would doubtless have hoped that it would be him-self, but he would unhesitatingly have replied: Shakespeare.

SELECT BIBLIOGRAPHY

Some sections of this essay draw on my previous work on the subject: see Bate 1986, Bate 1989, Bate 1992, Bate 1997, Bate and Jackson 2001. See also Haines 1925; Tieghem, 1947; LeWinter 1963; Bragaglia 1973; Vickers 1974–81; Booth 1981; Blinn 1982–88; Meisel 1983; Taylor 1989; Dobson 1992; Habicht 1994; Stríbrný 2000

LIVERPOOL JOHN MOORES UNIVERSITY
LEARNING SERVICES

CASSANDRA.

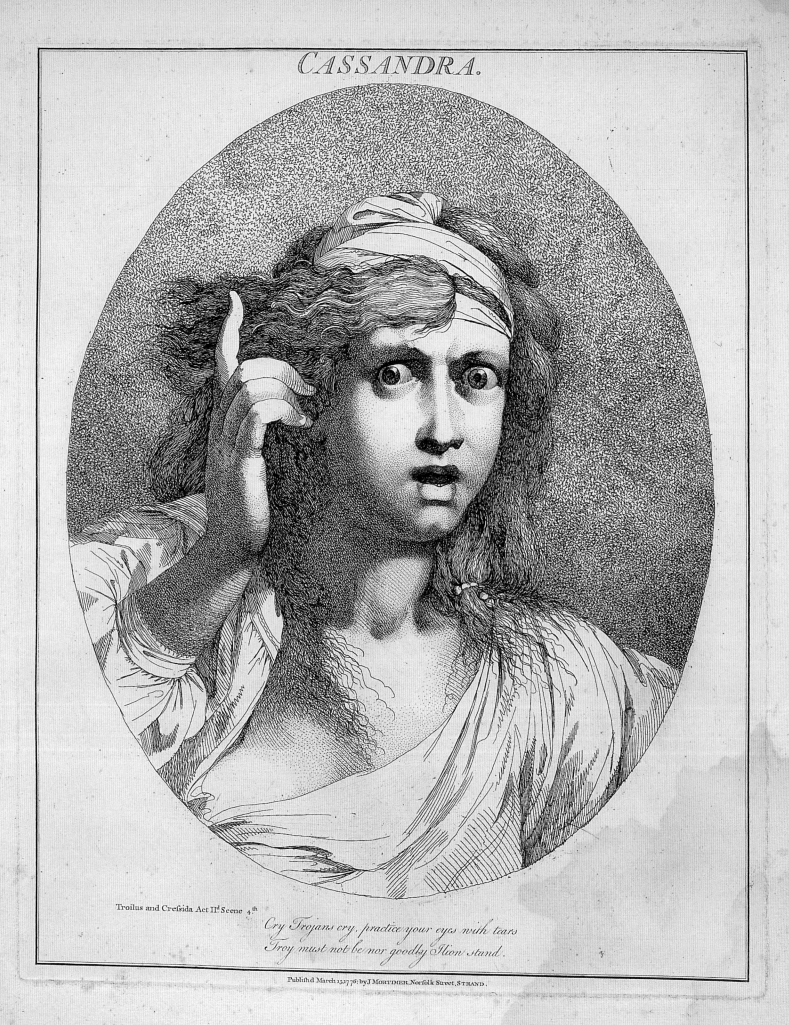

Troilus and Cressida Act II.ᵈ Scene 4.ᵗʰ

Cry Trojans cry, practice your eyes with tears
Troy must not be nor goodly Ilion stand.

Publish'd March 15.1776: by J.MORTIMER, Norfolk Street, STRAND.

SHAKESPEARE AND THE BRITISH PRINT MARKET
1700–1860

DAVID ALEXANDER

Numerous British artists produced paintings and drawings of Shakespearean subjects during the eighteenth and nineteenth centuries. It is nowadays easy to overlook the fact that many of these were produced primarily to be engraved. Although a few artists, for example James Barry, were also painter–etchers, making prints themselves, most prints were reproductive, engraved by professional engravers working for commercial publishers. There was a demand on the one hand for book illustrations, and on the other hand for single prints, either of stage personalities in their best-known roles, or of scenes from the plays. Excessive attention has been paid to the prints of the Boydell Shakespeare, published at the end of the eighteenth century, which should be seen as the culmination of British interest in illustrating the plays rather than the great innovation that the publisher John Boydell claimed it to be.[1]

A combination of the spread of literacy, the revival of the theatre as a form of entertainment after the Restoration of the English monarchy in 1660, and pride in Shakespeare as a national poet and dramatist, saw the publication of texts of the plays in the late seventeenth century. Imaginative illustrations, however, as distinct from portrait frontispieces or symbolic title pages, were relatively rare at the time, and it was not until 1709 that an edition of the plays with plates was issued by Jacob Tonson, without the name of a designer.[2] At the same time a few portraits of actors were engraved as single prints in mezzotint, the technique so associated with England that it became known as la manière anglaise.[3]

The arrival in London in 1732–33 of the French draughtsman Hubert Burguignon (1699–1773), known as Gravelot, soon brought a new elegance to English book illustration.[4] Among the many works he illustrated in the 1730s was Lewis Theobald's edition of Shakespeare, published in 1740 in eight octavo volumes with thirty-six plates designed by him, of which he also engraved eight. In addition, Gravelot was engaged by Sir Thomas Hanmer to provide illustrations for his lavish quarto edition of the plays that was printed by the university press at Oxford in 1743–44, but it was his pupil Francis Hayman (1707/8–1776) who produced most of the designs.

Unlike his master, Hayman aspired to paint in oil, and he adapted his design for As You Like It into a painting (pl. 3). Later he used some of his other designs as the basis of paintings for the supper boxes and pavilions at Vauxhall Gardens, the main pleasure-ground for all classes of Londoner. For many, this would have been their first sight of oil paintings that were not shop signs or family portraits. Hayman's pictures were issued as line-engravings, which were designed primarily as 'furniture', to use the contemporary phrase, that is, to be framed and displayed on the wall.[5]

In the mean time, public awareness of Shakespeare's plays was increased by the emergence of the actor David Garrick (1717–1779), whose initial fame rested to a great extent on his success in Shakespearean roles, notably Lear, Hamlet and Richard III. William Hogarth captured the moment at which Garrick as Richard III awakes from his dream: "O coward conscience, how dost thou afflict me"; his painting of c. 1745 (fig. 3) soon appeared as a large line-engraving by Hogarth, with the help of Charles Grignion (1717–1810). This was the first of a large number of engraved portraits of Garrick to appear in the actor's lifetime. He was not, of course, the only stage performer of whom portraits were produced. James Quin (1693–1766) was engraved as Falstaff, perhaps the most popular of Shakespeare's humorous characters. The mezzotint, which was engraved and apparently drawn by James McArdell (1729–1765), served as the model for porcelain figures.[6] Pieter van Bleeck (1695–1764) engraved and published four mezzotints of actors and actresses, notably a large plate of Mrs Cibber in the Character of Cordelia, Play of Lear Act III[d] of 1755, after his own painting (pl. 30).[7] However, the fame of Garrick gave rise to an exceptionally large number of prints.[8] He employed his gift for publicity at the Shakespeare Jubilee at Stratford-upon-Avon, which he personally organized in 1769. It was what we would today call a 'media event', with artists and journalists in attendance (fig. 4).[9] Most prints of Garrick depict him in famous roles, for example Nathaniel Dance showed him as Richard III (pl. 35), a picture engraved in mezzotint by John Dixon in 1772. Among the most successful paintings was that of him as

OPPOSITE Fig. 6 John Hamilton Mortimer (1740–1779), Cassandra: "Cry Trojans, cry …" (Troilus and Cressida, II. iv), 1776, etching, platemark 40 × 32.5 cm (15¾ × 12¾ in.), Collection of David Alexander

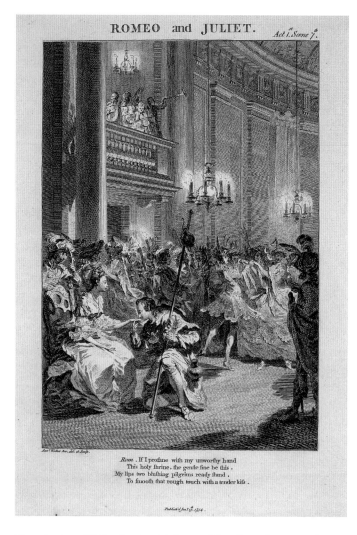

Rom . If I profane with my unworthy hand
This holy shrine , the gentle fine be this ,
My lips two blushing pilgrims ready stand ,
To smooth that rough touch with a tender kiss .

Published Jan.ᵗʰ 1ˢᵗ 1754 .

Fig. 7 Anthony Walker (1726–1765), *Romeo: "If I profane with my unworthy hand"* (*Romeo and Juliet*, I. vii), 1754, etching and engraving, image 21 × 14.7 cm (8¼ × 5¾ in.), Collection of David Alexander

Hamlet, engraved by James McArdell after Benjamin Wilson; the latter's depiction of Garrick as Lear was possibly the best-known image, reproduced in many inexpensive prints.[10] Wilson's picture of Garrick and George Anne Bellamy in the tomb scene in *Romeo and Juliet* (pl. 32) was published by subscription in 1753 as a line-engraving in the hope that people would buy it as a pendant to the print of Garrick as Richard III by Hogarth.[11]

The illustrated edition of Theobald's *Shakespeare* was reprinted in 1752. By now few patriotic Englishman with any pretensions to education would be without an edition of the plays to stand beside the Bible and Bunyan's *Pilgrim's Progress*. Those with the means would have had the sheets bound to their own specifications, giving them the opportunity to have additional illustrations bound in at the same time. Many purchasers of the Oxford folio edition of Clarendon's *History of the Rebellion* had added extra prints, and the same was now

done with Theobald's edition. The growth of the market for plates suitable for such 'extra-illustration' encouraged the ablest of the new generation of English draughtsmen, the engraver Anthony Walker (1726–1765), to begin the production of a series of delightful plates of Shakespearean scenes, including *Romeo and Juliet* (fig. 7); these deserve to stand beside *Designs by Mr R. Bentley, for Six Poems by Mr T. Gray* (1753), as the best of English Rococo book illustrations.[12]

Public exhibitions began in London in 1760, and Walker exhibited one of his plates at the first public exhibition that year. The exhibitions, held by the Society of Artists and its offshoot, the Free Society, made it much easier for artists to paint pictures on speculation, that is without having a prior commission for the painting. It also gave them a shop-window for prints of their paintings. Many painters had earlier published prints as a form of advertisement for their skills. Now others hoped to profit, bypassing the print publishers as Hogarth had done by selling their prints directly to the public. Both painters and engravers belonged to the two societies, and on occasion a painting and a print of it were seen in the same exhibition. The most prominent new genre of print that came into being at this time was the theatrical conversation piece, showing groups of actors on stage, engraved in mezzotint; this genre was pioneered by the painter Johann Zoffany (1733–1810). Understandably Garrick, as the leading actor, featured in many of these prints; by the 1760s he was known for more than his Shakespearean roles, and the plate of him as Macbeth, engraved by McArdell, is the only Shakespearean part in the dozen or so prints of him after Zoffany.[13] Other painters who followed Zoffany in painting stage scenes that were engraved in mezzotint included John Hamilton Mortimer, Benjamin Vandergucht and Francis Wheatley, and some of their paintings were shown at the Royal Academy, founded in 1768. The Academy exhibitions soon became more influential than those of the other societies, though the virtual exclusion of prints meant that there was not the same relationship between painters and engravers.

It was with the help of Garrick that one of the most interesting younger English artists, John Hamilton Mortimer (1740–1779), brought out *Twelve Characters from Shakespeare*, which he etched and published by subscription after drawings exhibited at the Society of Artists in 1775 (fig. 6).[14] This was a rare example of a leading artist using etching to produce prints for public sale. The only other painter of the time to use etching so publicly was James Barry (1741–1806). Most of his etchings related to his decoration of the Great Room of the Society of Arts, but in 1776 he produced a large plate of Lear and Cordelia (fig. 8) related to his painting of 1774 (pl. 10).[15]

Until the mid-1770s, mezzotint and line-engraving were the principal engraving techniques used by the London print trade. Line, which took longer to engrave than mezzotint, was used for prints that were expected to have a long life: most publishers expected their copper plates engraved in line – with the exception of satirical ones

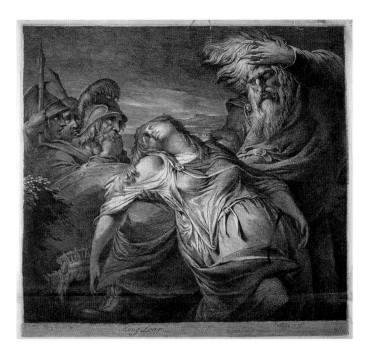

Fig. 8 James Barry (1741–1806), *King Lear* (V. iii), 1776, etching, platemark 51.5 × 55 cm (20¼ × 21⅝ in.), Collection of David Alexander

peddlers. After the death of Ryland, stipple engraving in England was of course dominated by the figure of the Italian engraver mainly active in England, Francesco Bartolozzi (1727–1815) and his pupils; one of the latter, Mariano Bovi (*fl.* 1758–1805), engraved and published some Shakespearean subjects, including a plate of a supplicant Juliet after a drawing by G.B. Cipriani (fig. 9).

It should not be thought that the success of stipple engraving put an end to the use of mezzotint for engraving subject pictures. Mezzotint had a richness and power of dramatic chiaroscuro which could not be matched by stipple, particularly for larger plates. Most mezzotint engravers, however, now had to adopt the new technique to meet popular demand. The most outstanding mezzotint engraver, John Raphael Smith (1751–1812), who had engraved Francis Wheatley's amusing *Scene from 'Twelfth Night'* in 1774, published on 1 January 1783 a stipple engraving by Thomas Burke of the arresting painting *The Nightmare* (1781) by Henry Fuseli, measuring 19 × 23 cm (7½ × 9¹⁄₁₆ in.), which sold in great numbers at the price of five shillings each.[18] Smith also engraved a number of large mezzotints after paintings of literary subjects by Fuseli, the most learned of painters then at work in London. Three of these were of Shakespearean subjects: *Lady*

of topical interest, which were generally etched – to be printed over a period of many years. Mezzotint, with its tonal qualities close to that of painting, was used for reproducing singly issued portraits and figure compositions. Although the plates wore down more quickly, many of the mezzotint engravers, such as McArdell, published their own plates and could themselves retouch areas of a plate as they became worn. However, the increased demand for decorative prints meant that the engravers began to look for a tonal technique that could be worked as easily as mezzotint and yet had the longer life of line-engraving. They found it in the dotted or stipple manner, adapted from the French crayon manner, which was quickly adopted from the mid-1770s, and was made famous by the plates published by William Wynne Ryland (1733–1783) after the paintings and drawings of the Swiss painter Angelica Kauffmann (1741–1807).[16] She led the way in using a wide range of sources for her pictures, including English history and literature as well as Classical mythology. Some of these were Shakespearean scenes, for example *Coriolanus*, published 3 November 1785, and *Miranda and Ferdinand*, from *The Tempest*, published 1 September 1786. A mass of stipple engravings of literary subjects appeared in the last quarter of the eighteenth century, though it must be added that many purchasers bought the prints purely on their decorative appeal, displaying them in elegant gilt frames, and had little knowledge of the subjects which they depicted.[17] Many of the prints were soon copied in France, and also with less skill in the town of Bassano, Italy, where the celebrated firm of Remondini produced copies that were sold cheaply throughout Europe by their teams of

Fig. 9 Mariano Bovi (*fl.* 1758–1805), after G.B. Cipriani, *Juliet: "Come, gentle night …"* (*Romeo and Juliet*, III. ii. 20), *c.* 1800, stipple engraving, image 28 × 23 cm (11 × 9 in.), Collection of David Alexander

LIVERPOOL JOHN MOORES UNIVERSITY
LEARNING SERVICES

Fig. 10 Caroline Watson (1760–1814) after Robert Edge Pine, *Miranda: "What is't, a Spirit?"* (*The Tempest*, I), as reissued by John Boydell, 1784, stipple engraving, platemark and image 38 × 45.5 cm (14⅞ × 17⅞ in.), Collection of David Alexander

Macbeth (*Macbeth*, V. i), dated 6 January 1784, after the painting shown at the Royal Academy that year; *Lear & Cordelia* (*King Lear*, IV), dated 21 May 1784, and *The Weird Sisters* (*Macbeth*, I), dated 10 March 1785, after the painting exhibited at the Royal Academy in 1783 (see pl. 8).[19] *The Weird Sisters* was successful enough for a smaller stipple version, engraved by P.W. Tomkins, to be published by Thomas Macklin in 1788.[20]

Stipple was the fashionable medium of the 1780s and it was chosen by the painter Robert Edge Pine (1742–1790), when in 1781 he announced that he was painting a series of Shakespearean scenes, of which he would publish prints in pairs "till a set is obtained, which will sufficiently illustrate the first of Dramatic Poets". In newspaper advertisements, headed "Historical Painting" to emphasize the seriousness of the scheme, he suggested that Shakespeare,

> of all writers, claims the attention of the Historic Painter. These subjects, having hitherto been unattended to, but for frontispieces to the plays; it may be proper to observe, that the pictures proposed, are not meant to be representations of stage scenes, but will be treated with the more unconfined liberty of painting, in order to bring those images to the eye, which the writer has given to the mind; and which, in some instances, is not within the power of the Theatre.

In 1782 Pine showed six of his Shakespearean paintings in a special exhibition in London, and published a number of prints engraved by

Caroline Watson (1760–1814), the first Englishwoman to work as an independent engraver. As well as plates of *Miranda* (fig. 10), which was dedicated by Pine to Georgiana, Duchess of Devonshire, and of *Ophelia*, he also published a large stipple by Watson of his rather absurd picture of Garrick declaiming the Ode at the Shakespeare Jubilee at Stratford-upon-Avon (fig. 4). However, despite Pine's efforts, which seem to have been particularly directed towards female purchasers, the venture was a failure. Pine, a man of radical views – a fact that may have prejudiced the London public against him – sold the plates to the principal printseller, John Boydell (1719–1804), who was based in the City of London, but shortly emigrated to the United States, where he exhibited the pictures in Philadelphia in 1784; they were subsequently destroyed by fire in 1803.[21]

The kind of frontispiece that Pine may have had in mind and to which he referred with so little enthusiasm in his advertisements were those that had recently been issued by the entrepreneurial publisher John Bell (1745–1831). In 1773–74 Bell issued a set of nine small volumes of Shakespeare's plays with rather wooden illustrations, principally after Edward Edwards (1738–1816). In 1778 he began a more elegant series of *Bell's Poets of Great Britain Complete from Chaucer to Churchill*, the frontispieces of which were principally designed by Mortimer, who died in 1779. Bell subsequently produced, from 1788, a new twenty-volume Shakespeare. The main illustrator was Philippe de Loutherbourg (1740–1812), the artist brought to London from Paris as a stage-designer by Garrick (see pls. 37, 38). These little volumes were designed both for the pocket and for the library, and are in their way small miracles both of typography and of engraving in miniature.

Bell's illustrations were not the only Shakespearean illustrations of the decade. In 1782 the engraver Isaac Taylor Jr (c. 1750–1829) launched a subscription for a set of oval line-engravings called *The Picturesque Beauties of Shakespeare*; scenes after drawings by two young artists, Thomas Stothard (1755–1834) and Robert Smirke (1781–1867), the first number of which was dated 1 January 1783.[22] That year Taylor exhibited "three frames" of subjects at the Society of Artists, then in its final days, in order to promote the project. These accomplished plates, published rather irregularly over the next five years, could be used by purchasers in a number of different ways. They could be bound up together as a volume of plates facing a letterpress extract from the play, used for extra-illustration, or framed as decoration. However, Taylor was not successful in promoting the series; he resumed work for publishers, notably Boydell, who admired the standard of engraving in the set, but was never to give either Taylor or Pine credit for encouraging his own interest in Shakespearean illustration.

Prints would not sell unaided. Although a few prints, such as *The Nightmare* after Fuseli, became bestsellers, most prints had to be assiduously promoted. When a print was published by subscription, social contacts were used to encourage subscribers to come forward. Printed circulars were often produced, and people of social standing

were asked to pass them on to their friends and dependents. Prestigious dedications such as Pine's to the Duchess of Devonshire, and the publicity given when important figures became subscribers, showed that powerful society figures had approved the project. Prints were heavily advertised in the newspapers, which were also paid to insert promotional paragraphs in their news columns. What is more, printsellers, like other shopkeepers, found that it was necessary to have elegant premises in fashionable locations in order to attract buyers of the highest incomes and status, the so-called 'carriage trade', while they themselves had to be good salesmen, persuasive and yet deferential and obliging.

These skills were often overlooked by painters or engravers who sought to sell their productions themselves, and this perhaps explains in part why neither the ventures of Pine nor Taylor were commercial successes and were soon forgotten. The one man who best employed these skills was Boydell, an indifferent engraver who had established himself as a printseller in the City of London in 1750. He made his name as the publisher of prints of Old Master paintings, and claimed by his efforts to have revived the art of line-engraving in England; it was his promotion of the work of such engravers as William Woollett that made their names known throughout Europe. He had not attempted to challenge the publishers of decorative stipple engravings, such as James Birchall, J.R. Smith or Thomas Macklin, who had exported huge numbers of decorative prints to the Continent. Boydell had a more ambitious and elevated idea of his role as a publisher. In the 1780s, when he acquired Pine's plates, he was midway through the publication of *The Houghton Gallery*, prints of the pictures collected by Sir Robert Walpole and sold in 1778–79 to Catherine the Great, which were eventually issued in two large volumes.

To maintain his pre-eminent position, Boydell needed another ambitious project, which would rest less on selling individual prints in his shop than on persuading a group of purchasers to subscribe to the entire set. This was the background to his announcement of the Shakespeare Gallery project. The contemporary artist and diarist Joseph Farington recorded that, according to Boydell's nephew and business partner, Josiah:

> the first idea of publishing their edition of Shakespeare was started at his house … in December 1786 … . After dinner it was remarked that the French had presented the works of their distinguished authors to the world in a much more respectable manner than the English had done. Shakespeare was mentioned, and several present said they would give 100 guineas for a fine edition … . Alderman Boydell expressed a desire to undertake it which was warmly encouraged.[23]

The project received the enthusiastic support of a number of painters, notably Fuseli, who wrote in support of it as well as becoming one of the most important contributors. Nearly all the pictures that were to be engraved were especially commissioned, and in 1789 Boydell and his nephew opened their Shakespeare Gallery in Pall Mall, in the fashionable West End of London, to show the first thirty-five pictures. The project, however, got out of control, and it was not only the delays in completion that threatened its success. The engravings of the hundred paintings proved too large to be bound up with the text, and a second set of paintings had to be commissioned and engraved in 1802 to provide smaller plates to be inserted in the huge volumes of text. The use of stipple proved unsatisfactory on such a large scale, and this was emphasized by the superiority of the few line-engravings, notably the plate of Lear engraved by William Sharp after Benjamin West, who insisted on line-engraving. This and the print of James Northcote's *Murder of the Princes in the Tower*, engraved in 1790 by Francis Legat (1755–1809), were among the relatively few prints that were generally admired. Apart from the eight large plates after Fuseli, which were not to everyone's taste, and the amusing paintings of William Peters, the pictures were on the whole disappointing. The disruption of the export trade after the outbreak of the war with France gave Boydell a face-saving excuse for the artistic and commercial failure of the venture.[24]

In turn Boydell's project attracted some rival ventures, none of which provided serious competition. Thomas Macklin, the principal publisher of stipples of literary subjects, produced twenty amusing large prints after drawings by the amateur draughtsman Henry Bunbury (1750–1811; see pl. 39) between 1792 and 1796. In 1793 a stationer, James Woodmason, opened a Shakespeare Gallery in Dublin, with pictures by some of the Boydell artists, notably Peters and Fuseli (pls. 27, 29), which he later transferred to London, publishing a few prints of the paintings.[25] He did not attempt to publish an edition of the plays, but in the late 1790s the line engraver James Heath together with the publishers G. & J. Robinson planned a six-volume edition, to be issued in thirty-six numbers, each with a plate; this was launched in 1802, with plates principally after Stothard but also two after Fuseli, who by then was concentrating his interest in literary illustration upon Milton. Although this Shakespeare edition was never completed, there were many other editions of the plays with plates, notably the editions published by Kearsley and F. & C. Rivington. The former, edited by Manley Wood, came out in parts (1802–05), with most of the plates after drawings by Stothard, and was then published in fourteen volumes in 1806. Rivington's publication, edited by Alexander Chalmers, was issued in forty two-shilling numbers by Rivington and others, with small plates after drawings by Fuseli. This was a major undertaking: 3250 sets were issued in no less than 46,000 numbers, while further copies were sold in other formats.[26]

Boydell's Shakespeare had provided many artists with the opportunity that they would not otherwise have had to paint history paintings.

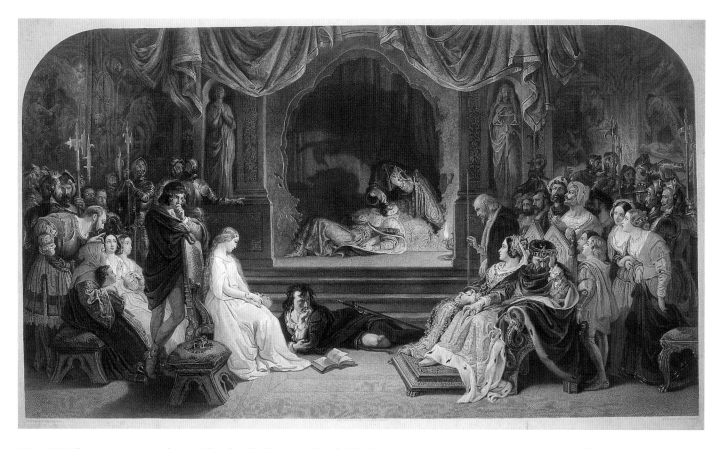

Fig. 11 C.W. Sharpe (*c.* 1830–1870) after Daniel Maclise, *The Play Scene in 'Hamlet'* (III. ii), 1863, line-engraving, 47 × 84 cm (18½ × 33 in.), Collection of David Alexander

Those who tried to paint such pictures without patronage, such as Benjamin Robert Haydon (1786–1846), found it an impossible path. David Wilkie (1785–1841) succeeded with his genre paintings, but until Victorian times the only profitable paintings remained portraits. Shakespeare was seen in prints not in the form of imaginative depictions of the plays but as portraits of the principal stage performers. Sir Thomas Lawrence (1769–1830) painted John Philip Kemble in four major roles, including Coriolanus (fig. 42, p. 117), exhibited at the Royal Academy in 1798, and as Hamlet, exhibited in 1801, and engraved as a very large mezzotint in 1805. Kemble and his sister Sarah Siddons were shown together in *The Trial of Queen Katharine* by Lawrence's pupil George Harlow, exhibited at the Royal Academy in 1817 (pl. 45); the print publisher William Cribb paid Harlow a hundred guineas (£105) for the engraving copyright, and he published a large mezzotint by George Clint (1770–1854) the following year.[27] While other types of print sold badly during the Napoleonic Wars, the demand for theatrical portraits had remained a profitable business. In 1810, for example, the print publisher J.P. Thompson sold his general stock of copper plates in 1810 to concentrate wholly on "his Superior Publications of Drawing Books and Portraits of Theatrical Performers". Interestingly the engraver George Clint gave up engraving and became a painter specializing in theatrical portraiture.

Technological change soon altered the nature of book illustration. The introduction of steel plates in the 1820s meant that far larger printings from a plate were possible. At the same time many books were produced, not with intaglio illustrations that had to be printed separately from the text illustrations, but with small wood-engraved blocks which could be integrated into the letterpress. For example, the 1829 Caxton Press edition of Shakespeare's plays carried 230 wood-engravings after John Thurston (1774–1822), while a three-volume edition published between 1839 and 1843 had nearly a thousand wood-engravings after Kenny Meadows (1790–1874).

Steel-engraving enabled large prints to be purchased by a much wider range of the public. Many prints of Shakespearean subjects were engraved, either as single plates, such as *Portia*, engraved by George Thomas Doo (1800–1886) after G.S. Newton, or in a smaller format, for example in the Vernon Gallery catalogue, which included such plates as a scene from *King John* after Clint. Prints could be produced from a steel plate in such large numbers that, from 1840, printsellers began to declare the numbers of prints they issued in order to restore some measure of exclusivity to their products. Huge amounts of money were raised by the sale of the most popular pictures, especially after individual pictures began to be taken on tour. Not all large plates were strictly commercial undertakings. The Art

Unions, at their most active between 1845 and 1870, supplied an annual print to the subscribers, who then had a chance of winning cash prizes – provided by the surplus – that had to be spent on the purchase of contemporary pictures.[28] There were a few Shakespearean subjects among their prints: the large plate of *The Play-scene in Hamlet* engraved by Charles William Sharpe (fig. 11), after the picture by Daniel Maclise originally exhibited at the Royal Academy in 1842 (see pl. 77), was given to subscribers of the Art Union of London in 1868.[29] This picture, now hardly known, became one of the most famous Shakespearean pictures.

Many of the Pre-Raphaelite painters, notably John Millais and Holman Hunt, were acclaimed for their depiction of Shakespearean scenes (see pls. 82, 84). The drowning of Ophelia (fig. 61, p. 221), for which Elizabeth Siddal – later the wife of Dante Gabriel Rossetti – posed for Millais in a large bath, to some danger to her health, was engraved by James Stephenson (1808–1886) in 1866.[30] Shakespearean subjects were, in contrast to the previous century, now in the minority. As Jane Munro has written, "the fashion for illustrating Shakespeare's plays was essentially an eighteenth-century phenomenon".[31] At the same time, the days of engraving as a reproductive medium were drawing to a close, and photographic methods were increasingly used both for book illustration and for reproducing paintings.

NOTES

1. This essay is dedicated to the memory of Geoffrey Ashton. In 1975 he assisted Iain Mackintosh on the large exhibition *The Georgian Playhouse*, the catalogue of which, London 1975,[2] remains immensely useful; his publications over the following fifteen years, of which the last was his essay in London 1991, contributed greatly to the study of British theatrical art. I am grateful to Jane Martineau, and to my wife Helena Moore, both of whom kindly commented on drafts of this essay.
2. For illustrations see Hammelmann 1975, and Moelwyn Merchant 1959. The latter remains the most valuable study of Shakespearean illustration as a whole, though engravings are only part of its subject matter. Many prints are reproduced in Salaman 1916.
3. Mezzotint portraits are catalogued according to engraver by Chaloner Smith. A most useful work, which covers portrait book illustrations and single prints, is Hall 1934.
4. For Gravelot see London 1984,[1] especially pp. 55–56.
5. For Hayman see Allen 1987. The prints are listed in Gowing 1953.
6. Chaloner Smith, 149; see also Arthur Lane, *English Porcelain Figures of the Eighteenth Century*, London 1961, p. 103.
7. Chaloner Smith, 1.
8. See London 1994.
9. See Deelman 1964.
10. For Garrick and Wilson see Mackintosh 1985.
11. A five-shilling subscription for the print was widely advertised in newspapers in March 1753, stressing that "the Size of the print is the same with Mr Hogarth's Garrick in Richard".
12. Attention was drawn to Taylor's series in Hammelmann 1975. There is a fuller discussion of it in San Marino 1985.
13. See Alexander 1977, pp. 64–67.

14. The prints were issued in two sets of six, dated 20 May 1775 (*Poet, Richard II, Ophelia, Edgar, Bardolph* and *Caliban*) and 15 March 1776 (*Beatrice, Lear, York, Falstaff, Shylock* and *Cassandra*; those in the second set have a ruled frame within the platemark (see Sunderland 1986, 96.1–12, figs. 160–71, pp. 76–79). After Garrick's death, Mortimer etched and published a plate entitled *Nature & Genius Introducing Garrick to the Temple of Shakespear* (Sunderland 1986, 152, fig. 271, and Mackintosh 1985, 75).
15. Barry's prints are catalogued in Pressly 1981.
16. See Alexander 1992; this essay is accompanied by a chronological list of English prints after Kauffmann.
17. See York 1993.
18. For Smith's career as an engraver see D'Oench 1999.
19. For the wide range of prints after Fuseli see Weinglass 1994.
20. The print, engraved by P.W. Tomkins, is illustrated in New Haven CT 1981.
21. Pine exhibited his pictures in Philadelphia in 1784, see Washington 1979.
22. Whereas Smirke made his name as a painter (see pl. 26), Stothard remained primarily a draughtsman, responsible for a large number of illustrations; see Bennett 1988. This is excellent on his work as a book illustrator, but does not cover single plates for such print publishers as Macklin, several of which were of Shakespearean subjects (e.g. York 1993, 58).
23. Farington, *Diary*, III, 1979, p. 1057.
24. A great deal has been written about the Shakespeare Gallery, notably by Boase and Friedman 1976. The most recent publication is Bottrop 1996. Santaniello 1979 illustrates all the prints.
25. Hamlyn 1978, pp. 515–29.
26. For these editions see Weinglass 1994.
27. O'Connell 1991, pp. 48–49.
28. See Smith 1986, pp. 95–108.
29. See Guise 1980, 169. This useful work illustrates and comments on nearly two hundred singly issued prints.
30. Guise 1980, 167.
31. Cambridge 1997.

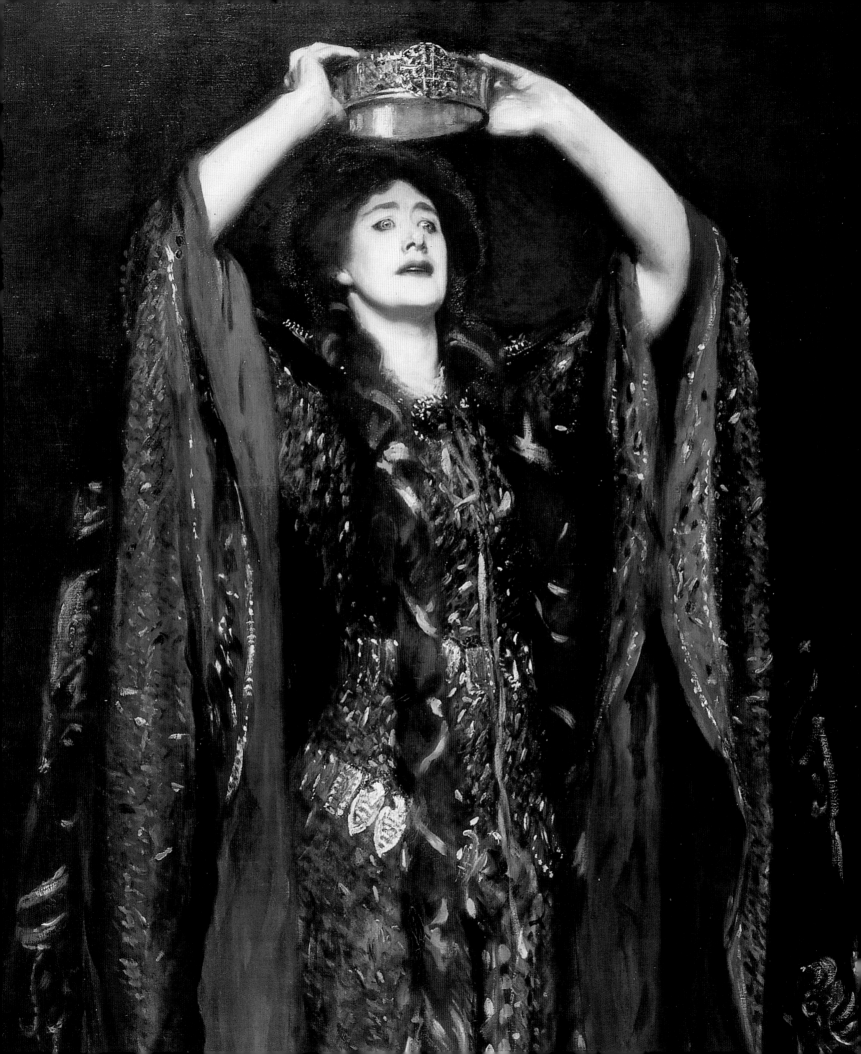

"OUR DIVINE SHAKESPEARE FITLY ILLUSTRATED"
Staging Shakespeare 1660–1900

CHRISTOPHER BAUGH

On his retirement on 26 February 1851, the great actor William Charles Macready spoke of his lifelong ambition to see "our divine Shakespeare fitly illustrated": that is, to find a way of staging the plays that would reflect the beauty and majesty of Shakespeare's poetry. This desire to 'illustrate' Shakespeare began when Charles II was restored to the throne in 1660 and theatres, which had been closed since 1642, opened again. Theatrical change was inevitable. Not only was the way paved by changing times and manners, but also by the terms of royal patents that were issued by the king in order to license public performance. In 1660 Thomas Killigrew (1612–1683) and William Davenant (1606–1668) were granted exclusive rights to open and run two theatres: the King's Company and the Duke of York's Company respectively. Most radically, the patents enabled women to appear for the first time on the English public stage. Within a decade, parts were being written for them that are among the most artistically challenging in the repertoire, and the great female roles of Shakespeare rapidly became standards whereby talent was assessed. The plays of Shakespeare were popular during the Restoration, although in the early years the Jacobean and Caroline dramas of Beaumont and Fletcher suited the taste for tragicomedy and heroic drama. The appearance of women actors led to considerable adaptation, as did the taste for scenic spectacle that plays such as *The Tempest* and *Macbeth* could offer.

The intimate indoor theatres of the Restoration shared many similarities with the private playhouses of the Jacobean and Caroline periods, but of particular relevance to the staging of Shakespeare was the introduction in 1660 of painted, representational and changeable scenes. Davenant's scenic artist, John Webb (1611–1672), had worked with Inigo Jones (1573–1652) on the sophisticated masques of the Stuart court, and he adapted Jones's scenic techniques for the new theatre. However, many who opposed the introduction of stage machinery and scenes blamed the experiences of the courtly audience who had spent the period of the Commonwealth in France. Playwright Thomas Shadwell (c. 1642–1692) complains in his *Squire of Alsatia* (1688):

OPPOSITE John Singer Sargent (1856–1925), *Ellen Terry as Lady Macbeth*, 1889, detail (fig. 19, p. 38)

There came Machines, brought from a Neighbour Nation;
Oh, how we suffer'd under Decoration!

Such scenic innovation contributed to a fundamental change in the presentation of Shakespeare, and generated new visual expectations. The formal architectural framework of the theatre of Shakespeare's day gave way to the decorated and painted illustrations of the Restoration playhouse. In addition, for a Neo-classical age that based its dramaturgy upon what it believed occurred in antiquity, licence for the use of the visual was found in the *Poetics* of Aristotle, where spectacle is listed as a necessary quality of tragedy. The presentation of the tragic (and its Italian operatic progeny) was therefore seen as being classically authorized to offer scenic richness and spectacle.

The royal patents also stated that old plays should be "reformed and made fitt" for revival, an injunction that the Restoration was to obey in full measure. In 1663 *Macbeth* was "alter'd by Sir William Davenant … in the nature of an opera", with rhyming couplets and "divertissements" of singing and flying witches. John Dryden (1631–1700) and Davenant created *The Tempest, or the Enchanted Isle* (1667). In his preface, Dryden says:

Sir William Davenant, as he was a man of quick and piercing imagination, soon found that somewhat might be added to the design of Shakespeare … and therefore … he designed the counterpart to Shakespeare's plot, namely, that of a man who had never seen a woman; that by this means, those two characters of innocence and love might the more illustrate and commend each other.

Shadwell converted *The Tempest* into an opera in 1674, and the 'enchantment' of the island is given free reign (fig. 12). John Downes, the prompter in the theatre, notes:

In the midst of the shower of fire, the scene changes. The cloudy sky, rocks, and sea vanish; and when the lights return discover that beautiful part of the island which was the habitation of Prospero.

Fig. 12 Elisha Kirkall (1685–1742), after François Boitard, frontispiece to *The Tempest*, for Nicholas Rowe's edition of Shakespeare, 1709, engraving, 18 × 11.5 cm (7¹⁄₁₆ × 4¼ in.), Theatre Museum Library, London

Dryden also reworked *Antony and Cleopatra* into a fashionable heroic tragedy, *All for Love* (1678). Henry Purcell provided music for Thomas Betterton's version of *A Midsummer Night's Dream*, renamed *The Fairy Queen* (1692), for which Downes noted: "Scenes, Machines, and Decorations ... all most profusely set off." Colley Cibber's (1671–1751) version of *Richard III* (1699) succeeded because it created excellent theatre by simplifying Shakespeare's text, and quickly became the standard acting text for almost two centuries. It also introduced the well-known non-Shakespearean phrases "Off with his head, so much for Buckingham", and "Richard's himself again".

The version of *King Lear* (1681; see pl. 30) by Nahum Tate (1652–1715) attempts "to rectify what was wanting in the Regularity and Probability of the Tale", and has a happy ending in which Edgar marries Cordelia, and Gloucester and Lear look forward to a peaceful retirement from public life. But at the same time the regularly performed *Othello, Henry IV, Henry VIII, Julius Caesar* and *Hamlet* were more conservatively treated and less 'reformed' during the Restoration. Nevertheless, the new licensing system, women actors, and the change in architectural, scenic and performance conventions, meant that Restoration revivals of Shakespeare were all, to a greater or lesser extent, adaptations.

Nicholas Rowe's 1709 edition of Shakespeare's play provides the first illustrations of Shakespeare as he was presented on the late-Restoration stage. Although designed as frontispieces to each play, and while not giving precise scenic details, they provide significant information about approaches to staging and stagecraft. Thomas Betterton (1635–1710) as Hamlet (fig. 13) wears contemporary wig and dress with stockings "down gyved", and knocks over a stool in Gertrude's closet as he rises in terror at the appearance of his father's ghost. Davenant had instructed Betterton on playing the part in the 1660s; Davenant had seen Joseph Taylor (1586–1652) play it in the pre-Commonwealth King's Company; Taylor had seen Richard Burbage (*c.* 1567–1619) play the role that Shakespeare had written for him; and it was reported that Shakespeare suggested the business of overturning the stool to Burbage. Theatrical apprenticeship such as this made stage business as much a part of the 'text' of the play, to be passed on to the next generation, as the poetry itself. These significant theatrical moments formed the basis for an actor's 'points', and audiences would eagerly await such crucial stage business (Hamlet seeing his father's ghost; Romeo entering Juliet's tomb; Richard III encountering the ghosts; Macbeth, Banquo and the witches; King Lear in the storm) as they might the well-known speeches. Actors' 'points' began to provide the easel painter with an iconography of Shakespeare that was more potent than the poetry itself.

The *Measure for Measure* illustration from the Rowe edition provides an indication of the general scenic approach early in the eighteenth century. The upstage painted representation serves more as an aesthetic background to the action taking place downstage, than as a scene of dramatic action itself. Actors may enter or exit through these scenes, but the dominant action takes place on the forestage close to the audience, sharing the same space and light. From a performer's perspective, less had changed since the Elizabethan and Jacobean theatre than might at first meet the eye. The large forestage operated much like the scenically neutral platforms of Shakespeare's day. Novelty lay in the upstage painted representations that replaced the ornate architectural façade, the *scenae frons*, of Renaissance theatre. The forestage continued to be the seat of dramatic action and theatrical rhetoric until the nineteenth century, when stage

pictorialism aimed to integrate the actors within the scene behind the proscenium arch.

Whereas today scenery tends to be disposed of when a production closes, the Restoration and eighteenth-century scenes – in the form of wing flats (known as 'shutters'), painted sky headers (known as 'cloudings'), hanging cloths and back-scenes – were regarded as a capital investment on the part of theatre management. A 'set' of scenes would normally include wing shutters placed on either side of the stage and large flats that 'closed' the scene towards the back. The shutters were supported in grooves set upon the stage and in corresponding grooves suspended above. Scenes were changed by sliding the wing shutters and the large back shutters off the stage in order to reveal new shutters behind. 'Sets' of scenes were painted, often by visiting Italian painters who were considered specialists in such work, and became the stock of the theatre. They were used time and again, as the repertoire required, until they were too old and overpainted to serve.

With characteristic British moderation coupled with antipathy to what was considered Italianate excess, the 'stock' approach to scenery and staging prevailed throughout most of the eighteenth century and is neatly summarized in the anonymous *The Case of the Stage in Ireland* (1758):

> The Stage should be furnished with a competent number of painted scenes sufficient to answer the purpose of all the plays in the stock, in which there is no great variety, being easily reduced to the following classes, 1st, Temples, 2ndly, Tombs, 3rdly, City walls and gates. 4thly, Outsides of palaces. 5thly, Insides of palaces. 6thly, Streets. 7thly, Chambers. 8thly, Prisons. 9thly, Gardens. And 10thly, Rural prospects of groves, forests, deserts, &c. All these should be done by a master, if such can be procured; otherwise they should be as simple and unaffected as possible, to avoid offending a judicious eye. If, for some particular purpose, any other scene is necessary, it can be got up occasionally.

As actors developed their 'points' of performance, so stock scenery developed a parallel visual iconography. Notwithstanding Aristotle's sanction on the importance of spectacle in tragedy, new scenes for a specific production seem to be little more than 'optional extras' for Roger Pickering in *Reflections upon Theatrical Expression in Tragedy* (1755):

> I am not extravagant enough to suggest that a new Set of Scenes should be produced at every new Tragedy. I mean only that there should never be such a Scarcity of Scenes in the Theatre, but that, whether the Seat of Action be Greek, Roman, Asiatic, African, Italian, Spanish, &c., There may be one Set, at least, adapted to each Country; and that we, the Spectators, may not be put upon to believe ourselves

Fig. 13 Frontispiece to *Hamlet* showing Thomas Betterton in the role of Hamlet, for Nicholas Rowe's edition of Shakespeare, 1709, engraving, 18 × 11.5 cm (7 × 4¼ in.), Folger Shakespeare Library, Washington, DC

Abroad, when we have no local Imagery before us, but that of our own Country.

While throughout the eighteenth century this scenic system was used for the majority of repertoire plays, new, more scholarly editions of Shakespeare by Alexander Pope (1728), Lewis Theobald (1733), Thomas Hanmer (1744) and above all Samuel Johnson (1765), led to changing perceptions of Shakespeare production. Moreover, the editions were illustrated by such artists and engravers as Francis Hayman, Michael and Gerard van der Gucht and Hubert Gravelot,

LIVERPOOL JOHN MOORES UNIVERSITY
LEARNING SERVICES

Fig. 15 J. Wright, after W.R. Pyne, *An English Country Performance of 'Macbeth'*, 1788, sepia aquatint, 33 × 41.9 cm (13 × 16½ in.), detail, The Houghton Library, Harvard University, Cambridge MA

Fig. 14 Anon., *Henry Woodward as Mercutio in 'Romeo and Juliet'* (I. iv. 53), 1753, engraving, published by William Herbert, Folger Shakespeare Library, Washington, DC

and generated considerable visual interest in the plays. This renewal of interest in Shakespeare led to revivals of plays that had not been performed since the Restoration and, in the case of *All's Well that Ends Well*, not since the closing of the theatres in 1642. At this time, *As You Like It* (1740), *Twelfth Night* (1741), *The Winter's Tale* (1741), *Cymbeline* (1744) and, most significantly, *Romeo and Juliet* (1744), entered the repertoire of the patent theatres. But the taste for adaptation did not decline with this revival. The Rococo taste of the age created *The Fairies* (1755), David Garrick's version of *A Midsummer Night's Dream* that focused solely upon the woodland fairies of Oberon and Titania and the quartet of crossed lovers. Similarly, his *Florizel and Perdita* (1756) provided an opportunity to dwell almost exclusively upon the Arcadian world of country love and the sheep-shearing of *The Winter's Tale*. Garrick's *Catharine and Petruchio* (1756) held the stage as a short farce adaptation of *The Taming of the Shrew* until late in the nineteenth century. Charles Macklin (*c.* 1699–1797; see pl. 33), the first

actor to treat Shylock as a more serious role, created much interest in 1741 in *The Merchant of Venice*. *Romeo and Juliet* held an especial interest when it was performed simultaneously at Covent Garden and Drury Lane in September 1750, creating 'the battle of the Romeos'. It became fashionable to see the first half of the play at Covent Garden, where Spranger Barry's virile manliness appealed, and then to cross to Drury Lane to appreciate Garrick's sensitivity and command of sentiment that were more suited to the tragic second half of the play (pl. 32). John Doran's *Annals of the English Stage* (1890) reports a female member of the audience exclaiming:

> Had I been Juliet to Garrick's Romeo, so ardent and impassioned was he, I should have expected he would have *come up* to me in the balcony; but had I been Juliet to Barry's Romeo, – so tender, so eloquent, and so seductive was he, I should have *gone down* to him.

In an age where leading actors dominated the theatre, the repertoire of plays reflected their acting strengths and inclinations as well as the tastes and fashions of society. Whenever James Quin (1693–1766) was to appear for a season, the audience could count upon seeing *Henry IV, Richard III, Othello* and *The Merry Wives of Windsor*. Garrick's strength

in *Richard III, Hamlet* and *King Lear* greatly increased their popularity, while at the end of the century John Philip Kemble (1757–1823) became associated with *Coriolanus* (fig. 42, p. 117) and, with his sister Sarah Siddons (1755–1831), generated a revival of interest in *Macbeth* (fig. 43, p. 118). But social and political factors were also relevant. By the early years of the nineteenth century, for example, *King Lear*, notwithstanding the acting abilities of Edmund Kean (1789–1833) or Kemble, was not performed on account of the recurring mental illness of the monarch, George III.

Interest in the archaeological investigations of ancient Greece and Rome, promoted by travel and by the avaricious acquisitiveness of *milord anglais* on the Grand Tour, encouraged new values in and approaches towards theatrical presentation during the eighteenth century. As a 'grand tourist' himself, Garrick, who travelled through France and Italy from 1763 to 1765, began the process of transforming attitudes to staging Shakespeare. His long working career (1741–76) also saw the development of a taste for the picturesque and the designed landscapes of his friend Lancelot 'Capability' Brown, the rise in popularity of history painting, and especially the emergence of a native school of landscape painting. Garrick established Shakespeare as an icon of the theatre and of British culture at a time, not altogether coincidentally, when easel images of his plays were becoming a popular genre.

In September 1769 Garrick organized the Shakespeare Jubilee in Stratford-upon-Avon, which was at that time a rather grubby market town where most of the population had little idea of the fame of their local playwright. There were dinners and speeches, concerts, processions of costumed Shakespeare characters, and an ode to Shakespeare written and recited by Garrick (fig. 4). London flocked to Stratford, Garrick was made an honorary burgess of the town, and Thomas Gainsborough painted the actor's portrait for its town hall (fig. 16). Events and masquerades floundered as the River Avon burst its banks and flooded the celebrations. Never one to waste an investment, Garrick transported the idea to Drury Lane, where he staged *The Jubilee* during the season of 1769–70. Shakespeare was transformed into 'the Bard', becoming the 'patron saint' of theatre and a mirror of British culture. While we may smile at Garrick's exercise in puff and 'spin', his imagination and energy reflected the growing desire to do justice to Shakespeare and to stage his plays as befitted a national treasure.

Benjamin Wilson's painting of Garrick's adaptation of *Romeo and Juliet* (1757; pl. 32), popularized in an engraving by Simon-François Ravenet (1706–1774), is important evidence of this growing concern. The 'set-piece' of the tomb is backed by a painting in fashionable Gothic style. In Garrick's version, Juliet wakes to take leave of her lover before the poison works. Garrick "brings her from the tomb" close to the audience for a poignant dying duet. Where styles of scenery and costume were concerned, until the very last decades

Fig. 16 Valentine Green (1739–1812) after Thomas Gainsborough, *David Garrick with the bust of Shakespeare*, 1769, engraving (original painting destroyed in 1946), Gainsborough's House, Sudbury, Suffolk

of the eighteenth century, the plays were generally considered to be 'modern'; so Garrick and George Anne Bellamy (*c.* 1731–1788) appeared in contemporary clothes and Mercutio became a snuff-taking man about town (fig. 14). Similarly, Hamlet was dressed as a 'modern' prince, Macbeth was dressed in the Highland regimentals of a high-ranking officer (pl. 34), and women appeared in fashionable clothes of the day, modified into stage costume (see pl. 30). Gestures to period costume would have the air of a splendid charade – a Roman breastplate and plumed helmet over an eighteenth-century wig, jacket and breeches. Nevertheless, the historicism of the plays (although not yet the original staging) was becoming a topic of interest. It is significant that Garrick's friend 'Hogy', William Hogarth, chose to paint Garrick as Richard III "starting from his

dream" (fig. 3) in a character that is fully contextualized in terms of costume and properties, and appropriately and dramatically lit. Garrick's production of *Antony and Cleopatra* (1759) developed away from the conventions of stock scenery, and the printed edition of Garrick's version moves the action precisely from 'room' to 'room' in the palaces of Alexandria and Rome.

During Garrick's final years at Drury Lane in the 1770s, he employed a painter from Alsace, Philippe Jacques de Loutherbourg. Garrick wanted him to provide extravagant scenery for Christmas pantomimes and 'entertainments' – productions of a topical and topographically spectacular nature. But de Loutherbourg's ambition seems to have been for a more thoroughgoing reform of scenery and stage aesthetics. He demanded (and received) complete visual control of the stage – over costumes, scenery and properties. He wanted the stage to offer a harmoniously unified picture. He established the tradition of detailed models being prepared for the scene-painters. Yet although the forestage had been periodically reduced in size since the Restoration, it was still dominant as the area of performance, and the candle and oil lighting could not be controlled significantly enough to dim the auditorium. Nevertheless, lighting became an important new aesthetic in the emerging scenographic sensibility, and this can be seen in the strong side lighting in the theatre paintings of Johann Zoffany (pl. 34), Wilson (pl. 32), Henry Fuseli (pl. 42) and J.A. Roberts. Ideas such as these prefigure the nineteenth century, when the audience might sit in a dimmed auditorium and be presented with completed stage images of other worlds; worlds where the actors could be 'designed' and harmonized through costumes to complement the detailed and 'archaeologically' accurate scenery.

As the intense images of Fuseli and William Blake indicate (see pls. 12, 13, 17–22), Shakespeare's characters, narratives and themes were well able to supply the situations and locations of the 'other' worlds of the Romantic imagination. His forbidding castles and menacing supernatural worlds could be conjured up by the haunted and charged performances of John Philip Kemble, Sarah Siddons or Edmund Kean (pl. 44). As the upper and literary classes of society increasingly lost their controlling dominance within theatre during the 1790s, the theatre acquired (or had thrust upon it) some of the reputation for violence of revolutionary France. The public's demand for performances outstripped licensed theatre provision at Covent Garden and Drury Lane, the two patent theatres, and the patent to present plays in summer that applied to the Haymarket Theatre. A new 'illegitimate' Shakespeare began to flourish in the minor, unlicensed theatres of the Regency (1810–20) of George, Prince of Wales. *Macbeth* appeared as a burletta, with songs and dances for the witches, enabling it to be performed in a minor theatre where legitimate plays were forbidden. *Richard III* was frequently performed on horseback or even by an infant prodigy such as the thirteen-year-old 'Young Roscius', Master William Henry West Betty,

in 1804–05 (pl. 40). Such 'illegitimacy' gave the performance of Shakespeare political overtones at a time when the English cast a fearful eye over the Channel at the populism and revolution in France. The perceived decline in standards, represented in the minor theatres, was regarded by many as a denigration of the British spirit and a sure sign of impending revolution and republicanism. Shakespeare and his respectful presentation in the theatre were considered to be crucial symbols of a national dramatic tradition under threat from popularizing 'illegitimate' and unlicensed forces such as pantomime and melodrama. Theatrical illegitimacy, with its hybrid mixture of content and styles, represented a break from order, degree and government, and from Shakespeare's proper place in the patent theatres. Nevertheless, lacking aristocratic patronage, the patent theatres were obliged to compete in the market economy. Spectacle, infant phenomena, performing dogs and horseback Shakespeare appeared at Drury Lane, and the stage at Covent Garden was strengthened to take the weight of horses and elephants. With Britain under military, political and cultural threat, there was increasing concern for the presentation of its history and traditions of government. Dramatic tradition in the theatres Royal acquired a range of political significance. In 1809 there were riots at Covent Garden against attempts to institute changes – raised seat-prices, privileged subscription-boxes, more Italian opera. The audience violently demanded respect for what it considered to be true 'national' theatrical traditions.

Robert William Elliston (1774–1831) began his managerial career at the 'illegitimate' Surrey Theatre south of the River Thames. But in 1820, he staged *Coriolanus* at Drury Lane starring Edmund Kean, whose erratic, fiery and indecorous performance contrasted strongly with Kemble's dignified grandeur. William Hazlitt (1778–1830), who generally admired the fire and energy of Kean, criticized the spectacle, noise, music and processions that might more properly be found in a circus. Elliston was regarded as a cultural upstart, with no appreciation of the dignity and seriousness of Shakespeare. Much as Hazlitt admired Kean's performance, the production worryingly conjured the nightmare of popular uprising in which Harlequin might overturn dramatic dignity.

Garrick had been an avid collector of books and engravings, but his 'scholarship' was very much that of the working actor. By the early years of the nineteenth century, in response to the perceived decline in dramatic standards, such critics as Hazlitt, Charles Lamb (1775–1834), James Leigh Hunt (1784–1859) and Samuel Taylor Coleridge (1772–1834) were establishing a tradition of academic Shakespeare scholarship. The antiquarian Edmond Malone (1741–1812), serving as literary adviser to Kemble at Covent Garden, helped to locate the plays within their historical context and initiated an unprecedented degree of textual authority in his 1790 edition. It was believed that the political respectability (and therefore the

Fig. 17 William Capon (1757–1827), *Design for a Stage Setting made for J.P. Kemble at the New Theatre Royal, Covent Garden*, 1808, 51.5 × 64 cm (20¼ × 25¼ in.), Royal Shakespeare Company Collection, Stratford-upon-Avon

implicit educational value) of Shakespeare should be matched in the theatre by care and diligence in staging. Kemble's principal scene-painter, William Capon (1757–1827) – significantly nicknamed 'Pompous Billy' by fellow workers at Covent Garden – spared no pains to research and meticulously recreate an image of England at the time of Shakespeare's history plays (fig. 17). During the 1820s, the antiquarian stage-designer, James Robinson Planché (1796–1880), established an approach of archaeological realism that, with modifications and developments in stage and lighting technologies, persisted until the First World War.

The cultural values of Shakespeare appealed both to the romantic and the revolutionary. His plays had longevity and stature, and were believed to have emerged from a 'people's' theatre and from the pen of a 'man of the people'. He offered (especially within the history plays) themes and narratives that could be seen as key historical stepping-stones in the progress towards the civilized achievements of the present day. In this way the Tudor supremacy that Shakespeare presented could be neatly transferred into a celebration of the triumph of the Victorian reign over the confusion and 'irregularity' of the Regency court and late Georgian England.

Although Garrick, Kemble and, to a lesser extent, Edmund Kean, had all experimented with antiquarian settings, it was William Charles Macready (1793–1873) who created the Victorian aesthetic of spectacular Shakespeare. His production of *King Lear* in 1838 was firmly set in Saxon times, with Druidical stone circles, round-helmeted soldiers, Saxon architecture and all the elaborate detail of 'historicist' settings. Macready's lead was followed by Samuel Phelps (1804–1878) at Sadler's Wells Theatre in 1845, Charles Kean (1789–1868) at the Princess's Theatre in 1858 (see pls. 52–59), Edwin Booth (1833–1893) in 1881, and Henry Irving (1838–1905) at the Lyceum in 1892, in an upward spiral of ever more detailed (and expensive) attempts at historical reconstruction. Macready employed the considerable skill of Clarkson Stanfield (1793–1867) as a painter of panoramas to illustrate Agincourt for *Henry V* at Covent Garden in 1839 (pl. 51).

In general, the nineteenth century preferred the simplified and 'operatized' versions of Shakespearean comedy, infamously adapted and arranged by Frederick Reynolds (1764–1841), and the taste for historical accuracy created a particular kind of archaeological Shakespeare spectacle. The history plays grew in popularity, especially *King John, Richard II* and *Henry VIII*, all with copious opportunities for processions, fanfares and heraldic display. Few of Shakespeare's plays could resist the historicizing tendencies of Macready, Kean or Irving. However, the trajectory of the century was to see the restoration of the scenes and words of Shakespeare to their proper place, and the century is well provided with reviews of productions that begin similarly to that in *John Bull* of February 1816, on the occasion when Robert Elliston and Edmund Kean removed Nahum Tate's alterations:

LIVERPOOL JOHN MOORES UNIVERSITY
LEARNING SERVICES

Nothing can be more judicious ... than restoring the original of our immortal author, and we are quite sure that every man of taste will render thanks to Mr. Kean for having taken the step of bringing back the last act of *King Lear* nearly to its ancient purity.

Nevertheless, stage presentation frequently disappointed the audience, and Macready's aim to see the work of Shakespeare "fitly illustrated" was fraught with problems. Astonishing achievements in art and technology were increasingly on display everywhere in Victorian society. In the spirit of progress and improvement that characterized the age, the theory of attempting archaeological realism in the theatre could not fail. If it did not work today, then it would tomorrow – find a better painter or sculptor, invent a brighter lamp or design a better machine. The theatrical art, it was believed, would inexorably progress towards perfectibility. Macready's friend and the biographer of Dickens, John Forster, wrote in *The Examiner* on 29 October 1842:

We have had nothing so great as the revival of *King John* [Drury Lane, 1842]. We have had no celebration of English history and English poetry so worthy of a national theatre.

But after his retirement in 1851, Macready said of Charles Kean's production of the play that "the text allowed to be spoken was more like a running commentary upon the spectacles exhibited, than the scenic arrangements an illustration of the text".

In Victorian Britain, Shakespeare became a sophisticated and subtle agent in cultural politics. In him, the Victorians had a vehicle for living out their own political and social dilemmas: Shakespeare as cult historian and psychologist of the British character; Shakespeare as the preacher of liberal moderation; Shakespeare as upholder of the status quo (law and order, strong government, proper 'degree'); but also Shakespeare with a kindly, paternalistic concern for the 'little person' (Henry V in the soldiers' camp on the night before Agincourt); Shakespeare as pro-Tudor propagandist and supporter of an enlightened, knowledgeable and beautiful Queen Elizabeth, qualities that could easily be transferred to Queen Victoria. Victoria was a regular visitor to Kean's theatre and much admired his work.

Through touring companies and translations, Shakespeare's growing worldwide reputation assumed an imperial role as a validation of British culture and its institutions. Paternal, suppressive colonialism could be philosophically supported through such plays as *The Tempest*, and the history plays offered numerous images of the struggle for rightful relationships between monarch, parliament and subject. *A Midsummer Night's Dream*, *The Tempest* and *As You Like It* fed the 'other' world of the spiritual, medieval past promoted by the Pre-Raphaelites, in which the Victorians liked to find their moral base and democratic ancestry.

For Kean at the Princess's Theatre in the 1850s, the plays also offered a route to social respectability. His *mise-en-scène* became a medium not only for a national drama, but also for the display and reconstruction of national heritage. To parallel the educational Royal Colleges and Institutes that had been recently established, Kean wanted to found a national theatre dedicated to Shakespeare and the British dramatic tradition. Henry Morley published his newspaper reviews of London theatre in *The Journal of a London Playgoer 1851–1866* (1891) and summarized Kean's achievements in his entry for 29 August 1857:

Mr. Charles Kean's season is memorable for the liberality by which it was distinguished. Four plays were produced, all mounted not only in the most costly way, but so mounted as to create out of the theatre a brilliant museum for the student, in which Mexican antiquities, the days of English chivalry, Greek and Etruscan forms were presented, not as dusty broken relics, but as living truths, and made attractive as well by their splendour as by the haze of poetry through which they were to be seen.

Shakespeare became a "haze of poetry" through which scholarly, beautifully reconstructed ancient art and architecture might be viewed, a respectable cultural parallel to the display of goods and treasures of the world at the Great Exhibition of 1851 and in the new museums of South Kensington. Frederick Lloyds and William Gordon prepared scenes for Kean's enormously successful *Midsummer Night's Dream* of October 1856 (pls. 52–59). Morley considered some of the challenges generated by this 'illustrative' ambition:

but there may be a defect of taste that mars the effect of the richest ornament, as can best be shown by one or two examples. Shakespeare's direction for the opening scene of the *Midsummer Night's Dream* is: "Athens, a Room in the Palace of Theseus". For this is read at the PRINCESS'S THEATRE: "A Terrace adjoining the Palace of Theseus, overlooking the City of Athens"; and there is presented an elaborate and undoubtedly most beautiful bird's-eye view of Athens as it was in the time of Pericles. A great scenic effect is obtained, but it is, as far as it goes, damaging to the poem. Shakespeare took for his mortals people of heroic times, Duke Theseus and Hippolyta, and it suited his romance to call them Athenians; but the feeling of the play is marred when out of this suggestion of the antique mingled with the fairy world the scene-painter finds opportunity to bring into hard and jarring contrast the Athens of Pericles and our own world of Robin Goodfellow and all the woodland elves In the second act there is a dream-like moving of the wood This change

Fig. 18 James Hopwood (*c.* 1752–1819), *The Theatre Royal, Drury Lane* (detail), 1813, engraving, The Mander and Mitchenson Collection, London

leads to the disclosure of a fairy ring, a beautiful scenic effect, and what is called on the play-bills, "Titania's Shadow Dance". Of all things in the world, a shadow dance of fairies! If anything in the way of an effect of light was especially desirable, it would have been such an arrangement as would have made the fairies appear to be dancing in a light so managed as to cast no shadow, and give them the true spiritual attribute. Elaborately to produce and present, as an especial attraction, fairies of large size, casting shadows made as black and distinct as possible, and offering in dance to pick them up, as if even they also were solid, is … a sacrifice of Shakespeare to the purposes of the ballet-master.

Of course, such attitudes put pressure upon companies with less scenic facility and financial resource than Kean's. The Prince of Wales theatre owned by Squire Bancroft (1841–1926) was small, and his programme note for *The Merchant of Venice* in 1875 suggested that grand-scale scenic illustration had been rejected in favour of William Godwin and George Gordon's more precisely observed architectural detail. Bancroft and Gordon visited Venice: "in the Palace of the Doges we saw at once that the Sala della Bussola … was the only one capable of realization within our limited space; and this room we resolved should be accurately reproduced for the trial." Ominously for the future of this scenic approach, Bancroft reported in *The Times* (19 April 1875):

Mr. Gordon … devoted months of labour to the scenery, which was very realistic; elaborate capitals of enormous weight, absolute reproductions of those which crown the pillars of the colonnade of the Doge's palace, were cast in plaster, causing part of the wall to be cut away to find room for them to be moved, by means of trucks, on and off the tiny stage.

The scene-changes must have been lengthy, but were no doubt enlivened by Gordon's painted act-drops that presented the larger vistas of St Mark's, the Rialto and the Grand Canal. At the Oxford Union in 1900, Herbert Beerbohm Tree (1852–1917), the last of the great Shakespeare-producing actor–managers, described this as "the first production in which the modern spirit of stage-management asserted itself, transporting us as it did, into the atmosphere of Venice, into the rarefied realms of Shakespearean Comedy".

Henry Irving's achievement at the Lyceum Theatre during the last two decades of the century is frustrating for the theatre historian. There are no photographs of his productions and few designs or engravings that properly record his theatrical achievement, yet Irving lavished huge resources upon the creation and presentation of carefully orchestrated and composed stage pictures. The diligent actor–manager paid meticulous attention to detail and gave the compositional care of a Pre-Raphaelite painter to his productions. But if the stage was a picture, then the actor also had to be a picture. Pictorialism on stage was matched by actors composing their bodies into a continuous series of beautiful pictures, since poetic beauty remained one of the principal aims of acting. Irving achieved his greatest success with characters that were complex, introspective and individual to the point of eccentricity. His hypnotic performances built upon the literary fashion for 'secret life' and split-personality stories, offering the Lyceum audience an escape from the light of Victorian virtue into darker human truths.

In his two productions of *Macbeth* of 1875 (fig. 20) and 1888, he developed what George Rowell (1981) called "the diptych of demon

LIVERPOOL JOHN MOORES UNIVERSITY
LEARNING SERVICES

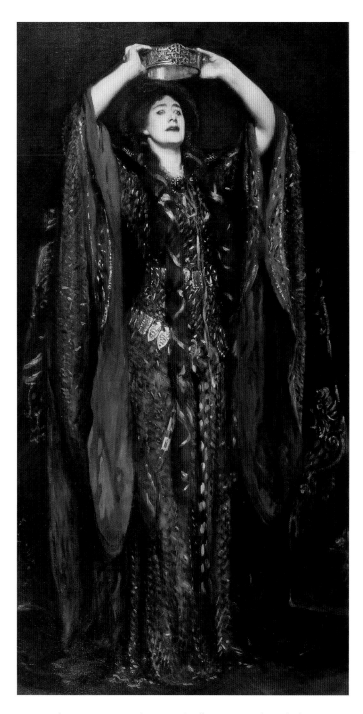

Fig. 19 John Singer Sargent (1856–1925), *Ellen Terry as Lady Macbeth*, showing her wearing the Beetle costume, 1889, oil on canvas, 221 × 114.3 cm (87 × 45 in.), Tate, London

sir, why do you start, and seem to fear/ Things that do sound so fair?" Ellen Terry (1847–1928) playing the part in 1888, answered in her production notes: "Because he had longed for it before & here's his secret thought revealed" (Terry, 'Studybook', no. 97). Ellen Terry thought that "he looked like a great famished wolf" (Terry 1908), and *The Times* (31 December 1888) concluded its review: "the dominant impression left upon the mind is that of a wild, haggard, anguish-stricken man, battling for his miserable existence with the frenzy of despair."

Considerable attention was also paid to costume, and Ellen Terry used the fabrics and designers of the firm of Liberty & Co. to considerable acclaim (fig. 19). *The Times* (31 December 1888) described her costume for Lady Macbeth: "long plaits of deep red hair fell from under a purple veil over a robe of green upon which iridescent beetles glinted like emeralds, and a great wine-coloured cloak, gold-embroidered, swept from her shoulders." Oscar Wilde remarked: "Lady Macbeth seems an economical housekeeper and evidently patronises local industries for her husband's clothes and the servants' liveries, but she takes care to do all her own shopping in Byzantium" (Graham Robertson 1931).

Although most applauded Irving's Shakespeare revivals, those who did not touched upon the scenic weakness of his approach. *The Times* (12 October 1882) concluded its review of *Much Ado About Nothing*: "Fortunately the acting, not merely of Mr Irving and Miss Terry, but of the Company generally, redeems the play from being a mere medieval panorama." In lesser hands, with less taste and less sense of order, composition and propriety, late nineteenth-century staging descended into the merely overdressed and well-upholstered, the Shakespeare of the respectable showground.

Irving resisted the introduction of electricity to the Lyceum Theatre during the 1880s, preferring the more controllable and atmospheric gas lighting. Ellen Terry says in her *Memoirs*: "The thick softness of gaslight, with the lovely specks and motes in it, so like *natural* light, gave illusion to many a scene which is now revealed in all its naked trashiness." The introduction of electric lighting (at the Savoy Theatre in 1881) was significant. Although very basic technology existed to dim electric lighting, the potential of electricity to provide more brilliance than gas could not be resisted. Reviews and advertising were seasoned with phrases such as "never was a stage more brightly lit". But at the same time, this harsh brilliance overexposed the delicate scenic language of painting and painted shadows. The starkly lit reality of the three-dimensional actors threw the painted artificiality of stage scenery into jarring contrast. Stage managers responded by using ever more 'real' and built-up details, but inevitably, fuelled by new technologies, the 250-year-old scenic tradition began to collapse beneath the sheer weight of its own scenery. Heavy, three-dimensional, constructed scenery could not easily be manoeuvred within the elegant simplicity of the sliding groove and shutter system. Scene-changes became longer and longer (Irving's

and saint". But Irving's slender frame and ascetic appearance disqualified him from achieving the popular stereotype of Macbeth as a burly, claymore-wielding Highlander. The *Saturday Review* (5 January 1889) said: "This Macbeth is from the first 'a man forbid'. His lined and haggard features, his restless movements, his wild and wandering eye give him such a thoroughly unreliable look." Lady Macbeth asks, "Good

meticulously stage-managed *Macbeth* in 1888 had five intervals totalling forty-six minutes, and the cathedral scene in *Much Ado About Nothing* took fifteen minutes to erect) and, to meet the final trains and omnibuses to carry the audiences home, the plays were rearranged, cut and further adapted, until they became little more than accompaniments to spectacular *tableaux vivants*. George Bernard Shaw scathingly reviewed Beerbohm Tree's *A Midsummer Night's Dream* at Her Majesty's Theatre in January 1900: "you can't see the Shakespeare wood for the Beerbohm Trees!" The welter of heavy stage scenery, the exposure of its artificiality, notwithstanding the expense and artistry, and the mutilation of the drama instigated the collapse of a theatrical language that had supported the plays since the seventeenth century, and by the First World War had turned mainstream Shakespeare production into little more than a museum of arts and crafts.

The antiquarianism initiated by Malone was renewed with vigour in the medievalism of the last decades of the nineteenth century. During the 1880s, the Johannes de Witt and Arend van Buchell drawing of 1596 of the Swan Theatre was discovered, offering the first real image of the interior of a public theatre at the time of Shakespeare. Research into the early theatres and conditions of performance by W.J. Lawrence, William Poel (1852-1934) and Ernest K. Chambers began to reveal a theatre in which scene design and architecture were aesthetically united. This vision has driven the atavistic yearning of the twentieth century in its abandonment of the excrescences of theatrical presentation in favour of a purer, clearer vision of presenting Shakespeare. The cool, clean scenographic modernism proposed by Edward Gordon Craig (1872–1966) in the early twentieth century has combined with a minimal production aesthetic focusing on the performance skills of the actor through the experimental work of Harley Granville Barker (1877–1946) and William Poel. Notwithstanding this radical change in attitude to the staging and performance of Shakespeare, his cultural status in the twenty-first century remains undiminished. He may no longer serve as a powerful source of imagery for the easel artist, nor may the theatre feel that it must 'illustrate' the plays, nor indeed may we any longer see his plays as directly supportive of our current monarchy and government; nevertheless the plays have the breadth and sheer imaginative scale that constantly provide theatre artists with opportunities for examinations and re-evaluations of politics, nationality and humanity.

SELECT BIBLIOGRAPHY

Terry, 'Studybook'; Odell 1920–21; Sprague 1945; Moelwyn Merchant 1959; Rosenfeld 1973; Powell 1986; Taylor 1989; Brewster and Jacobs 1997; Wells 1997; Schoch 1998; McIntyre 1999; Moody 2000

Fig. 20 James Archer (1823–1904), *Henry Irving as Macbeth*, dated 1875, oil on canvas, 198 × 88.8 cm (77⅞ × 34⅞ in.), Private Collection

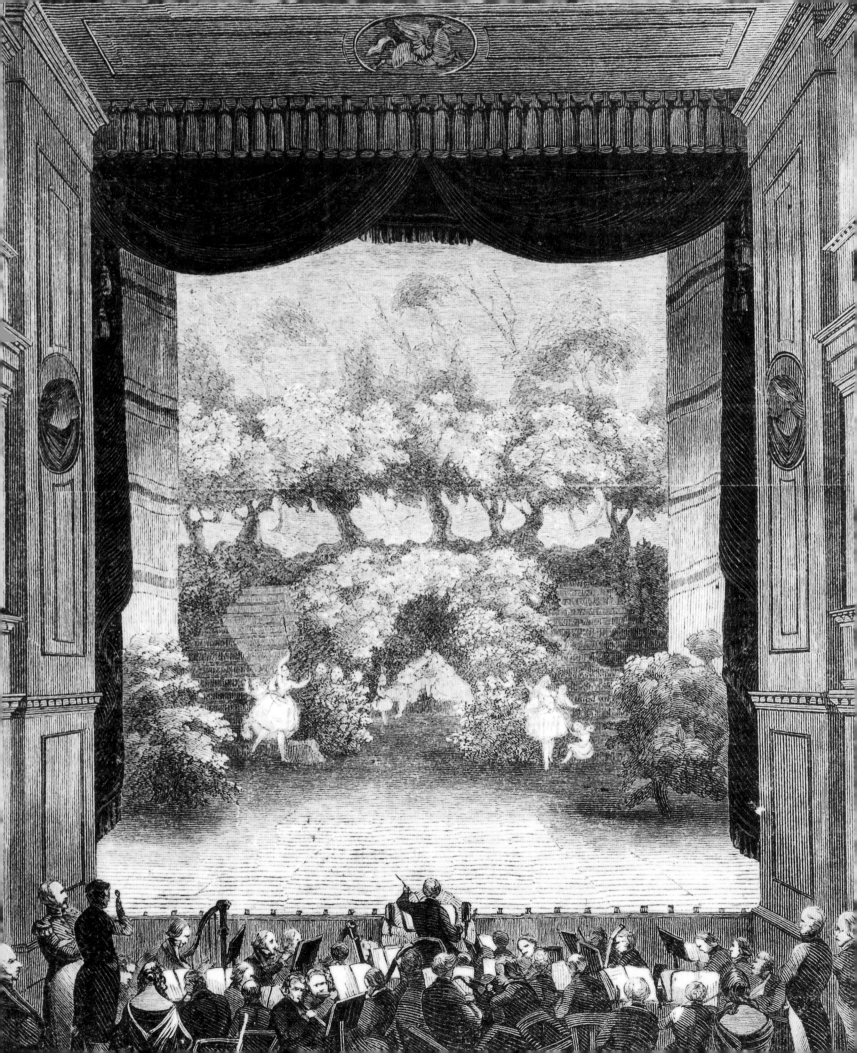

SHAKESPEARE AND MUSIC

John Warrack

The theatres of Elizabethan England rang with music. Fanfaring 'alarums' would signal a battle and 'tuckets' or 'sennets' announce a formal arrival, mimed scenes brought on cornetts, flutes or oboes, jigs were danced to fiddles, songs were sung to a lute or viols or even a little reed-organ, all within the play itself, with performers above or below or to one side of the stage or taking part with the actors. There were musical interludes between the acts and 'soundings' of music lasting anything up to an hour beforehand. All this and much more was part of Shakespeare's theatrical life. He had a good knowledge of music, and his abundant love of it shows everywhere, perhaps never more movingly than near the end of *The Merchant of Venice* when Lorenzo reflects on the power of music, scorning "the man that hath no music in himself", and inviting Jessica to listen to the musicians who come to play to them.

Even though this famous scene is suffused with music, we have no idea of what was played. It was 'incidental' in the sense that, though it would naturally have been suitable for the gentle night setting, it was performed by a group of amateur players and would not have portrayed the scene with a composer's imagination, after the manner of Mendelssohn's Nocturne in his *Midsummer Night's Dream* music (1826). Many years were to pass before that could come about. Music, nevertheless, is woven into the fabric of the plays to differing degrees, though most intensely in the comedies and tragedies. It may enhance the portrayal of the characters or contribute to the mood of an individual scene or colour a whole play, from the contrast of ceremony and battle with sensuous pleasure in *Antony and Cleopatra* to the invisible musicians of Prospero's mysterious isle, one "full of noises, sounds, and sweet airs, that give delight and hurt not", moving even the earthbound Caliban.

With the restoration of the monarchy in 1660, and the reopening of the theatres after their closure during the Commonwealth, came the revival of Shakespeare's plays, if generally in chaotic versions. Nothing epitomizes the state into which the stage had sunk more

than the 1667 version of *The Tempest* by William Davenant and John Dryden. In this farrago, there is a ludicrous duplication of the characters, such as a young man with no knowledge of women to match Miranda, and so forth; a valiant revival at the Old Vic in 1959 fully demonstrated its absurdity. Contributions were made to it by a number of composers, possibly including Purcell, who, despite also writing music for versions of *A Midsummer Night's Dream* (as *The Fairy Queen* in 1692) and *Timon of Athens*, never set an actual line of Shakespeare in them. Songs in the plays were given music by various composers, most famous among them Thomas Arne and William Boyce in the mid-eighteenth century, but the lack of an English operatic tradition meant that the genius of Purcell went to waste in this respect, and that no serious attempt at a Shakespeare opera was made in the land of his birth for many years to come.

Abroad, Shakespeare came to Germany after a fashion, with the troupes of *Englische Komödianten* who toured with their own corrupt versions of the plays, such as a *Merchant of Venice* that finds room for the German clown Pickelhäring and a *Hamlet* which, though it includes the no doubt much-needed advice to the players, is turned into a crude revenge tragedy. The need for these hugely popular English players to put their wares across among foreigners added to the importance of music, not only with sennets and tuckets but also with musical interludes and the use of old tunes fitted to new words. Readers of *Wilhelm Meister* (1795–96) will recall, besides the famous discussion of *Hamlet*, Goethe's description of the strolling players hastily cobbling together an entertainment, with their musician hunting out familiar tunes to fit the words. Yet these impoverished entertainments helped the humble German *Singspiel*, or song-play, develop into something more substantial, until by the end of the eighteenth century it was capable of sustaining the contributions of composers of real talent and, in Mozart's case, genius. And with Germany's literary revival, awareness of Shakespeare led to his being regarded in a new light. Frederick the Great was still following his friend Voltaire's notorious opposition to Shakespeare when in 1780 he wrote, in *De la littérature allemande*, of "*les abominables pièces de Schakespear traduits en notre langue*"; but Christoph Martin Wieland's translations of 1762–66 had meanwhile introduced Shakespeare to a

OPPOSITE Fig. 21 Anon., Ludwig Tieck's production of *A Midsummer Night's Dream* in Potsdam, 1843, in which Mendelssohn's incidental music was heard complete for the first time, Deutsches Theatermuseum, Munich

the genii, and Trinculo or Stephano and Papageno. But even Mozart would have needed to shed rather than transcend the limiting conventions of Viennese comedy that shape *The Magic Flute*. Though F.W. Gotter's libretto *Die Geisterinsel* considerably distorts the play, it was constructed to invite an operatic response to Shakespeare (and was hailed by Goethe as a masterpiece). Gotter turned down Karl Ditters von Dittersdorf (1739–1799) for all his high reputation, on realizing that the text was going to be reduced to operatic cliché. At least two of the other operas, by Johann Reichardt and Johann Zumsteeg, hardly lift the characters beyond operatic stereotype – each of their Mirandas is in her own way a charming version of the operatic ingénue – but, as composers feeling their way into a Romantic world, they use music to respond to the storm and magic enveloping the characters, in a manner that has caught something from Shakespeare.

Even after he had been claimed by the Romantics as one of their own, indeed perhaps the greatest of their own, the problem of reconciling Shakespeare with the conventions of opera remained. In some cases, this was scarcely attempted. Rossini's *Otello* (1816) was a well-loved work in its day, and is still sometimes revived, but his dilettante librettist, Francesco Berio di Salsa, was only concerned to accommodate the plot to the operatic conventions of the time. It was at Rossini's suggestion that Salsa inserted, into Desdemona's sorrowful tale of her woes to Emilia, an off-stage gondolier singing Dante's lines, "*Nessun maggior dolore che ricordarsi del tempo felice nella miseria*" (there is no greater suffering than to remember happy times when sad). It is a touch of dramatic irony worthy of Shakespeare; but it is only a touch. Neither Salsa nor Rossini, nor their audiences, would have been minded to go against the general acceptance of the conventions. Nor, indeed, would they have been likely to reject the Aristotelian dramatic unities more or less strictly observed in this opera, which the French had originally learnt from the Italian critic Lodovico Castelvetro (1505–1571), and that were still casting a long shadow over Italian as well as French ideas about Shakespeare.

In France the shadow had become oppressive to the young Romantics of the 1820s, and among musicians especially oppressive to the composer who of all composers most thoroughly understood Shakespeare, Hector Berlioz (1803–1869). Like his contemporaries, he can at first have known Shakespeare only through Pierre Le Tourneur's emasculated prose translations and their subsequent concoctions in the manner of French Classical tragedy by Jean-François Ducis. The first relatively faithful French translation was that of François Guizot, which burst like a ray of light on the young Romantics in 1821. Berlioz's first stage experience of Shakespeare was one of the most famous *coups de foudre* in the history of Romanticism (see p. 18). In 1827 Charles Kemble brought an English company to Paris to play *Hamlet* and *Romeo and Juliet* at the Théâtre de l'Odéon. Only five years previously, a Paris performance of *Othello*

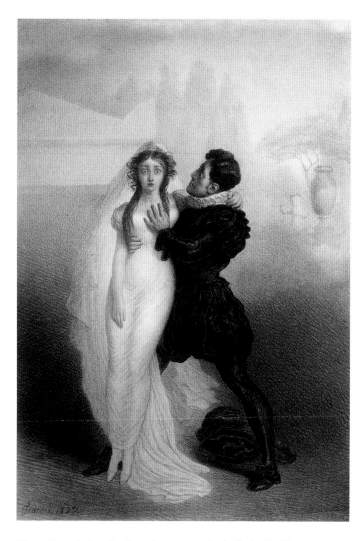

Fig. 22 Francis-Antoine Conscience (1795–1840), *Charles Kemble as Romeo and Harriet Smithson as Juliet Performing at the Odéon, Paris*, 1827, engraving, Theatre Museum, London

hungry audience. The ears of German writers and intellectuals were caught by the essays of G.E. Lessing's *Hamburgische Dramaturgie* (1767–79), bravely holding Voltaire up to ridicule, and by the resonant voice of Herder in *Von deutscher Art und Kunst* (Of German Art) of 1773, where the Shakespeare essay takes up Lessing's praise for *Richard III*. In the *Sturm und Drang* of the 1770s, Shakespeare was now regarded in Germany as a great playwright. Composers were alerted. In a sudden flurry, the closing years of the century saw no fewer than seven operas based on *The Tempest*.

To these might have been added an eighth, had negotiations with Mozart not been broken off by his death. The loss of a Mozart opera on *The Tempest* seems one of the cruellest of all musical might-have-beens, especially in view of the correspondences that have been noted between Prospero and Sarastro, Miranda and Pamina, Ferdinand and Tamino, Caliban and Monostatos, perhaps Ariel and

had caused Shakespeare to be dubbed *un aide de camp de Wellington* and the actors to be pelted with rotten fruit; but 1827 was also the year of Victor Hugo's *Cromwell*, with its famous preface calling for liberation from the constraints of French Classical drama. A new generation of artists, eager to search out where new inspiration might lie, flocked to see what Shakespeare had to offer. Together with Alexandre Dumas and Hugo himself went Eugène Delacroix, Alfred de Vigny, Gérard de Nerval, Charles Sainte-Beuve and Théophile Gautier, as well as Berlioz, assembling their troops in – where else? – the Café Voltaire opposite the stage door as they confronted the old guard ranked in another café. The battle was suitably vociferous. Berlioz understood no English, but like his companions he was carried away by the fluency and force of this thrillingly novel form of drama. More, he was transfixed by the young actress Harriet Smithson (fig. 22), whose slender form and huge, compelling eyes, and her half-miming, half-singing of Ophelia's madness, took complete possession of his imagination. Unable, or romantically unwilling, to distinguish between art and life, he was immediately obsessed with the ambition to marry her.

Though Berlioz's eventual marriage to Smithson faded into unhappiness, his love of Shakespeare never dimmed, and it left an enduring mark on his art. His directly Shakespearean works are *Fantaisie sur la Tempête* (fantasy on *The Tempest*) of 1830, the overture *King Lear* (1831), the dramatic symphony *Roméo et Juliette* (1839), a funeral march for the last scene of *Hamlet* (1844), the ballade *La Mort d'Ophélie* (1848) and his late opera *Béatrice et Bénédict* (1862); there were unrealized projects for operas on *Romeo and Juliet* and *Antony and Cleopatra*. Moreover, his great operatic masterpiece, *Les Troyens*, completed in 1858, shows how the stately medium of French Grand Opera could be fertilized and brought to new life by Shakespearean ideas of mixed genres, heroic and lyrical dramatic language, violent action alternating with reflection, comedy briefly invading tragedy, and the contrast of small people's lives caught up with the heroic and regal, all in an epic sweep. Berlioz knew what he was doing: when he incorporated words from *The Merchant of Venice* ("In such a night as this …") into the nocturne by the sea in Carthage, he called it "a scene stolen from Shakespeare and Virgilianized. Shakespeare is the real author of the words and the music. Strange that he should intervene – he, the poet of the north – in the great work of the poet of Rome".

At this stage of his life, Berlioz saw no way of writing a Shakespeare opera. *The Tempest* fantasy began life as an overture for performance at the Théâtre Italien, with an Italian text by Berlioz himself, who was then learning the language. Shortly before it was premiered (in fact, at the Opéra), he wrote an article describing its four-part structure: a Prologue "in which the airy spirits in Ariel's charge predict to Miranda the arrival of her future lover"; tempest and a chorus ("Miranda! Miranda! He's here!"); an Action depicting

Fig. 23 Anon., Giuditta Grisi and Amalia Schutz-Oldosi as Romeo and Juliet in Vincenzo Bellini's *I Capuleti e i Montecchi*, Teatro alla Scala, Milan, 1831, Civica Raccolta di Disegni e Stampe Bertarelli, Milan

Ferdinand, Miranda, Caliban and Prospero; finally a Dénouement and the departure for Milan. Feeling the music too good to lose, Berlioz later rescored it for full orchestra and used it to round off the *monodrame lyrique* that he appended to the *Symphonie fantastique*, entitled *Lélio* (1832). This shows the drugged hero of the symphony returning to consciousness. He reflects on his life and his art, and especially on how "*Shakespeare a opéré en moi une révolution qui a bouleversé tout mon être*"; and he begins to imagine music ("*une instrumentation sourde une harmonie large et sinistre une lugubre mélodie*") as there sounds a magnificent *Chœur d'ombres*, rescued from a forgotten Prix de Rome cantata, *La mort de Cléopâtre*.

The Tempest fantasy always transcended its role as a theatre overture, as did the tremendous *Hamlet* funeral march, which originated in plans for incidental music. Like the later *La Mort d'Ophélie*, it was

LIVERPOOL JOHN MOORES UNIVERSITY
LEARNING SERVICES

an example of how a literary inspiration – especially from the three great figures in his pantheon, Virgil, Shakespeare and Goethe – could seize Berlioz's imagination and demand music before a home for it could be found (his *Damnation of Faust* had begun life in 1829 as eight separate moments in Goethe's poem, each of them prefaced by a quotation from *Hamlet* or *Romeo and Juliet*, the two plays in which he had seen Harriet act). Discovery of *King Lear* came, so he wrote in a long and colourful letter to a group of Paris friends in 1831, "*sur le bord de l'Arno, dans un bois délicieux à une demi lieue de Florence*", and it left him convulsed. Never intended for theatrical performance, the overture abstracts elements from the play into a symphonic piece of music. In his *Mémoires*, Berlioz quotes with approval the reaction of the blind old king of Hanover: "Your orchestra speaks, you don't need words. I followed it all: the King's entry into his council, the storm on the heath, the terrible scene in the prison, and Cordelia's lament. Oh, this Cordelia! How you have portrayed her – such tenderness and humility!"

It was in reaction to what he regarded as operatic wreckings of the plays that he turned to his largest Shakespearean project. Staying in Florence in 1831, he learnt that Bellini's *I Capuleti e i Montecchi* (fig. 23) was being performed, and hurried off to the theatre, his mind whirling with the possibilities: "the dazzling ball at the Capulets; those furious pitched battles in the streets of Verona, with the fiery Tybalt … the glorious night scene on Juliet's balcony; the dashing Mercutio; the cackling nurse; the stately hermit; then the catastrophe, extremes of joy and despair drained to the dregs in the same instant; and at the last, the solemn oath sworn by the warring houses, too late!"; he pours out his high hopes in rhapsodic prose. But then: "Bitter disappointment! The opera contained no ball at the Capulets, no Mercutio, no garrulous nurse, no grave and tranquil hermit, no balcony scene, no sublime soliloquy for Juliet as she takes the hermit's phial, no duet in the cell between the banished Romeo and the disconsolate friar, no Shakespeare, nothing – a wasted opportunity." And everyone sang out of tune, "with the exception of two women, one of whom, who was tall and substantial, played Juliet. The other, who was short and thin, played Romeo". There could have been no more challenging confrontation with the enduring problem of whether Shakespeare could be accommodated to the operatic stage at all without fatal losses. *Singspiel* had its limited, and limiting, set of stereotypes; what became known as the 'code Rossini' was effective for early Romantic Italian opera, but again reduced the plays to little more than the plots, which, taken by Shakespeare from many sources, often Italian, were only the starting-point for what made him Shakespeare. The fluency and variety of his dramatic forms conflicted with most operatic practicalities, and the strength and beauty of the language went against music taking the lead, which it must in the operatic complex.

Not for another six years, when a gift of twenty thousand francs from Paganini made it financially possible, did Berlioz find a way of turning again to *Romeo and Juliet*. Paganini's accompanying letter hailed him as Beethoven's successor, percipient words in that the impact of the Ninth Symphony in 1824, bursting symphonic bounds into choral life with its finale, had set Romantic composers a challenge. For Berlioz, especially in the wake of the failure of his *Benvenuto Cellini* at the Opéra in 1838, here was the opportunity to abandon operatic convention in favour of a free form, with mixed musical genres, that would be a Shakespearean 'dramatic symphony', not a substitute for the play but a musical experience of it.

So his Introduction begins with a headlong fugue depicting the fighting Capulets and Montagus, interrupted by a trombone suggesting the Prince's intervention. The scene is without words, which only appear and dominate the music in the succeeding Prologue, announcing the matter of the play in a choral recitative, then mingling instrumental passages and snatches of choral dialogue. Fragments of music we shall hear later are briefly introduced, but what is essentially introduced to the listener is the symphony's method, the cross-fertilizing of words and music in a symphonic parallel to Shakespearean open form and mixed genres. The second part of the symphony concerns Romeo at the ball, with his expressive oboe solo drowned by the festivities. In the Love Scene, words recede before music as the songs of the revellers fade into the night. Berlioz knew that no one could add music to Shakespeare's words for the Balcony Scene; this is the purest poetry, and so a composer's answer must be pure music – a rapt orchestral meditation that is among the most beautiful pieces he ever wrote. This slow movement is answered by a dazzling Queen Mab Scherzo. From meditation there is a return to imagery, and hence action. With Juliet's funeral cortège, words re-enter the symphony, in a chanted monotone later exchanged with the orchestra. In the Tomb Scene, the narration is entirely in the orchestra. Finally, the chorus returns as Friar Laurence preaches his sermon of reconciliation, and Berlioz marshals a full-scale symphonic reconciliation of words and music to match that of the Montagus and Capulets. The whole work is a vastly ambitious project, uneven in achievement, written out of a deep understanding of how a musician could respond to Shakespearean methods.

Not until near the end of his life did Berlioz write a Shakespeare opera, though the first ideas for it date from 1833, and this was his so-called "caprice written with the point of a needle", *Béatrice et Bénédict* (1862). Based on *Much Ado About Nothing*, with his own text "*imité de Shakespeare*", it was in part composed for light relief after the huge effort of *Les Troyens*, a refreshment of the kind that other composers have found congenial. Using his own spoken dialogue, it is really scenes from Shakespeare, reducing five acts to a two-act opera that concentrates on Beatrice and Benedick. It retains from *Les Troyens* the capacity for writing tender, nocturnal Mediterranean music, but also shows that Berlioz, happy to return to Italian (or Sicilian) subject-matter, never lost the mordant wit nor the warmth that could lie

beneath it, appropriately for the warring hero and heroine tricked into acknowledging their love for each other.

Years before, out riding near Rome with Felix Mendelssohn, Berlioz had confided his plan for a Queen Mab Scherzo, only to regret instantly having given away such an idea to one of the great masters of fleeting, fairy music. Mendelssohn never in fact used it, nor, despite considering a plan for *The Tempest*, did he ever write a Shakespeare opera. His operatic gifts were for lighter *Singspiels*; his one attempt at a larger work based on Cervantes, *Die Hochzeit des Camacho* (1827), failed, an unfamiliar shock which unnerved the brilliant boy used only to success. But Shakespeare ran in his veins. His grandfather, the philosopher Moses Mendelssohn, had read the plays in English and made some translations that include a very able version of "To be or not to be", as well as passages from *A Midsummer Night's Dream*. This was the favourite play of the children Felix and Fanny, who used to give domestic performances. "We were really brought up on *A Midsummer Night's Dream*", Fanny wrote. No wonder that, in 1826 and at the age of seventeen already a composer of genius, Mendelssohn should have turned to music for it. Hardly had the famous translations (1797–1810) by A.W. Schlegel and Ludwig Tieck come his way than he wrote his overture. It remains a brilliant distillation of the essence of a play into pure musical form: the four 'magic' chords that disclose the wood, the dancing, flickering theme of the fairies, the splendid figure for the lovers, the hee-hawing of poor translated Bottom.

So complete was Mendelssohn's response to the play that he allowed the overture to colour the invention when, sixteen years later, a new opportunity came. In the spring of 1842, the king of Prussia commissioned music for the play to celebrate his birthday, a gesture for which he was surprised to be congratulated by Berlioz, since not everyone shared his love of Shakespeare: supping at the king's table after the performance, a courtier sought to praise Mendelssohn by observing, "pity your wonderful music had to be wasted on such a silly play". It is the fairies who predominate, Mendelssohn seeing his music as the dimension of magic in which the play exists. So he writes no music until after the first act and the lovers' banishment to Shakespeare's mysterious "wood near Athens". As the interlude between Acts 1 and 2 comes the Scherzo, a virtuoso piece advancing the fairy world to the centre of the drama, but also containing a sense of danger in the headlong pace and glittering textures that bring us face to face with Puck as the curtain rises. In the depths of the wood's magic, as another entr'acte, horns sound the melody of a Nocturne. There are shorter interjections and a Bergomask (Shakespeare's term) for the "rude mechanicals", and the final entr'acte is the Wedding March, now filled with so many wedding associations that it is perhaps hard to hear it in its true context, as a jubilant turn from an Act that began in darkness towards the drama's resolution: "Jack shall have Jill, nought shall go ill".

Fig. 24 G. Mariani, after Vincenzo Moriani, *Maria Malibran as Desdemona*, from Gioacchino Rossini's *Otello*, 1832, engraving, Civica Raccolta di Disegni e Stampe Bertarelli, Milan

On its own, Mendelssohn's overture stands as an orchestral Shakespeare portrait, such as was the response of other nineteenth-century composers. In his 1858 *Hamlet* tone poem, Liszt concentrates on the character's indecision, even marking one theme "*vacillando*", and builds a powerful work out of the contrast between reflective elements and more hectic, nervous music. Only as an afterthought were two sections for Ophelia introduced. In some ways it anticipates Tchaikovsky's overture fantasia *Hamlet* (1888), which, he told his brother Modest, falls naturally into three parts: "1. Elsinore and Hamlet, up to the appearance of his father's ghost. 2. Polonius (scherzando) and Ophelia (adagio). 3. Hamlet after the appearance of the ghost. His death and Fortinbras". There is a love theme for Hamlet, with a charming, plaintive oboe melody for Ophelia, and the design includes a repeated march for Fortinbras; but the essence of the work is the dark, brooding atmosphere of Elsinore.

Hamlet was a character particularly absorbing to Russians, whose fascination with Shakespeare went back a long way. One of the first Russian operas, *The Early Reign of Oleg*, compositely composed in 1790 but with a text by Catherine the Great herself, was claimed as Shakespearean. Pushkin had, like many another educated Russian, read Shakespeare in the Ducis translations, and his passionate admiration led him to write *Boris Godunov* (1825) in imitation of

Shakespeare's history plays (a form that survives into Musorgsky's opera). Tchaikovsky had long shared this admiration, and *Hamlet* was in fact the third of his Shakespeare works. His first orchestral masterpiece was his overture *Romeo and Juliet*, in its original version dating from 1869, when he was twenty-nine. Though the ingredients of the drama are perceptible – Friar Laurence's priestly motive, the clashing swords of the warring families – these are made into an abstract musical drama. Love, conveyed in one of Tchaikovsky's most ravishing melodies, is crushed by the violence of the feud, with some of his most thrilling orchestral clashes, and ends in black oblivion. His symphonic fantasia, *The Tempest* (1873), provides graphic pictures of the sea and of Ariel, but there is not the same involvement with the events nor the same capacity to make a musical drama of them; while the comparative poverty of the Miranda theme suggests her touchingly innocent love, its happy outcome does not find the same acuteness of response that he gives the star-crossed lovers Romeo and Juliet. Other composers developed the idea of Shakespearean tone-poems, among them Bedřich Smetana, with a somewhat repetitive work based on *Richard III* (1858; the first of the plays was translated into Czech in 1851), Zdeněk Fibich with a symphonic poem (1873) and Anton Dvořák with an overture (1892), both based on *Othello*, and Richard Strauss's first tone poem, *Macbeth* (1888), which concentrates on the characters of Macbeth and Lady Macbeth and even carries some verbal quotations in the score.

In each of these works, formal coherence is achieved by the use of characters, events or ideas suggesting themes that can then be worked into a version of so-called sonata form. In this, two or more musical ideas are first set out in an Exposition, then explored in a Development and finally revisited in a Recapitulation. With some ingenuity, an inventive composer can often accommodate the nature and progress of a drama to these formal requirements. An exception is Edward Elgar's long 'symphonic study' *Falstaff* (1913), which he regarded as his best work. Based on the Henry IV plays, it portrays different aspects of Falstaff's character in his relationship to Prince Hal with as many as five different themes, and the narrative element (with interludes portraying the boy Falstaff and the gathering in Shallow's orchard) really concerns the development of the relationship leading up to Falstaff's rejection and death.

Despite the problems, opera composers continued to be fascinated by Shakespeare, with predictably mixed results. Wagner, who had a lifelong veneration for Shakespeare, tried his hand not very successfully at *Measure for Measure* in his second opera, *Das Liebesverbot* (1836), as part of his search for Italian lyricism and in particular for the melodic elegance of Bellini (whom he never ceased to admire). French composers found ways of making accommodation with their own kind of lyric opera, charmingly with Gounod's *Roméo et Juliette* (1867), awkwardly with a *Hamlet* by Ambroise Thomas (1868) that imports a Donizetti-like Mad Scene for Ophelia and

pastes on a happy ending. Italian Romanticism reacted against previous French-inspired hostility by welcoming Shakespeare, and opera formed part of the movement, including Pietro Generali's *Rodrigo di Valenza* (1817), a version of *King Lear*, Saverio Mercadante's *Amleto* (1822), settings of *La Gioventù d'Enrico V* by Giovanni Pacini (1820) and Mercadante (1834), and especially versions of *Romeo and Juliet* by several composers before Bellini's of 1830. Matters were not helped by translation being slow and sporadic: the first complete translation was Carlo Rusconi's prose version of 1839, which Verdi used for *Macbeth* in 1847. Verdi was much affected not only by the influential writings of Giuseppe Mazzini and Alessandro Manzoni, but also by his close friendship with the Milanese poet Giulio Carcano, author of the *Teatro scelto di Shakespeare* (1843) and eventually of the complete translation that appeared between 1875 and 1882. Verdi's 1847 version of *Macbeth*, for which he drafted his own text before handing over to his librettist Francesco Piave, dominates the scene, though at this comparatively early stage of his career (and even in the much stronger Paris version of 1865), his powerful dramatic sense and superb inventions lie alongside such conventional material as the opening chorus of witches and the trivial *banda* march for Duncan.

No reservations need apply to *Otello* (1887) and *Falstaff* (1893; fig. 25, p. 47). For them, Verdi had the services of an exceptional librettist in Arrigo Boito, an intelligent writer and moreover a composer himself who knew and understood Verdi well. Boito's major alterations to *Othello* were the removal of Shakespeare's first act, leaving music to define Otello's heroic nature on disembarking in Cyprus after the conquest of the Turkish fleet, and the addition of a Credo to define in Iago the villainy that Shakespeare leaves enigmatic. He also absorbs into the text various traditional numbers, such as a drinking song and a concerted finale to Act 3, familiar ground for Verdi, while encouraging him in the direction he was by now seeking to follow, that of a more fluent, forward-looking musical drama. If not a compromise of genius, it could be called a compromise for a genius (fig. 24). The pace is still more fluent, and much faster, in *Falstaff*, based on *The Merry Wives of Windsor*. A lifelong admirer of Shakespeare, Verdi in his old age was now able, as he often told Boito, simply to enjoy himself. For his part, Boito was clever enough to give Verdi a profusion of words, from a less distinguished play, that provide an abundance of musical action. The opera speeds on its way, with the music enlivening and enriching the characters as the plotting grows ever more intricate, until all is resolved with Falstaff's good-humoured acknowledgement of defeat; and Verdi can turn his characters to the audience in a musical form that sums up all the intricate verbal and narrative counterpoint, a fugue: *"Tutto nel mondo è burla"* (All the world's a stage).

Though the twentieth century brought to the stage a masterpiece of ballet in Prokofiev's *Romeo and Juliet* (1935), and many Shakespeare operas – among almost twenty settings of *Macbeth*, a strong,

Fig. 25 Gennaro Amato, *Falstaff: La scena della cesta* (from the opera *Falstaff*, II. i), showing Alfredo Hohenstein's set, with Victor Maurel as Falstaff, A. Pini Corsi as Ford, with E. Zilli, G. Pasqua and V. Guerrini, engraving from *L'illustrazione italiana*, 19 February 1893, Giancarlo Costa, Milan

claustrophobic one by Ernest Bloch (1910) – the most successful is Benjamin Britten's A *Midsummer Night's Dream* (1960). Britten had played the viola in Mendelssohn's incidental music as a boy, and from Mendelssohn, perhaps, came his use of 'magical' chords opening the work and introducing the wood into which the lovers stray. He makes brilliant use of different levels of voice: high, for Titania, a counter-tenor Oberon, the child fairies, and a spoken boy Puck; conventional pairings for the four lovers; all-male for the "rude mechanicals", whose playlet *Pyramus and Thisbe* is perhaps a piece of self-indulgence in its parodying of various Italian operatic conventions. The wood remains all-embracing, a magic realm with its own musical identification, where the confusions of the lovers in the darkness become resolved as dawn breaks over them. The opera has a strong claim to be Britten's operatic masterpiece, and to be one of the very few Shakespeare operas to set beside Verdi.

Even Britten, as Verdi had before him, drew back, after much consideration, from *King Lear*. Shostakovich also held back, fascinated by the subject but composing only incidental music in his darkest manner

for a production in 1940. He provides music for the storm on the heath, and for the blinding of Gloucester, and a miniature cycle of songs for the Fool. There is much to regret in these losses. But perhaps all three composers were right. Perhaps *Lear* is one work of Shakespeare that really does lie beyond the reach of music.

SELECT BIBLIOGRAPHY

Gooch and Thatcher 1991; Hartnoll 1964; Hotaling 1990; LeWinter 1963; Schmidgall 1990; Weaver 1981

LIVERPOOL JOHN MOORES UNIVERSITY
LEARNING SERVICES

THE EARLY ILLUSTRATORS OF SHAKESPEARE

Brian Allen

With the notable exception of scene painting, there was very little tradition of theatrical painting in England. Even during the fruitful years after the restoration of the monarchy in 1660, drama was barely reflected in the visual arts. The few theatrical paintings surviving from the first decades of the eighteenth century are mainly the products of foreign artists. A good example is Giuseppe Grisoni's portrait of the celebrated actor Colley Cibber as Lord Foppington in Vanbrugh's *The Relapse* (Garrick Club, London, no. 116), which, with its exaggerated and affected gestures, is in the tradition of the French Baroque court portrait. Until William Hogarth (1697–1764) and Francis Hayman (1708–1776) developed the genre, there was nothing in English painting comparable to the Dutch artists' depiction of either the professional theatre in Amsterdam or the amateur players, painted by Jan Steen and his contemporaries in the seventeenth century (Heppner 1939–40).

By the time Hogarth painted his representations of *Falstaff examining his Troops* (1730s; pl. 1) and John Gay's *The Beggar's Opera* (1729; Tate, London), the relationship between painting and the theatre was beginning to take root. The actor Thomas Betterton (1635–1710), for instance, advised his fellow thespians to study history painters for their accuracy of expression, remarking on the talents of Charles Le Brun and Antoine Coypel in their use of gesture and facial modifications (Rogerson 1953; Yonker 1969). Coypel himself, director of the Academy in Paris, had conversely, in his *Discours* of 1721, urged painters to seek their inspiration in the theatre (Coypel 1721). In England at about the same time, Jonathan Richardson, in his influential *Theory of Painting* (first published 1715), also drew comparison between painting and theatre. Similar ideas are explored in a fascinating letter from the dramatist Aaron Hill (1685–1750) to the most famous actor of the eighteenth century, David Garrick, written on 3 August 1749, in which he notes that the abundance of engraved material in France could "furnish infinite supply of hints to so compleat a judge of attitudes". Hill notes later in the same letter "how

much the painters may improve, by copying Mr Garrick, and what little room there is, for his improving, by the painters" (Hill 1753, II, pp. 378 ff.).

The illustrating of Shakespeare, which was to reach gigantic proportions by the end of the eighteenth century, had begun very modestly in England in 1709 with Jacob Tonson's six-volume octavo *Works of Shakespeare*, edited by Nicholas Rowe (see Boase 1947). The forty-three engravings in this edition are rather artless performances, but they do, at least, provide evidence about contemporary attitudes to Shakespeare and the interpretation of his plays (see Hammelmann 1968). François Boitard (c. 1670–c. 1717), who executed these stilted illustrations (see fig. 12, p. 30), had no tradition to draw upon and appears to have looked, where possible, at contemporary staging of the plays for ideas. Paradoxically, as Shakespeare's plays became better known in the course of the eighteenth century, illustrations were less likely to be inspired by live performances. More than thirty years later, the designs of another French artist, Gravelot, for the second printing of Lewis Theobald's octavo edition of Shakespeare, stand in sharp contrast to the crude plates that had served for Tonson (Hammelmann 1958). Gravelot's light, Rococo manner is best judged from the original drawings – many survive in the Albertina, Vienna, and in the Huntington Library in California (Wark 1973) – rather than from Michael van der Gucht's engravings, but his elegant figure style was not always entirely suitable for such tragedies as *Hamlet*.

It has been convincingly suggested that the publication record of Shakespeare's plays in the first half of the eighteenth century had a strong bearing on the increased offering of the plays on the London stage (Scouten 1956). Rowe's early edition had been printed three times, and Alexander Pope's edition had gone through two printings (1725 and 1728). Theobald's Shakespeare, with Gravelot's illustrations in the 1740 edition, had first appeared in 1733 and the luxurious six-volume quarto edition published for Sir Thomas Hanmer, with Hayman's and Gravelot's illustrations, was published in 1743–44.

A new phase of Shakespearean popularity was certainly under way by the mid-1730s, promoted by the Shakespeare Ladies Club at Covent Garden, whose members included some of the most

OPPOSITE Fig. 26 Francis Hayman, modello for *The Play-scene from 'Hamlet'*, c. 1745, oil on canvas, 33 × 26.7 cm (13 × 10½ in.), Folger Shakespeare Library, Washington, DC

LIVERPOOL JOHN MOORES UNIVERSITY
LEARNING SERVICES

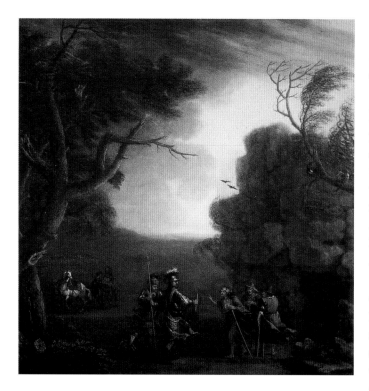

Fig. 27 John Wootton (1622–1764), *Macbeth and Banquo meeting the Weird Sisters* (*Macbeth*, I. iii), dated 1750, oil on canvas, 152.5 × 146 cm (60¼ × 57⅝ in.), Private Collection, USA

intelligent and fashionable women of the time (Avery 1956). Although the appearance of Garrick on the London stage in 1741 in the role of Richard III has been taken by scholars to herald the Shakespeare revival (Stone 1950), a good deal of evidence points to other sources. The Theatre Licensing Act of 1737 officially silenced all but the Drury Lane and Covent Garden Theatres, and even at these venues new plays were often shouted down by a hostile audience resentful of the new legislation. As a result, the market for new plays suddenly collapsed and theatre managers began to look to the well-established, older repertory, such as Shakespeare, to fill the play-houses. The dearth of new comedies led to the selection of Shakespeare's, five of which were performed in 1740–41. During that season, Shakespeare accounted for twenty-five per cent of the total repertory (Scouten 1945).

Perhaps the earliest painted illustrations of Shakespeare to survive are Hogarth's *Falstaff examining his Troops* of 1728 (pl. 1) and his *Scene from 'The Tempest'* (pl. 2) dating from the mid-1730s. These suggest that Hogarth was aware of the longer-established French tradition, particularly the uncomplicated stage scenes of Claude Gillot (1673–1722) or perhaps even the more poetical adaptations of the Comédie-Italienne by Jean-Antoine Watteau (1684–1721), which he was able to modify to the requirements of the smaller-scale English conversation piece (group portrait) model. In about 1738, Philip

Mercier (1689–1760), a Huguenot born in Germany who worked in England for much of his career, produced a group of theatrical pictures, including two Shakespearean subjects: *Falstaff at the Boar's Head Tavern*, from 1 *Henry IV*, and *Falstaff with Doll Tearsheet*, from 2 *Henry IV* (Ingamells and Raines 1976–78, p. 58, nos. 247, 248). A decade later Marcellus Laroon (1679–1772) was painting scenes from actual stage performances, such as the *Scene from Henry IV, Part I*, which was possibly influenced by one of Francis Hayman's pictures for Vauxhall Gardens (Raines 1967, pp. 110, no. 6). Even artists rarely associated with literary pictures occasionally tried their hand at Shakespeare illustration. A fascinating example is John Wootton's *Macbeth and Banquo meeting the Weird Sisters*, signed and dated 1750 (fig. 27; see London 1991, p. 46), which illustrates the same episode from Act 1, Scene 3 painted by Francesco Zuccarelli a few years later (pl. 4).

Hayman's earliest datable theatrical pictures are from 1741–42, exactly contemporary with his illustrations for Sir Thomas Hanmer's edition of Shakespeare. Some of the Hanmer illustrations, closely supervised by the editor himself, clearly recall actual theatrical performances. During these, his most productive years, Hayman was also at work on the decorations for the supper boxes at Vauxhall Gardens, and in that context Shakespeare and the theatre provided subject-matter for several of the large pictures (Allen 1986). Two of Sir John Falstaff's more amusing escapades, *Falstaff in the Buck-Basket* from *The Merry Wives of Windsor* and *Falstaff's Cowardice Detected*, the scene in the Boar's Head Tavern (1 *Henry IV*, II. iv) – wherein Poins and Prince Henry reveal that they had engineered the highway robbery to which Falstaff had fallen victim – are, with their panelled backdrops and carefully arranged props, reminders of the staging techniques of mid-eighteenth century Shakespearean productions (New Haven CT and London 1987).

Hayman's *Wrestling Scene from 'As You Like It'* (pl. 3), although not one of the Vauxhall Gardens pictures, seems to have been originally owned by the Gardens' proprietor, Jonathan Tyers, and was probably painted for him to provide an idea of the likely appearance of the series of much larger paintings that Hayman then executed to commission. Tyers was evidently pleased enough with the Hayman supper-box pictures to commission from him four even larger pictures to decorate the pavilion of the Gardens' most important patron and ground landlord, Frederick, Prince of Wales (1707–1751), which were completed in 1745. Alas, none of these paintings survive, although they are recorded by George Vertue (1684–1756), whose *Notebooks* provide much of our knowledge of the visual arts in early eighteenth-century England (Vertue, *Notebooks*, pp. 141–42). Three of them, which must be those recalled by Vertue (New Haven CT and London 1987, p. 178, nos. 128, 130, 133) as *King Lear in the Storm*, *The Play-scene from 'Hamlet'* (fig. 26, p. 48) and the *Scene from 'Henry V'* appear, judging from contemporary descriptions, to have been adapted from the recently published illustrations for Hanmer's edition

of Shakespeare (for contemporary accounts of the Shakespearean pictures, see Anon. 1762, pp. 11, 19). Only Hayman's *Scene from 'The Tempest'* for the pavilion, perhaps completed slightly later and without the entirely appropriate royal allusions of the other three, was an independent design (New Haven CT and London 1987, p. 178, no. 134). Judging from a surviving sketch that probably relates to it (sold Christie's, London, 10 November 1995, lot 31). Hayman's picture appears not to owe much to Hogarth's of the same subject (pl. 2).

By 1745 Hayman was already on good terms with Garrick, and in that year he was apparently planning a set of six prints of Shakespearean subjects, perhaps encouraged by the critical success of the large pictures for the Prince of Wales's pavilion at Vauxhall Gardens. From the delightfully intimate letter from Garrick to Hayman written after 10 October 1745, it appears that Garrick was helping to solicit subscribers for Hayman's proposed set of prints but, in the light of his own experience on stage, he also offers the artist some advice about modifying the design of the large picture of Lear at Vauxhall (Little and Kahrl 1963, I, pp. 68–71, no. 40).

Garrick first appeared as Lear on 11 March 1742 at Goodman's Fields Theatre (Burnim 1961, p. 143). One of Garrick's innovations was for Lear to lie down and fall asleep during the storm scene, requiring him to be carried off stage by Gloucester and Kent for an even more dramatic exit. Charles Macklin always claimed that this device was used by Garrick to gain advantage over his great rival, Spranger Barry, who was too large to be carried off stage with the same ease (Kirkman 1799, II, p. 261).

Although the proposed set of prints never materialized, Hayman retained Garrick's instructions and implemented them later when designing his frontispieces for Charles Jennens's edition of *King Lear*, which remained unpublished until 1770 (repr. New Haven CT and London 1987, p. 18, fig. 5). In this small frontispiece, Hayman places Lear on the ground pointing to the heavens, flanked on either side by Kent, on one knee, and Gloucester with a torch. The Fool, who appeared in the Hanmer illustration, was removed, as in the Garrick and Nahum Tate staging of *King Lear* (1681). The pose of Lear is similar to Hogarth's celebrated *Garrick as Richard III* (fig. 3, p. 12), with the left hand supporting the weight of the body. Lear's pose also seems to derive from the figure of Diogenes, reclining on the steps, in Raphael's famous *School of Athens* (1510–11; Vatican Palace).

Garrick provided painters with the opportunity of working outside the parameters of traditional history painting by having his portrait painted on numerous occasions *en rôle*; he also inspired perhaps more portraits than any other figure of his age except King George III (Anglesea 1971). Hayman's best-known portrait of Garrick is the small scene from *Richard III*, signed and dated 1760, which he showed at the first public exhibition of works by living painters in London, at the Society of Artists in 1760 (Maugham Collection, National Theatre, London; see New Haven CT and London 1987,

pp. 116–17, no. 42). Garrick was particularly associated with the part of Richard III since it was in that role that he made his London début on 19 October 1741 (Scouten 1961, II, p. 935). The picture is almost certainly based on a revival of the play for a command performance given for the Prince of Wales at Drury Lane on 8 March 1759. Actor and artist have chosen the moment from Act 5, Scene 8 when Richard on Bosworth Field cries out: "A Horse, a Horse! My Kingdom for a horse." Although not the earliest rendering of Garrick in this role – that belongs to Thomas Bardwell's picture (Russell-Cotes Art Gallery, Bournemouth) – Hayman's adaptation of the pose of the famous ancient statue, the Borghese *Gladiator* (Louvre, Paris) heightens the sense of drama.

Hayman's favourite Shakespearean personality was not, however, Richard III, but the outrageous Sir John Falstaff. Hayman seems to have developed a particular affinity with Shakespeare's bawdy and boastful glutton. The physical resemblance between Hayman and the traditional image of Falstaff can hardly go unnoticed, and it is surely not a coincidence that in *The Academicians of the Royal Academy* (1772; The Royal Collection) by Johann Zoffany (1733–1810) the corpulent figure of Hayman can be seen in the foreground, seated legs apart, surveying the assembly of artists as if they were his recruits. Hayman painted a number of versions of *Falstaff examining his Troops*, and it seems to have been his favourite Shakespearean subject in his later years (New Haven CT and London 1987, pp. 21–22, 179, nos. 141–44).

In the 1760s Hayman must have been disheartened to discover a serious rival in the field of theatrical art. In 1762 Zoffany, recently arrived from Germany, began exhibiting at the Society of Artists. In successive years, until transferring to the Royal Academy in 1770, Zoffany exhibited theatrical scenes characterized by a startling realism that could not be matched by Hayman's failing powers. Even painters such as Francesco Zuccarelli, who was hitherto associated primarily with landscape painting, now began to try their hand at Shakespeare illustration (see pl. 4). With the advent of the public exhibitions in the 1760s, a new and more competitive era for theatrical painting had begun.

SELECT BIBLIOGRAPHY

Vertue, *Notebooks*; Coypel 1721; Hill 1753; Anon. 1762; Kirkman 1799; Heppner 1939–40; Scouten 1945; Boase 1947; Stone 1950; Rogerson 1953; Avery 1956; Scouten 1956; Hammelmann 1958; Burnim 1961; Scouten 1961; Little and Kahrl 1963; Raines 1967; Hammelmann 1968; Yonker 1969; Anglesea 1971; Wark 1973; Ingamells and Raines 1976–78; Allen 1986; New Haven CT and London 1987; London 1991

1

WILLIAM HOGARTH (1697–1764)
Falstaff examining his Troops (2 Henry IV, III. ii)

Inscribed bottom left *W.Hogarth Pinx. 1730*
1730
Oil on canvas
49.5 × 58.3 cm (19½ × 23 in.)
Private Collection, UK

The scene shows Sir John Falstaff and his henchman Lord Bardolph in the house of his old friend Justice Shallow in Gloucestershire, examining local citizens in order to impress them for military service in the war against the rebels. Shallow and his assistant Silence are seated behind the table as witnesses. In the play, two recruits offer Bardolph a bribe, later passed on to Falstaff, who then duly rejects the hale candidates, seen on the right, and enlists in their stead two unsuitable weaklings, seen standing in the doorway on the left. The action is conflated here into a single moment, with Falstaff accepting the bribe with one hand and pointing at his hapless victims with the other.

As noted by Mary Webster, the scene is drawn out of perspective and lit from the front, suggesting a real stage setting, which makes it the earliest painting of an actual Shakespearean stage performance. The Falstaff represented here is John Harper (died 1742), who was celebrated in this role from 1723 until about 1733. He played it at Drury Lane Theatre in 1728, in a production that had been severely cut to give the popular part of Falstaff greater prominence. The costume he wears was traditional for the character, regardless of fashion, from the seventeenth century until Victorian times. Even his buckler (small round shield) is included, raised above the fireplace in useless display. Known also as a 'target', it marks a counterpoint to the real archery target, longbow and quiver of arrows hung on the back wall, symbols of a martial art at which the English famously excelled. The painting beside the target is of the legendary Gloucestershire Giant, in effect a superhuman English fighting man, depicted in sad contrast to the feeble specimens on the stage.

Two scenes by Hogarth based on London stage performances in 1728 stand at the beginning of his career as a painter (Paulson), both of which can be seen to carry a topical satirical subtext. For both there are lively sketches, probably made in the theatre, on sheets that come from the same sketchbook (both The Royal Collection). The first is from John Gay's revolutionary *The Beggar's Opera* (1728), a tuneful production in modern dress that achieved unprecedented popularity because its thieves and criminals were thinly disguised caricatures of the ruling élite. Hogarth painted at least five versions of it between 1728 and 1731. The second is this picture, the date of which (1730) probably marks its completion for an unknown client. Both scenes deal with bribery and the perversion of justice, and it is not difficult to see in both allusions to the king's First Minister, Sir Robert Walpole, reviled by many for his coarse – one could say 'Falstaffian' – style, for his neglect of the British army and for the vast fortune he amassed through corrupt practices.

This scene perhaps expresses the subversive hope that he might share Falstaff's fate at the end of the play, that of being dismissed by the new king.
EE

PROVENANCE William Anne Holles (Capel), 4th Earl of Essex; his sale, Christie's, 31 January–1 February 1777 [first day], lot 38, "Hogarth. A humorous Scene with Sir John Falstaff", £36. 15s., bought by David Garrick; Mrs Garrick; her sale, Christie's, 23 June 1823, lot 20, sold for £46. 4s. to Charles Henry Core; Sir Arthur Helps by 1874; sold by him to H.W.F. Bolckow; his sale, Christie's, 2 May 1891, lot 106, bought by Agnew for the Earl of Iveagh; thence by descent

BIBLIOGRAPHY Beckett 1949, p. 65, pl. 4; Webster 1978, 1979, p. 12; Highfill, Burnim and Langhans 1982, pp. 114–20; de Marly 1982, pp. 45–46; Paulson 1982, pp. 36–47; Paulson 1991–93, I, pp. 159–65

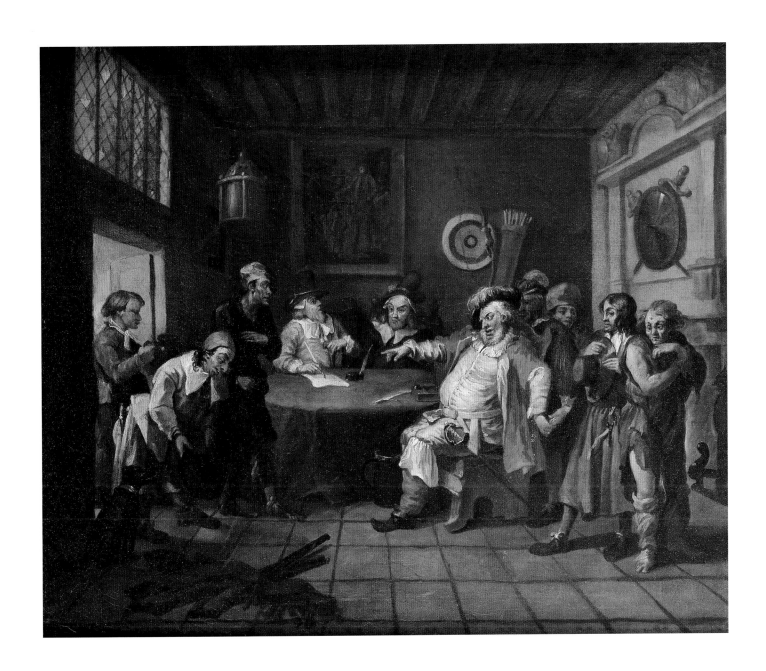

2

WILLIAM HOGARTH (1697–1764)
A Scene from 'The Tempest' (I. ii)

c. 1735
Oil on canvas
80 × 105.4 cm (31½ × 41½ in.)
Nostell Priory, Wakefield, Yorkshire, The Winn Collection (acquired by the National Trust with the aid of the National Art Collections Fund)
Dulwich only

Hogarth was the dominant artistic personality in England in the first half of the eighteenth century. He made his name initially by painting conversation pieces (small-scale group portraits), but the success of his 'Modern Moral Subjects', a new genre he created in which a story from contemporary life is told in a series of paintings designed to be engraved, liberated him from the drudgery of portrait painting. Among his earliest works were theatrical pictures, including *Falstaff examining his Troops* (pl. 1) and a scene from John Gay's immensely popular *The Beggar's Opera* (1728), painted in 1729.

The present work probably dates from *c.* 1735 when, after the death of his father-in-law, the history painter Sir James Thornhill (1672–1734), Hogarth seems to have experimented with history painting. As in his scenes of healing painted for St Bartholomew's Hospital in London, the influence of High Renaissance art, albeit as a kind of parody, can be seen here.

In this scene from *The Tempest*, Hogarth appears to draw on the Shakespearean text rather than a stage production, and Robin Simon (1979) believes the lines illustrate Ferdinand's first meeting with Miranda (I. ii. 422–24):

> Most sure the goddess
> On whom these airs attend! Vouchsafe my pray'r
> May know if you remain upon this island

Hogarth here ignored the stage tradition of his time, which until 1746 was based on the operatic version of 1674, adapted by Thomas Shadwell from the stage version by Sir William Davenant and John Dryden (1667). In the opera there was not even a scene corresponding to the one Hogarth paints. The original version of the play was revived only in 1757 by Hogarth's friend David Garrick, many years after Hogarth produced this painting (see Stone 1956).

In this picture Miranda can be seen in the centre seated on an exotic shell and coral throne, with her father Prospero, as playwright–magician, hovering behind. She is flanked by Ferdinand and Caliban, both in their different ways her prospective suitors, although, interestingly, the latter does not appear at the moment Hogarth has chosen to illustrate, since he is offstage gathering wood for a fire. Ferdinand's question to Miranda (who has never before seen a man except for her aged father) is about her virginity, and so it is entirely appropriate that Hogarth should not only employ a pose similar to that of Mary at the Annunciation, but also dress her in the traditional colours of the Virgin Mary (Paulson 1992).

Here Miranda has been interrupted in the act of feeding her lamb, a further symbol of her innocence. The contrast between the handsome and genteel Ferdinand on the left and the grotesquely malevolent and plebeian Caliban on the right could hardly be more exaggerated. Caliban is shown as an emblematic threat to marriage, crushing underfoot one of a pair of linked doves, Venus's doves. Ariel, meanwhile, becomes one of the heavenly angels floating overhead.

The painting's first owner was almost certainly the 2nd Earl of Macclesfield (1697–1764), an exact contemporary and noted patron of Hogarth, who had both himself and his tutor, the mathematician William Jones (Private Collection and National Portrait Gallery, London, respectively) painted by the artist. As Elizabeth Einberg has pointed out to the present author, Lord Macclesfield was a highly respected mathematician and astronomer, and the choice of Prospero from *The Tempest* for this picture may well reflect his scientific interest in subjects such as alchemy.

A large version of the same subject was painted by Francis Hayman for the loggia of the Prince of Wales's pavilion at Vauxhall Gardens in London.
BA

PROVENANCE 2nd Earl of Macclesfield; his sale, by Mr Guibert at the Earl's house in St James's Square, 7–10 May 1766 [10 May], lot 9, sold for £23. 2s. [to Sir Rowland Winn]; thence by descent

BIBLIOGRAPHY Brockwell 1915, no. 378; Beckett 1949, p. 74; London 1964, no. 9; Paulson 1971, I, pp. 388–90; London 1971–72, no. 88; Simon 1978; Simon 1979; Paulson 1982, pp. 48–54; Paulson 1992, II, pp. 105–07

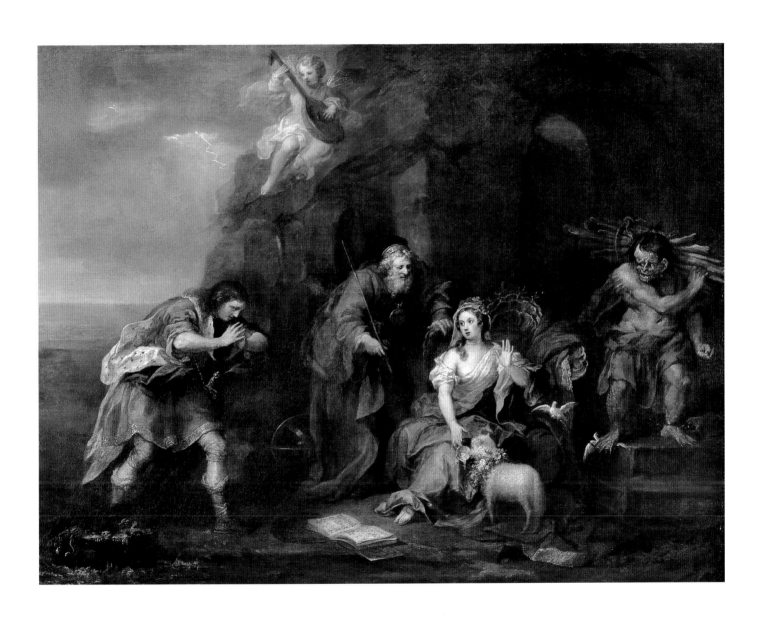

3

FRANCIS HAYMAN (1708–1776)
The Wrestling Scene from 'As You Like It' (I. ii; Hanmer edition, I. vi)

c. 1740–42
Oil on canvas
52.7 × 92.1 cm (20¾ × 36¼ in.)
Tate, London. Purchased 1953

Hayman was one of the most versatile and original artists of his generation. He trained as a decorative painter and also painted scenery at the Drury Lane Theatre, where he made useful professional contacts. Although he was the most prolific theatrical painter before Zoffany, in his lifetime his reputation rested primarily on his history paintings, which were important precursors of the popular history-piece exploited later by Benjamin West (1738–1820) and John Singleton Copley (1738–1815).

The horizontal design of this picture suggests that it may have been a design (not executed) for one of the much larger works painted to decorate the supper boxes at Jonathan Tyers's Vauxhall Gardens in London. In view of its provenance, it may even have been painted for Tyers to demonstrate what Hayman had in mind for the ambitious scheme of painted decorations.

On the basis of style, a date of execution at the beginning of the 1740s is likely, and the composition has been adapted from the designs made *c.* 1740–41 for Sir Thomas Hanmer's edition of Shakespeare. The upright format of the book illustration is modified here in favour of a horizontal composition in which a few minor modifications have been made, primarily the introduction of a Classical colonnade in the top left of the composition and the necessary addition of a few more figures.

Hayman illustrates the moment when Orlando has thrown Charles, the Duke's wrestler, on the ground while Celia, Duke Frederick and others watch (Hanmer edition, I. vi). The influence of contemporary French painting, imparted in this instance through Hayman's friend, the French painter and illustrator Gravelot (1699–1773), is especially marked, and as recently as 1950 it passed as a work by the French painter Jean-François De Troy.

It is worth noting that a "Mr Hayman", probably our painter, appeared on stage in the role of Silvius in *As You Like It* at Covent Garden Theatre on three occasions between 1744 and 1746 (see Scouten 1961, III, pp. 1127, 1182, 1273).

BA

PROVENANCE Probably Jonathan Tyers, before 1767; possibly the "Scene from As You Like It" sold at the Jonathan Tyers Jr sale, Christie's, 28 April 1830, lot 28, bought by Gilmore, 1830; anon. sale (Sir Alec Martin), Christie's, 19 November 1948, lot 131, bought Jameson (bought in); Dr Brian Rhodes; his sale, Christie's, 28 July 1950, lot 173, as De Troy (bought in); anon. sale, Christie's, 18 December 1953, lot 77, as Hayman, bought Agnew's, from which acquired by the Tate Gallery

BIBLIOGRAPHY Boase 1947, p. 83; Gowing 1953, p. 16; Hammelmann 1958, pp. 148–49; Moelwyn Merchant 1958; Moelwyn Merchant 1959, p. 47; London 1960, no. 16; Nottingham 1961, under no. 15; London 1964, no. 12; New Haven CT and London 1987, pp. 16, 114; London, 1987, no. 109; Einberg and Egerton 1988, p. 43, no. 17; Norwich 1996, no. 2

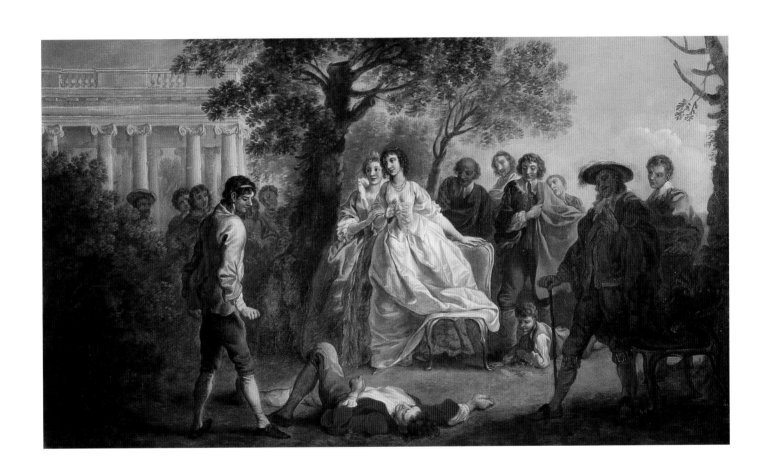

LIVERPOOL JOHN MOORES UNIVERSITY
Aldham Roberts L.R.C.
TEL 0151 231 3701/3634

57

LIVERPOOL JOHN MOORES UNIVERSITY
LEARNING SERVICES

FRANCESCO ZUCCARELLI (1702–1788)
Macbeth, Banquo and the Witches (Macbeth, I. iii)

Mid-1760s
Oil on canvas
68.6 × 91.4 cm (27 × 36 in.)
From the Royal Shakespeare Company Collection with the permission of the Governors of the Royal Shakespeare Theatre, Stratford-upon-Avon, inv. 123

Zuccarelli was perhaps the most successful Italian painter to visit England in the eighteenth century. In addition to enjoying royal patronage, he was a founder member of the Royal Academy of Arts on its establishment in 1768. He was in England from 1752 to 1762 and again from 1764/65 to 1771. Zuccarelli inherited the market for Italian landscape and was viewed as the best available living substitute for the hugely admired Claude Lorrain (Levey 1959). Many of his landscapes were enhanced with mythological subject-matter, but this picture represents a rare foray into a literary subject relevant to his place of residence.

The precise date of execution for the present picture is not entirely clear, but it was probably painted in the mid-1760s. Zuccarelli's idea for the composition seems to have originated in several pen-and-ink sketches; one eventually became the property of Benjamin West, the second son of the well-known American painter who settled in London in 1763, and is referred to by J.T. Smith (1829, II, p. 166) as "the original pen and ink study". This is probably not, as Levey thought, the pen-and-wash drawing now at Stourhead; that seems to have been purchased from Zuccarelli himself by Richard Colt Hoare (see *Stourhead List*, p. 5, no. 340).

Zuccarelli's first painted version of this subject, probably executed *c.* 1760, was on a rather narrow panel; it was acquired by the 1st Earl Grosvenor (1731–1802), and was eventually sold by his descendant the Duke of Westminster in 1925. He painted another version in oil on canvas, and it was this work that was acquired by the patron and collector William Lock of Norbury (1732–1810). The engraver William Woollett (1735–1785) made his print from this second version in 1770, and noted Lock's ownership of the picture on the letterpress below the image. J.T. Smith (1829, note 18, p. 166) noted that this was "that painter's masterpice [sic]", although he does not state whether, as seems likely, Lock actually commissioned the picture. This seems to be the version (signed and dated "*fecit in Londra. 1760*") sold at Christie's on 14 December 1956 (lot 52) with a Lock provenance. A third version, possibly the present picture, was sold in a London sale in 1761 (see Levey 1959, p. 7), and may possibly be the version shown at the Society of Artists exhibition in London in 1767 (no. 196).

This striking composition seems to be closely based on Gaspard Dughet's *Landscape with a Storm* (Denis Mahon Collection, London), painted originally for Palazzo Colonna in Rome, where Zuccarelli may have seen it. It also bears a close resemblance to similarly inspired works by the Welsh landscape painter Richard Wilson (?1713–1782), whom

Zuccarelli first met in Venice in 1750, and whose historical landscapes, several of which were engraved by Woollett, were exhibited at the Society of Artists in London in the 1760s.

Zuccarelli illustrates the moment at which Macbeth first encounters the three witches and is assailed by them in front of their cave. They prophesy that Macbeth, who is Thane of Glamis, will also become Thane of Cawdor and king of Scotland. Macbeth is confused and alarmed by this news, which instantly appears to be true when Lord Ross enters and announces that the present king has awarded Macbeth the title of Thane of Cawdor as a reward for his courage in battle. Zuccarelli's rendering of the scene is theatrical without being based on a theatrical performance. It is not so much a representation of the play as a violently atmospheric interpretation of the landscape with a literary basis.

BA

PROVENANCE Elliot Galer, before 1881; presented by him to the Royal Shakespeare Theatre Picture Gallery, 1881

BIBLIOGRAPHY Levey 1959, pp. 1–20; Moelwyn Merchant 1959, p. 65; Nottingham 1961, no. 19; Stratford-upon-Avon 1970, no. 123

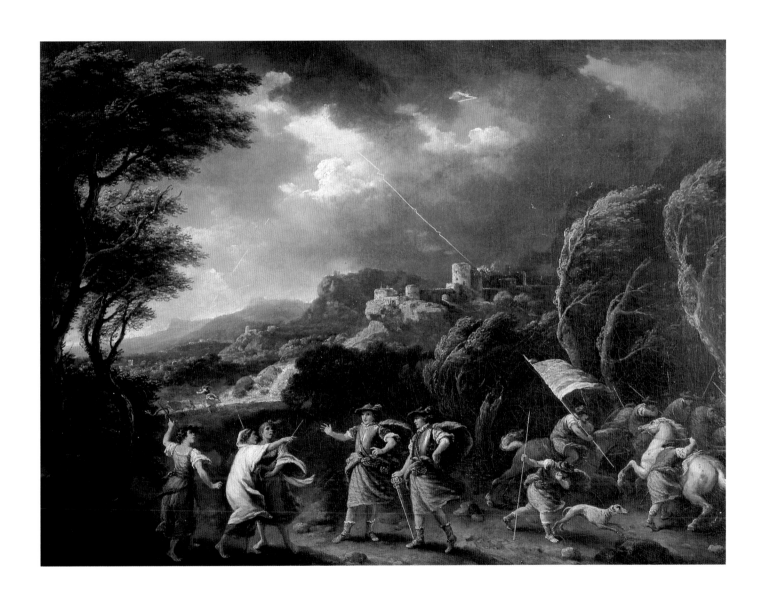

SHAKESPEARE AND THE SUBLIME

Maria Grazia Messina

James Barry (1741–1806) was already established as a history painter when, in 1774, he exhibited his *King Lear mourns the Death of Cordelia* (pl. 10) at the Royal Academy, the subject, according to the catalogue, taken "from the tragedy as written by Shakespeare". Shakespearean subjects were common enough at this time in public exhibitions, but most were theatrical portraits, conceived as promotional vehicles for actors – part of the increasing commercialization of every aspect of cultural life in London during these years. Critics of this painting emphasized the point: "A painter of less original genius than Mr. Barry would have made Mr. Garrick his model for Lear and by that method would have played up to the imagination of the public, by making them umpires how far he had succeeded in the *likeness* or not; but Mr. Barry considered Shakespeare as the poet of Nature, who drew his characters without intending them for particular individuals", so much so that the face of Lear seemed to be inspired by a "combination of all the attributes of despair and old age" (*Morning Chronicle*, 26 April 1774).

Unlike the artists of the previous generation who took their cue from the playhouse, Barry found his inspiration in Shakespeare's poetry: he respects the original text in choosing to depict Cordelia dead in her father's arms, rather than marrying her off to Edgar, as Nahum Tate had done, a happy ending still used unquestioningly even by Garrick. Barry challenged the canons of good taste, which forbade the death of an innocent victim in a tragedy as contrary to 'poetic justice'; he had learned from his own experience to abandon the notion that a work of art should offer an ethical system based on the idea of earthly happiness and reward for virtue. In the same year, 1774, he wrote a pamphlet attributing the slow progress of the visual arts in England to an excess of such emotional timidity and conformism: "We affect such nice feelings and so much sensibility, as not to be able to bear the sight of pictures where the action turns upon any circumstance of distress", whereas in fact, according to Barry, great art is created out of exactly this extremity of feeling. His argument reveals a significant shift in taste: up until this time the notion of the Sublime signified a loftiness, derived from noble subject-matter intended to encourage the disinterested exercise of virtue; now the accent moves to the experience of the work of art, rather than its beneficial influence. The Sublime, as Edmund Burke explained in his treatise of 1756, arises from "terror" – from inflicting the maximum of danger and anguish on spectators, who know themselves to be safe from these things but are nonetheless profoundly stirred by them. To achieve this, an artist's formal language had to abandon the composure and restraint of Classicism and exaggerate expressions, disturb compositions, and shock the audience with its singularity. One critic found himself uncomfortable with Barry's painting, accusing it of oddity and a strangeness of proportion; the same critic was even more disconcerted by a newcomer's submission to the same exhibition, "*The Death of Cardinal Beaufort*, a Drawing by Mr. Fuseli" (pl. 9), which he found savage in expression and extravagant in subject (*Public Advertiser*, 3 May 1774).

When he arrived in London from Switzerland in 1764, Henry Fuseli (1741–1825) was already known to the reading public as the author (among other works) of the essay *Remarks on Rousseau* (1767), which uses the example of Shakespeare as a counterbalance to the rationalism of Hume and Locke. Though a passionate reader of Shakespeare since adolescence (when he attempted a translation of *Macbeth*) and an enthusiastic patron of London theatres (where he particularly admired Garrick's performances), Fuseli was ambitious above all to be a painter; he stood out from his fellow artists in London precisely because of this rich literary apprenticeship. In his native Zurich, Fuseli studied with two writers, Johann Jakob Bodmer and Johann Breitinger, both of whom anticipated the culture of *Sturm und Drang*, which taught that poetry was born out of the invention of the imagination and the power of sympathetic feeling, justifying on this basis the genius of Shakespeare. In their writing, Horace's conception that painting and poetry are mirror images ("*ut pictura poesis*") acquires a new life. A logical consequence of the idea is that painting can become more 'poetic' by straying into the realm of the 'probable' or 'miraculous', that which remains obscure and indistinct to the senses. In the history of British aesthetics, from Shaftesbury to Burke, painting had suffered, more or less explicitly,

OPPOSITE Henry Fuseli (1741–1825), *The Witches show Macbeth Banquo's Descendants*, c. 1773–79, detail (fig. 30, p. 72)

Fig. 28 Alexander Runciman (1736–1785), *Lear on the Heath, c.* 1767, pen and ink on paper, 27.9 × 24.7 cm (11 × 9¾ in.), National Gallery of Scotland, Edinburgh

study antique sculpture and above all Michelangelo: "The Cappella Sistina is the production of the greatest genius that ever was employed in the arts; it is worth considering by what principles that stupendous greatness of style is produced and endeavouring to produce something of your own on those principles." Michelangelo was strong meat for the Classical taste of the time – Reynolds did not yet feel able to recommend him so warmly in his public *Discourses* – but he must have exerted a powerful fascination for the impetuous Fuseli. Reynolds's proposed programme of study for artists in Rome included a profound knowledge of the Old Masters and a routine of drawing from the life (but only to check the forms of the artist's imagination against the reality of the model): the student, thus nourished and disciplined, as he wrote in his first Discourse, "may now, without fear try the power of his imagination, may be indulged in the warmest enthusiasm, and venture to play on the borders of the wildest extravagance".

Fuseli shut himself up for months in the Sistine Chapel and became a fanatical student of antiquity, expertly guided by his friends, Tobias Sergel and Thomas Banks. From Michelangelo he learned compositional tension, created out of the twists and turns of heroic forms; in antique statuary, and especially the colossal group of the *Horse Tamers* on the Quirinal Hill, he found a cast of timeless characters able to embody passions in their most elemental form. But it was Mannerist painting, studied in its many guises in the work of artists from Baccio Bandinelli and Parmigianino to Luca Cambiaso, which taught him how to match the complex emotions, visionary experience and awesome power of poetry: in fact to strive after all those things that were forbidden by the Classical aesthetic of painting.

In his Roman drawings, many of Shakespearean subjects, the sense of the Sublime, on which Fuseli had previously written an entry for Georg Sulzer's *Allgemeine Theorie der Schönen Künste* (1764), captures the imagination through the visual language and choice of forms, even before we recognize the subject. Years later in his own lectures to the Royal Academy, Fuseli wrote that the Sublime requires the expression of a "monolithic" passion, in which all elements of the work participate, so as to force upon the imagination a single irresistible idea. Fuseli takes the inevitable comparison with the theatre one step further: he is no longer content with the vivid naturalism of Garrick but seeks instead to create a visual equivalent of his own reading of the works of Shakespeare, a poet singled out in Bodmer's teachings and by his perceived affinity with the ideals of the early exponents of the Romantic movement in Germany. It was Johann Gottfried Herder, in an essay of 1771, the fruit of exchanges with fellow members of the *Sturm und Drang* movement, Johann Georg Hamann and Goethe, who recognized in Shakespeare an impetuous force of nature, a barbaric sublimity and an instinctive and primordial creative energy. He found something similar in Fuseli, when he encountered his work thanks to Lavater, who sent

as the poor relation of poetry because it was seen to be chained to the close imitation of nature, to the extent that any representation of the fantastic, terrible or abhorrent was forbidden: Fuseli approached Shakespeare not just as source material to be translated into painting, but as a kind of sparring partner with whom to compete in psychological penetration and dramatic intensity. This spirit of emulation must have struck Sir Joshua Reynolds, when Fuseli showed him his drawings in May 1768, especially as Reynolds was engaged at this time in promoting the idea of a British School of history painting at the projected Royal Academy. Fuseli told his friend Johann Kaspar Lavater (in a contemporary letter) that it was Reynolds's admiration for his work which convinced him that all he lacked to become a great master was a trip to Italy, so as to educate his taste through direct contact with Classical and Renaissance art.

Fuseli's stay in Rome, from 1770 to 1778, settled him in his determination to become the 'painter of Shakespeare', and he was to make his name as such. What sort of advice would Reynolds have given him for his journey? In a letter of 1769, Reynolds urged James Barry (then in Rome, though he left before meeting Fuseli) not to waste time making copies for rich English tourists, but instead to

him two drawings: "There is living in Rome", he wrote to Goethe in 1774, "a noble German from Zurich, Henry Fuseli, a genius like a mountain torrent, a worshipper of Shakespeare, and now, Shakespeare's painter … . He is the disciple of Shakespeare with every stroke of his pen". Lavater sent to Fuseli in the same year a copy of Goethe's semi-autobiographical epistolary novel, *Die Leiden des jungen Werthers* (The Sorrows of Young Werther), published that year, and Herder's essays; the painter replied with a harangue about the fundamental role of archetypal images in poetic creativity: "They it is that authenticate the value of emotions. A genuine, universal, vital emotion streams through the medium of an appropriate image into all hearts, while a spurious merely local and private emotion will please only a few."

Young artists went to Rome for the sake of their careers as well as their art. It was a place in which to build a personal market, through contacts with aristocrats and amateurs on the Grand Tour. As journals and letters witness, artists competed for commissions, and tried to find 'backers' to help them establish their careers on their return home. To distinguish oneself in this lively, litigious and cosmopolitan ambience (as in the crowded exhibitions of the Royal Academy in London), it was necessary to construct a unique identity, something more easily achieved through singularity of invention than painfully acquired technical competence. Reynolds in his *Discourses* of 1770 and 1771 admitted that, if the "great end of the art is to strike the imagination", this occurred to a large extent because "a painter must strive for fame, by captivating the imagination". Fuseli worked on at least sixteen Shakespearean subjects (as we know from a letter from Lavater to Herder of 1774), evidently wanting to monopolize this field at exactly the moment (the mid-1770s) that the Grand Tour reached its zenith with a plethora of visitors in Rome. These were the sort of people who in England would commission only portraits, but might return from their Italian trip furnished with their cultural status symbols – some history paintings as well the obligatory (usually heavily restored) antique sculptural fragments. Fuseli's personal magnetism and the eccentricity of his style and subject-matter attracted a circle of artists and intellectuals around him. His fame was still limited to an élite, but he was a first port of call for all aspiring artists who followed Reynolds's advice and undertook the journey.

We should not suppose that Fuseli's choice of style was just a ploy to break into a market eager for sensation: his language is fundamentally motivated by the struggle to find common ground between the dramas of Shakespeare and the paradigms of the artistic tradition in Rome. The Shakespearean paintings that Fuseli exhibited at the Royal Academy during the 1780s, and those executed subsequently for the Boydell Shakespeare Gallery, have their origins in his Roman drawings. From the many sketches he made of the *Horse Tamers* derive the unusual – and for contemporaries unnatural – points of view that make his figures swagger like Titans over a low

Fig. 29 James Northcote (1746–1831), *Macbeth and the Witches*, c. 1777–78, brown wash with pen and brown ink over graphite laid on paper, 32.4 × 41.1 cm (12¾ × 16¼ in.), Yale Center for British Art, Paul Mellon Fund, New Haven CT

horizon, an effect later explained in Fuseli's fourth Lecture: "each individual form to be grand, ought to rise upward in moderate foreshortening, command the horizon, or be in contact with the sky." The abrupt relief with which Fuseli's figures emerge from their dark ground derives from memories of the frescoes of the Sistine Chapel and the antique sculptures of the Museo Pio Clementino seen by torchlight, as was usual at the time. Fuseli's distinctive figure type results from his realization, through the study of antique sculpture, that Shakespeare's timeless characters can only be recreated in art by avoiding particularized physiognomies.

More than anything, Fuseli believed in an entirely personal and subjective reading of Shakespeare. In one of his later *Aphorisms* (written from 1788 and published in 1818) he discusses the risk that an artist may depend too much on his masters or on the study of Nature, and suggests that the artist has another way: "What then remains," he asks, "but to transpose yourself into your subject?"

SELECT BIBLIOGRAPHY

Freyer 1809, I, p. 85 and II, p. 261; Knowles 1831, II, p. 226 and III, pp. 115, 137; Mason 1951, pp. 69–70, 92–93; Schiff 1973, p. 78; Weinglass 1982, p. 13

63

LIVERPOOL JOHN MOORES UNIVERSITY
LEARNING SERVICES

5
GEORGE ROMNEY (1734–1802)
King Lear in the Tempest tearing off his Robes (King Lear, III. iv. 107–12)

c. 1760–61
Oil on canvas
106 × 104 cm (41¾ × 40⅞ in.)
Kendal Town Council, on loan to the Abbot Hall Art Gallery, Kendal, inv. T40/97

Romney, born at Dalton-in-Furness in Lancashire, was largely self-taught. In 1762, thanks to holding a lottery of twenty of his works at Kendal, he earned one hundred guineas, which enabled him to move to London, where he established a reputation by exhibiting regularly in the annual exhibitions at the Free Society and the Society of Artists. From 1773 to 1775 he toured Italy, staying in Rome, and on his return he competed with Sir Joshua Reynolds and Thomas Gainsborough as a fashionable portrait painter. History painting remained his passion, for the most part indulged in the private production of countless sketches and drawings. This was matched only by his passion for the theatre, which he visited frequently, influenced by his friend, the noted Shakespearean actor, John Henderson (1747–1785). In 1786 Romney was one of the principal contributors to Boydell's Shakespeare Gallery, for which he made three paintings: a scene from *The Tempest* (an oil sketch survives in the Galleria Nazionale d'Arte Moderna, Rome), *Cassandra Raving* from *Troilus and Cressida,* known from an engraving, and *The Infant Shakespeare nursed by Nature and the Passions* (Folger Shakespeare Library, Washington, DC).

The story of King Lear obsessed the artist throughout his life, inspiring at least five paintings: his very first history painting, exhibited here, which was paired with *Lear woken by Cordelia* in the 1762 Kendal lottery (the two valued at eight guineas); a painting (now lost) sent to the 1763 Free Society exhibition, with the catalogue entry, "A scene from King Lear, as written by Shakespeare"; and a late storm scene of 1798, also lost. His enthusiasm for the tragedy may have been kindled by visits to the theatre opened in Kendal by Thomas Ashburner in 1758, but increasingly Romney, a moody and misanthropic character, identified with Lear.

This painting follows Shakespeare's original text in including the Fool, a character omitted as indecorous from Nahum Tate's version of the play (see pl. 30). Romney's image derives not from the stage but from the frontispiece of *King Lear* engraved by Louis du Guernier in Nicholas Rowe's 1714 edition of Shakespeare. Lear has been driven by the ingratitude of his two elder daughters, who have refused him refuge, on to a stormy heath where he meets Edgar, who feigns madness and has stripped down to a loincloth. Impulsively Lear too begins to tear off his clothes, while Gloucester emerges out of the darkness bearing a torch and hoping to lead his king to shelter. The Fool sees him coming and announces: "Look, here comes a walking fire." The wild excitement of the king, already on the threshold of madness, is echoed in the sudden burst of lightning in the stormy sky but, as in the text, the torchlight is

also a dramatic element in the scene, which throws the figure of the king into relief, seen among glimpsed faces and figures emerging from the shadows.

As Alex Kidson points out (2002), these effects must derive from life studies; it would have been impossible for a young artist brought up in Kendal to have known the works of the great seventeenth-century Netherlandish tenebrists, such as Gerrit van Honthorst. Other candle-lit figures are mentioned in the catalogue of the 1762 lottery, and Romney was famous in later years for working on his history subjects by artificial light at night. Despite its awkward proportions – understandable in a young artist and exaggerated by the canvas having been cut down on one side – this painting demonstrates an understanding of composition, a subject upon which Romney wrote many years later: "Composition is conceiving the Subject poetically … it should be heated or fermented long in the Mind and varied every possible way to make the whole perfect that the whole composition may come from the mind like one sudden impression or conception" (Washington 1998, p. 233).
MGM

PROVENANCE Mrs Robinson, housekeeper to Captain Wilson of Bardsea Hall, 1762; Mr Braddyll, Conishead Priory, 1830; Miss Elizabeth Romney; Christie's, 24–25 May 1894, lot 164, acquired by Ernest Leggatt; Christie's, 11 March 1918, lot 125, bought in; J.R. Cookson; acquired by the present owner, 6 March 1919

BIBLIOGRAPHY Romney 1830, pp. 24, 26, 40; London 1964, no. 16; Tokyo *et al.* 1992–93, no. 20; Cross 2000, pp. 15–16, 59, 83, 150; Liverpool, London and San Marino CA 2002, no. 7; Pressly 2002, pp. 99–101

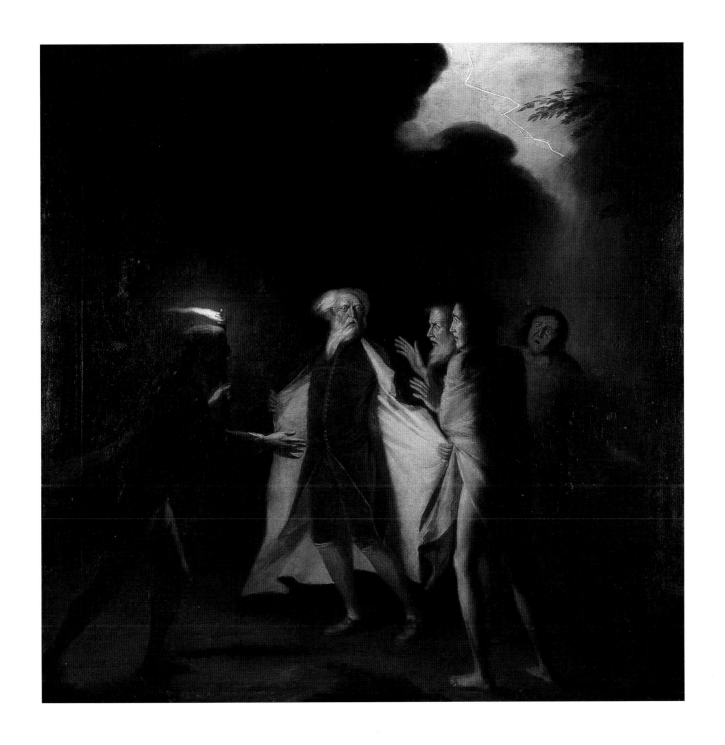

JOHN RUNCIMAN (1744–winter 1768/69)
King Lear in the Storm (King Lear, III. i. 2)

Signed and dated *JR p.1767*
1767
Oil on mahogany panel
44.8 × 61 cm (17⅝ × 24 in.)
National Gallery of Scotland, Edinburgh, inv. NG 570

The brothers Alexander and John Runciman arrived in Rome in 1767, their trip paid for with one hundred and fifty guineas from Sir James Clerk (1709–1782), an advance for a decorative cycle to be executed on their return for his Palladian house, Penicuik, near Edinburgh. In Rome, John was recognized as a promising history painter and crossed swords with a rival, James Nevay (died 1796), in the litigious community of young British painters competing for work. Nevay's criticisms may have precipitated a nervous breakdown, during which John destroyed many of his own paintings. This trauma exacerbated his consumption, which led to his premature and lonely death in Naples.

This painting was executed in Scotland before John's departure for Rome and before he came under the spell of Michelangelo. Its sources are still northern: Rubens's famous *Landscape with the Shipwreck of Aeneas* (Gemäldegalerie, Berlin) influenced the composition, atmosphere and loose technique, while the fantastic costumes (something between those of Van Dyck and Rembrandt) derive from memories of the theatre in Edinburgh, where John Runciman worked as a young man, and where he learned from the French scene-painter, William Delacour (died 1767).

As Moelwyn Merchant pointed out, this painting is not a record of a production, but the fruit of the artist's imagination. Runciman includes Shakespeare's full cast of characters – Lear, Edgar, Kent, a Gentleman and the Fool, here represented as a boy – and is so deeply immersed in the text that he even finds a visual equivalent for Shakespeare's rich descriptive imagery. The stormy sea (certainly not mentioned in any stage direction) is suggested by the First Gentleman's words describing Lear in his madness:

> Contending with the fretful elements;
> Bids the wind blow the earth into the sea,
> Or swell the curled waters 'bove the main

There is also an echo of Lear's own defiant words in the face of a storm, which he finds gentle in comparison with his own inner tempest:

> Blow, winds, and crack your cheeks; rage, blow.
> You cataracts and hurricanoes, spout

But we should not rule out a connection with the theatre: David Garrick's performance in this scene was made famous by Benjamin Wilson's print of 1762. Garrick had restored much original Shakespeare material in this scene, though he persisted in omitting the Fool.

The conflation in this one image of various Shakespearean passages (based on Runciman's own reading of the text) follows the example of the theatre, where producers (including Garrick) tended to manipulate, interpolate and generally 'clean up' original texts.
MGM

PROVENANCE Edinburgh, sale Lord Eldin, 16 March 1833, lot 162; bequeathed by David Laing to the Royal Scottish Academy, 1879; transferred to the National Gallery of Scotland, 1910

BIBLIOGRAPHY Edinburgh 1957; Moelwyn Merchant 1959, pp. 190–98, fig. 56a; Nottingham 1961, no. 22; London 1964, no. 29; Macmillan 1970, no. 802, p. 28; Irwin 1975, p. 111; Montgomery, New York and Chicago 1985–86, p. 4; Edinburgh and London 1986, pp. 47–49, no. 72; Macmillan 1990, p. 117, fig. 93

7
NATHANIEL DANCE (1735–1811)
Timon of Athens (IV. iii. 134–38)

c. 1767
Oil on canvas
121.9 × 137.2 cm (48 × 54 in.)
Her Majesty The Queen, The Royal Collection, inv. no. 1261

Nathaniel Dance, son of the architect George Dance the Elder, and pupil of Francis Hayman, lived in Italy from 1754 to 1765, where he painted Virgilian subjects in a Classical style learned from Pompeo Batoni (1708–1787), with well-structured compositions and an emphasis on tone rather than colour. His *Death of Virginia* (untraced), sent to the first exhibition of the Society of Artists in 1760, marked the birth of British Neo-classicism and exerted a powerful influence on the development of its most famous exponent, Gavin Hamilton (1723–1798), who was also in Rome at the time.

The present painting is directly inspired by reading Shakespeare's text and by the frontispiece to this play in the illustrated editions of Nicholas Rowe in 1709 and Sir Thomas Hanmer of 1744 (the latter designed by Hayman). This was chosen as the key moment in the drama when Timon, disgusted by the meanness of his fellow citizens, hurls some gold coins, just unearthed, at Phyrnia and Timandra who are visiting him with Alcibiades, shouting: "hold up, you sluts, your aprons mountant."

The painting was admired by Horace Walpole at the Society of Artists in 1767 (no. 43), and soon after was acquired by George III for the library of Buckingham House – the first example of the royal taste for Neo-classicism, not shared by many of the king's subjects. Critics recognized that the painting emulated the Old Masters in its stately composition, anatomical accuracy and intensity of expression, but were perplexed by its dull colour:

> A dusky grey the colouring lets down
> And clouds the splendour of its just renown
> Thou' well this artist claims a foremost place
> He wants a Titian tint, yet wants not grace
> (*The London Chronicle*, 5 May 1767)

During the summer of 1767, Dance's elder brother, the actor James Love (see pl. 36), produced an adaptation of the tragedy at his own theatre at Richmond Green, repeating the performance the next year and publishing the text. The fame of this painting, however, owes less to this revival of a neglected play and more to a print designed by James Hall and published by Boydell in June 1771, and to the fact that the subject was widely understood to be autobiographical. According to gossip (repeated by the satirist Anthony Pasquin as late as 1796), Dance identified with Timon's misogyny, having been wounded by an unrequited passion for the brilliant painter Angelica Kauffmann, whom

he had known in Rome. She subsequently came to London and showed a preference for Sir Joshua Reynolds. According to his younger brother George, "his distress was excessive, even to a degree to quite unman him in expression of grief" (Farington, *Diary*, 26 November 1811).
MGM

PROVENANCE Acquired by George III for The Royal Collection, 1767 or 1771

BIBLIOGRAPHY Pasquin 1796, pp. 45–46; Farington, *Diary*, 1978–84, XI, 26 November 1811; Moelwyn Merchant 1959, pp. 166–77, fig. 65a; Nottingham 1961, no. 21; London 1964, no. 18; Bregenz 1968, no. 186; Millar 1969, I, pp. 23–24, no. 725; London 1977, no. 16; Montgomery, New York and Chicago 1985–86, p. 4, pl. 2

8

ALEXANDER RUNCIMAN (1736–1785)
Macbeth and the Witches (Macbeth, IV. i. 67–71)

Inscribed bottom right *ARunciman*
c. 1771–72
Pen and brown ink above pencil under-drawing
61.2 × 45.8 cm (24⅛ × 18 in.)
National Gallery of Scotland, Edinburgh, inv. D296

Alexander Runciman lived in Rome from the spring of 1767 until the autumn of 1771; during the final year of his stay he saw much of Henry Fuseli, who thought him the best of the British painters he knew. On his return to Scotland he made his name with a cycle of paintings illustrating the Ossianic poems by James Macpherson, executed for Penicuik House, the home of his patron, Sir James Clerk. Both Runciman brothers were interested in Shakespeare before they left for Rome: Alexander produced a rapid drawing of *Lear on the Heath* (fig. 28, p. 62) probably in the same year as John's famous painting (pl. 6). Alexander's enthusiasm for Shakespeare was renewed in Rome by Fuseli, and by his decision to become a history painter himself, possibly as a result of his brother's death. This drawing was probably executed at this time and may even be a study for a painting mentioned in 1778, now untraced.

Instead of illustrating the usual scene of Macbeth and Banquo's encounter with the witches (see pls. 4, 12), Runciman depicts a scene in Act 4, when Macbeth, in the witches' cave and in the presence of the infernal Hecate, has a terrifying vision of an armed head, which warns him to beware his rival Macduff. The visual source for the drawing was the famous print after *Saul and the Witch of Endor* (Louvre, Paris) by Salvator Rosa (1615–1673), the prototype for most of the scenes of necromancy painted by British artists in the 1770s, many illustrating Shakespearean subjects. In Runciman's drawing, Rosa's basic idea – the swirls of smoke in which spirits and skeletons appear while bats and owls circle above – is drawn into a dramatic vortex centred on a boiling cauldron. The scene is probably a recollection of contemporary theatrical productions of witchcraft scenes.

Another Scot, Runciman's contemporary Henry Home, Lord Kames (1696–1782), the essayist and author of *Elements of Criticism* (1762), had attacked the "false Sublime", which sought "to force elevation by introducing imaginary beings without preserving any propriety in their actions, as if it were lawful to ascribe every extravagance and inconsistence to the beings of the poet's imagination". Runciman, who normally painted heroic and elevated subjects as recommended by Kames, here indulges in effects of horror, which even go beyond anything in Fuseli. Fuseli's first treatment of this theme, a painting made in Rome (1774–78; Private Collection), is an austere interpretation, concentrating on Fuseli's own, highly original reading of the psychology of the scene, in which Macbeth's terror derives from his recognition of his own features in the decapitated head. The serpentine movement employed here to depict the horrified Macbeth, returns in a stiffer form

in Fuseli's painting, confirming that he must have known and admired Runciman's drawing. The hellish crew conjured up by Runciman, derived ultimately from Rosa, reappears in Reynolds's large painting of *Macbeth and the Witches* (1789) made for Boydell's Gallery (National Trust, Petworth House, West Sussex), which in turn influenced (probably through a print) Romantic treatments of the same subject by Eugène Delacroix, in a lithograph of 1825, and Alexandre Decamps (1803–1880) in an oil of 1841–42 (Wallace Collection, London).
MGM

PROVENANCE Bequeathed by David Laing to the Royal Scottish Academy, 1879; transferred to the National Gallery of Scotland, 1910

BIBLIOGRAPHY Edinburgh 1960, p. 201; Nottingham 1961, no. 24; London 1964, no. 21; New Haven CT 1979, no. 11; Edinburgh and London 1986, p. 44; Tokyo et al. 1992–93, no. 33

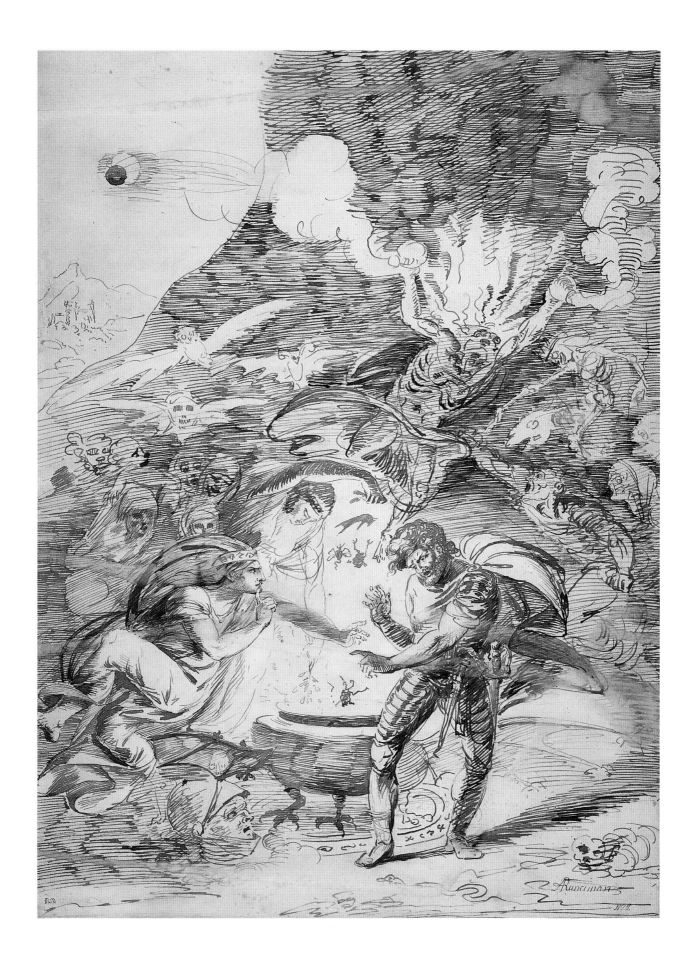

9

Henry Fuseli (1741–1825)
The Death of Cardinal Beaufort (2 Henry VI, III. iii)

Inscribed lower left *Roma 1772*; and in a different hand in brown ink *Fuseli*
1772
Pen, ink, pencil, grey and yellow gouache on paper
65 × 81.9 cm (25½ × 32¼ in.)
Lent by the Board of Trustees of the National Museums and Galleries on Merseyside (Walker Art Gallery), Liverpool, inv. no. 1540

This drawing was sent from Rome to the Royal Academy exhibition of 1774 (no. 90), Fuseli's first submission to the institution. There it aroused the interest of at least one reviewer: "There is evidently an originality of genius in this Sketch (for it is by no means a finished Drawing) which displays itself by extravagance in the Ideas, Wildness in the Expression and Violence in the Actions of his Figures; in the Light and Shadow is disposed in broad Masses and the tout ensemble is well composed" (*Public Advertiser*, 3 May 1774). The fact that this play was rarely staged allowed Fuseli to adopt a novel approach to the death of Beaufort, a pivotal scene in the plot, chosen in 1709 by Rowe as the illustration of this play and for the 1744 Hanmer edition, illustrated by Gravelot. Fuseli extends the circle of bystanders and emphasizes the contrast between the piety of the young king, urging the cardinal to turn to God, and the tormented cardinal, who hallucinates, plagued by his guilt for the murder of the Duke of Gloucester. Standing by his bed, Warwick observes: "See how the pangs of death do make him grin."

With this drawing, Fuseli wished to announce himself to the Royal Academy as a history painter, which explains the elaborate construction of the scene, in comparison with the two more summary preparatory sketches (Schiff 1973, nos. 438, 439), and the impressive range of art-historical sources. Fuseli has borrowed from Giambologna's *Hercules and Nessus* (Loggia dei Lanzi, Florence) and Poussin's *Death of Germanicus* (The Minneapolis Institute of Arts), a canonical heroic death scene, while also paying tribute to Benjamin West's *Departure of Regulus* (The Royal Collection), commissioned by George III and exhibited at the Royal Academy in 1769, as the epitome of his new Neo-classical aspirations. But the high-minded rhetoric of those works is here turned on its head: the protagonist of this drawing is a villain.

The monk in the foreground looks straight at the viewer, leading our gaze towards the climax of the scene, the contorted face of the dying man, who is placed at the centre of the diagonals of the composition and picked out with a shaft of light in the manner of Rembrandt. This interest in expression is something Fuseli shared with another artist in Rome at the time, the Scotsman John Brown (1749–1787), who sent some of his *Character Sketches* to the same exhibition of 1774. In his subsequent Roman drawings, Fuseli evolved towards a schematic abstraction, which allowed him to respect the primacy of the passions expressed by Shakespeare. Artists' enthusiasm for the Henry VI plays reached its apogee in the fourteen paintings executed for the Boydell Gallery, of which the most famous is Reynolds's *Death of Cardinal Beaufort* (1789; National Trust, Petworth House, West Sussex), a more concise and

faithful version of Shakespeare's text. Fuseli adapted Reynolds's model in a painting of 1803, engraved by William Bromley for the Historic Gallery of Robert Bowyer, and again in 1808 by Moses Houghton (Musée d'Art et d'Histoire, Geneva).
MGM

PROVENANCE William Roscoe (1753–1831); acquired between 1834 and 1846 by the Liverpool Royal Institution; bequeathed to the Walker Art Gallery, 1948

BIBLIOGRAPHY Boase 1947, pp. 102–03; Antal 1956, pp. 29, 30, 34, 125, 134; Moelwyn Merchant 1959, pp. 78–79, fig. 27a; Macandrew 1959–60, pp. 27, 29; London 1964, no. 24; Stevens 1967, no. 45; Tomory 1972, pp. 77–78, fig. 25; Schiff 1973, no. 440, pp. 98–99; Dotson 1973, pp. 375–79; New Haven CT 1979, pp. 56–58 , fig. G, p. 78; Tokyo *et al.* 1992–93, no. 12; Parma 1997, nos. 34, 69; Myrone 2002, pp. 25–26

Fig. 30 Henry Fuseli, *The Witches show Macbeth Banquo's Descendants* (*Macbeth*, IV. i. 112–24), *c.* 1773–79, pen and gouache on paper, 36 × 42 cm (14⅛ × 16½ in.), Kunsthaus, Zurich

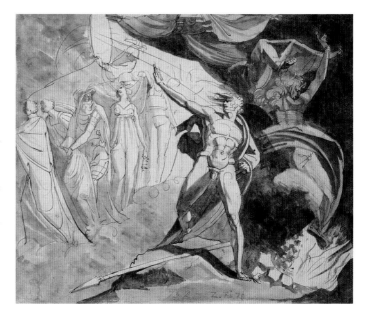

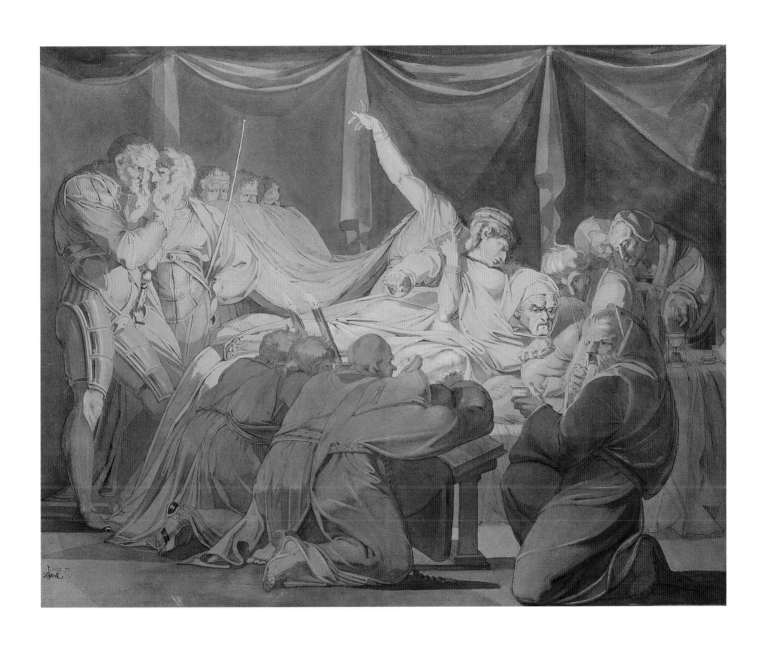

LIVERPOOL JOHN MOORES UNIVERSITY
LEARNING SERVICES

73

JAMES BARRY (1741–1806)
King Lear mourns the Death of Cordelia (King Lear, V. iii. 257–59)

Signed on the shield to the left *Jams Barry Pinxt.*
1774
Oil on canvas
101.5 × 128 cm (39⅞ × 50⅜ in.)
The John Jefferson Smurfit Foundation, Dublin, inv. 34

Barry was born in Cork in Ireland, exhibited in Dublin from 1763 onwards and was noticed there by the essayist Edmund Burke, who introduced him to Reynolds and paid for his study in Paris and Rome, where he stayed from autumn 1766 to spring 1770; although of a stormy and saturnine temperament he joined the circle of artists that included the Runciman brothers (see pls. 6, 8). On his return to London he exhibited regularly at the Royal Academy, mostly history subjects, and won a commission from the Society of Arts to decorate its Great Room with a series of six large paintings depicting *The Progress of Human Civilization* (1777–84). As a leading historical painter, along with Reynolds and Benjamin West, Barry was made professor at the Royal Academy, though he was expelled in 1799 because of his radical attack on the prevailing system of private and public artistic patronage in England, which favoured the Old Masters at the expense of living artists.

While in Italy, Barry was influenced by an essay, *An Inquiry into the Beauties of Painting* (1760), by fellow Irishman Daniel Webb (1719–1798), who recommended Italian art and Greco-Roman sculpture as the essential models for any aspiring artist, on account of their moral elevation, the nobility of their forms and their effect of concentrating drama – their ability to "render the soul visible" by expressing a dominant passion. The advice pervades this scene from *King Lear*, exhibited in 1774 at the Royal Academy, where the slumped abandon of the body of Cordelia is suggested by the *Mourning over the Dead Christ* of Annibale Carracci (The National Gallery, London), admired by Barry in the Orléans collection in Paris. Lear's expression of despair derives from the Hellenistic group of *Laocoön* and also from the description and illustration of 'Anger' in Charles Le Brun's famous *Conférence sur l'expression (Lecture on Expression)*, which was published in a variety of French and English editions throughout the eighteenth century (see Montagu 1994, p. 164, fig. 208, pp. 175–87). The expression matches Lear's words:

> Howl, howl, howl, howl! O, you are men of stones!
> Had I your tongues and eyes, I'd use them so
> That heaven's vault should crack. She's gone for ever.

The pale colouring of this work and the pared-down composition, with two principal figures who seem to burst out from the restricted space of the frame, give it a sculptural character, derived from antique bas-reliefs. It was this quality, and its pathos, that disconcerted early critics, though reviewers applauded Barry's bold decision to illustrate Shakespeare's tragic ending rather than Nahum Tate's version. The critic of the *Public Advertiser*, who signed himself 'Dilettante', noted (3 May 1774): "There is something grand and uncommon in the idea of this Performance; but either from a want of knowledge of Nature, or an affectation of singularity, it is executed in so strange a manner, and so cold a style of colouring as almost overbalances its beauties." Another reviewer, called 'Guido', in the same paper that day, in an article entitled 'The Painters' Mirror for 1774', was more dismissive: the painting is "demoniac and extravagant", and "the Artist certainly meant it as a Burlesque: Cordelia represented by a fat Billingsgate Fish-woman overpowered with Gin, and Lear personated by an old Cloaths-man, or Jew Rabbi picking her pocket". The playwright Richard Cumberland (1732–1811) felt the same, though he expressed himself more formally: in a letter of August 1774 to his friend George Romney, then in Rome, he concludes that "Barry fell into the false sublime and became ridiculous" (Romney 1830, p. 108).

Barry returned to the subject in a popular aquatint of 1766 (fig. 8, p. 23) and in an enormous painting executed in 1786–87 for the Boydell Gallery (Tate, London), where Cordelia's death is witnessed by a full cast of bystanders and is set in an archaic Britain, suggested by Stonehenge in the background. This reference to the *Anglo-Saxon Chronicle*, which inspired the drama, follows Boydell's intention to promote, through Shakespearean subjects, a national school of history painting.
MGM

PROVENANCE Artist's sale, 1806, no. 113, probably acquired by Penrose; Charles Bianconi, 1855 until (1873); sale, Dublin, Bennett's, *c.* 1910; H. Tyrrel Smith, Frascati, Blackrock County, Dublin, 1913; Count Plunkett; Kathleen, Countess Plunkett, 1952; from whom purchased by present owner

BIBLIOGRAPHY Dotson 1973, pp. 413–19; Pressly 1981, P14; London 1983, no. 5

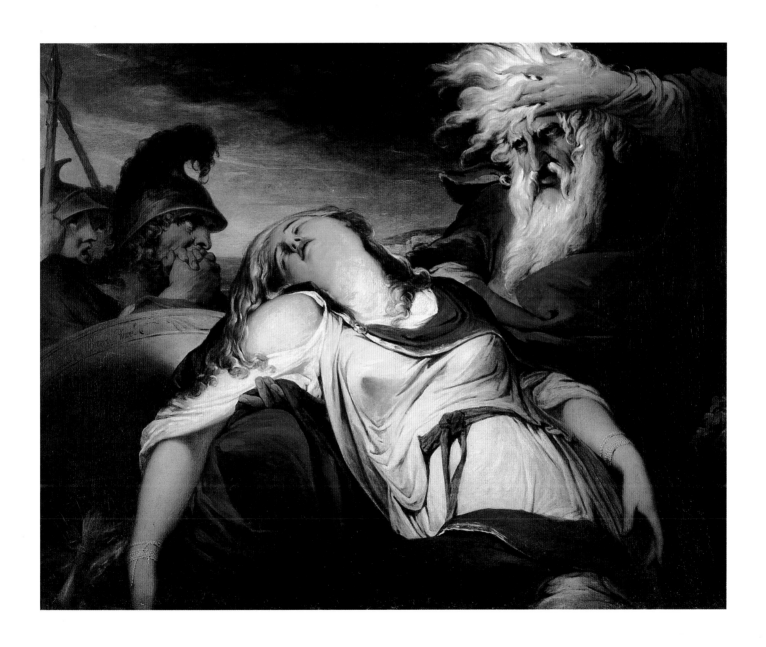

11
HENRY FUSELI (1741–1825)
The Vision of Queen Katharine (Henry VIII, IV. ii. 81–94)

Label on the back of the canvas *L&YR* [Lancashire & Yorkshire Railway] *to Blackburn; A9280A*
1781
Oil on canvas
151.1 × 212.1 cm (59½ × 83½ in.)
Fylde Borough Council, Lytham St Annes, acc. no. 52

Fuseli mentions that he is working on this painting in a letter of 3 September 1780 to the banker Sir Robert Smyth (1735–1805), his patron and an acquaintance from his Roman days. The picture was subsequently exhibited at the Royal Academy in 1781 (no. 118). Though the critics were transfixed by Fuseli's other entry that year – the *Death of Dido* (Yale Center for British Art, New Haven CT), also commissioned by Smyth, possibly intended as a pendant for this picture and certainly as a challenge to Reynolds's treatment of the same subject – they also noticed *The Vision of Queen Katharine*: "The composition is capital. There is a display of the most elegant figures imaginably grouped with the best judgement and taste. This is indeed the particular excellence of this ingenious artist – we could wish, however, that he would attend more to the colouring" (*The Gazetteer and New Daily Advertiser*, 12 May 1781).

Ever the pioneer, Fuseli was the first artist to treat this subject, which became popular after 1788, when the Kemble family made *Henry VIII* their war-horse (see pl. 45). With characteristic originality, Fuseli brings together all the elements contained in the text: the night preceding her death, Queen Katharine of Aragon, wife of Henry VIII, had a vision (not shared by her gentleman-usher, Griffith, or lady-in-waiting, Patience) of a procession of figures dressed in white crowning her with laurel garlands. For the circle of gracefully linked nude figures of the vision, Fuseli drew upon his memories of *Bacchanti* from Roman sarcophagi or from the Greek vases in the collection of Sir William Hamilton in Naples; he also shows his debt to the rhythmic elegance and distortion of Mannerist painting, which he admired in Italy.

The figures seem to be holding martyrs' crowns, an allusion to the queen's words to Griffith on waking:

> Saw you not, even now, a blessed troop
> Invite me to a banquet; whose bright faces
> Cast thousand beams upon me, like the sun?
> They promised me eternal happiness,
> And brought me garlands … .

A precedent for this painting, both in form and subject, is the oval marble relief by Thomas Banks (1735–1805) of *Thetis and her Nymphs rise from the sea to console Achilles* (fig. 31), executed *c.* 1778, when Banks and Fuseli were close associates in Rome, commissioned by the famous collector Frederick Hervey, Earl of Bristol and Bishop of Derry. Fuseli countered the angelic character of the *Vision* with his next Royal Academy submission, the 'sensation' of 1782, his demonic *The Nightmare*

(The Detroit Institute of Arts); both these works illustrate the principle, subsequently expressed in one of Fuseli's *Aphorisms*, that "one of the most unexplored regions of art are dreams" (Knowles 1831, III, p. 145).

Fuseli's later painting of the subject, made for Thomas Macklin's *Poets' Gallery* of 1787, inspired William Blake (see pl. 19). There are also two fragments from another version of 1788–90 (Victoria and Albert Museum, London).
MGM

PROVENANCE Commissioned by Sir Robert Smyth, 1780; by descent to Thomas George Graham White; Christie's sale, 23 March 1878, lot 19, acquired by Waters; Blackpool, Lenore M.M. Tiller collection, after 1930; Lytham St Annes, Alderman James Herbert Dawson collection; sold to current owner, 1950
BIBLIOGRAPHY Schiff and Viotto 1977, no. 48; Weinglass 1982, pp. 19–20, 32; Parma 1997, pp.100–01, no. 17

Fig. 31 Thomas Banks (1735–1805), *Thetis and her Nymphs rise from the sea to console Achilles for the Death of Patroclus, c.* 1778, marble, Victoria and Albert Museum, London

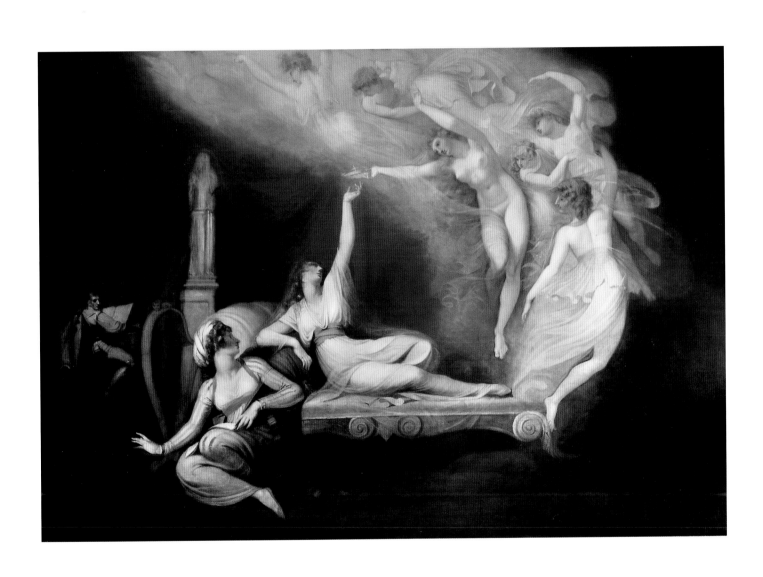

12

HENRY FUSELI (1741–1825)
The Weird Sisters (Macbeth, I. iii. 44–45)

c. 1783
Oil on canvas
75 × 90 cm (29½ × 35½ in.)
From the Royal Shakespeare Company Collection with the permission of the Governors of the Royal Shakespeare Theatre, Stratford-upon-Avon, inv. no. 49

Fuseli regarded *Macbeth* as the apogee of poetry (Farington, *Diary*); he read it when he was an adolescent, translated it at the instigation of Johann Jakob Bodmer in Zurich and experienced it at first hand in David Garrick's production in London in 1768, an event that inspired a dramatic watercolour drawing (Kunsthaus, Zurich). As usual, Garrick adapted Shakespeare's text, preserving from Davenant's operatic version the spectacular stage mechanics that accompanied the appearance of the witches and which exaggerated their importance in the play. The witches dominate Fuseli's *Macbeth* drawings from the time of his second Roman stay – for example, *The Witches show Macbeth Banquo's Descendants* (fig. 30, p. 72) – though echoes of Classical sculpture and Italian Mannerism tend to sublimate the reality of a performance into a private world of visionary abstractions.

In 1777 Fuseli submitted his first oil to the Royal Academy (no. 187), a work described by one critic as of "enormous size", with Macbeth's harrowing "vision of the ghosts of kings who shall be", all, of course, descendants of Banquo (*Morning Chronicle*, 28 April 1777). Another critic saw in the work a realization of the aesthetic of the Sublime: "The whole indeed is most pleasingly dreadful" (*London Chronicle*, 24 April 1777). Fuseli again took up the theme on his return to London, submitting to the Royal Academy of 1783 a painting (no. 10) drawn from the first act of the play, when Macbeth meets the witches on the heath, a subject already treated by painters from Zuccarelli (pl. 4) to Romney (fig. 32). With a touch of genius, Fuseli isolates the heads of the witches, each seen in profile and each repeating the same gesture and expression, a device – derived ultimately from antique sculpture and from the theory of the Sublime – that conveys a terrifying solemnity, at the same time as it embodies Shakespeare's line: "each at once her choppy finger laying upon her skinny lips." The painting, now in the Kunsthaus, Zurich (pl. 12 is a replica), attracted the attention of a critic on the *Morning Chronicle* (9 May 1783), who criticized the tension between the fidelity to the text and the need for a more traditional pictorial representation. For others the work confirmed Fuseli's status as art's 'mad professor': "Mr. Fuseli's Weird Sisters are like everything else of Mr. Fuseli, in 'the extravagant and errant spirit'. He draws correctly, but his imagination, impetuous but not full, is the most incorrect thing imaginable" (*The Public Advertiser*, 1 May 1783). In 1785 John Raphael Smith made a mezzotint of this image, which ensured its iconic fame as an inspiration for artists ranging from the cartoonist James Gillray (1757–1815) to the Romantics Eugène Delacroix and Théodore Chassériau.
MGM

PROVENANCE Graves Bequest, 1892

BIBLIOGRAPHY Farington, *Diary*, 1978–84, 26 March 1804, VI, p. 2277; Antal 1956, p. 40; Schiff 1973, I, pp. 145, 288, 319, 321 no. 734; Parma 1997, pp. 33, 108–09, no. 21

Fig. 32 George Romney (1734–1802), *Macbeth and the Witches*, *c.* 1780, oil on canvas, 74.9 × 63.4 cm (29½ × 24⅞ in.), Folger Shakespeare Library, Washington, DC

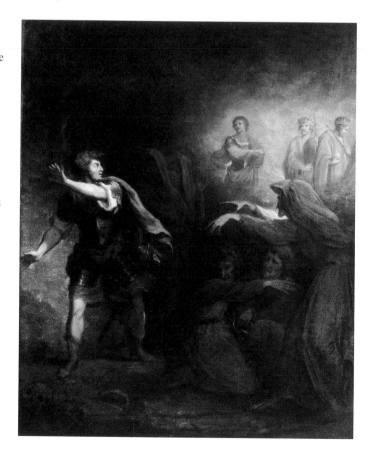

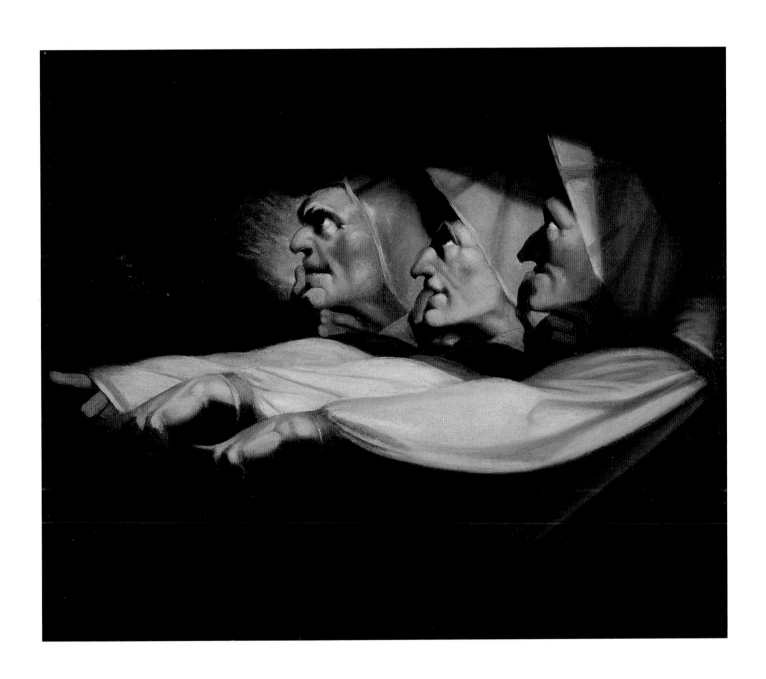

13

HENRY FUSELI (1741–1825)
The Dispute between Hotspur, Glendower, Mortimer and Worcester
(I Henry IV, III. i. 92–130)

1784
Oil on canvas
211 × 180 cm (83 × 70⅞ in.)
Birmingham Museums and Art Gallery, gift of Sir Alec Martin and Lady Ada Mary Martin, 1947, inv. no. P.6.47

In 1784 this painting was sent to the first exhibition of the Liverpool Society for Promoting Painting and Design, which was established by the lawyer and banker William Roscoe (1753–1831). Fuseli wrote to Roscoe, one of his most cultivated patrons, describing the subject: "when I painted it, it was meant to express the clashing of Hotspur's and Glendower's temper about turning Trent and the conciliatory exertions of Mortimer and Worcester"; adding, in case Roscoe might think of acquiring the work: "I painted it for myself." In the event the painting was bought by Roscoe's brother-in-law, Daniel Daulby, a brewer who collected Rembrandt etchings and patronized Joseph Wright of Derby. The *Henry IV* plays were valued by artists chiefly for the character of Falstaff, who offered opportunities for grotesque realism. Fuseli, on the other hand, chose the moment when the conspirators fall out over the future division of the kingdom, arguing that bends in the River Trent gave Glendower more territory than Hotspur. The clash between the impetuous and sarcastic Hotspur and the vain and boastful Glendower makes a vivid study of character.

Schiff argues that the introspective nature of this painting and its figure types, so different from Fuseli's Roman works, is due to his rediscovery of the London theatre after his return to England; Schiff sees the features of the famous actor, John Philip Kemble (1757–1823), in the young Hotspur and the older Glendower. This suggestion is undermined by the fact that Kemble was only just making his London début at the time it was painted (autumn 1783), and in the very different part of Hamlet. The work seems to derive from stylistic traits developed during Fuseli's Roman stay: the low viewpoint that amplifies the impact of the figures; and the Mannerist composition based on a series of divergent lines flying out from a nodal point, marked by the gesticulating hands at the centre of the painting. The obvious way in which the painting has been worked up – with a neatness of touch, a subtle distribution of shadows and carefully calibrated colour-range – is evidence of Fuseli's desire to refute the standard criticism of his works that they were all invention and no technique. The figure of Hotspur, in particular, echoes a pose adopted by the painter in his self-portrait in conversation, which his mentor, Johann Jakob Bodmer, exhibited at the Royal Academy in 1781 (fig. 33). In both cases the poses derive from figures on Michelangelo's Sistine Ceiling – Hotspur's from the Prophet Isaiah, seen in reverse, and Fuseli's from the nude youth next to the lunette of Eleazar. It is easy to see why Fuseli might have intended this work for himself: it offers a subjective reading of Shakespeare and a celebration of superhuman egos. Fuseli himself identified with this indulgent flaunting of individuality on the part of characters who are recast in the mould of Michelangelo's Titans.
MGM

PROVENANCE Daniel Daulby, Liverpool, 1784; Daniel Daulby auction, Liverpool, no. 78, 27 August 1798; Joshua Lace collection, Liverpool, 1841; Ambroise Lace, 1857; Col. H.R. Sandbach, Denbighshire, 1876; Mr and Mrs Ernest Milton collection; Sir Alec and Lady Martin collection; gift to Birmingham Museums, 1947

BIBLIOGRAPHY Birmingham 1951, no. 24; Antal 1956, p. 100, fig. 416; Schiff 1973, pp. 124–25, 144–45, no. 723; Weinglass 1982, pp. 24, 26; Altick 1985, pp. 289, 291, fig. 206; Parma 1997, pp. 94–95, no. 14

Fig. 33 Henry Fuseli, *The Artist speaking to Johann Jakob Bodmer*, 1779–80, oil on canvas, Kunsthaus, Zurich

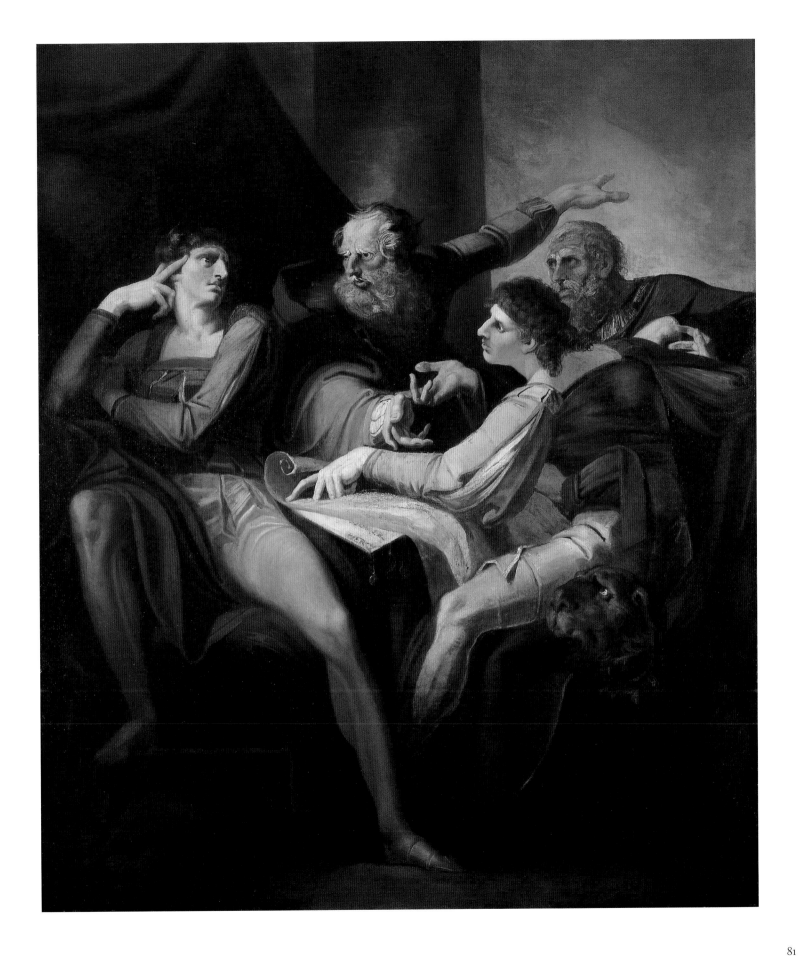

14
NICOLAI ABILDGAARD (1743–1809)
Richard III (V. iii. 180–82)

Signed and dated on the letter on the right *NAbildgaard MDCCLXXXVII*
1787
Oil on canvas
38 × 29 cm (14⅞ × 11⅜ in.)
National Gallery of Norway, Oslo, NG. M. 03196
Ferrara only

Abildgaard, a pupil at the Royal Academy of Copenhagen, was awarded a travel scholarship in 1772 to study in Rome, where he stayed from 1772 to 1777. He became a close friend of the sculptor Tobias Sergel (1740–1814), who introduced him to Fuseli's circle, in which company he was encouraged to copy Michelangelo's Sistine Ceiling and to study a wide range of literary sources. His work shows the impact of his reading of Homer and the classics, but also of Icelandic poems taken from such German legends as the *Nibelungenlied*, and from the Ossianic poems and *The Anglo-Saxon Chronicle*, as well as Shakespeare, whose plays had, at that date, never been staged in Denmark. His Roman studies ensured his rapid rise on his return to his homeland: he became professor of the Copenhagen Academy in 1778 and later its director; he also won prestigious commissions to decorate two royal palaces, the Christianborg and the Amalienborg, with cycles of history paintings.

Abildgaard's Italian years were marred by financial difficulties, illness and solitude; nonetheless he remembered them fondly enough to petition the king (unsuccessfully) for permission to return there in 1785, shortly before starting this painting. The Shakespearean subjects he worked on immediately after his return to Denmark, *Hamlet and his Mother* (1778; Statens Museum, Copenhagen) and *The Dream of Richard III* (fig. 34), were inspired, in subject and treatment, by Fuseli drawings; indeed they seem to be acts of homage to his friend. This scene repeats the painting of 1780, and shows Richard on the eve of the Battle of Bosworth visited in his sleep by the ghosts of those he has slain, who predict his death. Abildgaard returns to Shakespeare's text and chooses the moment when the usurper, waking with a start, springs forward fully armed only to discover that his enemy is himself:

> The lights burn blue. It is now dead midnight.
> Cold fearful drops stand on my trembling flesh.
> What I do fear? Myself? There's none else by.

This is Richard, not Macbeth, as was once thought, as can be seen from the arms of the House of York on the shield and the withered right arm. Abildgaard gives his Richard a heroic form, which owes much to Fuseli in its scale and in the tension of the opposing motion of the arms and legs. He also recalls here the life-drawing classes, open to all artists in Rome, at the Accademia di San Luca and the French Academy, held after sunset when candlelight made the nude body of the model stand out better. The pose here – standing and on guard – differs from the semi-reclining and barely awakened Richard seen in William Hogarth's

depiction of David Garrick in the part (fig. 3, p. 12), a type repeated in the 1788 version by William Hamilton (1751–1801), engraved for the Boydell Gallery, with John Philip Kemble as protagonist. Only in the setting does Abildgaard follow Hogarth, in the theatrically conceived elements of the tent and the details of Richard's fantastical costume.
MGM

PROVENANCE Johan Friedrich Clemens (1748–1831), friend of the artist; Clemens Sale, Copenhagen, 1832, no. 3; Bruun Rasmussen Auction, Copenhagen, 7 February 1978, no. 1, lot 374, acquired by the National Gallery of Norway, Oslo

BIBLIOGRAPHY Skovgaard 1961, pp. 21–22; Cedergreen Bech 1979, pp. 438–39; Oslo 1992, no. 4; Kragelund 1999, I, pp. 136–40

Fig. 34 Nicolai Abildgaard, *The Dream of Richard III*, 1780, oil on canvas, Randers Kunstmuseum

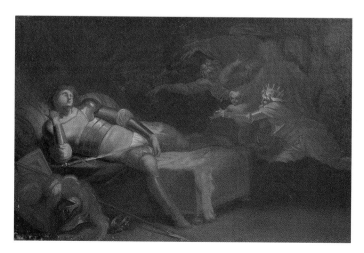

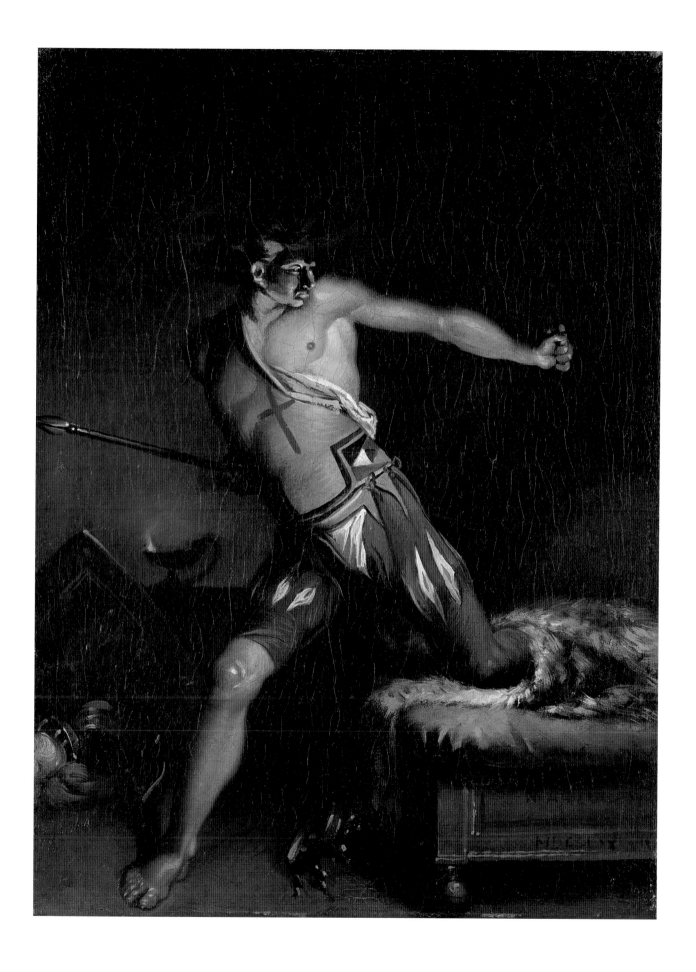

15, 16
George Romney (1734–1802)
Margery Jourdain and Roger Bolingbroke conjuring up the Fiend
(2 Henry VI, I. iv. 23–40)

Pl. 15 (top): *c.* 1787–88, pen, ink and grey wash over pencil on paper, 38.2 × 56.2 cm (15 × 22⅛ in.)
Lent by the Syndics of the Fitzwilliam Museum, Cambridge, inv. B.V.135, Ferrara only

Pl. 16 (bottom): *c.* 1787–88, pen, ink and grey wash over pencil on paper, 37.9 × 55.9 cm (14⅞ × 22 in.)
Lent by the Syndics of the Fitzwilliam Museum, Cambridge, inv. B.V.134, Dulwich only

The first subjects that Romney proposed to illustrate for Boydell's Shakespeare Gallery, two scenes of witchcraft from *Macbeth* and *Henry VI*, were in the event snapped up by his rivals Sir Joshua Reynolds and John Opie; this was because of Romney's slowness in executing history paintings, which he first studied in myriad sketches. These drawings present two solutions for a painting, which was abandoned and then ruined by being left outside Romney's Hampstead studio during the winter of 1799. The drawing pl. 16 was considered by Patricia Jaffé to be the earlier, but in fact must be the definitive idea, with its greater emphasis achieved by eliminating secondary figures and in the deliberately uncomfortable way in which the composition reads from right to left, a homage to the classic scene of witchcraft for the period, *Saul and the Witch of Endor* by Salvator Rosa (Louvre, Paris), engraved by Laurentius in 1744–45, a work that also inspired two of Romney's contemporaries in this field, John Mortimer and Benjamin West.

The ambitious Duchess of Gloucester, who in drawing pl. 15 watches from the ramparts of her garden, has employed a sorcerer to find out if her husband, the good Duke of Gloucester and Lord Protector, will become king. From the depths of the night and the smoke of Hell appear a spirit conjured up by the sorceress Jourdain, who lies prostrate on the floor, the priest Southwell and the necromancer Bolingbroke, who asks to know the destiny of the ruling Henry VI and of Gloucester's adversaries, the dukes of Suffolk and Somerset. The spirit predicts the rise of the Duke of York, the future Richard III, and his subsequent demise. The terrifying features of the spirit are inspired by the illustrations to Charles Le Brun's *Conférence sur l'expression (Lecture on Expression)*, of which Romney owned an English edition, *A Method to Learn to Design the Passions*, published in 1743 by John Williams. Le Brun's lecture, published posthumously in 1698 as a small treatise, *Méthode pour apprendre à dessiner les passions …* was an essential reference work for history painters and was also much used as a manual by actors of the period (see fig. 44, p. 119). The spirit's mask is a graphic example of what Le Brun calls mixed passions, in this case of fear and despair: "Fear is the apprehension of a future evil, which anticipates the ills with which we are threatened … extreme Fear becomes despair". These two passions, so clearly seen in Romney's image, also correspond to Shakespeare's text, in which the spirit trembles with fear at the name of God, spoken by the witch. According to Le Brun, when experiencing fear, the "shoulders are pressed together, the arms and hands drawn close against the body", while "Despair can be shown by a man grinding his teeth … having his forehead furrowed with vertical folds. The hair will stand on end" (Montagu 1994, pp. 126, 138–39).

The ability of painters to represent passions by exaggerating the lines of physiognomy had fascinated Romney since his Roman stay, thanks to his acquaintance with Fuseli and the Scottish painter John Brown (1747–1787), who deals with the same theme in his graphic work. We gain some insight into the way in which these issues were discussed among English artists from a letter sent to Romney by the essayist and collector Richard Payne Knight (1751–1824) from Rome in 1776. Payne Knight objected, contrary to the teachings of rationalist philosophers, that in art the Sublime does not belong to the senses, but depends upon 'reflex passions', induced by the viewer's empathy with the subject of the work. For this reason the painter must draw those forms which "are expressive of passions he wishes to transfuse into the breast of the spectators", concentrating on these rather than on grandiose proportions or contortions of anatomy: "The Sublime in painting consists in expression, not in forms" (Romney 1830, pp. 321–22). In this drawing the mask of agony on the face of the spirit excites the same effect on the viewer, supported by a skilful use of the language of the Sublime: the tension of divergent compositional forces, the violent contrasts of light and dark and a carelessness of touch, which gives the apparition a magical, unreal quality.
MGM

PROVENANCE Gift of J. Romney to The Fitzwilliam Museum, Cambridge, 1818
BIBLIOGRAPHY Romney 1830, p. 154; Antal 1956, p. 82, fig. 12a; Cambridge 1977, no. 78; Cambridge 1997; Cross 2000, p. 154; Liverpool, London and San Marino CA 2002, no. 123

LIVERPOOL JOHN MOORES UNIVERSITY
LEARNING SERVICES

17
WILLIAM BLAKE (1757–1827)
Oberon, Titania and Puck with Fairies dancing (A Midsummer Night's Dream, V. i)

c. 1786
Pencil and watercolour on paper
47.5 × 67.5 cm (18⅝ × 26½ in.)
Tate, London. Presented by Alfred A. de Pass in memory of his wife, Ethel, 1910

This watercolour illustrates the final scene of Shakespeare's
A Midsummer Night's Dream, celebrating the reconciliation of Oberon and
Titania and the successful resolution of the other elements of the plot.
The work can be dated to about 1785 on account of its closeness in style
to the three watercolours illustrating the biblical story of Joseph,
exhibited at the Royal Academy in that year (The Fitzwilliam
Museum, Cambridge; Butlin 1981, nos. 155–57). Although this
Shakespearean watercolour was neither exhibited nor engraved, it
may well have been painted to establish Blake's claim to be represented
in Boydell's Shakespeare Gallery, on which work began in 1786;
in the event, however, he received no commission for an original
work, merely engraving one illustration to *Romeo and Juliet* after
John Opie in 1799.

The work shows Blake at his most conservative and traditional,
working in the Neo-classical idiom established in England by Benjamin
West. The figures on the left stand in elegant contrapposto, while the
circle of dancing figures and even their relationship to the standing
figures seem to reflect George Romney's *Leveson-Gower Family* of
1776–77 (fig. 35). Blake executed two further compositions illustrating
A Midsummer Night's Dream, though these adhere less closely to the text.
One is the watercolour of the early 1790s, *Oberon and Titania, Preceded by
Puck* (Folger Shakespeare Library, Washington, DC; Butlin 1981, no. 246),
which shows Puck dancing ahead of Oberon and Titania who float
through the air, their trains held by two fairies, also airborne; the figures
are set against a starry sky. The other composition shows Oberon and
Titania on the petals of a lily; she is asleep, while he sits up alertly. The
first version of this latter composition, a watercolour, also seems to date
from the early 1790s (Private Collection, USA; Butlin 1981, no. 245),
though it was derived from a drawing by Blake's younger brother,
Robert, who had died in 1787 (in William Blake's Notebook; The British
Library, London; Butlin 1981, no. 201 5, 13). The composition was
repeated in reverse as plate 5 of Blake's poem *The Song of Los* (1795),
executed in Blake's own development of colour-printing in thick,
opaque pigments (reproduced in colour in Bindman 2000, p. 198).
This is a completely personal vision, the tiny scale of the fairies
being enhanced by the life-sized depiction of the flower.
MB

PROVENANCE The Artist's widow; sold to Francis Cary; Leggatt's from
Christie's, London, 13 March 1895, lot 16; Alfred A. de Pass, given to the Tate
Gallery, 1910

BIBLIOGRAPHY Butlin 1981, p. 61 no. 161; London 2000–01, p. 183, no. 227

Fig. 35 George Romney (1734–1802), *The Leveson-Gower Family*, 1776–77, oil
on canvas, 202 × 232 cm (79½ × 91⅜ in.), Abbot Hall Art Gallery, Kendal

18, 19

WILLIAM BLAKE (1757–1827)
The Vision of Queen Katharine (Henry VIII, IV. ii)

Pl. 18 (opposite): *c.* 1790–93, pen and watercolour over pencil on paper, 20.3 × 16.2 cm (8 × 6⅜ in.)
Lent by the Syndics of the Fitzwilliam Museum, Cambridge, inv. 712, Dulwich only

Pl. 19 (below): signed and dated lower left *WB. inv 1807*, 1807, pen and watercolour over pencil on paper, 40.1 × 31.3 cm (15¾ × 12¼ in.)
Lent by the Syndics of the Fitzwilliam Museum, Cambridge, inv. 1771, Ferrara only

These two watercolours illustrate the vision scene in *Henry VIII* in which Henry's first queen dreams of peace and happiness: "Enter, solemnly tripping one after another, six Personages, clad in white robes, wearing on their heads garlands of bays, and golden vizards on their faces; branches of bays or palm in their hands." Two of the figures in turn hold a garland over the queen's head, "at which, as it were by inspiration, she makes in her sleep signs of rejoicing … . The music continues". On awakening she exclaims,

> Spirits of peace, where are ye? are ye all gone,
> And leave me here in wretchedness behind ye?'

Blake's first treatment of the subject, dating from the early 1790s (pl. 18), is basically that of his Neo-classical contemporaries such as, in this case, Thomas Stothard, but less severe, more graceful than in *Oberon, Titania and Puck with Fairies dancing* (pl. 17). As David Bindman, who dates it to the later 1780s, points out, "it has something in common with the decorative style of *Songs of Innocence* and *The Book of Thel*", two of Blake's illuminated books of 1789. It also bears similarities to certain of the books of the early 1790s, up to and including *America* (1793) and *Europe* (1794), hence the dating given above.

On stage, the vision had to be practicable but, particularly in the later drawing, Blake transformed it into a true vision, with airborne figures hovering over the queen, who sits up in a state of exaltation. There she is flanked by the sleeping seated figures of her gentleman-usher Griffith and her woman Patience, omitted in the earlier version. In addition, Blake omits the golden vizards and shows the figures holding a variety of wreaths, a basket of flowers and musical instruments.

The watercolour of 1807, which was painted for Blake's great patron Thomas Butts, is considerably indebted to two works by Fuseli of the same subject. The pose of Queen Katharine is close to that in Fuseli's painting for Thomas Macklin's *Poets Gallery*, engraved by Bartolozzi in 1788, while the figures of Griffith and Patience, particularly the former, are derived from those in Fuseli's illustration to Alexander Chalmer's *The Plays of William Shakespeare*, engraved by Blake himself in 1804. The spiralling angels above are characteristic of a number of Fuseli's paintings such as *The Shepherd's Dream*, painted for his Milton Gallery in 1793 (now Tate, London). The Gothic arch behind reflects Blake's apprenticeship in Westminster Abbey, working for the antiquarian publisher and engraver Thomas Basire. However, the delicacy of the figures, their ecstatic expressions and the flowing composition are typical of Blake's mature style.

The same composition as the 1807 watercolour reappears, painted in Blake's more colourful, later style in a work commissioned in about 1825 by Sir Thomas Lawrence (National Gallery of Art, Washington, DC; Butlin 1981, no. 549). Blake also painted a rather more varied version of the 1807 watercolour in 1809 as one of the group of Shakespeare illustrations made for the Revd Joseph Thomas (see pls. 20–22); the Queen, though alert, has barely raised her head from the pillow, and the figures of her vision rise in two interlocking spirals (The British Museum, London; Butlin 1981, no. 547 3).

MB

PROVENANCE FOR PL. 18 Perhaps Thomas Butts; perhaps Thomas Butts Jr; sold Foster's, London, 29 June 1853, lot 137, bought by H.G. Bohn; … ; perhaps J.H. Chance (nephew of Blake's patron John Linnell) by 1863; perhaps Samuel Prince, sold Sotheby's, London, 11–14 December 1865, lot 276, bought by Halstead; … ; the Revd Stopford A. Brook by 1876, sold Sotheby's, London, 9–11 December 1935, lot 621, bought by Maggs, sold December 1935 to The Fitzwilliam Museum, Cambridge

BIBLIOGRAPHY FOR PL. 18 Bindman 1970, pp. 6–7, no. 2; Butlin 1981, pp. 126–27, no. 247

PROVENANCE FOR PL. 19 Thomas Butts; Thomas Butts Jr, sold Sotheby's, London, 26 March 1852, lot 166, bought by Sir Charles Wentworth Dilke, Bart; passed 1869 to his son Sir Charles Wentworth Dilke, 2nd Bart; sold Christie's, London, 10 April 1911, lot 127, bought by Sydney Cockerell for the Friends of the Fitzwilliam Museum, Cambridge

BIBLIOGRAPHY FOR PL. 19 Bindman 1970, pp. 27–28 no. 27; Butlin 1981, pp. 407 no. 548

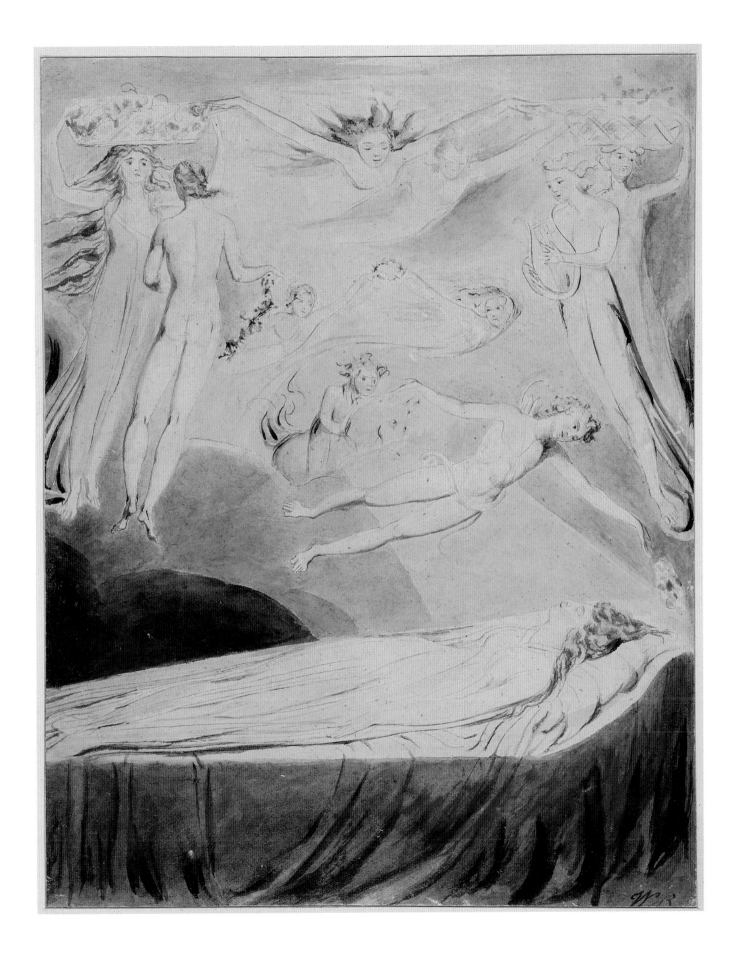

20

WILLIAM BLAKE (1757–1827)
Jaques and the Wounded Stag (As You Like It, II. i)

Signed and dated lower right *WB inv* [in monogram] *1806*
1806
Pen and watercolour on paper
22 × 15.8 cm (8½ × 6¼ in.)
The British Museum, London, inv. 1954-11-13-1 (11)

Blake depicts the episode from *As You Like It*, described by the first lord to the duke and other courtiers, in which Jaques, the epitome of melancholy, bewails the fate of a wounded stag:

> … as he lay along
> Under an oak whose antique root peeps out
> Upon the brook that brawls along this wood!

The stag meanwhile "stood on th' extremest verge of the swift brook/ Augmenting it with tears". Jaques had then gone on to attack "the body of the country, city, court". Blake shows Jaques seated on the bank of the brook pointing at the stag.

This watercolour, together with five further works by Blake (of which three, including this example, are dated 1806, two 1809, while one is undated; see also pls. 21, 22), comes from an extra-illustrated 1632 Second Folio of Shakespeare's plays, probably inherited by Millicent, wife of Blake's patron the Revd Joseph Thomas, from her father John Parkhurst the lexicographer. The book also contains thirty further watercolours by other contemporary artists including John Flaxman, William Hamilton, Robert Ker Porter and William Mulready. On 31 July 1801 Flaxman wrote to William Hayley (in whose cottage in Felpham, near Chichester, West Sussex, Blake lived from 1800 until 1803; see pl. 73), adding a postscript to Blake stating that Thomas, as well as being interested in a set of illustrations to Milton's *Comus* (Butlin 1981, no. 527), also wanted Blake to make two designs in bistre (a transparent brown pigment) or Indian ink from Shakespeare's *Troilus and Cressida*, *Coriolanus* and one or other of the three plays about Henry VI, Richard III or Henry VIII, for which he would pay one guinea for each design; Thomas specified that the paper should be an upright of 12½ × 8 in. (31.7 × 20.3 cm) with a moderate margin around the actual design, the principal figure in which should not exceed 6 in. (15.3 cm) in height. In fact Blake only illustrated, of this list, *Richard III* (*c.* 1806; pl. 21) and *Henry VIII* (1809), replacing the other suggestions by this work, together with *Brutus and Caesar's Ghost* (1806) from *Julius Caesar* (Butlin 1981, no. 547 4), *Hamlet and his Father's Ghost* (1806; Butlin 1981, no. 547 5) and an illustration to *1 Henry IV* (1809; pl. 22).

Despite Thomas's desire for monochromatic works in bistre or Indian ink, Blake has introduced some restrained colour into this work, as in the others of 1806; in this case blue and green offset the overall brownish grey.

MB

PROVENANCE The Revd Joseph Thomas; his widow; their daughter Mrs John Woodford Chase; her son Drummond Percy Chase; sold to Alexander Macmillan, 1880; George A. Macmillan; W.E.F. Macmillan, presented by his executors to The British Museum, 1954

BIBLIOGRAPHY Boase 1955–56, pp. 4–8; Moelwyn Merchant 1964, pp. 320–24 (1973 edn, pp. 247–52); Butlin 1981, pp. 405–06, no. 547 1

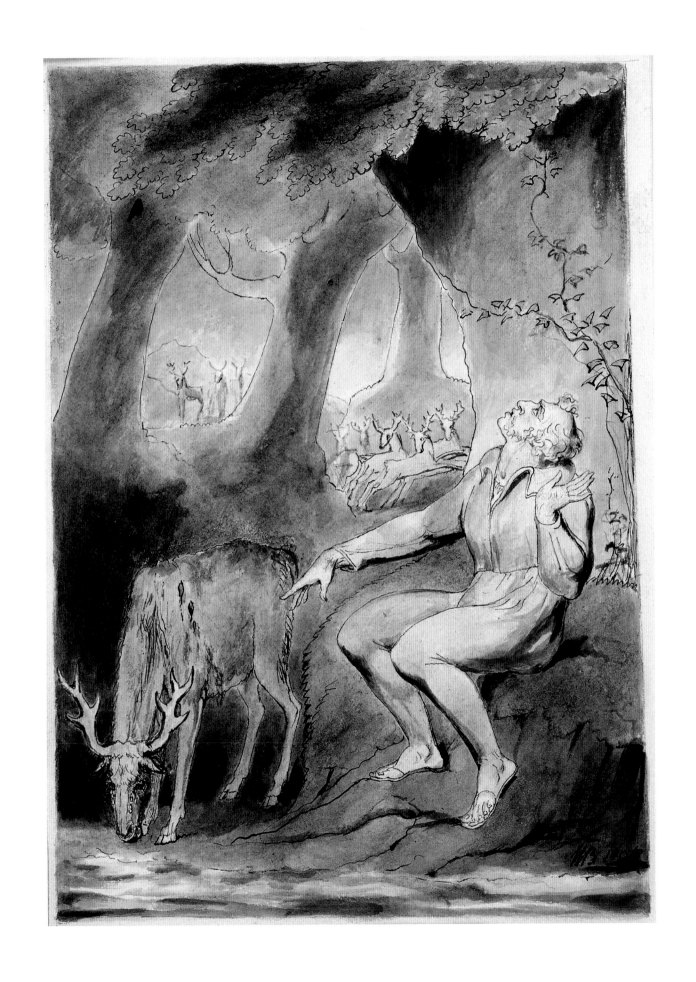

LIVERPOOL JOHN MOORES UNIVERSITY
LEARNING SERVICES

21

WILLIAM BLAKE (1757–1827)
Richard III and the Ghosts (Richard III, V. iii)

c. 1806
Pen and watercolour on paper
20.5 × 15.5 cm (8 × 6⅛ in.)
The British Museum, London, inv. 1954-11-13-1 (21)

This watercolour, from the Revd Joseph Thomas's album (see pls. 20, 22), illustrates the apparition to Richard III, on the eve of the Battle of Bosworth, of the ghosts of various of his victims from Shakespeare's *Richard III*. Nine of the ten ghosts of Shakespeare's text are shown, led by that of Henry VI on the left and Lady Anne (deceased wife of Richard III) on the right; the two young princes, sons of Edward IV, appear between Richard's legs. Richard III is shown in his tent but that of Henry, Earl of Richmond, the future King Henry VII, which in Shakespeare's text appears on the stage at the same time, is omitted. In the play the ghosts appear one by one, addressing first Richard III with the concluding words "despair and die", or some variation on this, and then Richmond to whom they promise victory; the two leaders only awake after their final disappearance. Blake however shows the ghosts all together, with Richard brandishing his sword to fight them off.

Blake uses a near monochrome as specified by Thomas; the overall sepia tones are only varied by an eerie blueish light thrown by the candles on the left. Moelwyn Merchant suggests the rare influence from actual stage practice in the depiction of Richard's tent, here shown as a characteristic eighteenth-century stage pavilion, and in the depiction of the stage tradition of the "starting from sleep", perhaps transmitted by way of Hogarth's painting of *Garrick as Richard III* (fig. 3, p. 12).

This watercolour is the only one of the group to be undated and could therefore have been done at any time after Thomas's commission in 1801. However, it is stylistically close to the other watercolours of 1806 and shares the very restricted palette of *Hamlet and his Father's Ghost* dated to that year (Butlin 1981, no. 547 5).
MB

PROVENANCE as pl. 20

BIBLIOGRAPHY Moelwyn Merchant 1964, pp. 302–04 (1973 edn, pp. 247–52); Butlin 1981, pp. 405–06, no. 547 2

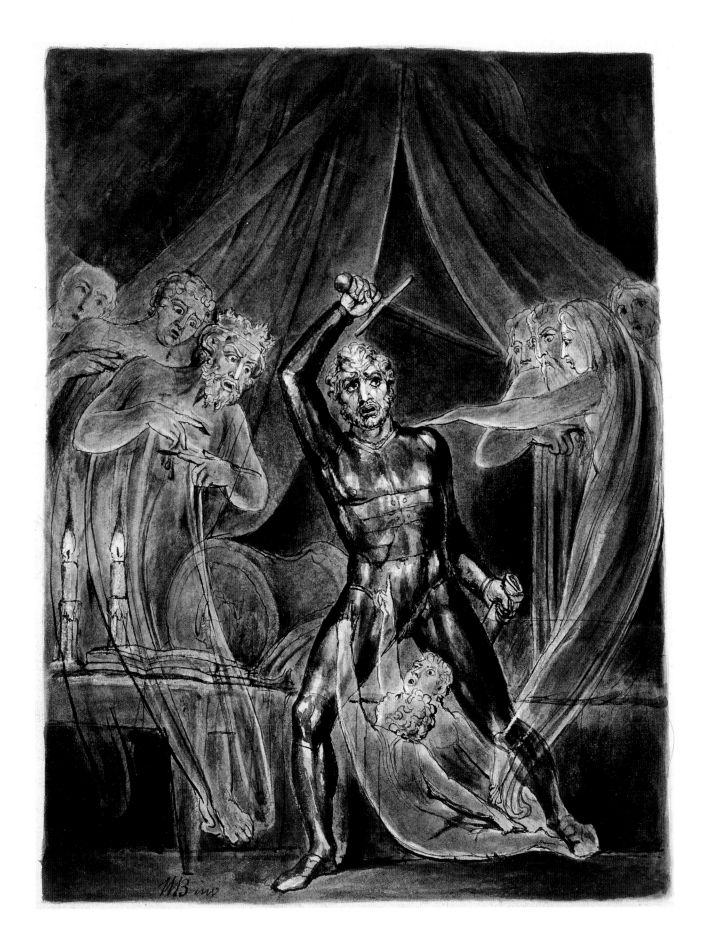

22

WILLIAM BLAKE (1757–1827)
"As if an Angel dropp'd down from the clouds" (1 *Henry IV*, IV. i. 108)

Signed and dated lower right *WBlake/ 1809*
1809
Pen and watercolour on paper
23.1 × 17.3 cm (9⅛ × 6¾ in.)
The British Museum, London, inv. 1954-11-13-1 (37)

This extraordinary watercolour has often been misidentified, although William Rossetti, in his revised lists of Blake's works of 1880, had already correctly seen it as a literal illustration to lines 104–10 of 1 *Henry IV*, Act 4, Scene 1:

> I saw young Harry with his beaver on,
> His cushes on his thighs, gallantly arm'd,
> Rise from the ground like feather'd Mercury,
> And vaulted with such ease into his seat,
> As if an angel dropp'd down from the clouds
> To turn and wind a fiery Pegasus,
> And witch the world with noble horsemanship.

Blake has taken Shakespeare's simile for the young Prince Harry (later King Henry V) and his skill as a horseman and depicted it, not by showing the young equestrian, but by startlingly juxtaposing two elements from Shakespeare's text: the fiery Pegasus leaping upwards from a rock, and the angel hovering over the horse and holding the reins with which to "turn and wind" it, to which Blake has added a recording angel reclining on a cloud with a large book open before her, presumably an embodiment of the poet–playwright's inspiration. As Anthony Blunt points out, Shakespeare's lines are the only passage from Shakespeare quoted in full by Edmund Burke in his *Philosophical Enquiry into the Origin of our Ideas of the Sublime and the Beautiful* (1757).

At more or less the same time, Blake included an unfinished picture of this subject in his sole one-man exhibition of 1809–10, number six in his catalogue, entitled "A Spirit vaulting from a cloud to turn and wind a fiery Pegasus – Shakespeare. The Horse of Intellect is leaping from the cliffs of Memory and Reasoning; it is a barren Rock: it is also called the Barren Waste of Locke and Newton". This work, described by Blake as one of his first "frescoes" or tempera paintings (presumably therefore done in or before 1795), is sadly now lost but may well have been similar to the watercolour. From his title, Blake appears to be demonstrating the leap of the intellect from the barren uninspired rationalism of the rock towards the airborne source of inspiration.

For another example of this visionary literalism, so different from the relatively straightforward renderings of Blake's other illustrations to Shakespeare, one can look at his large colour print of about 1795, *Pity* (examples also at The Metropolitan Museum of Art, New York, and Yale Center for British Art, New Haven CT; Butlin 1981, nos. 310–12; also a smaller, unfinished version, *ibid.* no. 213, and two pencil sketches,

nos. 314, 315), in which Shakespeare's lines in *Macbeth* "And pity, like a naked new-born babe,/ Striding the blast, or heaven's cherubim hors'd –/ Upon the sightless couriers of the air" are depicted with the same literal illustration of Shakespeare's images: the new-born babe and airborne and wind-blown horses.

This, one of the two watercolours done for the Revd Joseph Thomas in 1809, is in full colour. Like *Queen Katharine's Dream* (1806), it is on its original uncut sheet of paper measuring 30.8 × 19.1 cm, approximately the "12 Inches & half by 8 Inches" of Thomas's commission. It was originally bound in at the end of the Second Folio Shakespeare, another passage from the play having already been illustrated by Robert Ker Porter in 1801.
MB

PROVENANCE as pl. 20

BIBLIOGRAPHY Rossetti 1880, p. 217, list no. 1, no. 79; Blunt 1959, p. 19; Butlin 1981, pp. 405–07, no. 547 6

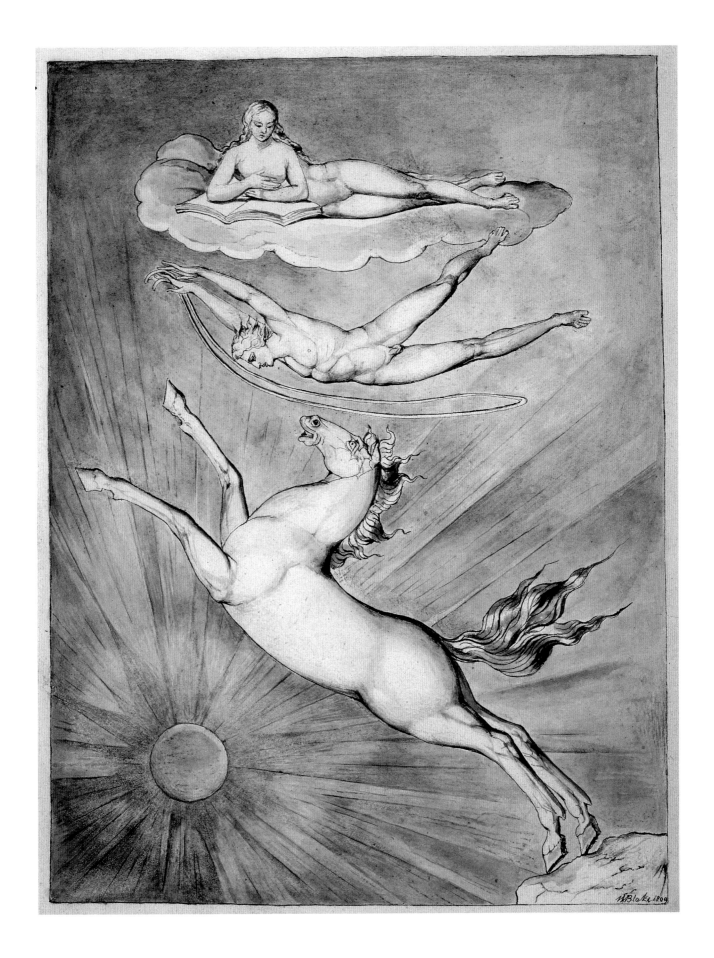

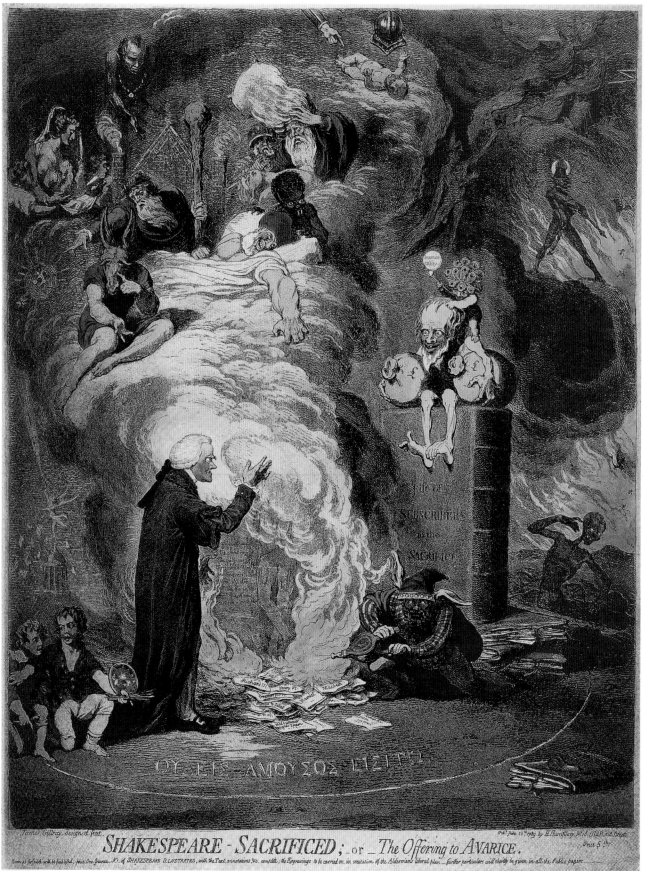

ΟΥΔΕΙΣ ΑΜΟΥΣΟΣ ΕΙΣΙΤΩ

James Gillray, design et fecit.

Pub: June 20th 1789 by H. Humphrey Nº 18 Old Bond Street
Price 5sh

SHAKESPEARE - SACRIFICED; _ or _ The Offering to AVARICE.

Soon as possible will be publish'd, price One Guinea, Nº of SHAKESPEARE ILLUSTRATED, with the Text, annotations &c complete, the Engravings to be carried on, in imitation of the Alderman's liberal plan _ further particulars will shortly be given in all the Public papers.

THE SHAKESPEARE GALLERIES OF JOHN BOYDELL AND JAMES WOODMASON

ROBIN HAMLYN

On 4 May 1789, an exhibition of paintings by British artists of subjects from the plays of William Shakespeare opened at a specially built gallery in Pall Mall, London. What it set out to do, what it achieved and to what extent it failed is central to any discussion about the ambitions of British art and artists at the turn of the eighteenth and nineteenth centuries. It was known as the Shakespeare Gallery and was financed by the most successful print publisher in London, John Boydell (1719–1804). It was an extraordinary and ambitious enterprise, the origins of which can be dated to a dinner given by Boydell's nephew Josiah Boydell at his house in Hampstead in November 1786. The thirty-four-year-old Josiah had trained as a painter and engraver. Having only moderate success by the 1780s, he went into partnership with his uncle, once an engraver but subsequently a print publisher. Josiah entertained eight guests that evening: three artists – George Romney (1734–1802), Benjamin West (1738–1820) and Paul Sandby (1730–1809); three men of letters – the translator and dramatist John Hoole (1727–1803), the poet and patron of artists (including Romney) William Hayley (1745–1820) and George Nicol (c. 1750–1828), the bookseller to George III; Romney's old friend Daniel Braithwaite (1731–1817), a wit, Fellow of the Royal Society, and on his way to high office in the Post Office (*Gentleman's Magazine*, 1817, 87, p. 632); and John Boydell. In its composition and range of interests this sort of group was not unusual for the times, being rather like other comfortable men's clubs found in cultivated society where literary, artistic and commercial men gathered together to converse. What emerged from the evening, after a discussion that embraced how "the French had presented the works of their distinguished authors in a much more respectable manner than the English had done", was a clear patriotic desire to see Britain emulate and then outdo a Continental rival in the way it honoured its greatest authors. It would do this by linking it with the desire by the community of artists – as the president of the Royal Academy

Sir Joshua Reynolds had said in 1769 – "that the present age may vie in Arts with that of Leo the Tenth", that is, the age of Raphael and Michelangelo, with these two the pre-eminent exemplars of painters in the Grand Style to which British art aspired. The obvious English author for such a project was, naturally, Shakespeare. Crucially, this discussion was coupled with the awareness, through John Boydell, that there were sound commercial possibilities at home and abroad, in the selling of prints. Imperial confidence found strength in art and trade combined.

One major contribution to the evening would have come from Romney, a successful painter of portraits and subject pictures. He seems to have been the prime mover in the creation of a Shakespeare Gallery, but on top of this he was something of an outsider. His natural artistic home should have been the Royal Academy, yet he did not often show at its exhibitions and he is recorded as saying that the Academy was "a manufacture of lifeless mechanisms, incompatible with the glowing ebullitions of feeling". Indeed, Romney never became a Royal Academician (Cross 2000, pp. 74–75). In other words, when it came to promoting the Grand Style of history painting, which was Reynolds's constant theme in the *Discourses* that he gave to Academy students usually every other year, Romney must have felt the Academy was failing because it was not stimulating patronage: something practical, beyond the reach of the Academy, had to be done. There was, then, some sense of a national failure, coupled with a long-standing pent-up creative energy, behind talk of this Shakespeare Gallery. Perhaps also at the back of the minds of the Hampstead eight was the fact that at that very moment Reynolds would have been working on his thirteenth Discourse, to be delivered on 10 December. It was a high point in the art-world calendar, and mention of such a grand project at such a moment would both be appropriate and help to crystallize support for it.

Just as many illustrated editions of Shakespeare's works had been published, so paintings of subjects from Shakespeare's plays also had quite a long history in public exhibitions in London from the 1740s onwards. In fact many of them were portraits of actors in particular parts, such as William Hogarth's *Garrick as Richard III* of c. 1745 (fig. 3, p. 12), and three portraits of the same actor in this part, by Francis

OPPOSITE Fig. 36 James Gillray (1756–1815), *Shakespeare Sacrificed, – or – The Offering to Avarice*, 1789/1800, etching finished with watercolour on paper, 50.5 × 38.5 cm (19⅞ × 15⅛ in.), published 20 June 1789, Trustees of The British Museum, London, Department of Prints and Drawings, no. BMC 7584

LIVERPOOL JOHN MOORES UNIVERSITY
LEARNING SERVICES

Fig. 37 Francis Wheatley (1747–1801), *The Interior of the Shakespeare Gallery, Pall Mall, The Boydell Gallery with Duke and Duchess of Clarence, Duke of York, Sir Joshua Reynolds, Richard Brinsley Sheridan, Alderman Boydell and his nephew, the Duchess of Devonshire and Countess of Jersey*, 1790, watercolour, 31.7 × 47.2 cm (12½ × 18½ in.), Victoria and Albert Museum, London, acc. no. 1719–1871

Hayman, shown at the Society of Artists in 1760, Nathaniel Dance, shown at the Royal Academy in 1771 (pl. 35), and Philippe de Loutherbourg, shown at the Academy in 1774. But these did not fit into the category of High Art. Between 1760 and up until the Royal Academy exhibition of summer 1786 – the last before the Boydell meeting – more than one hundred Shakespeare subjects had been shown at the main exhibiting bodies in London – the Society of Artists, the Free Society and the Royal Academy. Out of Shakespeare's thirty-six plays, eighty or so artists had selected scenes from fewer than thirty of them. Some formal recognition of the playwright as a source for academic art was to be found in the subject-matter selected on three successive occasions by the Academicians for the biennial Gold Medal for painting, to be awarded to a student in the Academy Schools: a scene from *Macbeth* in 1780, from *King Lear* in 1782 and from *The Tempest* in 1784. A few artists had already shown a particularly close interest in Shakespeare as just such a source. Most notable among them was Henry Fuseli (see pls. 9, 11–13) who, when in Rome in the 1770s and inspired by the Sistine Chapel, had sketched out his ideas for a hall frescoed with scenes from *Macbeth*, *King Lear*, *Twelfth Night* and *The Tempest* (Schiff 1973, nos. 475–77). Back in London he even set out to challenge the choice of Shakespeare for the Gold Medal painting competition, by working on other Shakespeare subjects and then submitting them to the exhibitions the following year: for the 1781 show he sent in *The Vision of Queen Katharine* from *Henry VIII* (pl. 11; Schiff 1973, no. 730); in 1783 *The Weird Sisters* from *Macbeth* (see pl. 12; Schiff 1973, no. 733) and *Constance, Arthur and Salisbury* from *King John* (The Smith College Museum of Art, Northampton MA; Schiff 1973, no. 722); and in 1785 *Prospero* from *The Tempest* (whereabouts unknown). Other artists, too, had explored Shakespeare: in 1782 Robert Edge Pine had unsuccessfully exhibited a group of Shakespeare paintings in London, and in 1785 James Northcote had painted a subject from *Richard III, King Edward the Vth, and his brother Richard, Duke of York, murdered in the Tower, by order of Richard III*[d]. Boydell bought this from him and showed it in

his London shop. The painting was shown at the Royal Academy in 1786, and Northcote later claimed that it led directly to the formation of the Boydell Gallery. By this time Romney himself had begun sketching the shipwreck scene from Act 1 of *The Tempest*, a subject that became the first of his Boydell subjects.

By November 1786 there was one notable omission from this list of Shakespeare artists – Sir Joshua Reynolds. Given its nationalistic ambitions and the need for its endorsement at the highest level, it was obviously important that the president of the Royal Academy, the 'official' leader of British artists, should be a contributor to Boydell's Gallery. As it happened, Reynolds had to be asked three times by John Boydell before he agreed to participate (Reynolds to Charles, 4th Duke of Rutland, 13 February 1787; Reynolds to Boydell 15 December 1791, see Ingamells and Edgcumbe 2000, nos. 171, 230). His hesitancy, partly explained by his commitment to portraiture, owed much to his doubt about his own and his fellow artists' ability to rise to Boydell's challenge. This was voiced in the Discourse he delivered the December following the Hampstead meeting, that "as a general rule … no Art can be engrafted with success on another art". The explicit association he was making was that between art and "theatrical representation". In this can be seen a warning to all artists that the leap from capturing stage performances – essentially the staple diet of Shakespeare in British art so far – to transmuting Shakespeare's words into High Art was not that easy. The 'stagey' effects seen subsequently in so many of the Boydell paintings show he had good reason for doubt.

A few days before Reynolds delivered his Discourse, Boydell published his "Proposal to Publish by Subscription A MOST MAG-NIFICENT AND ACCURATE EDITION of THE PLAYS OF SHAKSPEARE …". Seventy-two scenes from the plays were to be painted, displayed as they were completed, and then engraved, with some plays, for example *Hamlet* and *King Lear*, perhaps warranting three illustrations per play, while others, such as *A Midsummer Night's Dream* and *The Comedy of Errors*, only one. A new edition of the plays was to be printed, using a new typeface, in eight (later nine) hand-some volumes. Large engraved prints after the paintings were to be published, four per 'number', with at least one 'number' appearing each year. The plays were to be published two at a time, ready for subscribers to have them bound. In parallel with the appearance of the text, small prints after the same paintings, four in each number, were to be published as 'embellishments' to the texts. It was later decided that a separate series of small paintings of subjects different from those of the large paintings would be commissioned for the engraved 'embellishments'. Robert Smirke's scene from *The Merry Wives of Windsor* was one of these (pl. 26). The total cost of all this to a full subscriber was nearly £100.

When the Shakespeare Gallery opened in May 1789 it contained thirty-four pictures, by leading painters including Reynolds, James Barry, Benjamin West, Joseph Wright of Derby, Angelica Kauffmann, James Northcote, John Opie and Henry Fuseli, as well as works by such lesser knowns as Josiah Boydell and James Durno. In 1790 a fur-ther twenty-two pictures were added. These first years marked the high point in the Gallery's history. For artists generally there was all the air of a historic moment in British art having at last arrived, together with all the promise for future glory. As a place for fashion-able society to visit, as depicted in Francis Wheatley's 1790 water-colour showing the Boydells welcoming Royalty and Reynolds (holding his ear trumpet) to the Gallery, Benjamin West's powerful *King Lear on the Heath* just visible above them and two pictures by M.W. Peters behind them (fig. 37, p. 98), there was a sense of future patronage secured. Boydell was toasted as "the Commercial Maecenas" at an Academy dinner, the opening reviews were generally good, and subscribers numbered around six hundred (eventually reaching nearly 1400). Behind the scenes there had been disputes about the artists' fees, while others fished for commissions. James Gillray, having been rebuffed as an engraver, took his revenge on Boydell in a brilliant caricature that cleverly included details from eleven of the pictures in the inaugural display (fig. 36, p. 96) though its characterization of John Boydell as avaricious was unjust.

In June 1792 another Shakespeare Gallery was advertised, this time in Dublin. James Woodmason, the man behind this enterprise, was an opportunist who saw Shakespeare, as evidenced by Boydell's success to date, as good business. He was a stationer and in a bank-ing partnership with an Irish politician and, later on, reported to be not of "perfect morals". His gallery was directly modelled on Boydell's, claiming to be national in outlook in that it was announced as an initiative to promote the arts in Ireland, would commission the "first artists" to produce paintings that would be engraved for a new edition of Shakespeare, and would show the works in a gallery as a way of attracting subscribers to the publica-tion: the thirty-six plays were to be illustrated by seventy-two engravings from the pictures. At about the time the scheme was advertised, Woodmason commissioned work from some of Boydell's most successful artists – Fuseli (see pls. 27, 29), Northcote, John Opie, William Hamilton, Wheatley (see pl. 28) and Matthew William Peters. The six artists were by this time responsible for more than half of the seventy works that were on display in the London Shakespeare Gallery, though Peters, with Irish parents and having trained in Dublin, was the only one of them who could at this stage be con-nected with Woodmason's declared aim of promoting Irish artists. Ironically, because it was far less ambitious than Boydell's scheme, Woodmason's project was perhaps better placed to succeed. When the exhibition opened in a large refurbished room in Dublin to the paying public in May 1793, eighteen pictures were on display. Of these, four were by Fuseli – all of which, along with one later contri-bution, have survived. They remain the best of all the works from the

Gallery, despite the artist's complaint about the canvas size and shape being an inhibiting factor, with one of them, *Macbeth and the Armed Head* (Folger Shakespeare Library, Washington, DC) being one of his most powerful and original treatments of Shakespeare. From the surviving paintings we know that they were all upright compositions of one size (172.6 × 137.2 cm / 68 × 54 in., probably for ease of transport by sea from London to Dublin), all in frames of the same design and with the names of the plays, with act and scene numbers handsomely inscribed on them in black (fig. 38; pl. 29). The printed catalogue that accompanied the exhibition was similar in style to Boydell's. There was an elegance in all this, which can also be found in the prints after the paintings, of which sixteen were eventually engraved. Unsuccessful in Dublin, by January 1794 Woodmason had moved the paintings back to London and opened his New Shakespeare Gallery in London, just opposite Boydell's Gallery, where it survived until March 1795. Four more pictures were added, and eleven engravings were published in August 1794. By then, however, the start of war between Britain and France in 1793 had meant that almost all commercial enterprises were beginning to lose their market. Boydell's subscribers were falling away, though this was partly due to the variable quality of his Shakespeare prints. At the end of 1803, in order to raise cash to save his business, Boydell had to stop paying his creditors and plan a lottery, with the Gallery and its contents as a prize. In 1805 the lottery winner sold the 167 pictures at auction. They fetched less than Boydell had paid for them. When Woodmason's pictures later emerged on the market, they suffered the same fate.

One of the most remarkable features of Boydell's Shakespeare Gallery was that from its inception in 1786 until the publication of the last group, or 'number', of engravings in June 1803, it had an active life of some seventeen years. The project was very grand indeed, but Boydell had not taken into account the inevitable fickleness of public taste over such a long period. He had not anticipated subscribers withdrawing or dying, nor indeed the deaths of the artists themselves: Reynolds in 1792, Hodges in 1797, Wheatley in 1801, Romney in 1802 and Opie in 1807. There could be no more vivid register of fashion and taste passing away. The greatness of Shakespeare's words was unquestionable, but both Boydell's and Woodmason's galleries were conceived, launched and briefly borne aloft on the wings of novelty, which is cruel in the fleetingness of its flight. The outcome effectively demolished any hopes of establishing the Grand Style of painting in Britain.

Yet with this failure in the market-place came a liberation for artists that complemented the patriotic spirit of freedom in which Britain's war against a tyrannical France was being fought at the same time. While the war made it impossible for Boydell to sell his prints on the Continent and accelerated the demise of his Gallery, in Britain the public's love of landscape and its depiction in painting put down deeper roots. With Europe closed to them, artists and

Fig. 38 Henry Fuseli (1741–1825), *Gertrude, Hamlet and the Ghost of his Father,* 1793, showing the frame, the original for the Irish Shakespeare Gallery, oil on canvas, 165.8 × 133 cm (65¼ × 52½ in.), Magnani Collection, Fondazione Magnani Rocca, Mamiano di Traversetolo, Parma

patrons looked increasingly to their own countryside for subject-matter, and were quickly followed by critics and the public in their appreciation of it. For artists, the discipline of drawing and painting from the human figure in the studio, the requirement for large canvases to accommodate life-size figures, and even the primacy of oil paint, the accepted medium of the Grand Style and of exhibited works, became less imperative. A genuinely native school of landscape artists had long flourished but now assumed a higher status; it looked back to the Old Masters but was not overshadowed by them as the history painters of Boydell's generation had been: for Boydell's and Woodmason's contributors the problem had been compounded by the daunting combination of emulating the Old Masters and Shakespeare. The experience of landscape was something that artist and viewer shared; with such pictures there was no need to consult an exhibition catalogue to understand the subject. With the exception of Fuseli, who belonged to the Continent by birth and training, there was no British painter of the day who could respond to Shakespeare in a way that came anywhere near to emulating him.

Fig. 39 Sir John Soane (1753–1837), *Façade of Boydell's Shakespeare Gallery in Pall Mall*, 10 April 1810, 98.3 × 68.9 cm (38¾ × 27⅛ in.), Courtesy of the Trustees of the Sir John Soane Museum, London

young virtuosi – J.M.W. Turner and Thomas Girtin spring to mind – could elevate landscape, even on a small scale, to a grandeur comparable to what could be achieved with oil on the largest of canvases. With Turner and, from the early 1800s, John Constable, both oil painters treating landscape on a large scale, a great British School was finally established on a foundation that the illustration of Shakespeare's plays could never have provided.

SELECT BIBLIOGRAPHY

Schiff 1973; Bruntjen 1974; Friedman 1976; Hamlyn 1978; Cross 2000; Ingamells and Edgcumbe 2000

We have only to turn to *Hamlet* to see that it was precisely holding "the mirror up to nature", which Shakespeare had achieved through the medium of words, but that was now filtered through other imaginations and the medium of oil paint, which had made the Shakespeare galleries so vulnerable to failure. It was unreasonable to expect their artists to match Shakespeare's genius, yet, in those words from *Hamlet*, we see the path that had to be followed to create a great and truly British school of art, one which a new generation of its painters resolutely followed.

Landscape artists, aided by portable watercolours, found it increasingly easy to paint out-of-doors and consequently to hold "the mirror up to nature". In itself such an act could not guarantee success, but it was a starting-point shared with other great masters; one out of which greatness might arise, as it duly did. By the 1790s the growing acceptance of watercolours in exhibitions meant that

23

WILLIAM HODGES (1744–1797), GEORGE ROMNEY (1734–1802) and SAWREY GILPIN (1733–1807)
Jaques and the Wounded Stag in the Forest of Arden (As You Like It, II. i. 29–43)

c. 1788–89
Oil on canvas
92.1 × 123.2 cm (36¼ × 48½ in.)
Yale Center for British Art, Paul Mellon Fund, New Haven CT, inv. B 1976.1.1
Ferrara only

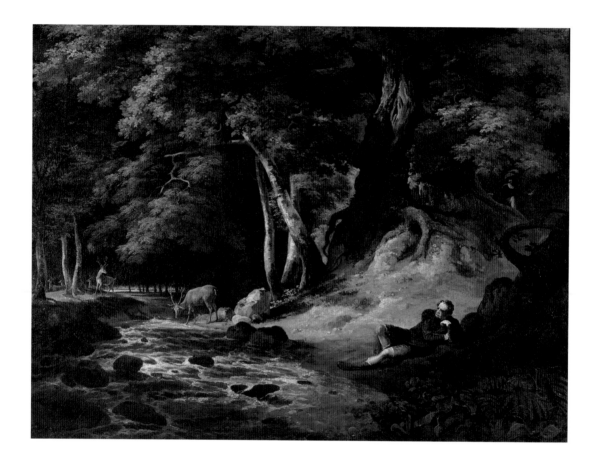

This painting was a collaborative effort, not altogether uncommon in British art of this period, during which painters specializing in different genres came together to ensure the success of a particular subject. Hodges was a landscape painter, best known for his place as official artist on Captain Cook's second voyage to the South Pacific in 1772–75. Gilpin was a successful animal painter, and painted the stags depicted here. Romney as a portraitist painted the figure of Jaques, whose face is that of Romney's friend and patron William Hayley (see pl. 73), who also played a part in the inception of the Shakespeare Gallery.

The scene is the Forest of Arden. A nobleman in the court of the exiled duke is describing how he and Lord Amiens saw another nobleman from their court, the "melancholy Jaques", "weeping and commenting" on the fate of a "sobbing deer" by a brook, which had been injured by huntsmen. Jaques was led to moralize "into a thousand similes" on the sight before him: "Tis right; … thus misery doth part/ The flux of company", he comments, on the separation of the wounded stag from its companions. Amiens and his companion are seen behind the tree above Jaques. The painting was engraved as a large Boydell plate by Samuel Middiman (1750–1831) and published in 1791.
RH

PROVENANCE Painted for John Boydell, *c.* 1789; Boydell sale, first day, Christie's, London, lot 41, 17 May 1805; sold to Sir Charles Merrick Burrell Bart, MP; with him in 1844 when lent to the British Institution; … ; American Shakespeare Festival Theatre and Academy, Stratford CT by 1954; … ; purchased by the Yale Center for British Art, 1977

BIBLIOGRAPHY Stuebe 1979

24
JOSEPH WRIGHT OF DERBY (1734–1797)
The Tomb Scene: Juliet with the dead Romeo (Romeo and Juliet, V. iii. 167–69)

?1786–91
Oil on canvas
177.8 × 241.3 cm (70 × 95 in.)
Derby Museum and Art Gallery, inv. 330-1981

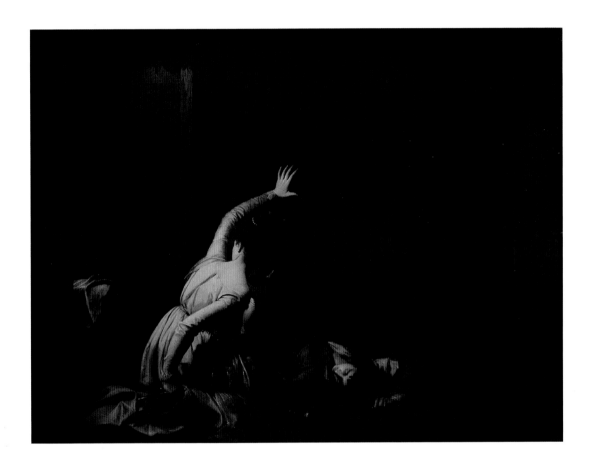

Wright was one of the first artists to be approached by John Boydell for a painting for his Shakespeare Gallery. After Boydell's dinner, Hayley sent Wright a letter inviting him to contribute (Friedman 1976, p. 107). Two works by Wright, scenes from *The Tempest* and *The Winter's Tale*, were finished in time for the opening of the Gallery in May 1789. A third painting, this scene from *Romeo and Juliet*, which the artist was certainly thinking about by late 1786 and was still working on in September 1789, appears to have been rejected by Boydell. Wright could be quite a difficult man, and initially complained that the size of canvas stipulated by Boydell was too small for him to show figures on a scale appropriate to a subject to be treated in the Grand Style. *The Tomb Scene* was not shown in Boydell's Gallery but at the Royal Academy in 1790; subsequently Wright worked on it until 1791, when it was exhibited at the Society of Artists,

after he had "simplified the back ground ... enlarged the parts, and thrown more light into the Tomb, so that Julia [*sic*] is bright without being a spot" (Nicolson 1968, I, p. 157). Juliet, alarmed, grips the dagger snatched from Romeo: "Yea, noise? – then I'll be brief. O happy dagger!" and prepares to kill herself.

RH

PROVENANCE The artist; his posthumous sale, Christie's, London, 6 May 1801, lot 51; offered for sale by Wright's executors, Derby, 11 October 1810, lot 7, bought in; bought by Robert Mosley and his nephew, by whom raffled at the "Museum Exhibition", Derby, 1843; Henry Mosley; ... ; Mrs Thomas Hope; with Thomas Haden Oakes; by descent to James Oakes, 1883; purchased Derby Museum and Art Gallery, 1981

BIBLIOGRAPHY Nicolson 1968; Egerton in London, Paris and New York 1990, no. 63

25

SIR JOSHUA REYNOLDS (1723–1792)
Puck, or Robin Goodfellow (A Midsummer Night's Dream, II. ii)

1789
Oil on panel
101.6 × 81.3 cm (40 × 32 in.)
Private Collection
Dulwich only

Reynolds, from the outset of Boydell's scheme for a Shakespeare Gallery, showed an awareness of the problems an artist would encounter when exploring Shakespearean subject-matter (see p. 99). Certainly two of the three works that he produced for Boydell, *The Death of Cardinal Beaufort* and *Macbeth and the Witches* (both National Trust, Petworth House, West Sussex), betray the artist's lack of ease in interpreting Shakespeare's words. By contrast, *Puck* owes its comparative success to the fact that it was essentially Reynolds at work as a portraitist, particularly of children. When John Boydell and George Nicol visited Reynolds's studio they saw a picture of a naked child that he had "painted from a little child he found sitting on his steps". Nicol said that if the child were portrayed sitting on a mushroom and were given the pointed ears of a faun he could look like Puck. Reynolds agreed, using another child model to help in capturing an "arch, roguish physiognomy" and setting him in "a Wood near Athens". Puck is shown holding in his right hand the flowers called "love-in-idleness". They had been fetched by him and given to Oberon, King of the Fairies; the juice from them was to be squeezed by Oberon on Titania's eyes (II. ii. 27–34) in order to make her fall in love with the first creature she sees on waking. Reynolds depicts the moment when Oberon has done his work and Puck is about to squeeze the same juice mistakenly in Lysander's eyes. Titania and Bottom with the head of an ass, with whom Titania falls in love, are asleep on a bank in the distance.

 Puck was first exhibited at the Royal Academy exhibition that opened at the end of April 1789, and not in the inaugural show of the Shakespeare Gallery. The critical reception was negative. The *Morning Post* thought that it "seems to be the portrait of a foetus taken from some anatomical preparation". Fuseli, who also painted a Puck for Boydell, writing in the *Analytical Review* thought that "this is a fairy whom fancy may endow with the creation of a midnight mushroom, a snow drop, or a violet; but he surely cannot be mistaken for the Robin of Shakespeare or Milton". *Puck* was engraved by the Italian-born Luigi Schiavonetti for the small series of Boydell illustrations and published in October 1799.
RH

PROVENANCE Bought from the artist by John Boydell, 1789; Boydell sale, third day, Christie's, London, 20 May 1805, lot 15, sold to William Seguier; Samuel Rogers's sale at Christie's, London, 2 May 1856, lot 714, sold to 5th Earl Fitzwilliam; by descent

BIBLIOGRAPHY Mannings and Postle 2000, I, p. 557, no. 2142

26

ROBERT SMIRKE (1752–1845)
Falstaff under Herne's Oak (The Merry Wives of Windsor, V. v. 31)

1793
Oil on canvas
80.8 × 55.5 cm (31¾ × 21⅞ in.)
From the Royal Shakespeare Company Collection with the permission of the Governors of the Royal Shakespeare Theatre, Stratford-upon-Avon, inv. 101

Smirke was the son of an itinerant artist and started his career apprenticed to a coach-painter. He was enrolled as a student in the Royal Academy Schools in 1772 and first exhibited there in 1786. He was best as a painter of humorous subjects and in this he was sometimes compared with William Hogarth. Along with Thomas Stothard, he contributed designs to *The Picturesque Beauties of Shakespear* (1783). He was a natural choice of artist for Boydell and in all contributed twenty-six paintings to the Shakespeare Gallery.

In this picture Smirke shows an episode from the last scene of the final act of *The Merry Wives of Windsor*. It is Shakespeare's most English play, being set wholly in Windsor and its surroundings. Windsor is dominated by its castle and adjacent Great Park and Windsor Forest. At the heart of the action is Sir John Falstaff's hopeless wooing of two married ladies, Mistress Page and Mistress Ford. In the hope of a successful outcome, Falstaff is persuaded to dress up as Herne, a former keeper and hunter at Windsor, after whom the oak tree in the forest was named. The plot was dreamed up by the ladies in order to cure Falstaff of his ridiculous behaviour. Herne's ghost, with horns on its head and rattling a chain "in a most hideous and dreadful manner", was said to walk through the forest on winter nights.

With his horns, Falstaff appropriately recalls the ancient Greek legend of the hunter Actaeon who, having surprised Diana bathing, was changed by her into a stag and devoured by his own dogs. Horns came to symbolize cuckoldom. The black-sleeved bodice, pointed at the front, of the female on Falstaff's left, suggests that she might be Mistress Ford, the "doe with the black scut" referred to by Falstaff. The word scut, or tail, has bawdy associations with female genitalia and we might read a similar sort of allusion into Smirke's juxtaposition of the tip of Falstaff's sword with the large ring on his chain; such imagery invites a comparison with the far more overt eroticism to be found in Fuseli's art. In this scene the time is midnight. Smirke depicts the moment when the two ladies cry "Away, Away", at the sound of the approaching townsfolk dressed as fairies, seen in the distance, who are to administer the final humiliation of Falstaff by pinching him and burning him with tapers.
RH

PROVENANCE Commissioned by John Boydell; Boydell sale, Christie's, London, lot 32, 20 May 1805, sold to — Page Esq.; … ; sold to the Shakespeare Memorial, Stratford-upon-Avon, now Royal Shakespeare Theatre, Picture Gallery, 1911

BIBLIOGRAPHY Friedman 1976, pp. 200–03

27

HENRY FUSELI (1741–1825)
Titania embracing Bottom (A Midsummer Night's Dream, IV. i. 1–44)

1792–93
Oil on canvas
169 × 135 cm (66½ × 53⅛ in.)
Kunsthaus, Zurich, Vereinigung Zürcher Kunstfreunde, inv. 1984/56

Puck has done his work (see pl. 25) and Titania has awoken to fall in love with Bottom the weaver, who now has the head of an ass. Her fairies, among them Peaseblossom, Cobweb, Moth and Mustardseed, lead Bottom to Titania's bower. In this painting of a scene from the next act, Fuseli shows Bottom sitting on "this flowery bed". Titania caresses his cheeks, having put "musk-roses" on his head while the fairies wait on him. So Peaseblossom scratches his head while Cobweb is out to kill "a red-hipp'd humble-bee" for its "honey-bag": two bees are seen near Bottom's left arm. Moth, her collar front shaped like a moth's wings, stands to the left of Peaseblossom. Titania's "venturous fairy that shall seek/ The squirrel's hoard, and fetch … new nuts" can be seen emerging from the ground behind Titania. An elf bearing "a handful or two of dried peas" on a small dish is flying towards Bottom just below a fairy playing a lute. Puck, the perpetrator of all this mischief and shortly to re-enter the action, looks down on it all from a tree at the top right of the composition. Shakespeare's stage directions at this point in the play emphasize the importance of music as a background to the action, and Fuseli – most obviously in the presence of the lutenist near Bottom but also in the presence of the diminutive musicians in the foreground – has observed this detail closely. As with its companion work painted for Woodmason, *Oberon squeezes the flower on Titania's eyelids* (Kunsthaus, Zurich) and as in his treatment of other *Dream* scenes for Boydell, Fuseli exploits the highly erotic element of the play. Bottom's drowsy confusion is the artist's cue for transforming the three principal fairies into dominatrixes.

Fuseli was a brilliant and highly original illustrator of literature and always richly allusive in his interpretation of it. Despite his complaint about the restriction that Woodmason's vertical format for his Gallery pictures forced on him, Fuseli's response was powerful. His debt to Michelangelo in this painting is obvious in the monumental treatment of the figure of Bottom. Titania's headwear has a crescent moon on it, the attribute of the moon goddess Diana. Fuseli would have included such a reference because, in line 72 of this scene, it is the juice from "Dian's bud" that Oberon squeezes on Titania's eyes to wake her from the dream which has found her in love with Bottom. "Dian's bud" is that of the artemisia flower, Artemis being the Greek equivalent of Diana.

The painting was engraved by Richard Rhodes (1765–1838) and published by Woodmason in London in August 1794. The title on the print describes the subject as taken from Act 3, Scene 1 of *A Midsummer Night's Dream*, though it clearly comes from the beginning of Act 4.
RH

PROVENANCE Commissioned by James Woodmason, ?1792; … ; Galerie Bollag; Frau Melanie Kaufmann-Frey; Kunsthaus, Zurich
BIBLIOGRAPHY Weinglass 1994, no. 133; Parma 1997, no. 2

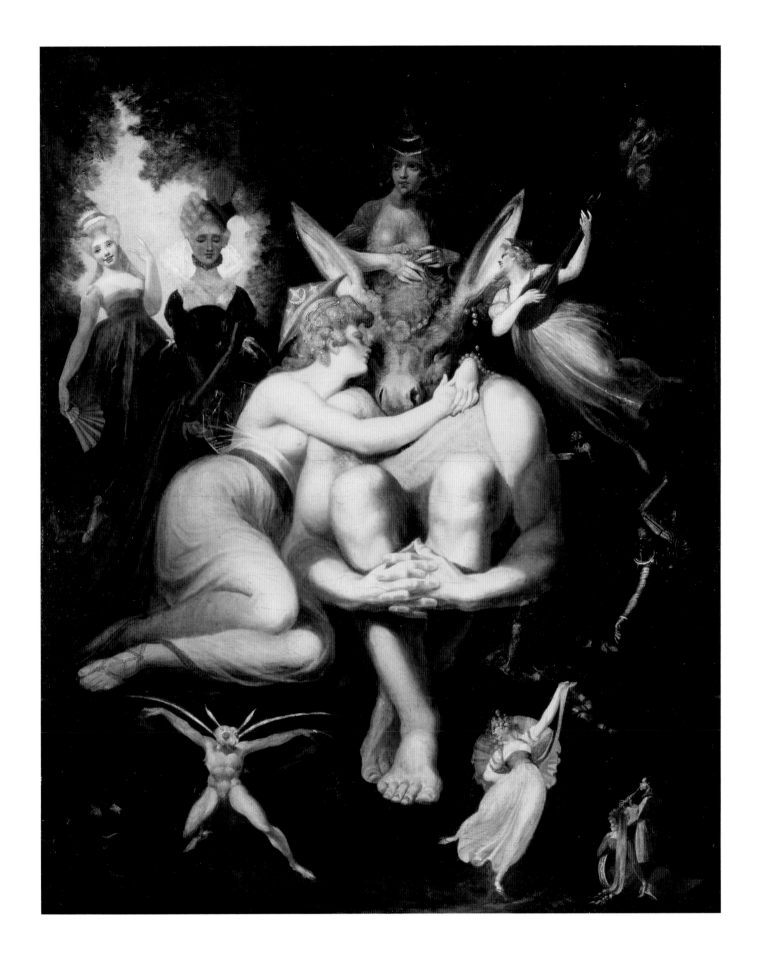

LIVERPOOL JOHN MOORES UNIVERSITY
LEARNING SERVICES

28

FRANCIS WHEATLEY (1747–1801)
Parolles ambushed and blindfolded (All's Well that Ends Well, IV. i. 68)

c. 1792–93
Oil on canvas
168 × 135 cm (66⅛ × 53⅛ in.)
Private Collection
Ferrara only

Wheatley was born in London, the son of a tailor. He trained in the Royal Academy Schools and early on contributed to the decorations at Vauxhall Gardens. He started exhibiting at the Royal Academy in 1771. His later success owed much to his treatment of genre subject-matter. Often engraved, these pictures became widely popular. He was elected a Royal Academician in 1791.

Wheatley painted three pictures for Woodmason's Irish Shakespeare Gallery, commissions that made some sense given Woodmason's interest in promoting art in Ireland. Between 1779 and 1783 Wheatley had lived in Ireland in order to escape his debtors – he was a lover of fashion – and an angry husband whose wife he had ravished. His work for Boydell and Woodmason is among the most attractive of all these Shakespeare paintings. Pretty and graceful female figures usually played an important part in his subjects, and his handling of colours and costumes, particularly those of silk, was painterly and harmonious. As an all-male subject *Parolles ambushed* is unusual in Wheatley's output.

All's Well that Ends Well was not often performed in the latter part of the eighteenth century, though the actor John Philip Kemble's edition of the play "with alterations" was published in 1793, and he performed in it at Drury Lane in 1794. Wheatley seems to have anticipated this re-awakened interest in the play and painted three subjects from it for Boydell, as well as this painting for Woodmason.

Parolles is the companion of Bertram, Count of Roussillon. He is a garrulous, showy braggart whose "soul … is his clothes" (II. v. 43). His name comes from the French for 'spoken words'. When Bertram is wedded to Helen against his will, Parolles persuades him to leave France and fight for the Duke of Florence. Bertram, eventually persuaded that Parolles is a treacherous coward, falls in with a plot to unmask him. He is ambushed one night by a group of men, led by a French lord, pretending to be enemy soldiers who speak in an invented language that Parolles does not understand. The splendidly dressed Parolles is blindfolded – "O ransom, ransom! Do not hide mine eyes" – and proceeds to give away his (invented) secrets of Bertram's army. The blindfolding is performed so that Parolles cannot recognize his tormentors, but a blindfold is also used in art and literature to signify moral blindness, Parolles's constant state. The French lord, shown in a fur hat to the left acting as interpreter of the unknown language for Parolles's benefit, is cleverly depicted holding a torch by Wheatley, and is thereby given the task of throwing real light on the incident. There is no dog in the play's action and Wheatley clearly introduced one into his painting as a symbol of fidelity, an ironic reference both to the disloyalty of Parolles and also to his friend Bertram's disowning of Helen.

Until now this picture has been attributed to Henry Tresham (1751–1814), but its dimensions match those of all the paintings in Woodmason's Gallery. Number eight in the Woodmason catalogue is 'Parolles ambushed' by Wheatley and this, along with the fact that the work is obviously from Wheatley's hand, confirms the re-attribution. RH

PROVENANCE Commissioned by James Woodmason, 1792; … ; sale, Sotheby's, London, lot 257, 28 October 1987; as 'Richard II' (*sic*) attributed to Henry Tresham; with The Heim Gallery, London, 1991; sale, Sotheby's, London, lot 189, 8 April 1992, as *The Condemnation of Bushy* from *Richard III* (*sic*) attributed to Henry Tresham RA

BIBLIOGRAPHY Webster 1970, pp. 87–92; Hamlyn 1978, pp. 519, 529; London 1991, p. 103 (as Tresham)

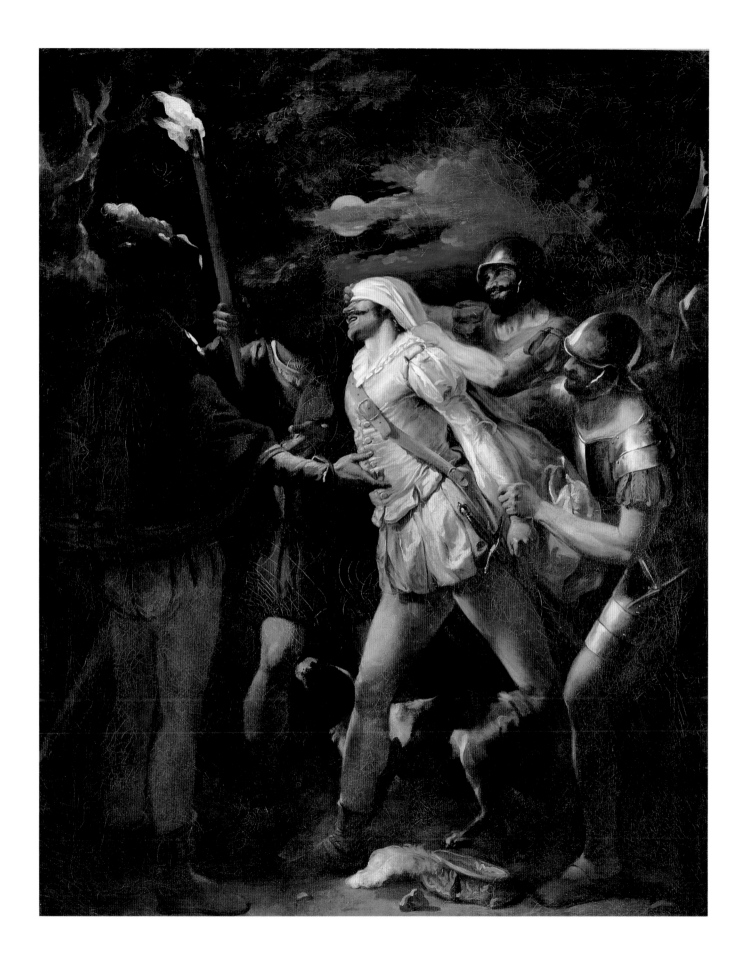

29

HENRY FUSELI (1741–1825)
Gertrude, Hamlet and the Ghost of Hamlet's Father (Hamlet, III. iv. 117–128)

Inscribed on the top of the frame *N°15 HAMLET. Act 3. SCENE 4. HY. FUSELI R.A.*
1793
Oil on canvas
165.5 × 134 cm (65⅛ × 52¾ in.)
Magnani Collection, Fondazione Magnani Rocca, Mamiano di Traversetolo, Parma, inv. no. 199
Ferrara only

This painting was commissioned from Fuseli by Woodmason for his Irish Shakespeare Gallery and was exhibited in Dublin in 1793. Hamlet, taken to task by his mother for his hostility to Claudius, once again sees the ghost of his father, an apparition invisible to Gertrude. Shocked by the fear on the face of her son, she asks (III. iv. 120–23):

> Forth at your eyes your spirits wildly peep;
> And, as the sleeping soldiers in th'alarm,
> Your bedded hairs stand like life in excrements
> Start up and stand an end.

Hamlet replies (III. iv. 125–27):

> On him, on him! Look how pale he glares.
> His form and cause conjoin'd preaching to stones
> Would make them capable.

The dramatic appearance of witches, fairies or ghosts was a stock-in-trade of 'Gothick' novels, fashionable at the time. In his *Letters on Chivalry and Romance* (1762), Richard Hurd gives his approval to this sort of effect, which he calls the "terrific sublime", citing Shakespeare's paranormal episodes (see for example pls. 8, 12, 15) as his precedent. Fuseli was a great fan of the 'Gothick', as his letters testify (Weinglass 1982, pp. 41–43, 49–50), and was already illustrating fabulous episodes from *Richard III* and *Macbeth* during his Roman years (Schiff 1973, pp. 444, 458, fig. 1; see pp. 61–63 above). He first treated this subject in a landscape-format drawing of 1780–82 (Schiff, no. 819), showing a more composed Hamlet, based on the gigantic statues of nude youths, the *Horse Tamers* (*Dioscuri*), on the Quirinal Hill, and including Polonius's body in the background. The portrait format prescribed by Woodmason obliged Fuseli here to adopt a more conventional composition, laid out as a kind of crescendo of emotions, and which by this date betrays the powerful impact of the Shakespearean productions Fuseli could have seen, starring David Garrick and John Philip Kemble. The latter made his début in the part in 1783 and wore a costume that, according to David Weinglass (Parma 1997, p. 70), inspired the picturesque habit worn by Hamlet in Fuseli's painting.

The theme here is Sublime, but the composition follows a format that Fuseli himself identifies as suitable for 'dramatic painting': in his fourth lecture to the Royal Academy he maintained that dramatic painting "distinguishes and raises itself above historic representation by laying the chief interest on the *actors*, and moulding the fact into mere situations contrived for their exhibition: they are the end, this is the medium. Such is the invention of Sophocles and Shakespeare" (Knowles 1831, II, pp. 195–96). This scene, in its staging and in the gestures of the main character, is inspired by the acting of David Garrick, whose *Hamlet* at Drury Lane is recorded in a famous James McArdell print of 1754 after a painting by Benjamin Wilson, and is described in enthusiastic detail by the German writer, Georg Christoph Lichtenberg, in his diary for 1774 and his *Briefe aus England* (letters from England) of the following year. At the moment the ghost appeared on stage, "the theatre was dark and the entire audience of several thousand people were so still that you could hear a pin drop at the other end of the auditorium, and their faces were so immobile thet they seemed to be painted on the walls"; the ghost's presence, at first unnoticed because of his stillness and because his armour was of the same colour as the background, was made known by the sudden reaction of Hamlet who "started back at the same instant two or three paces, with his knees knocking together and both arms (especially the left) outstretched, the fingers spread and the mouth open; he remained in this position as if frozen". This expression – with wan face, hair on end, eyes starting, mouth rigid – is borrowed from the expression of 'Horror' from Charles Le Brun's influential *Conférence sur l'expression* (see fig. 44, p. 119), but the authentic power of Garrick's long, frozen silence was something peculiar to his interpretation: "fear was so powerfully expressed in his aspect, that I was struck by a renewed sensation of horror, even before he started to speak. The fearful silence of the audience, before the apparition, which made everyone feel a nameless dread, contributed not a little to this sensation" (Lichtenberg 1972, III, pp. 335–36).

MGM

PROVENANCE Sir Gregory Osborne Page Turner; acquired by auction, 7–8 June 1824, lot 48, by John Bartie; C.W. Tayleur, Torquay; auction Bourne & Sons, Totnes, 9 October 1912, lot 312; B. Halliday; Sotheby's, 17 June 1981, lot 77; Colnaghi; Apolloni; Magnani Collection

BIBLIOGRAPHY Schiff 1973, no. 1747 (dated 1780–82); Hamlyn 1978, pp. 522, 529; Sgarbi 1984, pp.149–51; Parma 1997, no. 3; Deuchler 1999

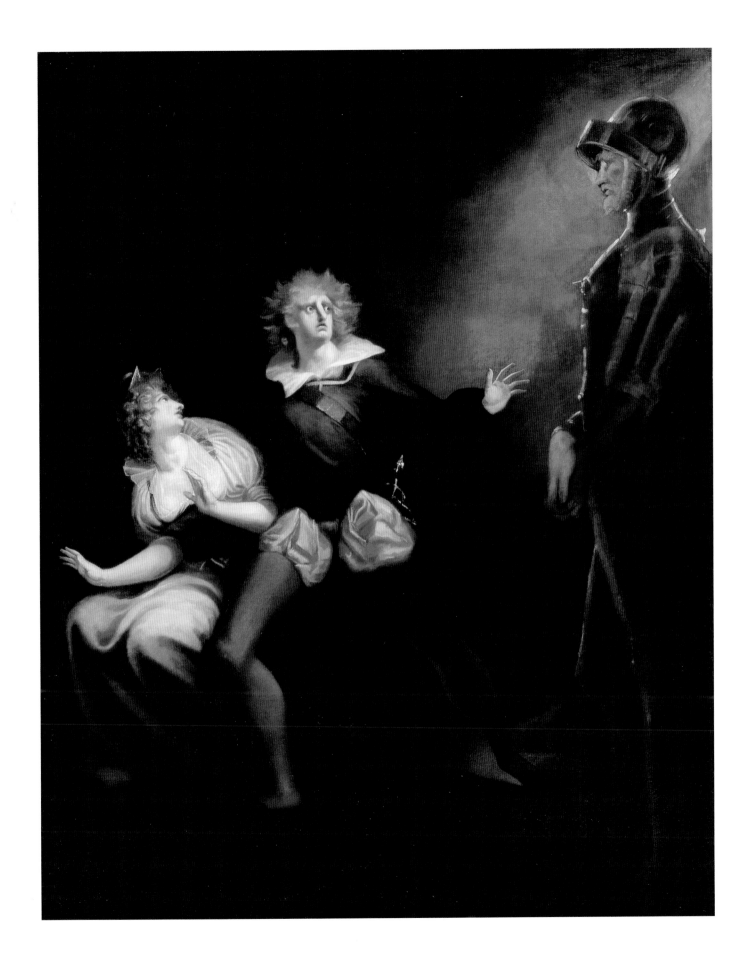

THEATRICAL PAINTING FROM HOGARTH TO FUSELI

DESMOND SHAWE-TAYLOR

"I will not go again to see any of Shakespeare's plays: you always associate the actors with the characters." This was the reaction of the young history painter Benjamin Robert Haydon after walking out in disgust at Sarah Siddons's (in his view) spiritless performance in *Macbeth* on 9 October 1808 (see also fig. 43, p. 118). A few years later Charles Lamb (1811) expressed the same thought:

> Never let me be so ungrateful as to forget the very high degree of satisfaction which I received some years back from seeing for the first time a tragedy of Shakespeare's performed, in which those two great performers [John Philip Kemble and Sarah Siddons] sustained the principal parts. It seemed to embody and realise conceptions which had hitherto assumed no distinct shape. But dearly do we pay all our life after for this juvenile pleasure, this sense of distinctness. When the novelty is past, we find to our cost that instead of realising an idea, we have only materialised and brought down a fine vision to the standard of flesh and blood. We have let go a dream, in quest of an unattainable substance.

For Haydon and Lamb actors get in the way of the imagination of the reader. But so do painters: this is how Lamb, in a letter to Samuel Rogers, reacted to some of the works illustrated in this book:

> What injury (short of the theatres) did not Boydell's Shakspeare Gallery do me with Shakspeare? To have Opie's Shakspeare, Northcote's Shakspeare, light-headed Fuseli's Shakspeare, heavy-headed Romney's Shakspeare, wooden-headed West's Shakspeare (tho' he did the best in Lear), deaf-headed Reynolds's Shakspeare, instead of my, and every body's Shakspeare. To be tied down to an authentic face of Juliet! To have Imogen's portrait! To confine the illimitable!

Theatrical painters combine both these evils – they obtrude themselves *and* an actor between the reader and *his* Shakespeare. The reactions of Lamb and Haydon are peculiar to the Romantic era, but there was throughout the eighteenth century (and before) an awareness of the same problems. Many accounts pay tribute to the excitement of individual performances and at the same time lament the compromises involved in theatrical presentation – the doctoring of Shakespeare's texts, the tawdriness of the sets and the mannerisms of the players. The actor, producer and rewriter of Shakespeare who more than anyone epitomized this dichotomy was David Garrick. Garrick was also the patron who did more than anyone to promote theatrical painting.

As David Alexander has discussed (pp. 21–22), theatrical painting was Garrick's means of self-promotion; writing to his brother George from Paris on 20 November 1764, he lamented:

> I am so plagu'd here for my Prints or rather Prints of Me – that I must desire You to send by ye first opportunity *six* prints from Reynolds's picture … . You must likewise send me a *King Lear* by *Wilson*, *Hamlet* d[itto] *Jaffier* & Belv[idera] by *Zoffani*, speak to him for two or 3, & what Else he may have done of Me – There is likewise a print of Me, as I am, from Liotard's picture Scrap'd by MacArdel, send me 2 or 3 of them, speak to MacArdel, & any other prints of Me, if tolerable, that I can't remember.

Garrick can with some justice refer to "my Prints", as his part in their creation was in many cases as important as that of their actual makers. He had a documented creative impact on the careers of an impressive range of artists: William Hogarth, Francis Hayman, Benjamin Wilson, Johann Zoffany and Henry Fuseli.

Garrick exerted this influence in part because the arts of painting and of acting were believed to overlap. In a passage referred to above by Brian Allen, Garrick's friend Aaron Hill calls him a "life painter". In a similar vein, the critic John Shebbeare, writing in 1755, suggested that Garrick was a Raphael of acting and that "the Genius of a Player is more analogous to the Painter and Musician than the Poet", because it concerns attitude, tone of voice and expression.

OPPOSITE Fig. 40 Sir Thomas Lawrence (1769–1830), *J.P. Kemble as Hamlet*, 1801, oil on canvas, 306.1 × 198.1 cm (120½ × 78 in.), Tate, London

Del mouimento dell'huomo. C A P. CLXXXII.

La somma e principal parte dell' arte è l'inuestigatione de' componimenti di qualunque cosa,& la seconda parte de' mouimenti, è che habbino attentione alle loro operationi ; le quali siano fatte con prontitudine, se-

Fig. 41 After Poussin, illustration based on a drawing in an edition of Leonardo da Vinci's *Trattato della Pittura* (1651, Paris), University of Cambridge

Hogarth's image of *Garrick as Richard III* (fig. 3, p. 12) is a fine example of the relationship between the real painter (Hogarth) and the "life painter" (Garrick). Hogarth has supplied a portrait with significant setting and attributes – the army's tents, the armour, the flame and the image of the crucifix, which Richard has significantly "turned his back on". Even the dangerously self-mutilating way in which Richard clutches his dagger is a significant Hogarthian touch. Garrick supplied the expression, a diagrammatic rendering of 'Horror' from Charles Le Brun's widely recommended treatises on expression (fig. 44, p. 119). Garrick's pupil John Bannister remembered his master making "faces in imitation of those by Le Brun" (Adolphus 1839). This same source is evident in Zoffany's later image of climactic terror (see pl. 34), creating another schematic, frontal, 'forensic analysis' of guilt.

Garrick also had strong ideas about how to illustrate Shakespeare, which he passed on to his friend Francis Hayman (1708–1776) in a letter of 18 August 1746. According to Garrick, Hayman should choose the moment "when Emilia discovers to Othello his Error about the Handkerchief"; here "at once the Whole Catastrophe of the play is unravell'd & the group of Figures in this Scene, with their different Expressions will produce a fine Effect in painting". The desire to convey the "whole catastrophe of the play" (as opposed to the moment of maximum action) also lies behind Hayman's later treatment of the closet scene in *Hamlet* (pl. 31). Hayman shows us the essential domestic drama: Hamlet transfixed by his father's ghost; Gertrude aware only of her son and rather ineffectually concerned with his state of

health. Hayman started his career as a scene-painter at Goodman's Fields Theatre and Drury Lane. Here he has created an ideal set, impossible in a real theatre, with spectral candlelight, claustrophobic space and a strangely permeable mirror.

Benjamin Wilson (1721–1788) was a minor portrait painter with a passion for Rembrandt and the theatre; like Hayman he worked as a scene-painter, for the Duke of York's private theatre in James Street in 1766. Between 1753 and 1762 Garrick commissioned a small group of theatrical paintings from Wilson, which convey the atmosphere of the *theatre* – with its crude lighting and stiff artifice – as distinct from the imaginary *scene* (see pl. 32). In 1760 Wilson had the good fortune to secure the services as a drapery painter of a German artist newly arrived in London – Johann Zoffany (1733–1810). Wilson introduced his talented assistant to theatrical painting and was very put out when, in 1762, Zoffany was discovered by Garrick, who thereafter employed him in preference to Wilson and enabled him to set up his own studio. If Wilson *records* the appearance of the Georgian stage, Zoffany *recreates* its impact. In all his theatrical work (see pls. 33, 34) we are conscious of layers of reality. We recognize Garrick and Charles Macklin; we admire the way in which they have transformed themselves into Macbeth and Shylock; we read their expressions; we even feel the shine of the footlights on their greasepaint; and yet none of this undermines our sheer excitement at the performance. Zoffany reminds us that this is play-acting and yet allows us to become caught up in the drama.

Zoffany had a broader training than most of his English contemporaries, having studied with a pupil of Francesco Solimena and spent seven years in Rome in the studio of Anton Raffael Mengs. His intimate knowledge of Italian, German and English art allowed him to adopt forms popular in England – the portrait, the conversation piece, the theatrical scene – with a kind of self-awareness, even a hint of irony. Sometimes Zoffany's painting seems to contain echoes that it is impossible to explain, such as the striking similarity between his *Macklin* and the portraiture of Velázquez. In many of his portraits, especially that of the actor, Pablo de Valladolid (Prado, Madrid), Velázquez surrounds a dramatic black silhouette with a halo of light, making the flat shape seem to assume form before our eyes. Zoffany here uses the same device to encapsulate Macklin's commanding stage presence. It is difficult to establish which paintings by (or thought to be by) Velázquez were known in Britain during the eighteenth century. Mengs was in Madrid at the time (1761–69) and enthusing about the art of Velázquez, but no documentary connection can be found between him and his former pupil.

Zoffany's portrait of Macklin (pl. 33) is an example of the most common type of theatrical portrait throughout the eighteenth century: an isolated figure against an entirely neutral background, revealing – by gesture, costume or expression – the essence of the character. In the last decade of the century portraiture as a whole was

becoming more ambitious and more theatrical, as Sir Joshua Reynolds advocated what he called the "Grand Manner", throwing his warriors into the thick of battle and casting his young ladies as Classical divinities. Nathaniel Dance was a pupil of Hayman, and spent a decade in Rome, 1755–65, where he assisted Pompeo Batoni, unsuccessfully wooed Angelica Kauffmann and became the first English artist to absorb mainstream European Neo-classicism (see pl. 7). His *Garrick as Richard III* (pl. 35) is a response to recently exhibited athletic and heroic portraits by Reynolds, notably his *Marquess of Granby* (Ringling Museum of Art, Sarasota FL), exhibited at the Society of Artists in 1766, and his *Archers*, exhibited at the Royal Academy in 1770. But there is also here a more conscious tribute to Garrick's learning and to the common language of painting and drama. Garrick's pose is a direct copy of the illustration to the 1651 edition of Leonardo da Vinci's *Trattato della Pittura* (*Treatise on Painting*), a print based on a drawing by Nicolas Poussin (fig. 41, p. 116). Leonardo's treatise contains some of the earliest and most detailed discussion of the anatomical roots of posture in the history of art. Poussin's drawing illustrates Leonardo's principle that, when preparing to throw something (or strike a blow) in one direction, a man stretches himself to the greatest extent possible in the opposite direction.

The only artist who surpassed Dance in grandeur was Sir Thomas Lawrence (1769–1830), whose subject was the actor who replaced David Garrick as the undisputed master of the London stage, John Philip Kemble (1757–1823). Lawrence exhibited a sequence of portraits of Kemble at the Royal Academy (almost one a year): as Coriolanus (1798; fig. 42); as Rolla in Sheridan's *Pizarro*, adopting the same pose as Dance's Garrick (1800; Nelson-Atkins Museum of Art, Kansas MO); and as Hamlet (fig. 40, p. 114). The two Shakespearean examples tell us something about the way in which the writer's reputation developed during the eighteenth century. In Garrick's day Shakespeare was seen as an inspired rustic: miraculous in the depiction of Nature and especially the wildest extremes of passion, effective in the use of the supernatural (into which he threw himself with touching credulity), but without regularity of structure or loftiness of thought. David Hume admired his "striking peculiarity of sentiment" but opined that "a reasonable propriety of thought he cannot for any time uphold" (Hume 1754). The Romantics on the other hand admired these same "touches of nature" but also found in Shakespeare the poet of exalted contemplation and sublime states of mind. Henry Mackenzie, the author of the cult novel *The Man of Feeling* (1771), saw in Hamlet a philosophical and amiable melancholy that looks down on "the bustle of ambition and the pride of fame" from the "elevation of its sorrows". For Hazlitt (1817), Hamlet became the personal champion of every brooding malcontent in the audience:

It is *we* who are Hamlet. This play has a prophetic truth, which is above that of history. Whoever has become thoughtful and

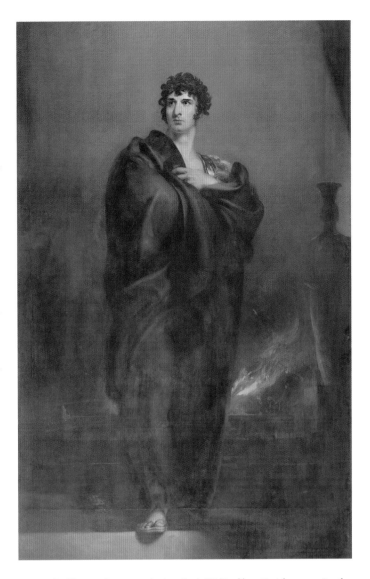

Fig. 42 Sir Thomas Lawrence (1769–1830), *J.P. Kemble as Coriolanus*, 1798, oil on canvas, 287 × 179.1 cm (113 × 70½ in.), Guildhall Art Gallery, Corporation of London

melancholy through his own mishaps or those of others … he to whom the universe seems infinite, and himself nothing; whose bitterness of soul makes him careless of consequences, and who goes to a play as his best resource to stave off, to a second remove, the evils of life by a noble representation of them – this is the true Hamlet.

Hayman's image of Spranger Barry as Hamlet summarizes the domestic interaction of the play. Kemble's Hamlet stands at the edge of the grave and contemplates the stars; this is the fatally philosophical Hamlet, the intellectual's Everyman, that inspired so many Romantic heroes – Byron's *Childe Harold*, Alfred de Musset's *Lorenzaccio* or Pushkin's *Eugene Onegin*.

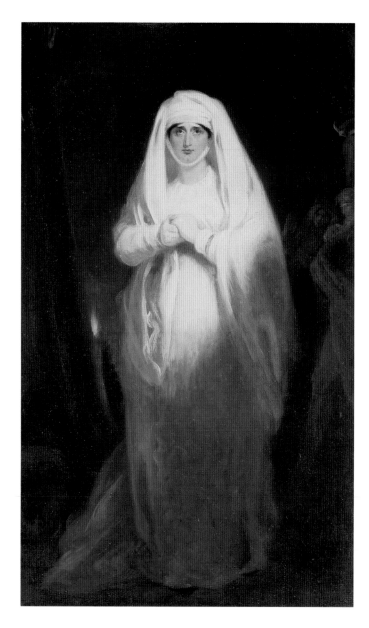

Fig. 43 George Henry Harlow (1787–1819), *Sarah Siddons in the scene of Lady Macbeth sleepwalking*, 1814, oil on canvas, 64 × 39.4 cm (25¼ × 15½ in.), Garrick Club, London

Lawrence's pupil, George Henry Harlow (1787–1819), provides a complete record of the Kemble clan in action (pl. 45). Some thought him lacking exactly that training which Dance was so anxious to advertise. According to Henry Fuseli's biographer, John Knowles (1831), when Fuseli first saw Harlow's *Trial of Queen Katharine* (pl. 45), he said:

> "I do not disapprove of the general arrangement of your work, and I see that you will give it a powerful effect of light and shadow; but you have here a composition of more than twenty figures, or I should say parts of figures, because you

have not shown one leg or foot; this makes it very defective. Now, if you do not know how to draw legs and feet I will show you", and taking up a crayon, drew two on the wainscot of the room. Harlow profited by these remarks, and the next time he saw the picture, the whole arrangement was changed. Fuseli then said, "So far you have done well; but you have not introduced a back figure, to throw the eye of the spectator into the picture", and then pointed out by what means he might improve it in this particular. Accordingly Harlow introduced the two boys who are taking up the cushion; the one which shows the back is altogether due to Fuseli, and is certainly the best drawn figure in the picture. Fuseli afterwards attempted to get him to improve the drawing of the arms of the principal figure (Mrs Siddons as Queen Katharine), but without much effect; for having witnessed many ineffectual attempts of the painter, he desisted from further criticism, remarking, "It is a pity that you never attended the Antique Academy".

Richard and Samuel Redgrave, the early historians of British art, concluded: "Our own opinion of this picture is that it is clever, but stagey, with rather too much of the tableau and attitude school; and, though the painter prided himself upon it as an historical picture, we consider that it has none of the qualities to uphold its claim to that rank." This judgement reveals another change in taste during the Romantic period: suddenly the expressive power of 'premeditated' posture, so admired in Garrick's acting, can be dismissed as the 'tableau and attitude school'. Lamb expresses similar ideas, when he speaks contemptuously of the average spectator at a theatre:

> Some dim thing or other they see, they see an actor personating a passion, of grief, or anger, for instance, and they recognize it as a copy of the usual external effects of such passions; or at least as being true to *that symbol of the emotion which passes current at the theatre for it*, for it is often no more than that.

If you wished to find an example of "that symbol of the emotion which passes current at the theatre", it would be Garrick's use of the expression-manuals of Charles Le Brun (fig. 44, p. 119). Hazlitt, too, felt that painting with the aid of Le Brun's heads produced "theoretical diagrams of the passions – not natural and profound expressions of them; forced and overcharged, without precision or variety of character".

It is clear from views such as this (and others quoted here) that Zoffany's depiction of Garrick and Mrs Pritchard (pl. 34) would not have appealed to a Romantic viewer: the acting "forced and overcharged"; the depiction "stagey". It is remarkable therefore that in 1812, when Henry Fuseli decided to depict the same scene (pl. 42), he

9 *L'Horreur*

Fig. 11.

Fig. 44 Charles Le Brun (1619–1690), illustration of 'Horror', from *Méthode pour apprendre à dessiner les passions*, 1702 edition, Cambridge University Library

They remind one of Haydon's first taste of Fuseli's art in 1805: "Galvanised devils – malicious witches brewing their incantations – Satan bridging Chaos, and springing upwards in a pyramid of fire – Lady Macbeth – Paolo and Francesca – Falstaff and Mrs. Quickly – humour, pathos, terror, blood, and murder, met one at every look!" (*Autobiography*). It is probably no accident that the figures here seem more like troubled spirits than mortals. There are many hints that Shakespeare intended his hero and heroine to be literally damned: the witches are described as "instruments of Darkness" who, as agents of the Devil, "win us to our harm"; the sleep-walking scene is a premonition of Hell; and both Macbeth and Lady Macbeth die without hope or repentance. Garrick's version of the play makes the point explicit with the following lines inserted for the dying Macbeth:

Tis done! The scene of life will quickly close.
Ambition's vain, delusive dreams are fled,
And now I wake to darkness, guilt and horror;
I cannot bear it! Let me shake it off –
'Tw'o not be: my soul is clogg'd with blood –
I cannot rise! I dare not ask for mercy –
It is too late, hell drags me down; I sink,
I sink – Oh! – my soul is lost for ever!
Oh!

Fuseli, as a lover and inspired illustrator of Dante, knows better than most what Hell looks like. Hell is where the guilty relive their crimes for all eternity. Macbeth and Lady Macbeth seem here condemned to re-enact this scene of horror, in a cell of empty darkness, without ever ridding themselves of the bloody daggers, just as, in her nightmares, Lady Macbeth can never wash her hands clean. Macbeth himself broods on just such an image of damnation and re-enacted crime (*Macbeth*, II. i):

Nature seems dead, and wicked dreams abuse
The curtain'd sleep: now witchcraft celebrates
Pale Hecate's offerings; and wither'd murder,
Alarum'd by his sentinel, the wolf,
Whose howl's his watch, thus with his stealthy pace,
With Tarquin's ravishing strides, towards his design
Moves like a ghost.

SELECT BIBLIOGRAPHY

Shebbeare 1755; Lamb 1811; Hazlitt 1817; Haydon, *Autobiography*; Adolphus 1839

should have chosen the same pair of actors as his vehicle (rather than John Philip Kemble and Sarah Siddons or indeed no actor at all). Why pay tribute to long-dead exponents of the 'tableau and attitude' school? Like Lamb, Fuseli apparently feels that his first experience (nearly a half-century previously) of a great Shakespeare tragedy in performance has "seemed to embody and realise conceptions which had hitherto assumed no distinct shape" and that he too has found this "sense of distinctness" difficult to dislodge. Fuseli has made this personal nostalgia part of the power of the painting: this is a painting of memories, in which oblivion has eroded the incidentals of the scene down to spectral essentials.

But what is the meaning of these strange ghostly figures that seem to be skeletons clothed in faded fashions and dipped in phosphorous?

LIVERPOOL JOHN MOORES UNIVERSITY
LEARNING SERVICES

30
PIETER VAN BLEECK (1697–1764)
Mrs Cibber as Cordelia in Nahum Tate's adaptation of 'King Lear'
(Tate's version, III. iv)

1755
Oil on canvas
210 × 205 cm (82⅝ × 80⅝ in.)
Yale Center for British Art, Paul Mellon Fund, New Haven CT, inv. B1981.25.46
Ferrara only

This painting depicts Nahum Tate's 1681 version of Shakespeare's play, complete with happy ending, though nobody at this date would have thought the fact worthy of remark. There were already complaints about Tate's "execrable Alteration", but audiences were accustomed to it as the only performed version of the play.

The episode depicted here is pure Tate: Cordelia returns to England in time for the storm in Act 3; while searching for her father on the heath, she and her maid Arante are attacked by two of Edmund's ruffians (visible here on the left). They are fought off by Edgar, newly disguised as Poor Tom (visible here on the right). Edgar then asks the women:

> O speak, what are ye that appear to be
> O' th' tender Sex, and yet unguarded Wander
> Through the dead Mazes of this dreadfull Night,
> Where (tho' at full) the Clouded Moon scarce darts
> Imperfect Glimmerings?

The scene is a remake of Shakespeare's Act 4, Scene 6, when Edgar defends Gloucester from Oswald in similar circumstances, but with an extra pathos (detectable in these lines) derived from the fact that the intended victims are women.

Pathos was something at which Mrs Cibber excelled. Born Susanna Maria Arne (1714–1766), the sister of the famous composer Thomas Arne, she was an accomplished mezzo-soprano as well as an actress – she gave the first performance of many Handel parts, including the alto in the *Messiah*. She joined the company of Theophilus Cibber in 1733 and married him a year later. Her acting was distinguished by a fine musical voice and melting expression. Thomas Davies summed up her appeal in his *Dramatic Miscellanies* (1782–84): she "was the most pathetic of all actresses, the only Cordelia of excellence".

This painting is the perfect advertisement of her powers: she in the centre foreground, a crystallization of distress; her maid in solicitous profile, while her rustic champion and cowardly tormentors face each other across the painting in the shadows behind. Pieter van Bleeck's own print after this painting suggests that the canvas has been cut at the right side, thereby removing the ruffian's dog.
DST

BIBLIOGRAPHY Waterhouse 1969, pp. 128, 217, 247; Kerslake 1961, p. 56; New Haven CT 1981; Cormack 1985, p. 24; London 1994, pp. 11–13

PROVENANCE G.G. Blumenthal; Christie's, 5 March 1937, bought Banks; R.O. Gray; Colnaghi, from whom purchased in 1968

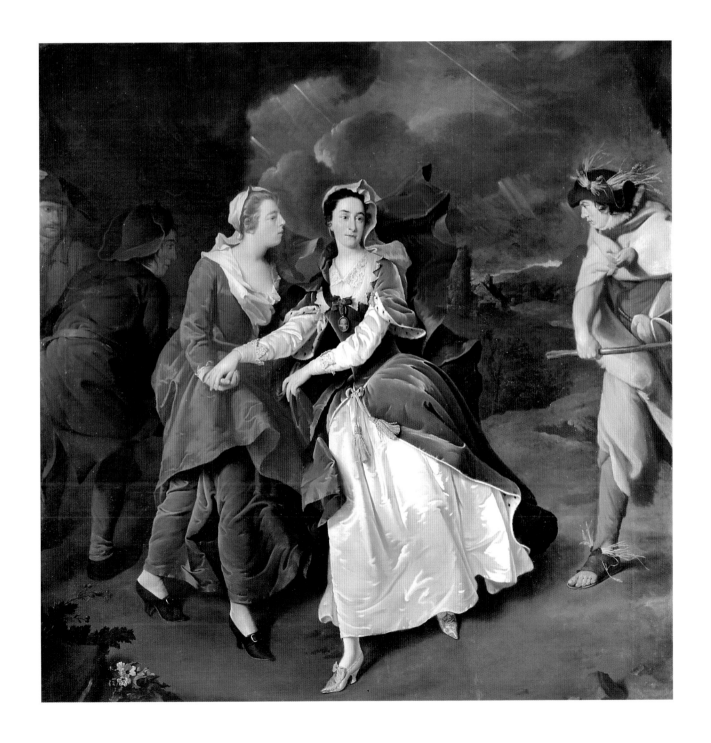

31
FRANCIS HAYMAN (1708–1776)
Spranger Barry and Mrs Mary Elmy in 'Hamlet' (III. iv. 116–19)

c. 1755–60
Oil on canvas
127 × 108 cm (50 × 42½ in.)
Garrick Club, London, inv. 49

Hayman depicts the moment when the ghost of Hamlet's father enters the closet, where Hamlet is berating Gertrude for her betrayal of his father's memory. Gertrude, who cannot see the apparition, reacts to the terror of her son:

> Hamlet: How is it with you, lady?
> Queen: Alas, how is't with you,
> That you do bend your eye on vacancy,
> And with th'incorporal air do hold discourse?

After he wakes from his ghostly visitations, Richard III notices that the "lights burn blue" (*Richard III*, V. iii. 181); Hayman has picked up on this paranormal symptom and given his candle an eerie blue aura, reflected in the mirror.

At the time of this painting Spranger Barry (1717–1777) was Garrick's principal rival on the London stage. Barry was born of well-to-do Irish parents and brought to the stage the sought-after qualities of gentlemanly manners and bearing. Samuel Foote contrasted his appearance with the "insignificant and trifling" person of Garrick:

> [Barry] has more Obligations to Nature … he is tall without Awkwardness … and Handsome without Effeminacy; his voice is sweet and permanent, but the Tone too soft for the Expression of any but the tender Passions, such as Grief, Love, Pity, &c.
> (*A Treatise on the Passions*, 1747)

Not surprisingly Barry's Hamlet here is more cultivated than tormented: even in the midst of his terror he stands exactly as a gentleman should, that is with his shoulders back and his feet turned out. As with all Hamlets of the period he wears modern dress, with a slight discomposure of stocking alluding to Ophelia's description of the prince:

> No hat upon his head, his stockings fouled,
> Ungart'red, and down-gyved to his ankle
> (II. i. 79–80)

DST

PROVENANCE Thomas Harris; sold 12 July 1819; bought by Charles Matthews, from whom acquired by the Garrick Club, 1835

BIBLIOGRAPHY New Haven CT and London 1987, no. 41; Ashton 1997, no. 49; London 1997, pp. 45–46

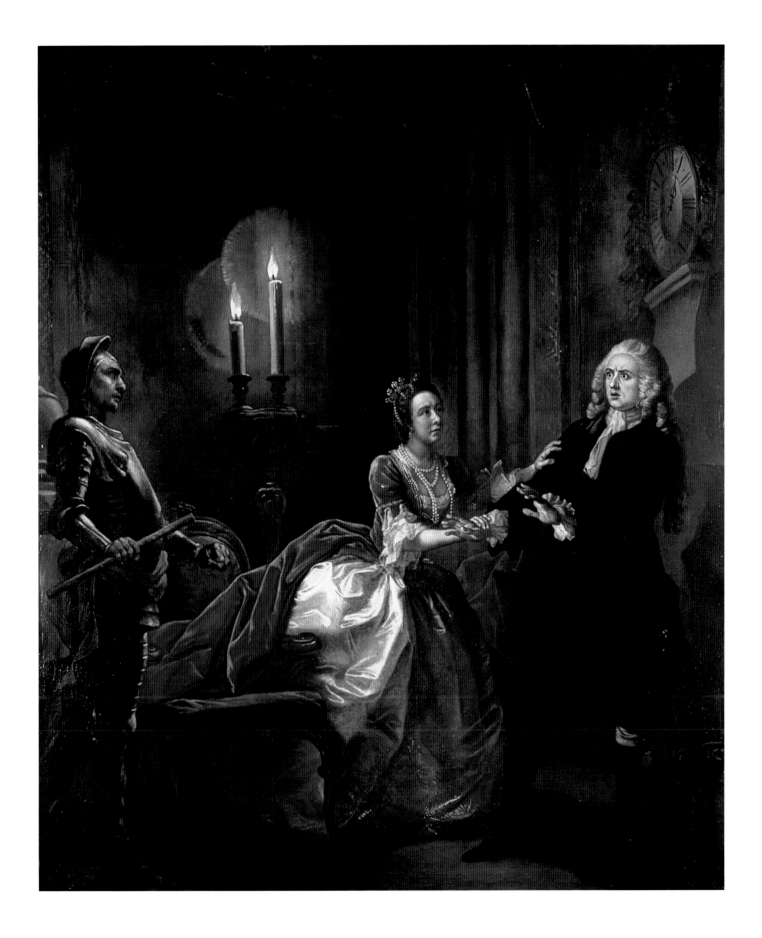

32

Benjamin Wilson (1721–1788)

David Garrick as Romeo, George Anne Bellamy as Juliet in David Garrick's adaptation of 'Romeo and Juliet' of 1748 (Garrick version V. v)

1757
Oil on canvas
63.5 × 76.3 cm (25 × 30 in.)
Victoria and Albert Museum (Theatre Museum), London, inv. S.1452–1986

Romeo and Juliet was first reintroduced to English audiences (after a hundred-year lapse) by Thomas Otway's reworking entitled *The History and Fall of Caius Marius* (1679), which includes the strangely familiar line, "Oh Marius! Marius! Wherefore art thou Marius?" Colley Cibber revived the original in 1744, but it was Garrick's adaptation of 1748 that established the play as a perennial favourite. Garrick omits Romeo's first love, Rosaline, altogether and extends the final tomb scene with the episode depicted here, in which Juliet wakes before Romeo's poison takes effect. Romeo's first words give no hint of his approaching death: "She speaks, she lives; and we shall still be bless'd!" (Garrick, *Romeo and Juliet*, 1748, V. v).

It is this fragile and delusive joy that Wilson depicts, in this autograph version of a larger painting in the Yale Center for British Art, New Haven CT. Though critics generally lamented Garrick's interventions, they loved this scene: one found the "circumstances of JULIET'S waking from her Trance before ROMEO dies, and he, in the Excess and Rapture of his Joy, forgetting he had drank Poison … perhaps the finest Touch of Nature in any Tragedy, ancient or modern" (MacNamara Morgan, *A Letter to Miss Nossiter*, London 1753).

Christopher Baugh has written of the 'battle of the Romeos' (see p. 32), which was joined in September 1750 when two productions of *Romeo and Juliet* opened on the same night: this one at Drury Lane and another at Covent Garden starring Spranger Barry and Mrs Cibber, with Macklin as Mercutio (see also pls. 31, 33). Such battles between the two licensed theatres were common enough. In this case Garrick considered himself the winner when Covent Garden closed its production after twelve nights. Not everyone agreed with the justice of this outcome: one critic found Barry's Romeo as much superior to Garrick's "as York Minster is to a Methodist Chapel".

This image shows various improbabilities in Garrick's production that were mocked at the time: the fact that Romeo has taken the trouble to change into black between this and the previous scene, and that the tomb is already lit by the lamp before Romeo breaks into it.

This image provides a rare insight into stage scenery before the reforms Garrick himself introduced in the 1770s, as described by Christopher Baugh (see p. 31). The shutters to the sides of the stage have been slid across in their grooves so that they meet in the middle. The double-doors of the Capulet tomb have been in some way built on to these shutters with a graveyard painted around them. The doors open on to the remaining depth of the stage, making the inside of the tomb, which is closed by the back-scene. In many ways this is a survival of the 'inner stage' of Shakespeare's day.

DST

PROVENANCE Christie's, 3 August 1978, lot 34; Iain Mackintosh; bought by the Theatre Museum, 1986

BIBLIOGRAPHY Mackintosh 1985; Bertelsen 1978, pp. 308–24; New Haven CT 1981, no. 162, pp. 56–57; Cormack 1985; London 1975², no. 40; London 1994, pp. 49–51

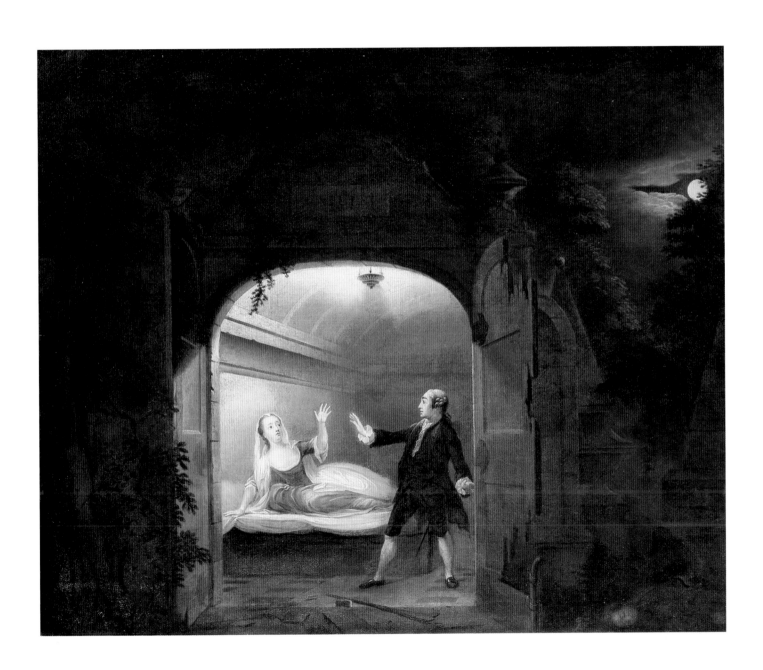

33
JOHANN ZOFFANY (1733–1810)
Charles Macklin as Shylock (The Merchant of Venice, III. i)

*c.*1768
Oil on canvas
81.3 × 71.1 cm (32 × 28 in.)
Maugham Collection at the Royal National Theatre, London

The 'natural revolution' in British acting can be said to date from 1741, in which year Garrick made his début as Richard III in Goodman's Fields Theatre (see fig. 3, p. 12) and Charles Macklin (1699–1797) played Shylock for the first time at Drury Lane. Shylock had previously been a figure of fun; Macklin dressed him in modern Jewish costume, made him believable, malevolent and terrifying, but also capable of exciting sympathy. Alexander Pope was so struck by the revelation that he is said to have spontaneously versified:

> This is the Jew
> That Shakespeare drew

Macklin was essentially a character actor, equally at home in comedy and tragedy. In spite of his range he remained, until the end of his career, identified with Shylock, a part that he had made fashionable enough to become a vehicle for the leading men of future generations – George Frederick Cooke, Edmund Kean and Laurence Olivier.

Zoffany depicts the moment when Shylock hears of his eloped daughter's prodigality and at the same time of the wreck of Antonio's ship. According to Macklin himself, "the contrasted passions of joy for the Merchant's losses, and grief for the elopement of Jessica, open a fine field for the actor's powers". The German philosopher Georg Christian Lichtenberg remembered Macklin at this moment: "hatless, with disordered hair, some locks a finger long standing on end, as if raised by a breath of wind from the gallows, so distracted was his demeanour. Both his hands are clenched, and his movements abrupt and convulsive. To see a deceiver, who is usually calm and resolute, in such a state of agitation is terrible." Zoffany is also using this scene to give a kind of summary of Shylock's character and predicament – a mix of frustrated thirst for revenge, suggested by flailing fists, and pitiable common humanity, suggested by his anguished expression.
DST

PROVENANCE Sir George Beaumont at Coleorton Hall; sold Sotheby's, 30 June 1948; bought by Somerset Maugham, by whom bequeathed to the National Theatre

BIBLIOGRAPHY Mander and Mitchenson 1955, pp. 55–63; Dotson 1973, p. 18; London 1975², no. 31; Montgomery, New York and Chicago 1985–86, no. 64

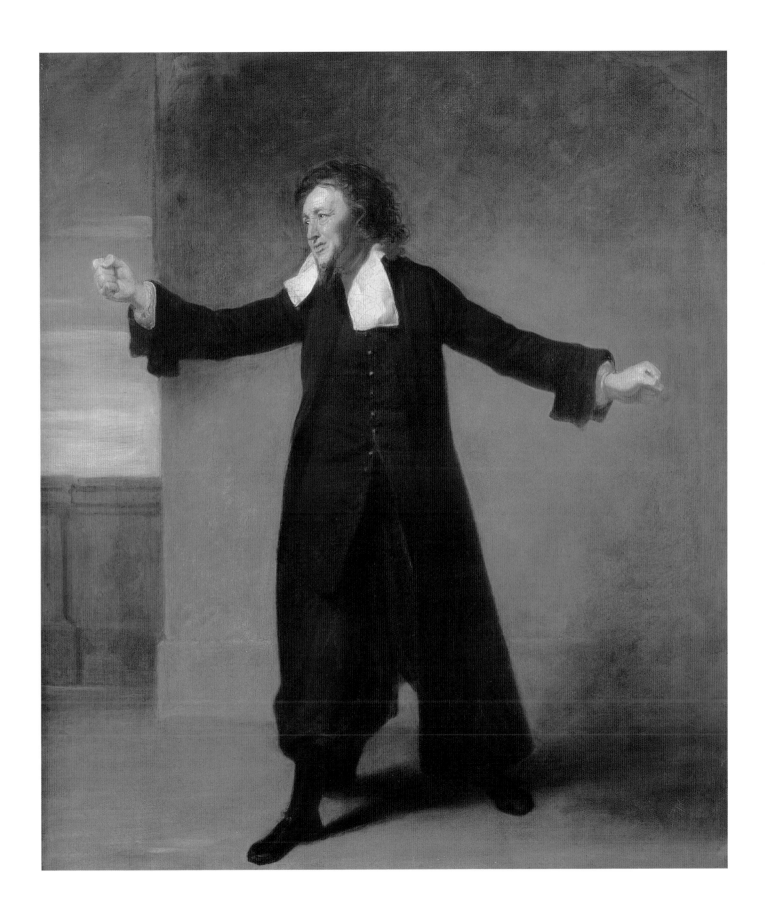

LIVERPOOL JOHN MOORES UNIVERSITY
LEARNING SERVICES

34
JOHANN ZOFFANY (1733–1810)
David Garrick as Macbeth and Hannah Pritchard as Lady Macbeth (Macbeth, II. ii)

c. 1768
Oil on canvas
102 × 127.5 cm (40⅛ × 50⅛ in.)
Garrick Club, London, inv. 253

Macbeth was one of Garrick's greatest parts, and his favourite Lady Macbeth was Hannah Vaughan, Mrs William Pritchard (1709–1768). Their partnership in the roles lasted from 1748 until her retirement in 1768, an event perhaps commemorated by this painting. They were especially famous in this scene, which Kalman Burnim (1961) calls "one of the greatest moments created by actors on the eighteenth-century stage".

Thomas Davies, in his *Dramatic Miscellanies* (1784), provides a description to complement Zoffany's image:

> His distraction of mind, and agonizing horrors were finely contrasted by her seeming apathy, tranquillity, and confidence. The beginning of the scene … was conducted in terrifying whispers. Their looks and action supplied the place of words. You heard what they spoke, but you learned more from the agitation of mind displayed in their action and deportment. The dark colouring given by the actor to these abrupt speeches, makes the scene awful and tremendous to the audience. The wonderful expression of heartful terror, which Garrick felt when he shewed his bloody hands, can only be conceived and described by those who saw him!

Garrick's debt to Le Brun's expressive heads (see fig. 44, p. 119) in conveying "heartful terror" has been mentioned in my introduction (see p. 116). Zoffany also suggests the nervous energy that for some marred Garrick's acting; his rival Theophilus Cibber (1756) complained of his "frequent affected Starts, convulsive Twitchings, Jerkings of the Body, sprawling of the Fingers, flapping the Breast and Pockets".

The costume worn here is entirely modern, and the scenery would probably not have been specially painted for the production. Christopher Baugh has described the recycled scenery of the Georgian stage (see p. 31), which was remembered by nineteenth-century commentators: "the miserable pairs of flats that used to clap together on even the stage trodden by Garrick; architecture without selection or propriety; a hall, a castle or a chamber; or a cut of wood of which all the verdure seemed to have been washed away." There is in fact some propriety here in the selection of a Gothic hall for Macbeth's castle, but audiences would have expected to see the same set used the next night for Elsinore.

Though suggesting all-purpose scenery, Zoffany has here included some details of symbolic significance for the story of Macbeth: the image of the king carved on the door leading to Duncan's chamber; the

Thane's arms hung on his wall; and the bolts of lightning seen through the window like a premonition of divine vengeance.
DST

PROVENANCE Charles Matthews Collection acquired by the Garrick Club, 1835

BIBLIOGRAPHY Burnim 1961, pp. 113–16; London 1975², no. 41; London 1994, pp. 81–82; Ashton 1997, no. 253; London, 1997, pp. 10ff.

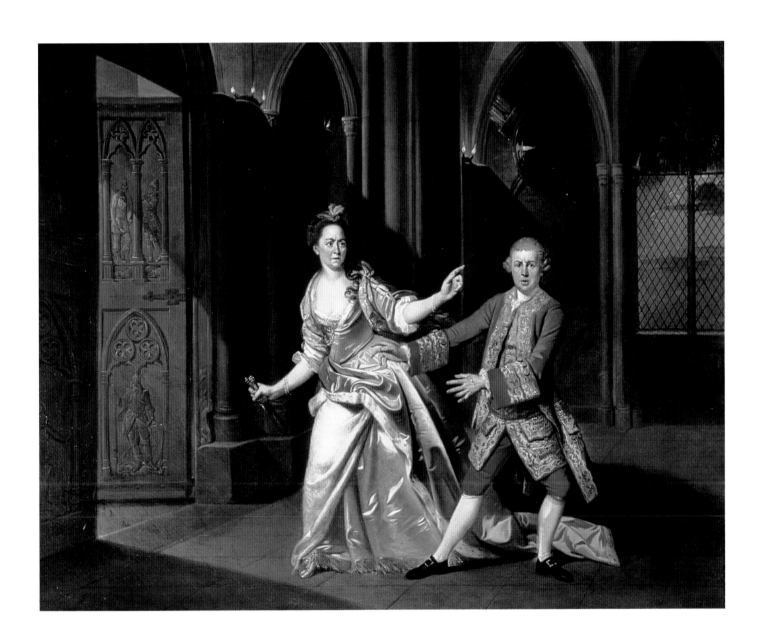

35
NATHANIEL DANCE (1735–1811)
David Garrick as Richard III (V. iv)

Exhibited at the Royal Academy 1771
Oil on canvas
243.8 × 152.4 cm (96 × 60 in.)
Stratford Town Hall, Stratford-upon-Avon, lent by Stratford Town Council

Garrick made his sensational London début as Richard III in 1741; this portrait was exhibited at the Royal Academy just before his retirement thirty years later.

Garrick was delighted with the image: though he was out-bid for the actual painting by the great collector of modern British art Sir Watkin Williams Wynn, he sent John Dixon's "excellent mezzotinto print" of the painting to "select friends". It is easy to see what would have pleased him: Dance shows Garrick with a nobility of stature that even his admirers were apt to deny him. He has found a suitably heroic source for the pose in Leonardo da Vinci's *Trattato della Pittura* (*Treatise on Painting*; see fig. 41, p. 116 and introduction p. 117)

Contemporaries were keen to establish that Shakespeare's Richard was evil but not contemptible. Charlotte Lennox (1753–1754) was even disturbed to find that in the battle scenes "our hatred of the Tyrant is wholly lost in our Admiration of the Heroe". Garrick portrays this "heroe", with the following defiant speech on his lips (V. iv. 9–12):

> Slave, I have set my life upon a cast
> And I will stand the hazard of the die.
> I think there be six Richmonds in the field;
> Five have I slain to-day instead of him.

Though the format, pose and mood is so much more Sublime than in Hogarth's earlier representation of Garrick in the part (see fig. 3, p. 12), the costume remains the same. Unlike most Shakespearean roles, Richard was always presented in historical costume. Contemporaries were aware of this oddity: Thomas Wilkes wrote (1759): "To see Richard, Henry VIII, Falstaff, &c. dressed in the habits of the times they lived in, and the others in modern ones, quite opposite, is an inconsistency which carries its own conviction with it." The surprise to modern audiences is that there is so little hint of Richard's deformity, which is so frequently mentioned in Shakespeare's text.

Nathaniel Dance may have come to know Garrick through his elder brother, James, who took the stage name James Love, and appears as Sir Toby Belch in pl. 36.

The elaborate frame was made, presumably, for Sir Watkin Williams Wynne.
DST

PROVENANCE Sir Watkin Williams Wynn, 4th Baronet (1748–1789) at 20 St James's Square; sold Sotheby's, 5 February 1947; bought by Mrs Mary Elliott Parker of The Lawn, Aigburth, Liverpool (a descendant of Garrick's brother) and presented to the Borough of Stratford-upon-Avon, 24 February 1947

BIBLIOGRAPHY Mander and Mitchensen 1955, pp. 181–83; London 1977; London 1994, pp. 67–68

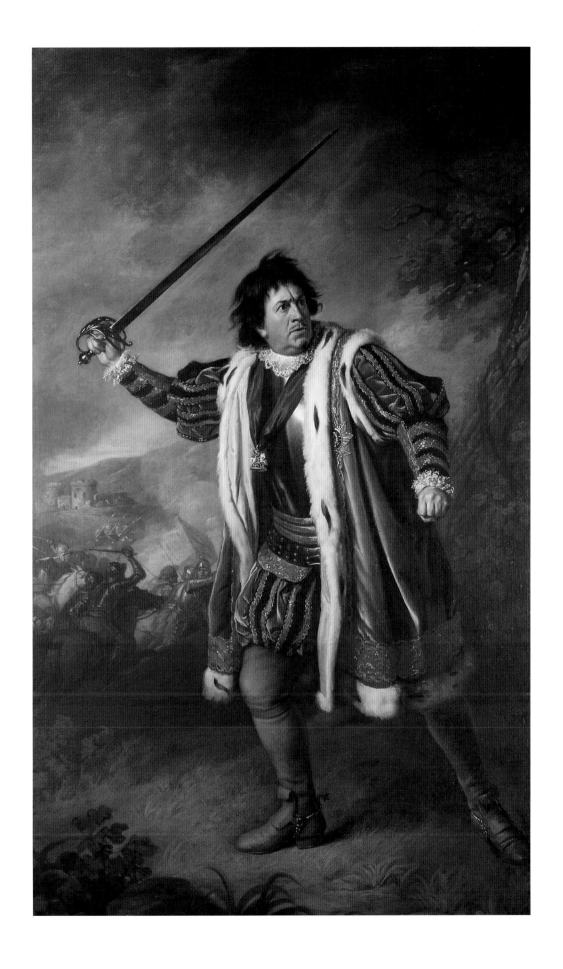

36

FRANCIS WHEATLEY (1747–1801)

Elizabeth Younge as Viola, James Love as Sir Toby Belch, James William Dodd as Sir Andrew Aguecheek and Francis Waldron as Fabian (Twelfth Night, III. iv)

Exhibited at the Society of Artists 1772 (no. 374)
Oil on canvas
99.8 × 124.8 cm (39¼ × 49⅛ in.)
Manchester City Galleries, inv. 1953.4

This painting celebrates the revival of *Twelfth Night* at Drury Lane Theatre on 10 December 1771. Sir Toby Belch (on the extreme right) and Fabian (on the extreme left) have engineered a duel between two principals with no stomach for the fight, Sir Andrew Aguecheek (on the right) because he is a coward, Cesario (on the left) because he/she is a girl, Viola, in disguise.

Drury Lane was under Garrick's management at this time, and all the participants in this wonderful evocation of ensemble acting could be called his pupils. James Love (Nathaniel Dance's elder brother) served in Garrick's company from 1762 until his death in 1774, was a staple Falstaff (as may be guessed from his physique) and a great friend of James Boswell. He also wrote short plays and comic verses, including 'Cricket, An Heroic Poem'. The most distinguished actor here was James William Dodd (1740–1796), whom Garrick enrolled in 1765, when he realized that his "white calf-like stupid face" (the talent-spotter's words) could be used for fools and fops. "What an Aguecheek the stage lost in him!" exclaimed Lamb (1823), who remembered him as the master of exactly the sort of comic vacancy we see here written across his drooping jaw:

> in expressing slowness of apprehension this actor surpassed all others. You could see the first dawn of an idea stealing slowly over his countenance, climbing up by little and little, with a painful process, till it cleared up at last to the fulness of a twilight conception – its highest meridian. He seemed to keep back his intellect, as some have had power to retard their pulsation.

To convey rustic clowns or those unschooled in the world (as is Sir Andrew's case), comic actors of the eighteenth century deliberately adopted the opposite of gentlemanly posture. Comparing Sir Andrew in this respect with the heroes in this section we begin to feel the inelegance that would have struck contemporaries immediately: his head slumps forward, his shoulders drop, his knees are bent and (what is worst of all) his feet are parallel.

Wheatley studied under Benjamin Wilson in 1762 (see pl. 32), but it was probably the example of Wilson's other pupil, Zoffany, that taught him the art of comic theatrical painting. Here glossy figures are set against a wobbly backdrop to suggest the gaudy artificiality of the theatre, their exaggerated postures conveying the choreography of comedy. The way in which Viola lists over like a half-felled tree in her reluctance to advance towards her adversary is a memorable touch.
DST

PROVENANCE Anon. sale, 1781, bought by Tassant; Sir Frederick William Shaw
BIBLIOGRAPHY Webster 1970, p. 118, no. 2; London 1975², no. 34

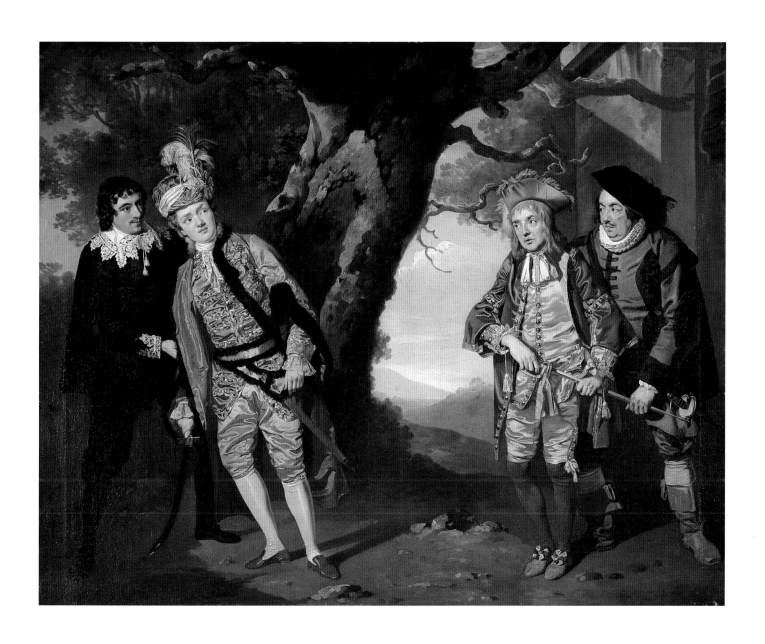

37, 38

Attrib. PHILIPPE DE LOUTHERBOURG (1740–1812) with later additions

Overturned war cart with arched viaduct

Inscribed *Original sketche(s) Made for 'Richard the 3d.' by de Loutherbourg for Mr. Garrick – the first practical Bridge. Presented to H Irving Esq by his old friend CR [CA?] July 1874*
1772–85, ink and grey wash on five pieces of paper pasted on thin card, 23 × 31 cm (9 × 12¼ in.), Victoria and Albert Museum (Theatre Museum), London, inv. S.1471–1986

Military camp with wooden trestle bridge

Inscribed *The original sketche(s) by De Loutherbourg Made for Mr Garrick – Ricard [sic] the 3d The first practical bridge Presented to Henry Irving Esq by his old friend CR [CA?] July 1874*
1772–85, ink with sepia and grey washes on six pieces of paper pasted on thin card, 23 × 31 cm (9 × 12¼ in.), Victoria and Albert Museum (Theatre Museum), London, inv. S.1473–1986

These are two of three designs in the same collection first published by the theatre historian W.J. Lawrence. The inscriptions date from 1874: the handwriting is mid-Victorian. It is possible that Irving's "old friend" was the novelist Charles Reade (1814–1884), who was fascinated with scene-painting and stage technology and frequently visited scenic workshops.

All three drawings are identical in style and degree of finish, and all consist of several pieces of cut paper glued to a paper backing. They all incorporate similar elements: military trappings – chests, carts, tent poles; all have military tents in the background and the suggestion of a wide river, perhaps with rapids, with further encampments on either side; all have rock- and tree-strewn embankments. Two of the sheets include sections of a large bridge, one an arched stone viaduct, the other a wooden 'trestle' type of bridge. The problem is that none of the three sheets creates a complete setting. It is as if elements from two, or even three, settings have been combined together; to make a coherent design they need to be sorted out again. The drawings are probably by de Loutherbourg and, although it is hard to be certain in their collage form, the imagery is strongly theatrical.

Overturned war cart with arched viaduct could be interpreted theatrically as a vista scene, intended to be set at the back of the stage. Alternatively, the foremost elements might have been used as ground rows (low, freestanding pieces of scenery placed on the stage floor), although this would be quite ambitious scenography for the 1770s. The front sections of the composition appear to be drawn to fit together. The arched viaduct beyond is clearly cut from another drawing on different paper and pasted on to yet another drawing of the distant military camp. If the added bridge is ignored, the sketchy but beautifully observed war cart and the destroyed paraphernalia of war might fit well with the last Bosworth scenes of *Richard III*.

The design of *Military camp with wooden trestle bridge* seems to make the more coherent stage setting. A large tent plus some tent-poles with hangings create the wings to the left of the sheet, behind which another piece of paper has a broken fence drawn upon it. To the right, exotic, even tropical, trees form the wings, which are cut at the bottom to suggest either the stage seen in perspective or to indicate their being set at an angle. A low row of tents stands in front of a different piece of paper on which is drawn the strange broken trestle bridge. This is pasted on to the sketch backcloth suggesting the continuation of the camp to either side of a river. As with the first sheet, the 'downstage' sections seem to be drawn to fit well together. To the right of the broken fence

there is a distinct fingerprint in what appears to be the ink of the main drawing (is this de Loutherbourg's?).

It is possible that these scenic sketches by de Loutherbourg were cut and pasted into their present form at a later date. The real problem comes in trying to relate them to *Richard III*. Neither Shakespeare nor Colley Cibber, whose version was still in use when Garrick last performed the play in 1775, indicates a "bridge", and the bridge elements of the designs are stylistically the least coherent.

Perhaps later scenic artists tried to amalgamate some de Loutherbourg sketches for *Richard III* with other sketches to create new scenes for a different play. For example, the original drawings may have been among those used by Gaetano Marinari and his assistants when designing and painting the scenery for Sheridan's *Pizarro* at Drury Lane in 1799. The military camp and the wild and exotic location could well serve Sheridan's play, which was reviewed in the *Lady's Magazine* of 1799: "the scenery, which is of the most magnificent kind, is chiefly from the pencil of Loutherbourg. The wooden bridge, over the tremendous chasm of two mountains, is one of the most picturesque and striking views that any stage has exhibited." John Britton (1799) wrote: "The scenery at Drury Lane is very grand and picttaresque [sic]. I understand some of the scenes are from sketches by the ingenious Loutherbourg. The wooden bridge over the chasm is one of the most striking views that any stage has exhibited."
CB

PROVENANCE Both drawings were presented to Henry Irving, 1874; sold Christie's, 19 November 1905, lot 400; Bertram Forsyth; passed to his brother Gerald Forsyth, 1927; Mrs Gerald Forsyth; bought by the Theatre Museum, 1984

BIBLIOGRAPHY Lawrence 1895; Moelwyn Merchant 1959, p. 61; Oliver and Saunders 1965, pp. 30–33; Baugh 1990, pp. 92–95; New York 1990, pp. 58–61; Baugh 1993, pp. 96–103

original Sketch made for Richard the 3d. by de Loutherbourg for Mr. Garrick — The first practical Bridge by his old friend Presented to H Irving Esq R Nb 1874

The original sketch by de Loutherbourg made for Mr Garrick — Richard the 3d. The first Practical Bridge Presented to Henry Irving Esq. by his old friend July 1874

39
HENRY WILLIAM BUNBURY (1750–1811)
The Duel Scene between Sir Andrew Aguecheek and Viola (Twelfth Night, III. iv)

1784–85
Pencil, pen, ink and watercolour heightened with white on paper
36.2 × 47.6 cm (14¼ × 18¾ in.)
National Museums and Galleries of Wales, Cardiff, inv. NMW A 1821

Amateur theatricals were performed at varying levels of competence by royalty, aristocrats and the gentry throughout the eighteenth century, but no amateur company lasted as long as that of Sir Watkin Williams Wynn (1748–1789) at his house Wynnstay in Denbighshire. Wynn was the friend of Sir Joshua Reynolds and the admirer of Garrick, buying a portrait of the latter in the role of Richard III for his London house (pl. 35), and acting as pallbearer at his funeral.

In 1771 Roger Johnstone of Drury Lane fitted up a playhouse and painted scenery at Wynnstay; that January a professional troupe, the Wrexham Players, performed there. In 1772 James Gandon converted an old kitchen into a theatre. The interior was simple, with a pit for the audience, but had one advantage over public playhouses in that there were no footlights, but instead overhead lighting suspended from a beam. In 1782 John Evans rebuilt the theatre and drew its plain façade on an entrance ticket.

Shakespeare featured regularly on the programme, Sir Watkin himself playing Pistol in *The Merry Wives of Windsor* in 1773. The cast was recruited from the local gentry, house guests (Henry Bunbury was a regular visitor) and Sir Watkin's servants. The leading lady in the 1770s was Mrs Cotes of Woodcote, who took on Portia and other roles despite the disapproval of her father, Lord Courtenay. Local farmers and tradesmen were asked to the dress rehearsals, while an invited audience of more than two hundred guests travelled to the performances from Chester, Wrexham and Oswestry, where Sir Watkin was mayor. Entrance was by ticket only (tickets designed by Bunbury and others are in the Cardiff Museum and Gainsborough's House, Sudbury, Suffolk); ladies were requested not to wear hats. Garrick visited Wynnstay in autumn 1777 but could not be persuaded to perform, although he was fêted by Mr Griffith of Rhual who wrote a Prologue "complimenting Mr. Garrick on his great Attention to Shakespear's Plays". George Colman, a professional actor, did act there, and complained about the amateurs; the under-butler was so clumsy in delivering a sword that Colman jumped up on stage to show him how to do it.

For January 1784 Sir Watkin devised an ambitious programme including *Macbeth* and *Twelfth Night*; in the latter play Anthony Kinnersley of Shrewsbury played Malvolio, and, shown here in the duel scene, Metcalfe was Toby Belch, the artist Bunbury was Aguecheek, Greaves was Fabian, and Sir Watkin's daughter played Viola. The duel is a fiasco since Viola, disguised as the boy Cesario, and the coward Aguecheek are both terrified at the idea of shedding blood. The costumes are eclectic: Metcalfe and Greaves wear Van Dyckian slashed doublets, while Bunbury sports elaborate contemporary dress and Miss Wynn has striped Turkish trousers, a cutaway military jacket and a hussar's plumed busby; Mrs Jordan wears a similar costume in the same role in her portrait by John Hoppner (Kenwood House, London). Two figures enter through a door cut in the flat backdrop painted as an interior. The drawing was engraved by C. Knight and published by W. Dickinson on 10 March 1788. Two other watercolours by Bunbury of the twins Viola and Sebastian (played by Bunbury's brother-in-law Mr Horneck), dated 1785, are also in the Cardiff Musuem.

William Bunbury, a gentleman from Suffolk, had taken part in Sir Watkin's theatricals since his schooldays. Garrick and Oliver Goldsmith frequently stayed with his brother at Barton Hall in Suffolk, and Bunbury had borrowed costumes from Sheridan's Drury Lane company for the Christmas holidays. While on the Grand Tour in 1769 he met the caricaturist Thomas Patch in Florence, and from the 1770s he exhibited cartoons at the Royal Academy (RA), which were admired by Horace Walpole. He served as groom of the bedchamber to George III's second son, the Duke of York. In 1791 under the duke's patronage he undertook to illustrate scenes from Shakespeare's plays to be published as prints by Thomas Macklin; they were immensely popular when published individually, evidently furnishing a popular demand for comic interpretations of Shakespeare as opposed to the highbrow prints published by Boydell. In mocking spirit Macklin eventually published twenty-two prints in book form as *Bunbury's Shakespeare Gallery*. Watercolours for the series are in the Victoria and Albert Museum, London, and Gainsborough's House.
JTM

PROVENANCE Henry Yool of Weybridge, Surrey (died late 1890s); Mrs Elizabeth Gash; sold Christie's, 5 November 1974; bought by Agnew's; presented to the Museum by the Friends of the Welsh National Museum, 1974

BIBLIOGRAPHY Rosenfeld 1978, pp. 76–94; Sudbury 1983; Belsey 2002, pp. 129–31

40
JAMES NORTHCOTE (1746–1831)
Master Betty as Hamlet

Exhibited at the Royal Academy 1805
Oil on canvas
55.9 × 40.6 cm (22 × 16 in.)
Yale Center for British Art, Paul Mellon Fund, New Haven CT, inv. B 1975–5.5
Ferrara only

Northcote was a portrait and history painter who trained with Sir Joshua Reynolds, though he is better known as Reynolds's biographer than as his pupil. Northcote was famously waspish, especially in old age (Haydon called him "little Aqua-Fortis"), but his conversation was considered sufficiently acute to be recorded by the critic William Hazlitt.

William Henry West Betty (1791–1874), 'The Young Roscius', was the original child star. Inspired by seeing Mrs Siddons perform in Belfast, he is said to have told his father "that he should die if he were not permitted to become a player". He made his London début at Covent Garden on 1 December 1804 at the age of thirteen. For the next four years he created a sensation in a limited range of parts, some justifiable on grounds of age, such as Romeo and the young Norval in John Home's *Douglas*, most not, such as Hamlet and Richard III. He is said to have learned the part of Hamlet in three hours and made it into his own; Pitt adjourned the House of Commons early in order that members might be in time to hear him in the part. Not that everyone was so stricken: "this ill-fated Baby has been exhibited as Hamlet!!!" complained John Wilson Croker (1804). "Absurdity, cruelty, and contempt, could have devised nothing more insulting to good sense, humanity to the public."

This is a reduced version of the full-length portrait commissioned by Thomas Lister Parker in 1804, now in the Royal Shakespeare Theatre, Stratford-upon-Avon. Parker also commissioned a full-length portrait of Betty as Norval from John Opie (National Portrait Gallery, London). Both these full-lengths were exhibited at the Royal Academy in 1805 – more symptoms of 'Bettymania'. Parker wrote to Master Betty on 13 November 1804 to assure him that Northcote "is most sensible of the favour [of Betty allowing him a sitting] and hopes to ground his fame upon the picture". It is difficult to imagine that the middle-aged and famously acerbic painter really felt this way about the "inimitable boy".

Northcote shows Betty ascending an imaginary shrine to Shakespeare, where a bust catches a mysterious light, as if the spirit of inspiration still lived in the stone. Betty speaks from the shrine like a priest interpreting the oracle. The idea probably comes from Gainsborough's lost portrait of Garrick (fig. 16, p. 33), which also includes a bust of Shakespeare animated by a similar 'trick of the light', and from prints of Garrick exclaiming his *Jubilee Ode* in front of another Shakespeare Temple (fig. 4, p. 13).

Master Betty dresses as Hamlet because this was his favourite Shakespearean part, but also because the play includes Hamlet's instruction to the players, which were often read as Shakespeare's own artistic manifesto (III. ii):

o'er-step not the modesty of nature; for any-thing so o'erdone is from the purpose of playing, whose end, both at the first, and now, was and is, to hold as 'twere, the mirror up to nature.

DST

PROVENANCE Lincoln Kirstein, 1975; A.S.T. from whom acquired by the Yale Center for British Art

BIBLIOGRAPHY London 1975², no. 124; New Haven CT 1981, no. 96; Cormack 1985, p. 174

41
ANTHELME-FRANÇOIS LAGRENÉE THE YOUNGER (1774–1832)
Talma as Hamlet

1810
Oil on canvas
137 × 105 cm (54 × 41¼ in.)
Comédie Française, Paris, inv. I 190
Ferrara only

François-Joseph Talma (1763–1826), for more than thirty years a star of the French stage in the crucial period between the Revolution (1789) and the Restoration (1814), had already appeared in a Shakespearean role in 1791, when he acted in *Jean Sans-terre, ou la Mort d'Arthur*, a free adaptation by Jean-François Ducis (1733–1816) of Shakespeare's *King John*, which was set in Scotland, like Ducis's equally free version of *Macbeth*, staged the following January. In both plays the emphasis was on lugubrious atmosphere and terrifying tales: Shakespeare and Talma became synonymous with a taste for English Gothic novels, and above all for turbulence and violence, mirroring the age. Despite the fact that France and England were at war, in 1803 Talma produced *Hamlet* in a mutilated text at the Théâtre de la Porte St Martin in the presence of Napoleon and again at the Comédie Française in 1807. Talma read English, and in his 1803 production changed Ducis's text of 1769, restoring the soliloquy "To be, or not to be" and creating a kind of adaptation faithful to the original, "alive and animated", which Ducis then transposed into Alexandrines. The poetic liberties of this version are all dictated by the actor's character: on his proposed rewriting of the last scene of the tragedy, Ducis told Talma in a letter of October 1803 that he had "let my heart and imagination take flight … we reach great heights!" (Talma Vanhove 1836, nos. 12–13). If certain scenes, always played in England, were cut from the French version for their indecorum – the ghost scenes in both *Hamlet* and *Macbeth* were eliminated – this was recompensed by Talma's emotional delivery, which inflamed the audience. Mme de Staël (1766–1817), who saw the tragedy in 1803 in the company of Friedrich Schlegel, recorded: "the audience did not see the ghost of Hamlet's father on the French stage, the apparition was effected entirely by the expression on Talma's face and in truth was no less affecting for that" (de Staël 1810, book II, chapter 27). In 1807 Geoffroy, writing in the *Journal de l'Empire*, declared "*Hamlet* is Sophocles's *Electra* destroyed by English barbarity", and concluded "one could fairly call this tragedy either Hamlet or Talma, given that there is nothing in the work but Talma's ability to magnetise his audience".

Talma toured his *Hamlet* in the provinces, and in 1809 Mme de Staël left her Swiss exile at Coppet and travelled to Lyons to see the production again. Her response was so intense that she dedicated a chapter of her *De l'Allemagne* (1810) to the actor; this, her manifesto of northern Romanticism so notorious in France that in 1810 Napoleon placed it on the forbidden index in order to promote French Classicism. She also started up a passionate correspondence with Talma: "In the role of Hamlet you inspired me with such enthusiasm that you were no longer you and I was no longer I: it is a poem of glances, accents and gestures, to which no writer has yet aspired … . You are not an actor, you are a man who elevates human nature, giving it a new ideal" (Talma 1928, p. 23). The "profound melancholy", "the questions of destiny" that aroused Mme de Staël's overwhelming emotions, were the same that were later recorded by René de Chateaubriand (1768–1848): for him Talma "had that fatal inspiration, the creative disorder of the Revolution he had lived through, profoundly sad, waiting for something unknown but denied it by an unjust heaven, he wandered, a prisoner of destiny, chained inexorably between fate and terror" (Chateaubriand 1849–50, II, book 13, chapter 9).

This figure of an introverted Hamlet was also sanctified by the present painting, shown at the Salon in 1814. Anthelme Lagrenée, son of the history painter Louis-François, formerly director of the French Academy in Rome, was known above all as a miniaturist. He was linked to Talma by the fact that he was the brother-in-law of Talma's mistress, Jacqueline Bazille. The actor is shown in a poignant pose, clutching to his breast the urn containing his father's ashes, a very different interpretation from that of John Philip Kemble, painted by Sir Thomas Lawrence in 1801 (fig. 40, p. 114), and seen silhouetted against a nocturnal sky. Stylistic differences do not detract from the similarities between the two actors, both conscious of their own dramatic brilliance. Early in the summer of 1817 Talma visited London, where he gave a successful recital of excerpts from the Classical French repertoire of tragedy, Racine and Corneille. The company of Covent Garden Theatre held a banquet in his honour, presided over by Kemble, while Talma attended Kemble's last appearance, in his war-horse, *Coriolanus*, and to great applause crowned him with a laurel wreath.

MGM

PROVENANCE Bought by Comédie Française, 1835

BIBLIOGRAPHY Monval 1897, no. 114; Chevalley in Paris 1980, no. 354; Fazio 1999, fig. p. 248; Villien 2001, p. 249, fig. p. 261

42
HENRY FUSELI (1741–1825)
Lady Macbeth seizing the Daggers (Macbeth, II. ii)

Exhibited at the Royal Academy 1812
Oil on canvas
101.6 × 127 cm (40 × 50 in.)
Tate, London. Purchased 1965

This is not a simple illustration of the text, nor is it an accurate record of a performance. There is however a distinct reminiscence of a drawing Fuseli made *c.* 1766 (fig. 45), soon after his arrival in London, of Garrick and Mrs Pritchard in this scene – the same cast as this painting, recorded at approximately the same date. Fuseli is said to have watched Garrick from the front row, the experience playing a crucial part in forming his own distinctive depiction of the passions. Though this painting was executed forty-six years later, and though the figures here are more expressive masks than portraits, there is still enough to suggest the specific physiognomy of Garrick and Mrs Pritchard, the identification retained by Gert Schiff in his definitive catalogue of Fuseli's work (1973). The celebration of yesterday's stars (Mrs Pritchard retired in 1768) could not be more perverse. In 1812 the greatest Macbeth and Lady Macbeth pairing in history seemed to be John Philip Kemble and his sister Sarah Siddons, whose art could be enjoyed any night of the week at Covent Garden Theatre. Sarah Siddons was so electrifying in the role that members of the audience were known to faint away at the sight of her in the sleepwalking scene. The sublime dignity of the Kembles taught a generation to remember Garrick as short and over-excitable. Kemble himself said of Zoffany's image of Garrick and Mrs Pritchard in these parts (pl. 34) that it reminded him "of a cook and a butler quarelling [*sic*] over a kitchen knife". What could have induced the sublime Fuseli to pay so nostalgic a tribute to an outmoded theatrical style? It should be said that Fuseli was not the only theatre-goer of his generation to remember Garrick with respect; Samuel Johnson's friend Mrs Thrale asserted in 1789 (well into the 'Kemble era') that in these parts Garrick and Mrs Pritchard remained "incomparable".

I argue in the introduction to this section that Fuseli intended this image to be an evocation of damnation, as if Dante had included these obscure Scottish regicides in his *Inferno* (as the real Macbeth died in 1057 this is technically possible). If this is the case, theatrical nostalgia is a powerful accompaniment to the message. Fuseli uses a strangeness of costume, antiquated histrionics of gesture and an affectionate memory of long-dead actors whose performances transformed his youth, to sharpen his sense of mortality, perhaps to exorcise his ghosts.
DST

PROVENANCE Clare Stanley-Clarke; T.E. Lowinsky

BIBLIOGRAPHY Schiff 1973, I, pp. 378, 6023; London 1975¹, no. 21; Norwich 1996, no. 11

Fig. 45 Henry Fuseli, *Garrick and Mrs Pritchard as Macbeth and Lady Macbeth*, *c.* 1766, watercolour heightened with white, 32.3 × 29.4 cm (12⅝ × 11½ in.), Kunsthaus, Zurich

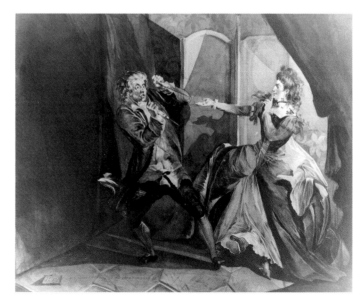

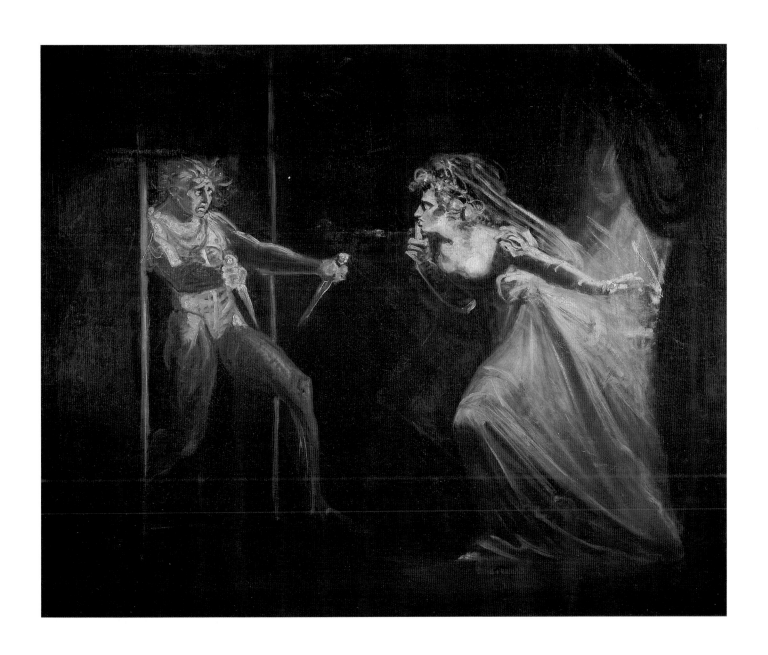

43

CHARLES ROBERT LESLIE (1794–1859)
George Frederick Cooke as Richard III

1813
Inscribed *by C.R. Leslie and by him/ presented to J.H. Payne/ London May 7 1813/ Cooke in Richard*
Oil on canvas
44.5 × 29.2 cm (17½ × 11½ in.)
Garrick Club, London, inv. 132

On 25 March 1811 an English actor, George Frederick Cooke (1756–1812), played the part of Richard III in Philadelphia and so impressed the young American artist Charles Robert Leslie, that he made a watercolour portrait. This in turn impressed members of the Pennsylvanian Academy sufficiently for them to raise £100 to send him to study in London. This painting is an autograph copy of that lost watercolour, made soon after his arrival in London and given to the actor John Howard Payne.

Cooke was hailed as the best Richard III since Garrick, but the two styles were quite different. Cooke was considered to be "somewhat deficient in the *kingly* and heroic part of the character" – exactly that part so admirably embodied by Garrick (fig. 3, p. 12) – and especially strong in "all the subtle, ludicrous, sarcastic turns of the character". Leigh Hunt described him as "the Machiavel of the modern stage". It is this *Machiavellian* Richard whom Leslie conveys here, ingratiating himself with his audience. Cooke steps forward, his arm sweeping outwards in preparation for a deep, sarcastically obsequious bow.

A contemporary description in *The Monthly Mirror* (1800) of Cooke's soliloquizing perfectly evokes Leslie's painting:

> His delivery of the passage … "Why I can smile and murder while I smile" [four lines transposed from 3 *Henry VI* into *Richard III*, Act 1, Scene 1] … conveyed the idea of a man, sensible of his personal deformities and the barriers which separated him from the rest of his brethren, hugging himself up and enjoying a horrible satisfaction in the possession of a faculty by which he hoped to overreach the rest of mankind and secure the grand object of his eye.

Lamb was one of the few commentators to dissent from the general admiration for Cooke in this part. "No where", he writes, "in any of his plays, is to be found so much of sprightly colloquial dialogue, and soliloquies of genuine humour, as in *Richard*. This character of unlaboured mirth Mr. Cooke seems entirely to pass over, and substitutes in its stead the coarse, tainting humour, and clumsy merriment, of a low-minded assassin."
DST

PROVENANCE John Howard Payne; T. Longman Jr, by whom presented to the Garrick Club, 1838

BIBLIOGRAPHY Ashton 1997, no. 123; London 1997, pp. 24–25

44

SAMUEL DRUMMOND (1765–1844)
Edmund Kean as Richard III (Richard III, V. iii)

Exhibited at the Royal Academy 1814
Oil on canvas
203 × 122 cm (80 × 48 in.)
Sadler's Wells Permanent Collection, London

Edmund Kean (1789–1833) was the perfect actor for the Romantic age:
sultry, unpredictable, self-destructive but, on his day, mesmerizing. Hazlitt
described his acting as "an anarchy of the passions, in which each upstart
humour, or frenzy of the moment, is struggling to get violent possession
of some bit or corner of his fiery soul and pygmy body – to jostle and lord
it over the rest of the rabble of short-lived and furious passions" (Dobbs
1972). This effect was obviously more exciting than instructive; Coleridge
said Kean's acting was "like reading Shakespeare by flashes of lightning"
(Donohue 1975). Another of Kean's trademarks was a careless insouciance,
strangely at variance with the febrile passions Hazlitt mentions. All agreed
that Kean's acting was 'natural', especially in comparison with John Philip
Kemble's stiff dignity, but some found it "matter of fact", like a "poet who
disdains metaphor" (Donohue 1975, p. 59).

Kean made his London début as Shylock in January 1814 and played
Richard III the following month – this painting records the impact of
that performance. The keynote is casual menace, especially in comparison
with Garrick's rendering of the part, seen in Dance's image of 1771
(pl. 35). The tents of the battlefield of Bosworth are visible in the
background, but Kean's Richard is shown brooding rather than fighting,
his sword doubling as a walking stick. Later in the scene Kean used his
sword in this way with more desperation and less swagger; a German
visitor describes the scene:

> He had his drawn sword beside him; supporting himself by it he
> tried to move forward, sank on his knee, started back as if to rise,
> lifting high his other arm, which shook violently to his finger tips;
> thus trembling, with wide staring eyes, dumb with terror he shuffled
> forward on his knees, impetuously but slowly, up to the proscenium.

There are many contrasts between this 1817 description of Kean's acting
and Lichtenberg's equally meticulous one of Garrick in 1774 (quoted in
pl. 29). The fear experienced by Garrick's Hamlet is conveyed through
a dignified and universal language of gestures; Richard's fear in Kean's
interpretation is peculiar and supremely undignified, as he shuffles
round the stage like a wounded animal. In the same way Garrick's
Richard in Dance's painting displays the universal virtue of courage;
Kean in this painting conveys the tormented defiance of an individual.
Garrick's Shakespeare is the playwright of thrilling situations; Kean's
Shakespeare is the poet of dark states of mind.
DST

BIBLIOGRAPHY Dobbs 1972; Donohue 1975; London 1975[2], no. 203

45

GEORGE HENRY HARLOW (1787–1819)
The Trial of Queen Katharine (Henry VIII, II. iv. 81–84)

Exhibited at the Royal Academy 1817
Oil on canvas
79 × 102.5 cm (31⅛ × 40⅜ in.)
From the Royal Shakespeare Company Collection, with the permission of the Governors of the Royal Shakespeare Theatre, Stratford-upon-Avon, inv. 31

This image introduces the Kemble family, who dominated the London theatre for forty years, roughly filling the era between Garrick's retirement in 1776 and Edmund Kean's début in 1814. This painting shows the trial of Queen Katharine in *Henry VIII* (Act 2, Scene 4) and recalls performances at Covent Garden between 1806 and 1812, fleshed out by individual sittings during 1817. The artist was a friend of the Kemble family and shows himself at the extreme left of the composition.

John Philip Kemble, playing the part of Cardinal Wolsey, sits to the left; his younger brothers Stephen (1758–1822) and Charles Kemble (1775–1854) play, respectively, King Henry and Thomas Cromwell, one seated immediately above the other at the back. Their sister, Sarah Siddons (1755–1831), plays Queen Katharine denouncing Wolsey with these words:

> I utterly abhor, yea, from my soul
> Refuse you for my judge, whom yet once more,
> I hold my most malicious foe, and think not
> At all a friend to truth.

This painting shows a new acting style: the Kembles were famous for their stateliness, even stiffness, seen particularly in Sarah Siddons's imperious gesture. Hazlitt called John Philip "the very still life and statuary of the stage … an icicle upon the bust of tragedy", though at the same time admitting that his characterization was more consistent and intelligent than the actors of the previous generation. What strikes us even more, however, are the improvements seen here in what would now be called 'production values'. This is a different type of theatre from that seen in Garrick's production of *Macbeth* (pl. 34). Like his friend Sir Walter Scott, John Philip Kemble loved 'dramatic antiquities' and used historical research to add authenticity to a spectacle: the scene here is packed with well-coached 'extras', all wearing sumptuous historical costumes, against elaborate and specially commissioned sets. A fascinating oil sketch of 1831 by Henry Andrews (pl. 49) depicts this same moment, but includes the surrounding boxes, orchestral pit and drop-curtain, and shows how this sort of pageantry was capable of filling the larger stage and impressing the larger audience of the new Covent Garden Theatre. This is one of the threads that lead to the tradition of nineteenth-century opera which is associated with the French librettist Eugène Scribe, and is best exemplified by Verdi's *Don Carlos*.
DST

PROVENANCE Commissioned by Thomas Welsh
BIBLIOGRAPHY Ashton 1997, under no. 750

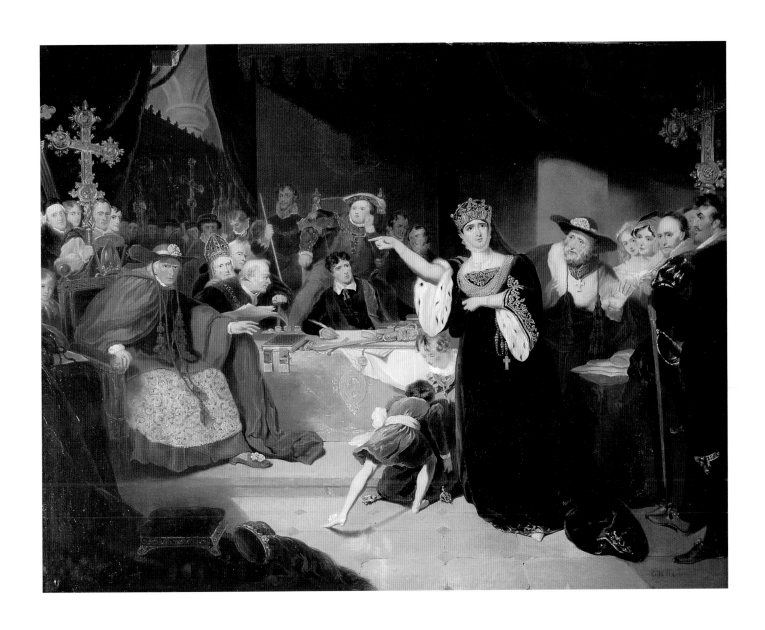

LIVERPOOL JOHN MOORES UNIVERSITY
Aldham Roberts L.R.C.
TEL 0151 231 3701/3634

46

THE GRIEVE FAMILY (CHARLES PUGH, *fl.* 1786–*c.* 1828)
Scenery design for *A Wood* (Kemble's production of *The Tempest*, IV. ii)

Inscribed on verso *Tempest*
1821
Watercolour and gouache
13.7 × 22 cm (5⅜ × 8⅝ in.)
Sterling Library, University of London, Grieve Collection, no. 11

For more than half a century the Grieve family team were the principal stage-designers in London, catering for the public's love of enchanting stage pictures and the growing demand for verisimilitude and historical accuracy. The founder of the family, John Henderson Grieve (1770–1845), was a Scot from Perth, who worked in London's minor theatres and with the dramatist–manager Richard Brinsley Sheridan at Drury Lane. From 1816 to 1832 Grieve was at Covent Garden, where, after a disastrous fire, the new theatre designed by Sir Robert Smirke had opened in 1809. The proscenium measured 42 ft (12.8 m) across, ample room for elaborate scenery. From 1816 it was lit by gas, which could create atmospheric lighting effects far more easily than the oil lamps it replaced. Working for the actor–manager Charles Kemble, Grieve was the first to exploit the full potential of the new invention of gaslight by developing a technique of producing translucent glazes with scenery paint; previously colours had been opaque. Always keen on innovations, he also painted moving stage panoramas.

His two sons, Thomas (1799–1882) and William Grieve (1800–1844), both worked with their father; they had a private studio in Lambeth in south London where they produced scenery for minor theatres, and were not solely dependent for space upon the scene-room in Covent Garden. Thomas was one of the principal artists employed by Charles Kean when he managed the Princess's Theatre from 1850 to 1859. Later, with his son Thomas Walford Grieve (born 1841), he ran a freelance scene-painting business. Both men worked with Clarkson Stanfield's follower William Telbin Sr (1813–1873) in presenting Charles Dickens's theatrical entertainments.

The Grieve team included Charles Pugh (*fl.* 1786–?1828), Henry Cuthbert (1810–1888), J. Days, William Gordon (1801–1874), Charles Fenton (1821–1887), Frederick Lloyds (1818–1894), Matthew Morgan (1839–1890), William Telbin Sr and briefly the young Gothic Revival architect A.W.N. Pugin (1812–1852). Although it is often difficult to distinguish the style of individual members of the team, more than nine hundred drawings at the Victoria and Albert Museum, London, and the Sterling Library, University of London, record many famous productions.

Several factors contributed to Charles Kemble's passion for historically authentic productions of Shakespeare. The scenic artist William Capon (1757–1827) meticulously sketched Gothic buildings for Kemble's medieval productions at Drury Lane (from 1794) and Covent Garden (from 1809; see fig. 17, p. 35). James Robinson Planché (1796–1880), a dramatist who held a post at the College of Heralds, was the author of the *History of British Costumes* (1834), and designed a production of *King John* for Kemble in 1823 at Covent Garden, with effigies, coats of arms and heraldic shields.

Caves, grottoes and woodland glades abound in Shakespeare's plays. Few designers have rivalled the Grieves in their masterly use of scenic devices. They created a drop-curtain of foliage, through which the audience's eyes were directed towards a path that led through an avenue of trees to a sunny glade. There are interesting comparisons here with the work of the early Romantic painters Samuel Palmer (1805–1881) and John Linnell (1792–1882).

The scene-painter would be allocated scenes to paint by the theatre manager, with individual painters doing individual scenes, sometimes in collaboration. The painters would produce initial sketches for discussion, and then elaborate their designs to scale, usually a quarter or half an inch to one foot, for setting up in simple model form. The design would then be squared up and transferred to canvas.

Charles Kemble first staged this production of *The Tempest* at Covent Garden on 15 May 1821, the scenery being painted by J.H. Grieve and Charles Pugh. The playbill for *The Tempest* is unique in listing all sixteen scenes and their designers. Pugh was credited with Act 4, Scene 2, *A Wood*. The play ended with a transformation scene, a Grieve speciality: *A Cave which changes to the last scene*. Pugh designed the cave, Grieve the finale. Pugh had worked at Sadler's Wells with Thomas Greenwood Sr, at Drury Lane (1798–1800) and at Covent Garden (1806–26). He exhibited landscapes at the Royal Academy from 1797 to 1803.
LL; JTM

PROVENANCE Bought from a provincial junkshop for Professor Jacob Isaacs through the Central Research Fund, 1939, deposited by him at the University of London Library (notes in the Historic Collections Section of the University of London Library)

BIBLIOGRAPHY Odell 1920–21, II, p. 160; Rosenfeld 1967; Rosenfeld 1969; Norris 1984; Highfill, Burnim and Langhans 1973–93, 1987, under Pugh; Hazelton 1993

THE GRIEVE FAMILY
Scenery design for *Hotspur's Camp – near Shrewsbury* (*1 Henry IV*, V. ii)

1824
Watercolour on paper
13.4 × 27.1 cm (5¼ × 10⅝ in.)
Sterling Library, University of London, Grieve Collection, no. 78

In 1823 Charles Kemble staged *King John* at Covent Garden Theatre, his first Shakespearean history play in which sets and costumes were intended to be historically accurate. It was followed on 3 May 1824 by *1 Henry IV*. The playbill boasted of "the same attention to costume which has been observed in the revival of King John. Every character will appear in the precise Habit of the Period, the whole of the Dresses being executed from indisputable authorities, viz. Monumental Effigies, Painted Glass, etc". The scenery was by John Henderson Grieve, his sons Thomas and William, and Charles Pugh; the costumes were by James Robinson Planché. In his memoirs Planché wrote: "I complained to Mr Kemble that a thousand pounds were frequently lavished on a Christmas Pantomime or an Easter spectacle, while the plays of Shakespeare were put on stage with make-shift scenery and, at best, a new dress or two for the principal characters."

The scene is the rebels' camp near Shrewsbury, where Henry Hotspur and his followers have pitched their tents before the decisive battle with Prince Hal. The blue Shropshire hills loom in the background; it is early morning:

> How bloodily the sun begins to peer
> above yon busky hill! The day looks pale …

The Times (3 May) reported:

> The "Getting up" throughout is of the most costly and tasteful description. The Rochester Scene, and the camp at Shrewsbury, are both admirably painted; and nothing can exceed the splendour of the armour and the dresses worn even by the minor characters. Two score of gentlemen, whose names one never hears, are clad in suits which "top tragedians" would not take shame to wear.

Unfortunately the performance itself was a disaster. One reviewer, after remarking on how rare it was to see the play, wrote: "Mr Young's Hotspur was dull, cold and monotonous. Mr Ward's Prince Hall [*sic*] was all this and worse, and Mr Charles Kemble's Falstaff was quite in keeping with the rest, a laboured, painful effort."

A watercolour for the King's Tent, mentioned on the playbill, is in the same collection (Grieve no. 46). The Grieve firm also designed the scenery for Charles A. Somerset's play *Shakespeare's Early Days*, staged at Covent Garden in 1829 with Kemble in the role of Shakespeare (see fig. 46). The design for Act 1, Scene 2, a view of the River Avon, is in the Victoria and Albert Museum, London (E1194–1924).

JTM

PROVENANCE as pl. 46

BIBLIOGRAPHY Anon. reviews in the Theatre Museum archive for 1827; Planché 1872; Odell 1920–21, II, p. 174; Rosenfeld 1967; Rosenfeld 1969

Fig. 46 Grieve firm, scenery design for Charles Somerset, *Shakespeare's Early Days*, first performed at Covent Garden Theatre, 29 October 1829, Act 2, Scene 1, *Exterior of the Falcon Tavern, London*, pen and sepia wash on paper, inscribed *Falcon*, 10.5 × 17.2 cm (4⅛ × 6¾ in.), Sterling Library, University of London, no. 185, box 10

Steffens Camp Heidelberg. G.G.

153

LIVERPOOL JOHN MOORES UNIVERSITY
LEARNING SERVICES

48

The Grieve Family
Scenery design for *Wales: A mountainous country with a cave* (*Cymbeline*, III. iii; repeated IV. i, ii and iv)

1827
Watercolour on paper
11 × 19.6 cm (4¼ × 7⅝ in.)
Sterling Library, University of London, Grieve Collection, no. 81

On 5 May 1827 Charles Kemble staged a new production of *Cymbeline* at Covent Garden with himself as Posthumus, but the novelty was that the play was set in Iron Age Britain. The playbill proclaimed that it would include "new scenery, dresses and decorations, executed from the Best Authorities and displayed as accurately as stage effect will permit, the Habits, Weapons, and Buildings of the Gaulish and Belgic Colonists of the Southern Counties of Britain before their Subjugation by the Romans". The scenery was painted by John Henderson Grieve with his sons Thomas and William; costumes were by Mr Head and Miss Abbot.

According to the playbill, Kemble had consulted ancient authors – Caesar, Pliny and Suetonius – as well as modern authorities, including Llewelyn Meyrick (1804–1827). He was the son of Sir Samuel Rush Meyrick (1783–1848), co-author with C. Hamilton Smith of *The Costume of the Original Inhabitants of the British Isles* (1815). Meyrick made his collection available to painters, writers and dramatists to help them avoid anachronisms, and Richard Bonington and Eugène Delacroix visited his house in Cadogan Place, Chelsea, in July 1825, making drawings of armour for use in history paintings. Meyrick and Francis Douche helped Planché in his efforts to reform stage costume.

An Iron Age cromlech covered with a red and yellow cloth decorated with a dragon, surrounded by a stone circle, stands before a thatched hut. Against the doorway lean a harp and two round shields; the posts are garlanded. Perhaps the dragon suggests the Welsh location of Act 3, Scene 3, set by Shakespeare in Belarius's cave; if so, it is a sumptuous dwelling.

Kemble's aim was to create "an historical correctness with which our ancestors were unacquainted", although one anonymous reviewer complained that "mere antiquarian love is concerned with not infrequently very absurd departure from poetical sense and the intention of the bard". Another reviewer praised the acting of Mr Egerton as Cymbeline and Charles Kemble as Posthumus, but added:

> Cymbeline is a play of no time, only of a place, so far as it is necessary to give general humanities "a local habitation and a name" … the mechanical is well done, there is needed only the direction of a more poetical mind. The scenery is beautiful; the dresses are often picturesque, and may be viewed, if not as illustrations of Shakespeare, as very good studies in the science of historical research. The house was respectably, but not fully, attended.

JTM

PROVENANCE as pl. 46

BIBLIOGRAPHY Odell 1920–21, II, pp. 175–76; Rosenfeld 1967; Rosenfeld 1969; Rosenfeld 1986

Cymbeline. C C.G. 1827

155

49
HENRY ANDREWS (died 1868)
The Trial of Queen Katharine (Henry VIII, II. iv)

1831
Oil on canvas
92.7 × 85.7 cm (36½ × 33¾ in.)
From the Royal Shakespeare Company Collection with the permission of the Governors of the Royal Shakespeare Theatre, Stratford-upon-Avon, inv. 17

The play *Henry VIII* contains several scenes that can be staged to spectacular effect: Cardinal Wolsey's banquet at Hampton Court; the coronation of Anne Bullen (as Shakespeare calls her), mother of the future Queen Elizabeth I, and the Princess's baptism. Given these scenes of triumphant royal pageantry, the play was revived on the occasion of coronations (of George III and George IV). The scenes that appealed to painters, however, were the fantastic vision of Queen Katharine the night before her death (see pls. 11, 18), and the trial of Queen Katharine, when her husband, Henry VIII, wishing to marry Anne Bullen, uses Cardinal Wolsey as his advocate in obtaining a divorce. One of Sarah Siddons's greatest roles was that of the spurned queen confronting the cardinal, his "heart cramm'd with Arrogance, Spleen and Pride" (see pl. 45). The First Folio of *Henry VIII* is rare among the plays in that it includes detailed stage instructions, and both John Philip Kemble and his brother Charles followed them almost to the letter in staging the trial scene.

This painting probably records the production of *Henry VIII* premiered on 21 October 1831 in Charles Kemble's last season as manager at Covent Garden. He played Henry VIII, Charles Young was the Cardinal and Fanny Kemble took the role of Queen Katharine. The painting is exceptional in showing the stage, pit and tiers of boxes as designed by Sir Robert Smirke after the disastrous fire of 1808. Smirke's theatre was vast, with space for an audience of more than three thousand; actors would have had to project their voices into the auditorium and played right at the front of the stage, beneath the boxes.

Scenery for *Henry VIII* was designed by the Grieve family, with A.W.N. Pugin, later famous as an exponent of Gothic Revival architecture, as part of the team. As might be expected of Pugin, the architecture of the Palace of Westminster was historically accurate, and the coronation of Anne was staged "as celebrated on the first of June 1533", with a diorama based on Wenceslaus Hollar's *Prospect of London* (1647) being unwound while actors mimed rowing a boat to Henry VIII's ship the *Royal George* at anchor on the River Thames. Lit by gas chandeliers and footlights (visible in this painting), effects could be magical.

Charles Kemble succeeded his brother John Philip Kemble as manager of the Theatre Royal, Covent Garden in 1822 and, despite his unprepossessing appearance, took Paris by storm in 1827 when he played Romeo to Harriet Smithson's Juliet at the Odéon (see fig. 22, p. 42). As Henry VIII he was "so well dressed and so well stuffed that if Holbein's picture of bluff King Hal could walk out of its frame and speak, we question if it would present us with a more perfect portrait"

(*Theatrical Observer*, 27 October 1831). Under his management Covent Garden was frequently threatened with closure, and was saved only by his daughter Fanny's popularity. Frances Anne (Fanny) Kemble (1809–1893) had as a child played the page in the production of *Henry VIII* painted by Harlow (pl. 45); soon she took on the roles that had made her aunt Sarah Siddons famous: her début as Juliet in 1829 was a sensation. Later she toured America with her father, giving up the stage on her marriage in 1834 to Pierce Butler, the second-largest slave-owner in the States. Her passionate abhorrence to slavery broke up the marriage, and she returned to the stage to give Shakespearean readings, much admired by the young Henry James. In 1882 she published *Notes on Some of Shakespeare's Plays*, commenting particularly on the female roles.

Henry Andrews exhibited at the Royal Academy and the British Institution from 1830 to 1838, painting pastiches of Antoine Watteau and some actors in character roles, for instance Davidge as Malvolio (Royal National Theatre Collection, London).
JTM

PROVENANCE Presented to the Theatre by Miss Ada Rehan, 1906

BIBLIOGRAPHY Playbills, Theatre Museum, London; Moelwyn Merchant 1959, pp. 199–207; Stratford-upon-Avon 1970, p. 9, no. 17; Williamson 1970, p. 196; Leacroft 1973, pp. 177–86; Lambourne 1994, pp. 39–40

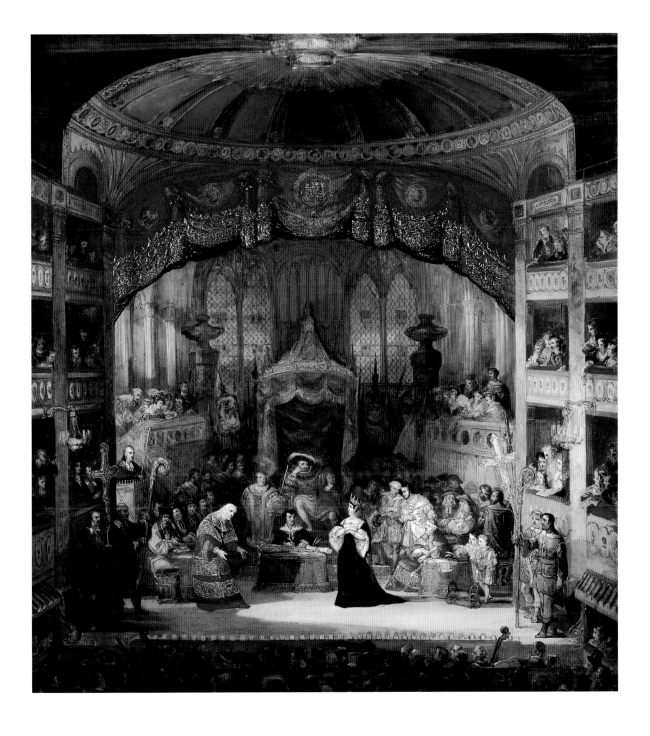

50
DANIEL MACLISE (1806–1870)
Priscilla Horton as Ariel (The Tempest)

1838–39
Oil on canvas
67.5 × 54.5 cm (26⅜ × 21½ in.)
From the Royal Shakespeare Company Collection with the permission of the Governors of the Royal Shakespeare Theatre, Stratford-upon-Avon, inv. 69

The tragedian William Charles Macready (1793–1873) managed Covent Garden Theatre from 1837 to 1839. He was famous for attempting to restore the text of Shakespeare's plays to the original versions and for his elaborate productions, his aim being "fidelity of illustration". In 1838 his *King Lear*, "freed from the interpolations which have disgraced it for nearly two centuries" (*John Bull*) was performed with Priscilla Horton (1818–1895) as the Fool, the first time the character had been seen for generations.

The next season Macready produced *The Tempest*, which until then was still performed in the version by Dryden and Davenant (see p. 41). The playbill states that this production is "From the Text of Shakespeare", although music by Purcell, Linley and Arne was retained. It opened on 13 October 1838 and proved so popular that it was performed fifty-five times that season. The next day Macready, who played Prospero, wrote in his diary: "Could not recover myself from the excitement of last night. The scenes of the storm, the flights of Ariel, and the enthusiasm of the house were constantly recurring to me." Priscilla Horton had spent that September mastering the art of flying on wires, and sang "Merrily merrily shall I live now" suspended high above the stage. Although Restoration productions had often featured flying, it had fallen out of fashion; Macready's " 'delicate Ariel' is now no longer … a thing of the earth but either 'a wandering voice' or a visible spirit of air, flitting in his own element". Maclise's portrait shows a rather earthbound Ariel; a better idea of the ethereal sprite is given by R.J. Lane's lithograph (Theatre Museum, London).

The scenery, by Marshall, was closely supervised by Macready. The critic of *John Bull* (21 October 1838) was unimpressed, particularly by the first scene in which a tempest was produced on stage: "a mimic vessel is outrageously bumped and tossed about on waves that we can liken to nothing save tiny cocks of hay, painted green, affected with spasm." Nor did he like Miss Horton who hovered over the shipwreck in her flying harness: "Ariel is whisked about by wires and a cog-wheel, like the fairies in Cinderella." But Charles Forster who, with Charles Dickens, attended many of the rehearsals, declared "it was a daydream realised for all eyes and hearts".

The Irish painter and illustrator Daniel Maclise first made his name with a drawing of Sir Walter Scott and, after moving to London, made friends with W.M. Thackeray and Dickens. His first exhibited painting was a scene from *Twelfth Night* (RA 1839, untraced); a scene from the same play (pl. 80) was based on a stage performance. The influence of German artists on his work was strong, evident in *The Play Scene from*

'*Hamlet*' (c. 1842; Tate, London), based on Moritz von Retzsch's popular line illustrations, *Outlines to Shakespeare*.
JTM

PROVENANCE Presented to the Theatre by Miss Ellen Terry, 1902

BIBLIOGRAPHY Playbills, Theatre Museum, London; Macready, *Journal*, pp. 124–25; Odell 1920–21, II, pp. 217–19; Sprague 1945, p. 44; Downer 1966, pp. 178–79; Stratford-upon-Avon 1970, p. 28, no. 69; Brighton 1980, pp. 74–75, no. c2a; London 1997, p. 91, no. 16

LIVERPOOL JOHN MOORES UNIVERSITY
LEARNING SERVICES

51

CLARKSON STANFIELD (1793–1867)
Design for a Diorama for *Henry V*; *Agincourt: The Scene of Battle* (*Henry V*, IV. vi–vii; v of Macready's production)

1839
Oil on brown paper, squared up
27.3 × 35.2 cm (10¾ × 13⅞ in.)
Victoria and Albert Museum, London, inv. E.39 -1926

Macready's production of *Henry V* at Covent Garden, which opened on 10 June 1839, was the most elaborate of his career. The speeches of the Chorus, which open each act, were at that date normally omitted: Macready restored them, having them declaimed by a character dressed as Time against a background of painted clouds that opened to reveal Stanfield's dramatic panoramas. The panorama, invented by Robert Barker in 1788, was a 360-degree illusionistic painting giving the effect of being 'on the spot'. The word was later also used to describe spectacular moving scenery. In the prologue of the play the Chorus asks the audience to help the actors by using their imagination:

> Can this cockpit hold
> The vasty fields of France? Or may we cram
> Within this wooden O [the theatre] the very casques
> That did affright the air at Agincourt?

Macready wrote in the programme:

> The play … is a dramatic history … and the poet … has adopted from the Greek Drama, the expedient of a Chorus to narrate and describe intervening incidents and events. To impress more strongly on the audience, and to render more palpable these portions of the story … the narrative … is accompanied with Pictorial Illustrations from the pencil of Mr Stanfield.

In Act 1, "Time is discovered upon a circular orifice occupied by clouds, which dissolve away, and present an allegorical scene representing 'the warlike Harry'".

The Diorama, housed in the Colosseum in Regent's Park, was a static scene the same vast size as a modern IMAX screen, cleverly lit from behind and the sides. The word was also used in the theatre to describe a scenic effect. The most elaborate diorama in Macready's *Henry V* showed the English fleet leaving Southampton and crossing to France. *John Bull* was less impressed by the aftermath of the battle, for which this is the sketch: for the effects "The Battle of Agincourt … is represented by a pantomimic trick; the scene changing … from a champaign [*sic*] to a field of battle strewed with the dead and dying; and to make matters worse, the painting is so indifferent, or so indistinct, that it is only by a stretch of fancy one can make out the artist's intent" (17 June 1839).

Although Macready formally credited Stanfield only with the 'chorus' illustrations, this vivid sketch, squared up for transfer for the scene-painter,

has been plausibly attributed to him; later it was owned by William Telbin Sr (see pls. 60, 61), who possibly painted the full-size scenery.

Macready played Henry V and studied for the part: "Put on my armour for King Henry V., and moved and sat in it until half-past three" (Journal, 9 June 1839). On 30 March 1839 he was guest of honour at a dinner given by the Shakespeare Club at which Dickens, Thackeray and Clarkson Stanfield were present. Macready modestly protested that he had "only restored to its sublime simplicity the text of Shakespeare".

Clarkson Stanfield was the son of actors who played on the York circuit. He worked as a scene-painter with David Roberts (1796–1864) and under the manager Robert Elliston at Drury Lane Theatre from 1822 to 1826, later for Macready at Covent Garden and Drury Lane from 1837 to 1843. Famous for his sea paintings, he also contributed a picture of *Macbeth and the Witches* (Leicester City Art Gallery) to the engineer Isambard Kingdom Brunel's Shakespeare Room in King Street, London.

Henry V contains some of the most patriotic lines written by Shakespeare, and for this reason it is one of the most frequently revived of all the history plays, often performed when public events demand a patriotic response; it was memorably filmed by Laurence Olivier during the Second World War in 1943–44. Similar sentiments produced by the recent coronation of the young Queen Victoria may have played a part in the timing of the production in 1839.
LL; JTM

PROVENANCE William Telbin Sr; William Lewis Telbin Jr, by whom presented to the Museum, 1926

BIBLIOGRAPHY Macready, *Reminiscences*, II, pp. 141–42, 144; Odell 1920–21, II, pp. 219–22; Pieter van der Merwe in Sunderland 1979, p. 79, no. 101

52

The Grieve Family (William Gordon, 1801–1874)
Scenery design for *At the Palace of Theseus*
(*A Midsummer Night's Dream*, I. i)

1856
Watercolour and gouache on paper
17.4 × 24.5 cm (6⅞ × 9⅝ in.)
Victoria and Albert Museum, London, inv. D 1566-1901

From 1850 to 1859, Charles Kean produced the most elaborate
Shakespearean productions of the mid-nineteenth century at the
Princess's Theatre in Oxford Street, London, his only rival being Samuel
Phelps at Sadler's Wells. Although his intentions were to play Shakespeare
using the most accurate text with 'authentic' costumes and sets, his
unwieldy scenery, multiple scene-changes, and enormous casts meant
that texts had to be cut and scenes transposed. His production of
A Midsummer Night's Dream was first performed on 15 October 1856;
there were in all one hundred and fifty performances. But the elaborate
sets meant that Act 1 was reduced from 251 to 161 lines, with some of
the greatest poetry being discarded. Kean explained that:

> the general character of the play is so far from historical, that while
> I have made Athens and its neighbourhood the subject of illustration,
> I have held myself unfettered with regard to chronology. … The
> building existing in Athens during that early age (twelve hundred years
> before the Christian era), were most probably rude in construction
> … [and] could have nothing in common with the impressions of
> Greek civilization that exist in every educated mind.

He decided to present Athens at the height of its glory, at the time of
Pericles. In the spirit of exactitude, the view of the Acropolis centred on
the Parthenon was created from drawings made on site by a member of
the Grieve team. The playbill boasted: "The Acropolis, on its rocky
eminence, surrounded by marble Temples, has been restored, together
with the Theatre of Bacchus, wherein multitudes once thronged to listen
to the majestic poetry of Aeschylus, Sophocles, and Euripides." At the
time such productions were considered to be a model of archaeological
exactitude, but later generations regarded Kean's productions as a
succession of magnificent pictures periodically interrupted by
recitations of Shakespeare.

 These commemorative watercolours of productions, including
properties, scenery and ensembles, framed in elaborate mounts, were
made presumably by the Grieve firm for Kean.
LL; JTM

PROVENANCE Kean collection; Mr and Mrs F.M. Paget (niece of Charles Kean);
presented by them to the Victoria and Albert Museum

BIBLIOGRAPHY Playbills, Theatre Museum, London; Cole 1859, II, pp. 196–99;
Odell 1920–21, II, pp. 291–92

Act 1st Scene 1st A Terrace adjoining the Palace of Theseus overlooking the City of Athens

53
THE GRIEVE FAMILY (WILLIAM GORDON, 1801–1874)
Scenery design for *The workshop of Quince the carpenter, Athens* (*A Midsummer Night's Dream*, I. ii; repeated, IV. ii)

1856
Watercolour on paper
19.4 × 24.5 cm (7⅝ × 9⅝ in.)
Victoria and Albert Museum, London, inv. D 1567-1901

Act 1st Scene 2nd Workshops of Quince the carpenter repeated in Act 4th Scene 2nd

The "rude mechanicals" meet at Quince the carpenter's house to discuss their contribution to the wedding festivities of Theseus, Duke of Athens, of Bottom the Weaver's play *Pyramus and Thisbe*. Gordon has deliberately given all the familiar tools used in the carpenter's trade an archaic appearance. In his notes on the play, Kean claimed to have used descriptions of objects found in the excavation of Pompeii and Herculaneum for the tools. In recognition of his archaeological exactitude he was elected a Fellow of the Society of Antiquaries in 1857. LL

PROVENANCE as pl. 52

BIBLIOGRAPHY Playbills, Theatre Museum, London; Cole 1859, II, pp. 196–99; Odell 1920–21, II, pp. 291–92

54
The Grieve Family (Thomas Grieve, 1799–1882, and William Gordon, 1801–1874)
Scenery design for *A wood near Athens, moonlight* (*A Midsummer Night's Dream*, II. i, finale)

1856
Watercolour on paper
18.5 × 25 cm (7¼ × 9¾ in.)
Victoria and Albert Museum, London, inv. D. 1568-1901

This is the setting for the meeting of Oberon and Titania, the King and Queen of the Fairies: "Ill met by moonlight, proud Titania." The landscape was copied from J.M.W. Turner's *Golden Bough* (RA 1834; now Tate, London). Often several of the artists worked on one production, each responsible for specific scenes and their props. Grieve, Gordon and Telbin were famous for their landscape settings, while Cuthbert and Lloyds specialized in architecture. The act concluded with a diorama; the effect of fairies flying in one direction against a woodland scene slowly moving the other way must have been magical.
LL

PROVENANCE as pl. 52

BIBLIOGRAPHY Moelwyn Merchant 1959, pp. 101, 108

55

THE GRIEVE FAMILY (FREDERICK LLOYDS, 1818–1894)
Designs for *The Dance of the Fairies* (*A Midsummer Night's Dream*, II. i)

Inscribed *F.Lloyds 1859*
1859
Watercolour and gouache on paper
24.8 × 35.7 cm (9¾ × 14 in.)
Victoria and Albert Museum, London, inv. D 1578-1901

Oberon and Titania, the King and Queen of the Fairies, have quarrelled
over a foundling boy, whom Titania holds by the hand. At the end of the
act this scenery 'dissolved' to show *A wood near Athens, moonlight* (pl. 54):
the tree can be seen to the right in the background of this scene.

The production was notable for the performance of the great actress
Ellen Terry (1847–1928), aged eight, in the role of Puck. Her abilities were
recognized by the Revd C.L. Dodgson (1832–1898), later to achieve fame
as Lewis Carroll, author of *Alice's Adventures in Wonderland* (1865), who
described her in his diary as "the most perfectly graceful little fairy
I ever saw". She is the small figure sitting cross-legged on a mushroom,
a mechanical device that rose through a trapdoor near Oberon's feet;
she was also recorded in a photograph by Adolphe Beau. Ellen Terry
recalled, "When Puck is told to put a girdle round the earth in forty
minutes, I had to fly off the stage as swiftly as I could, and a dummy
Puck was whirled through the air from the point where I disappeared.
One night, the dummy, while in full flying action, fell on the stage. …
I ran on, picked it up in my arms, and ran off with it amid roars of
laughter". On another occasion, as Ellen Terry ascended to the stage,
the trapdoor closed on her toe and broke it. From the wings the
manager's wife, Mrs Kean, admired the stoic courage with which Ellen
finished her speeches between moans. Ellen recalled: "The text ran
something like this: 'Think but this, and all is mended (Oh, my toe!)'."
As a reward Mrs Kean doubled her salary.

In this design the Grieve team employed a relatively small 'moving
diorama'. In the next scene Titania was lulled to sleep by "innumerable
fairy legions" singing "the melodious music composed by Mendelssohn
to the words of the author".

Frederick Lloyds was the author of the *Practical Guide to Scene Painting
and Painting in Distemper* (c. 1875), the chief handbook on the subject of the
nineteenth century. The chapter headed "Method of painting a large
quantity of Flowers in rapid and effective manner" must have been
born of the experience of working on *The Dream*.
LL; JTM

PROVENANCE as pl. 52

BIBLIOGRAPHY Terry, *Memoirs*; Moelwyn Merchant 1959, p. 108

The Grieve Family (Frederick Lloyds, 1818–1894)
Scenery design for *The Palace of Theseus, Athens: Dance of the Fairies* (*A Midsummer Night's Dream*, V, finale)

Inscribed *F. Lloyds 1859*
1859
Watercolour and gouache on paper
29.2 × 35.5 cm (11½ × 14 in.)
Victoria and Albert Museum, London, inv. D 1577-1901

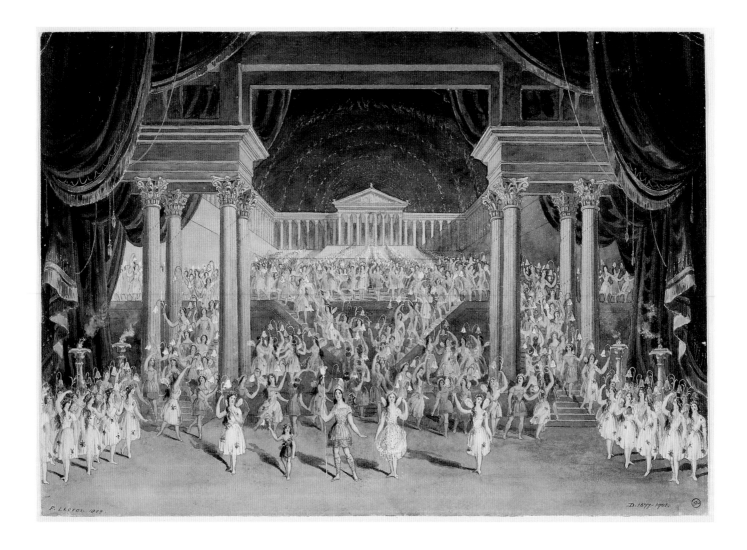

Frederick Lloyds devised a most effective transformation in the final act of the play. After Bottom's play was performed in Theseus's Palace, red curtains were drawn back to reveal a complicated arrangement of steps and a pedimented temple. The finale was the Dance of the Fairies led by Oberon, Titania and their trains. It is shown here performed by a full *corps de ballet* in the manner of a contemporary romantic ballet.
LL; JTM

PROVENANCE as pl. 52

BIBLIOGRAPHY Morley 1891; Terry, *Memoirs*; Moelwyn Merchant 1959, p. 108

57

THE GRIEVE FAMILY
Design for stage properties for *A Maypole Dance*
(*A Midsummer Night's Dream*, V, finale)

1859
Watercolour and gouache on paper
19 × 24 cm (7½ × 9⅜ in.)
Victoria and Albert Museum, London, inv. D 1582-1901

The critic Henry Morley commented:

> we get at the end, a ballet of fairies round a maypole that shoots up
> out of an aloe, after the way of a transformation in a pantomime,
> and rains down garlands. Fairies, not any beings of the colour of
> green wood or the sky, or robed in misty white, but glittering in
> the most brilliant dresses, with a crust of bullion about their legs,
> cause the curtain to fall on a splendid ballet, and it is evidence

enough of the depraved taste of the audience to say that the ballet
is encored.

JTM

PROVENANCE as pl. 52

BIBLIOGRAPHY Morley 1891; Odell 1920–21, II, pp. 345–46

LIVERPOOL JOHN MOORES UNIVERSITY
LEARNING SERVICES

58

THE GRIEVE FAMILY
Designs for stage properties for *The properties made by Quince the joiner*
(*A Midsummer Night's Dream*, V)

1856
Gouache on paper
18.5 × 24 cm (7¼ × 9⅜ in.)
Victoria and Albert Museum, London, inv. D 1584-1901

Theatrical props play a particularly important part in the play within a play, *Pyramus and Thisbe*, presented by Bottom the weaver and his cast of yokels to celebrate the wedding of Theseus, Duke of Athens. Quince the carpenter makes such vital props as a lion, which would not look too fierce, with a roar so quiet that it does not frighten the ladies, and a lantern that does duty as a symbol of the moon. Also shown here is the Wall, through which the lovers, Pyramus and Thisbe, converse,

and which has a speaking part in Bottom's play. Exceptional care was taken to make props 'accurate'. Ellen Terry recalled being given a toy cart, an exact copy of one depicted on a Greek vase.
LL

PROVENANCE as pl. 52
BIBLIOGRAPHY Terry, *Memoirs*

59
The Grieve Family
Scenery designs for *Ferns, blue bells, hare bells* (*A Midsummer Night's Dream*)

1856
Gouache on paper
18.2 × 24 cm (7⅛ × 9⅜ in.)
Victoria and Albert Museum, London, inv. D 1583-1901

A charming study for the bosky undergrowth in the woodland scenes of
the play.
LL

PROVENANCE as pl. 52

60, 61
WILLIAM TELBIN SR (1813–1873)
Scenery designs for *Hamlet. A platform before the Castle: Hamlet sees his Father's Ghost* and *Elsinore Castle (Hamlet, I. iv. 5)*

1864
Gouache on paper
Pl. 60 (top): 16 × 20.9 cm (6¼ × 8¼ in.); pl. 61 (bottom): 15.9 × 21 cm (6¼ × 8¼ in.)
Victoria and Albert Museum, London; pl. 60: inv. E 261-1925; pl. 61: inv. E 262-1925

The actor Charles Albert Fechter (1824–1879), of Franco-German parentage, was famous for his performances on both sides of the Channel as well as in the United States. Although he spoke English with a strong accent, he acted with an intensity and freshness that entranced London audiences. He first took the role of Hamlet at the Princess's Theatre in March 1861. Dickens, who admired him greatly, wrote that his acting "is in the highest degree romantic … there is always a peculiar dash and vigour to it". Fechter also dispensed with Hamlet's usual garb of black velvet and lace, instead adopting primitive Viking dress. Dickens reported that he was "a skilled painter and sculptor, learned in the history of costume", and described his appearance in *Hamlet* as a "pale, woe-begone Norseman with long flaxen hair, wearing a strange garb never associated with the part upon the English stage". Years later a stage-hand remarked: "Mr Kean was great. But with 'im '*Amlet* was a tragedy, with Mr Fechter it's quite another thing. He has raised it to a mellerdrama" (Ackroyd 1990).

Fechter managed the Lyceum Theatre from 1863 to 1867. He radically modernized the stage machinery, abolishing scenery running in grooves and replacing it with scenery that could be lowered by the use of counterweights into an understage. He did away with wings, and created an early type of cyclorama on which sky effects could be projected as the gas footlights were turned up or down. On 21 May 1864 he revived *Hamlet*, with himself in the title role and Kate Terry, Ellen's elder sister, as Ophelia. His designer was William Telbin Sr, who had worked with Macready at Drury Lane and, as part of the Grieve team, designed panoramas and scenery for Charles Kean. Telbin and his team of painters (Cuthbert, Dayes and Gates) were late with the scenery but, after losing a court case, Fechter had to pay them. By 1878, when Henry Irving took over the management of the Lyceum, Fechter's machinery had been scrapped.

In pl. 60 the figure of Hamlet is glued on to the sheet, a trick that gives a sense of immediacy to the action as the prince pursues the ghost of his father. In Fechter's production the ghost declaimed his speech in the moonlight, and as dawn broke he disappeared "without any motion on his part or any darkening on stage – and grew dimmer, by degrees, until he vanished altogether. It was brought about as follows: The ghost stood behind a large concealed wheel which, when started, caught up, at each revolution, a fresh piece of some almost transparent stuff, artfully tinted to match the background. … The ghost apparently melted into thin air".

The exterior of the castle at Elsinore may be another proposal for the same scene. The absence of wings added a stark intensity that anticipates Gordon Craig's revolutionary production of the play for Konstantin Stanislavsky's Moscow Art Theatre in 1912. The interior scenes of the castle in rugged Romanesque style were much praised; during the play scene, musicians played in a gallery, and as they left the stage Fechter took one of their instruments and used it to punctuate his talk with Rosencrantz and Guildenstern, who were "dressed like Northern warriors – bluff fellows with thick beards, coarse leggings".
JTM; LL

PROVENANCE Presented to the Museum by William Lewis Telbin, 1925

BIBLIOGRAPHY Dickens 1863; Dickens 1869; Odell 1920–21, II, pp. 253, 358–60; Southern 1970, pp. 86–87; Rosenfeld 1973, pp. 127–30; Ackroyd 1990, p. 909

LIVERPOOL JOHN MOORES UNIVERSITY
LEARNING SERVICES

SHAKESPEARE AND ROMANTIC PAINTING IN EUROPE

MARIA GRAZIA MESSINA

At the same time that he submitted yet another Shakespearean subject to the Salon (an *Othello and Desdemona*) in April 1849, Eugène Delacroix noted in his *Journal* (p. 188): "We shall never be Shakespeareans. The English are all of them Shakespeare. He has virtually made them what they are in every way." We learn from many such entries in his *Journal* that Delacroix was torn between his unease and downright disgust at Shakespeare's irregularity and wild flights of fancy, and his fascination with the intense impression of real life that breathes in his work. This is really the reaction of French culture as a whole, ever since the ambivalent judgement delivered by Voltaire in 1734: "The merits of this author have been the ruin of English drama" (Voltaire 1734, XVIII). Voltaire finds in Shakespeare the licence of genius, with its qualities of power and abundance, of nature and the Sublime, and with its flip-side of absolute absence of good taste or knowledge of the rules. He realized too that the fundamental problem lay in transposing from one culture to another: you could only do justice to Shakespeare by making a translation worthy of "those passages so miraculous that they make you forgive all their faults". He himself attempts this near impossible task with a translation of Hamlet's most famous soliloquy.

The challenge for all those painters who in the years to come undertook illustrations to Shakespeare was a compound of the 'usual' difficulties implied by the doctrine of *ut pictura poesis* – that of finding a convincing pictorial equivalent of the impalpable inventions of poetry – with the added problem of working 'at one remove', from secondary texts, the result of arbitrary adaptations either published or performed in the theatre. The first complete translation, published by Pierre Le Tourneur between 1776 and 1783 – "a parody" of the original, according to Victor Hugo – is in pedestrian prose, without any of the earthiness or the linguistic exuberance of Shakespeare's text. According to the publisher's prospectus, this series was to be accompanied by a set of engravings by Jean-Michel Moreau the Younger. The failure of this project and the difficulty of

disseminating in post-revolutionary France the two most important English series of illustrations to Shakespeare – the *Picturesque Beauties of Shakespeare* published in 1783 by Charles Taylor, illustrated by Thomas Stothard and Robert Smirke, and the prints of Boydell's Shakespeare Gallery, circulated after 1791 – meant that French artists were almost completely reliant on their own invention, fuelled by whatever they might have been able to see on the Parisian stage. Though no actual Shakespeare was performed, the poet and playwright, Jean-François Ducis (1733–1816), did produce a series of loosely Shakespearean dramas, starting with his first version of *Hamlet* in 1769. Ducis radically altered the texts, simplifying them according to the unities of time, place and action and adapting them to the taste of the public, with typecast characters, morally instructive plots and pompous language, declaimed in regular Alexandrines. This bastardized Shakespeare enjoyed scant success during the revolutionary years, and was supplanted in the repertoire of the popular theatre of the boulevards by melodramatic reductions of the works of Friedrich Schiller and his imitators, feeding the taste of the time for adaptations of Gothick novels, with a sinister atmosphere and effects of horror. The impact of this is seen in painting in the vogue for melancholy and spectral subjects taken from Ossian, but there is no trace of Shakespeare, apart from two lost studies by Jean-Antoine Gros (1771–1835) – a *Dying Desdemona* of 1804 and a *Lear and his Daughters*, exhibited in 1846 and admired by Charles Baudelaire for its "most striking and strange appearance" (Baudelaire, *Oeuvres complètes*, p. 593).

It was a great actor, François-Joseph Talma (1763–1826), who made Shakespeare's name during the Empire, as Garrick had done in Georgian London, and even then his success was with the public as a whole rather than the critics, who remained hostile. Talma played a memorable Hamlet in 1803 in the presence of Napoleon himself, in a production that was revived at the Comédie Française, the very temple of Jean Racine and Pierre Corneille, and followed by an *Othello* and *Macbeth* in 1809. Talma read Shakespeare in the original, corrected Ducis's versification with the realism of his performance, restored cuts, such as Hamlet's soliloquy, and mesmerized the public with the intensity of his expressions.

OPPOSITE Fig. 47 Eugène Delacroix (1798–1863), *Desdemona cursed by her Father*, 1852, oil on canvas, 59 × 49 cm (23¼ × 19¼ in.), Musée des Beaux-Arts, Reims

Fig. 48 Eugène Delacroix (1798–1863), *Hamlet and Horatio in the graveyard*, 1835, oil on canvas, 99 × 81 cm (39 × 31⅞ in.), Städelsches Kunstinstitut, Frankfurt-am-Main

In the wake of Talma's performances and as part of the fashion for things English, which spread with the success of the novels of Sir Walter Scott, Shakespearean subjects begin to appear in the Salon catalogues of the 1810s. They were still rare – fewer than a dozen between 1812 and 1822 – which probably reflects the nationalistic instinct of French culture during the immediate aftermath of the Restoration, that drove even liberal artists to march under the banner of Classicism. Talma's revivals of *Hamlet* in 1822 and *Othello* in 1825, when the battle raged between the Classicists and the Romantics – or as David's pupil, Etienne Delécluze, called them in his diary, the "*Homéristes et Shakespéariens*" – brought the interpretation of Shakespeare to the attention of a new generation of young artists. Delacroix is a good example of the phenomenon. The first of his four oil versions of the graveyard scene in *Hamlet*, a painting of 1835 (fig. 48), omits the gravediggers, as did the contemporary productions of Ducis and Talma, as the very worst example of Shakespeare's vice of mixing high tragedy and low comedy, something attacked by critics from Voltaire onwards. Delacroix's Hamlet – pale and effeminate in his mourning garb, without any of the picturesque attributes

common in English performances of the scene – like Talma's, is the essential figure of melancholy, more inclined to meditation than to the fury of revenge. The painting was refused by the Salon of 1836, which made it into a sort of manifesto of the Romantic party, immediately published as a lithograph in the periodical *L'Artiste*, and defended by the poet Alfred de Musset and the painter Alexandre Decamps. As late as 1846 Baudelaire remembered this picture as the epitome of that melancholy which characterizes all Delacroix's work and gives it its special affinity with Dante and Shakespeare, the two other great "painters of human suffering". "This Hamlet," he continues, "so mocked and so little understood … above all expresses – Oh! Prodigious mystery of painting – moral suffering! This lofty and serious melancholy shines with a dull brilliance, even in the colour, large, simple, abundant in harmonious masses like that of all great colourists, but at the same time plangent and profound like a melody of Weber" (Baudelaire, *Oeuvres complètes*, p. 620).

Delacroix, and through him Shakespeare, became shining examples of the '*mal de siècle*': they became artists for a generation who, according to Baudelaire, wore the distinctive black livery of mourning. In his diary entry for 27 February 1847, Delacroix compares Shakespeare and Beethoven and concludes: "The character of the arts today hangs on the expression of melancholy" (*Journal*, p. 136).

The explosive modernity of Shakespeare became apparent in Paris in the autumn of 1827, when a season of the Théâtre Anglais at the Odéon was seen as a theatrical equivalent of the more liberal régime, which in November of that same year replaced the government of the ultra-clerical Villèle. Delacroix was present at the first night of *Hamlet* in September; he recalls the occasion in a letter of 28 September 1827 to his friend Soulier: "the English have opened their theatre. They have done marvels: they have filled the Odéon and rattled the cobbles of every street in the neighbourhood with the coaches of their audience … the consequences of this innovation are incalculable" (Delacroix, *Correspondance*, I, p. 197). The Théâtre Anglais brought to the stage the very antithesis of the French repertoire: audiences experienced the raw and affecting impact of a type of drama that was not interpreted and purified, but presented in the original language, the roughness of which was made to seem almost incidental when set against the absolute and convincing realism of the acting. The critic Emile Deschamps wrote in the preface to his *Etudes françaises et étrangères* (1828) of the "expressive pantomine and natural declamation of the great English actors, the only ones since Talma to have given us the experience of tragic emotions".

The realistic novelty of pose and attitude introduced by Charles Kemble, Edmund Kean and Harriet Smithson inspired a delightful album, *Souvenirs du Théâtre Anglais* (1828), with twelve colour lithographs by Achille Devéria and Louis Boulanger (1806–1867), a rich mine for painters during the 1830s and 1840s. Boulanger also submitted a series of Shakespearean oils and watercolours to the

Salon from 1833 to 1859, including the affecting *King Lear in the Storm* (1836; Musée des Beaux Arts, Cambrai), which was published as a lithograph in *L'Artiste*. Significantly this capitulation of French taste to "*un lieutenant de Wellington*" coincides with the definitive affirmation of modern art for, as Emile Deschamps writes, "Shakespeare is a genius in tune with all the modern passions and who speaks to us in our own language". Deschamps gives as examples of this Shakespeare's depiction of real individual characters, the fact that his action takes place on the stage rather than being described by a narrator, and the immediacy and simplicity of his language.

Even before the advent of the classic of the new 'national drama' – Victor Hugo's *Hernani* of 1830 – the transformation in taste was exemplified by *Le More de Venise, ou Othello*, finally translated in the spirit of the original by Alfred de Vigny and Emile Deschamps and produced at the Comédie Française in October 1829. The first night aroused furious polemics, in part because *Othello* had been a favourite with the French since the previous century, owing to the simplicity of its plot – easily reducible to the rules of the three unities – and the stereotypical nature of its passions. After the restoration of the monarchy, *Othello* became even more of a 'national property', thanks to Rossini's highly successful operatic version, mounted in 1821 at the Théâtre Royal des Italiens and frequently revived in the following years with singers as famous as Giuditta Pasta, Giulia Grisi, Manuel Garcia and Maria Malibran (fig. 49), and typical of the widespread taste for the exotic and oriental in the art and literature of the period. It was the production of an 'English' *Othello* that guaranteed the failure of the first tour of the Théâtre Anglais in summer 1822, while Talma chose it, in the venerable Ducis version, for his farewell performance of 1825. But now Vigny created an *Othello* that was at once Shakespearean and modern: he abolished the gentrification introduced by Ducis – the sung interludes; the elaborate decor; the discreetly sun-tanned, rather than black, Moor; the use of a letter instead of the trivial handkerchief and a dagger instead of a pillow. The unprecedented sequence of eight scene-changes and the expressive acting of Mlle Mars made a startling impression, but a hostile press meant that these performances had no sequels, and *Othello* continued to be played in Ducis's version at the Comédie Française from 1835 to 1849. However by this time Shakespearean subjects had established themselves as the prerogative of artists in the Romantic camp, usually experienced in contemporary stage productions. There were exceptions: the *Children of Edward IV* of Paul Delaroche (Muée du Louvre, Paris) was the triumph of the 1831 Salon and is neither Romantic nor Shakespearean: it derives from the *Histoire d'Angleterre* of François Guizot and has nothing to do with Shakespeare's *Richard III*; it is a typical expression of the bourgeois taste for what was called the '*juste milieu*', or happy medium, with its affecting sentimentality, precise technique and historical pedantry.

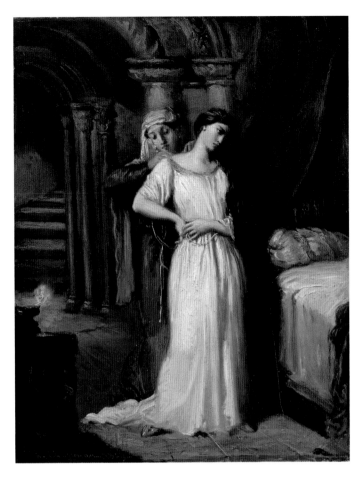

Fig. 49 Théodore Chassériau (1819–1856), *Desdemona and her Maid*, showing Maria Malibran in the role of Desdemona, 1849, oil on canvas, 73 × 60 cm (28¾ × 23⅜ in.), Musée du Louvre, Paris

During the July Monarchy (1833–48), Shakespeare was performed in the theatres and opera houses and stirred the imagination of artists. They tended to interpret his work with a new type of painting – with a careless abandon of technique, a dynamic use of outline and strong contrasts of colour. In 1844 the young Théodore Chassériau produced a series of etchings of *Othello*, executed in two months of febrile activity and immediately published. He was imitating Delacroix's set of lithographs from *Hamlet* of the previous year, but the subject came as much from Rossini's opera (first performed in 1844 in a French translation) as from Shakespeare's play. Rossini concentrated on the relationship between Othello and Desdemona, and gave little prominence to Iago. Chassériau's work was especially inspired by recollections of Rossini's most intense interpreter, Maria Malibran (1808–1836), who sang the part of Desdemona and who appears in twelve of the fifteen prints. Few impressions were made of this series, which had no successor, but the painter returned to some of the scenes in a group of paintings exhibited at the Salon between 1849 and 1852, where they competed

LIVERPOOL JOHN MOORES UNIVERSITY
LEARNING SERVICES

Fig. 50 Giuseppe Sabatelli (1813–1843), *Othello and Desdemona*, 1834, oil on canvas, Brera, Milan

with similar subjects by Delacroix. *Othello* had reason to be popular in France in these years immediately after the Revolution of 1848 (as it had been in the 1790s): there was a parallel drawn between Othello's loyalty to the Venetian Republic and the audience's enthusiasm for a new French Republic. Chassériau's motives however may have been personal, seeing in Othello's marriage an echo of his own stormy relationship with the beautiful actress Alice Ozy (1820–1893), also loved by Victor Hugo and Théophile Gautier.

Just as *Hamlet* and *Othello* entered the collective imagination of the French, typifying the passions and the behaviour of a generation, so *Romeo and Juliet* did for the Italians. We get an early indication of this in Mme de Staël's novel, *Corinne, ou l'Italie* (1807), where the beautiful Italian girl, Corinne, performs this play for her lover, an English lord, with such convincing transports of love that he concludes: "Shakespeare wrote this tragedy with the imagination of the South, at the same time so carefree and so passionate that the characters seem to pass with ease from happiness to despair and from despair to death." There is not even a language barrier, as Corinne has translated the work herself, so much does the tragedy "seem to have entered into her native language" (VII, chapter 3).

In the last decades of the eighteenth century, when Shakespeare was becoming compellingly up-to-date elsewhere, only two Italian writers defended him against the Classicists, and even these ran up

against the problem of his language: Alessandro Verri translated *Hamlet* in 1769 and *Othello* in 1777, and complained of the difficulty of the task, while Giuseppe Baretti, in his *Discours sur Shakespeare et sur M. de Voltaire* (1777), maintained that Shakespeare was untranslatable. Other writers, such as Melchiorre Cesarotti, the translator of the Ossian poems, the playwright Vittorio Alfieri, and the poets Vincenzo Monti and Ippolito Pindemonte, read his work (with no great enthusiasm) in Le Tourneur's French translation. One exception to this rule is the passion expressed by the hero of Ugo Foscolo's novel *Jacopo Ortis* (1802), who declares that Homer, Ossian and Shakespeare "have assailed my imagination and enflamed my heart, I have drenched their verses in hot tears". After the Restoration of the French monarchy in 1815, very imperfect translations of the tragedies by Michele Leoni began to circulate. Young Romantic writers, such as Silvio Pellico, Giovanni Berchet and Alessandro Manzoni, turned to Shakespeare as part of their struggle against the straitjacket of Classical theatre, but even they generally read him in French and could see only occasional and unremarkable productions of his plays, such as the *Otello* (in Leoni's translation) mounted in Naples in 1820. Shakespeare's language might have seemed hopelessly strange, but the popularity of melodrama in Italy at the time reconciled the public to a drama of wild passions and sudden mood changes, which they enjoyed in Shakespeare's work even if they were seeing grossly falsified plots. As material to be turned into opera, *Romeo and Juliet* was Shakespeare's most successful play with the Italians, partly because of its 'local interest'. It was performed in Milan and Venice in various versions, the most remarkable being that of Nicola Zingarelli (based on a libretto by Foppa), which was mounted for the first time in 1796, with Girolamo Crescentini and Giuseppina Grassini as the principals. All these adaptations preceded Bellini's *I Capuleti e i Montecchi* of 1830.

Perhaps the Venetian painter Francesco Hayez remembered this opera when, in 1823, he painted the balcony scene (pl. 64). This is an example of contemporary taste for medieval, or troubadour, painting, but it initiated a series of Romeos and Juliets at the Brera exhibitions by such artists as Agostino Comerio, Vitale Sala and Giovanni Migliara, which continued into the second half of the century. *The Death of Juliet and Romeo* (1882; Museo Civico, Vicenza) by Pietro Roi (1819–1896), is a late and melodramatic example of the type. *Othello* was another obviously Italian subject, which was guaranteed to appeal: a masked ball in Milan in 1828, at the Casa Batthyany, was directed by the painters Hayez and Migliara, and included a quadrille dedicated to *Otello*. It was probably Rossini's opera that inspired the *Othello and Desdemona* (fig. 50) of Giuseppe Sabatelli (1813–1843), exhibited with great success at the Brera in 1834 (Brera, Milan): the stagey contrast of the furious Moor and supplicant Desdemona and the sumptuous and exotic costumes are linked with the *tableaux vivants* then in fashion. The *King Lear and Cordelia* (Galleria d'Arte

Moderna, Milan) of Giuseppe Sogni (1795–1874), painted in Milan in 1835 and a rare Shakespearean subject for the period, is similar to Sabatelli's painting in its academic construction.

More accurate translations of Shakespeare finally began to appear from the 1840s onwards, through the work of Carlo Rusconi and Giulio Carcano. Even these, however, did not give painters any particular reason to familiarize themselves with Shakespeare's world; their real importance was that they inflamed the Shakespeare-mania of a young composer, Giuseppe Verdi, who in 1847 wrote *Macbeth*. They also led to the first 'authentic' productions of Shakespeare's operas, by Alemanno Morelli, beginning in 1850 with his *Hamlet* performed at the Fenice in Venice. Unfortunately the Shakespearean works from *Lear* to *Othello* of the Neapolitan painter, Domenico Morelli (1826–1901), produced during the 1850s to the 1870s, are sketches and have mostly disappeared, but they are intense works dealing with unusual subjects, and were inspired both by Morelli's friendship with Verdi and by the example of the great Shakespearean actors, such as Tommaso Salvini and Ernesto Rossi. Even at this date inauthentic adaptations of Shakespeare had not been altogether superseded: the *Death of Othello* by Pompeo Molmenti (1819–1894), painted between 1866 and 1880 for the Venetian Palazzo Papadopoli, is an excuse to treat a 'local' story as a scenographic melodrama painted with Venetian colours.

The situation in Germany was altogether different. Here the question remains why the quantity of intelligent and sensitive critical writing on the plays of Shakespeare by such German Romantics as Goethe, Herder, Ludwig Tieck and Auguste Schlegel (see pp. 14–15), did not spawn an equivalent in the visual arts. German Romantic artists looked to Nature for their inspiration: guided by the philosophy of Friedrich Schelling they sought in Nature the imprint of the divine presence, and of a transcendent spirituality, things that were certainly not to be found in the all too human dramas of Shakespeare. The 'interior' landscapes of Caspar David Friedrich or the figurative allegories of Otto Runge have a strong metaphorical dimension that, by their sheer force of actuality, makes any literary reference seem secondary, and merely illustrative. Shakespeare made little impact on the Nazarenes, because of their explicitly confessional piety. Peter Cornelius (1783–1867) never finished the series of drawings announced in 1813 for *Romeo und Juliet* (see fig. 54, p. 198), and the only Shakespearean oil-painting to survive is that of Joseph Anton Koch (1768–1839), entitled *Macbeth and the Witches* (three versions, the earliest, of 1829, in Kunstmuseum, Basle), where the hero becomes a sort of Dürer knight – a typical example of the revival of German nationalism during these years.

An excellent series of prints from the plays of Shakespeare appeared almost out of the blue in 1828, in emulation of Boydell's Gallery, the work of two German artists, Ludwig Ruhl (1794–1887) and Moritz von Retzsch (1779–1857; fig. 51). It enjoyed great success

Fig. 51 After Moritz von Retzsch (1779–1857), *The Madness of Ophelia* (*Hamlet*, IV. v), from *Gallerie zu Shakespeare's Dramatischen Werken*, Leipzig 1847, Witt Library, Courtauld Institute of Art, London

in France and England as well as Germany. However, German Shakespearean painting still tended to be either folksy 'Merrie Germanie' genre scenes, showing Falstaff in improbably *alt-deutsch* settings or late Romantic melodramas. The works of Friedrich Kaulbach (1850–1920) are examples of this latter tendency, as are the large paintings with subjects from *Hamlet* and *Romeo and Juliet* (now in Bayerische Staatsgemäldesammlungen, Munich, and Städelsches Kunstinstitut, Frankfurt-am-Main) commissioned in 1868 by the Munich publisher Friedrich Bruckmann from Victor Müller (1830–1871), an artist who produced a number of drawings of Shakespearean subjects, perhaps with the intention of producing another *Shakespeare-Galerie*.

SELECT BIBLIOGRAPHY

Voltaire 1734; Delacroix, *Correspondance*; Delacroix, *Journal*; Baudelaire, *Oeuvres complètes*

62

JOHN MARTIN (1789–1854)
Macbeth, Banquo and the Three Witches (Macbeth, I. iii. 73–76)

?c. 1820
Oil on canvas
50.1 × 71 cm (19¾ × 27⅞ in.)
National Gallery of Scotland, Edinburgh, inv. NG2115

John Martin was born in Northumberland. Like Robert Smirke (see pl. 26) he was apprenticed to a coach-builder, where he learned to paint designs on coaches. In 1806 he moved to London where he worked as a glass-painter while studying to become a painter of more exalted subject-matter. He started exhibiting at the Royal Academy and then at the British Institution, where his taste for the Sublime, frequently dealt with by depicting small figures either in craggy landscapes under dramatic skies or against dramatic architectural perspectives, secured him considerable success over many years.

This is a small version of a much larger picture, his first and only exhibited Shakespeare subject, now lost, which Martin showed at the British Institution, London, in 1820. The picture shows a "blasted heath" in Scotland; Macbeth and Banquo, generals of Duncan, King of Scotland, are returning from battle. Their army snakes away into the distance. They are confronted by three witches who prophesy that Macbeth will replace Duncan as king – as indeed he does by murdering Duncan. Macbeth is himself eventually murdered, and one of Duncan's sons becomes the rightful king.

Martin always had a forensic approach to his subject-matter. Although this landscape shown is by no means Scottish, the artist's attention to the text is scrupulous. The flashes of lightning convey the sound of the "Thunder" of Act 1, Scene 3. The vaporous effect enveloping the disappearing witches was clearly inspired by Banquo's words as they vanish: "The earth hath bubbles, as the water has/ And these are of them … ." Macbeth's outstretched arms create a gesture that echoes his words to the witches before they go:

> Say from whence
> You owe this strange intelligence, or why
> Upon this blasted heath you stop our way
> With such prophetic greeting? Speak, I charge you.

The 1820 work was reviewed in the periodical *The Examiner* on 5 March 1820. Including the work in a general "hailing the genius of our country [Britain]", the reviewer added that "we no longer give the long possessed palm of superior sensibility for the Arts to far-famed Italy". It seems unlikely that the reviewer, Robert Hunt, had in mind the 1760s painting of the same subject by Francesco Zuccarelli (see pl. 4) or even the well-known engraving after it. However, there is a comparison to be made between the two in that the Zuccarelli was one of the earliest treatments of the subject and Martin's 1820 picture, a product of a similar

sensibility, was one of the very last large oil-paintings of the subject in British art.

The 1820 *Macbeth* remained unsold until at least 1831, when Sir Walter Scott visited the artist's studio. Inevitably Scott was drawn to Scottish subject-matter, and Leopold Martin reported that he expressed "great regret at his inability to purchase it, as he would so like to place it on the walls at Abbotsford. My father's like inability to offer it as a gift was also a great regret".
RH

PROVENANCE Purchased from the artist by George Baron of Drewton Manor, Cave, near Hull; at Cadeby Hall, Lincolnshire until 1885; sale, Sotheby's, London, 30 March 1949, lot 105; … ; Robert Frank; purchased by the National Gallery of Scotland, 1949

BIBLIOGRAPHY Pendred 1923, pp. 91–92; Feaver 1971

63

EUGÈNE DELACROIX (1798–1863)
Hamlet sees his Father's Ghost (Hamlet, I. v. 9–25)

Inscribed lower left *Eug.Delacroix 1825* [or *1815*]
?1825
Oil on canvas
46 × 38 cm (18⅛ × 14⅞ in.)
Muzeum Uniwersytetu Jagielloñskiego, Krakow
Ferrara only

This painting, exhibited for the first time outside Poland, is probably Delacroix's first Shakespearean subject. The dating is disputed because of the illegibility of the inscription. Recently Jasinska has suggested the very early date of 1815, because of the schematic nature of the figures and the summary execution, but Johnson's dating of 1825 seems more likely. In the autumn of 1815 the seventeen-year-old Delacroix had just left the Lycée Imperial and was entering the studio of Pierre-Narcisse Guérin (1744–1833), a confirmed follower of David. His outlook for the next few years was entirely Classical: he enthused about Poussin and Raphael, read Virgil and Horace, and aspired to win the Prix de Rome so as to be able to study in Italy (Delacroix, *Correspondance*, I, pp. 24, 33).

The vogue of the Napoleonic era for pre-Romantic subjects with fantastic visions and apparitions, inspired by Ossian, meant that the subject chosen for the 1814 Prix de Rome competition was the *Appearance of the Ghost to Brutus* from Shakespeare's *Julius Ceasar*, but Delacroix appears to have become acquainted with the writer only in 1819, at the time that he was asserting his identity as a Romantic and when he came under the influence of his Anglo-French friend Charles Soulier. Reading Shakespeare in English began a personal, intense (though not uncritical) engagement with the writer that lasted throughout Delacroix's life: from the outset he admired Shakespeare for "the living painting and investigation of the secret motions of the human heart" (*Correspondance*, I, p. 77). *Hamlet* was his favourite tragedy, the subject of a series of thirteen lithographs, which he worked on between 1834 and 1843 and from which he drew many subsequent paintings.

There are several reasons for dating this painting to 1825: that year Delacroix, flushed with the success of the *Massacre at Chios* at the 1824 Salon, was staying in London and greatly enjoying a number of Shakespearean productions. Though he laments in one letter having missed *Hamlet*, it is probable that he saw the play some time later during his stay. This painting shows Hamlet in the tights and huge black cloak that he usually wore on the English stage. This scene of the ghost's appearance was in fact cut from the only version of the play he could have seen in Paris at the time, that of Jean-François Ducis (1733–1816). In its summary execution, the work is certainly earlier than the more complete treatment of the same subject, the lithograph of 1843, and may be the scene from *Hamlet* that Alexandre Dumas *père* (1802–1870) later remembered acquiring from the painter, along with other literary subjects, in the late 1820s. Johnson supposed that this purchase took place twenty years later, after the painting had been exhibited in the foyer of the Théâtre de l'Odéon; in which case there would have been an

interesting comparison between this painting and the first performances (between 1846 and 1847) of Dumas's own translation of *Hamlet*, performed with gusto by the actor (and one-time painter in the studio of Baron Gros) Philibert Rouvière (1809–1865), who modelled his performance on Delacroix's lithograph. In the exhibition the painting was admired by Théophile Gautier and Paul Mantz, for "the muted splendour of its harmonious colour" (Mantz 1845), though the critic of *L'Illustration* (6 December 1845, p. 213) had doubts about its careless manner: "his skilful hand has cunningly veiled the execution and the details in clouds of mist, in such a way as to conceal them entirely from our view." The picture was cleaned, possibly for an exhibition, as it bears a label on the back with the names of the framer, Souty, and the restorer, Haro, two men who often worked for Delacroix. The suggestion that this was Dumas's picture is supported by the fact that it was acquired on the Paris art market by Julia Puslowska around 1870, the year that Dumas's collection was sold.

The title of the 1843 lithograph shows that Delacroix chose the moment when the ghost admonishes his son: "I am thy father's spirit … Revenge his foul and most unnatural murder" (I. v. 9 and 25). Hamlet the elder turns on his terrified son in the cold light of dawn, here suggested by the crowing cock on the barrel of the cannon. In a fragment of his *Journal*, thought to date from 1847, Delacroix gives some insight into his procedure here: "It is possible to extract from a Shakespearean character the striking effect, that species of picturesque truth in their make-up, and add, according to one's ability, a certain element of subtlety" (*Journal*, p. 880).

MGM

PROVENANCE ?Alexandre Dumas; acquired in Paris by Julia Drucka-Lubecka-Puslowska, *c.* 1870; remained in the possession of the family in Krakow; given by Xavier Puslowski to the Muzeum Uniwersytetu Jagielloñskiego, 1958

BIBLIOGRAPHY Mantz 1845; Zebracka-Krupinska 1966, pp. 69–93; Johnson 1981, pp. 717–18 ; Johnson 1987, no. L99, p. xxvii; Jasinska 2001, pp. 61–72

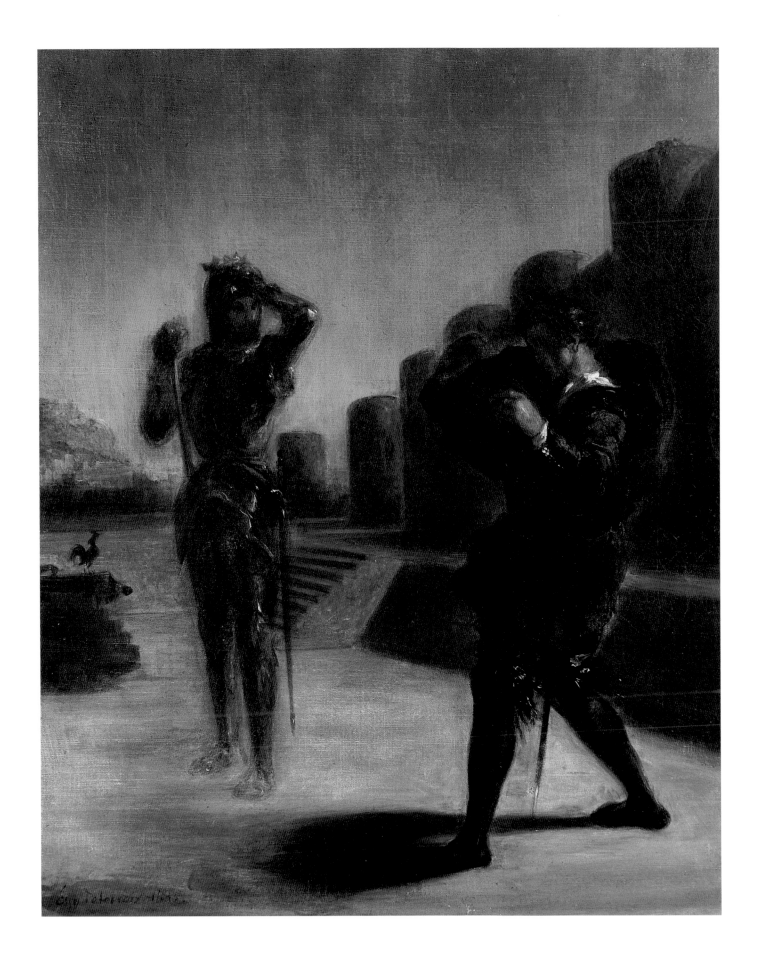

64

FRANCESCO HAYEZ (1791–1882)
The Last Farewell of Romeo and Juliet (Romeo and Juliet, III. v)

1833
Oil on canvas
177 × 115.5 cm (69⅝ × 45½ in.)
Private Collection, Milan
Ferrara only

Venetian by birth, in 1809 Hayez moved to Rome to complete his training with the sculptor Antonio Canova, who taught him to admire Raphael, as might be expected, but also to admire the Venetian 'Primitives', from Bellini to Carpaccio, learning from them the use of brilliant colour in rigorously controlled compositions. On his return to Venice in 1820 Hayez showed at the annual exhibitions at the Accademia di Brera in Milan. The paintings were of Italian historical subjects of a passionate nature typical of the Romantic ethos of the time and greatly admired by the liberal Milanese aristocracy. His decision to move to Milan in 1823 coincided with the huge public and critical success, at the Brera exhibition, of his monumental *Last Kiss of Romeo and Juliet* (fig. 52), commissioned by the collector Giambattista Sommariva for his house, the Villa Carlotta, on Lake Como. Given the number of free adaptations of Shakespeare in circulation at the time, it is probable that Hayez had only the haziest idea of the original text; his other submission to the same exhibition was a large *Marriage of Romeo and Juliet* (Graf von Schönborn Wiesentheid Kunstsammlungen, Nuremberg), an event that does not occur in Shakespeare's play, but is taken from the much earlier novella by Luigi Da Porto, on which Shakespeare's play was probably based.

Hayez's *Last Kiss* was one of his most popular subjects: there are four autograph versions, of which this is the best known, as well as countless engraved and miniature copies. Hayez sent it to the Brera exhibition in 1833 (no. 12B), by which time he was established as one of the leading Romantic painters in Italy; here he tempered the emotionalism and experimentation of the Villa Carlotta version. Then critics admired the accuracy of the historical reconstruction combined with a 'modern' unidealized interpretation of the scene. But Ludwig Schorn, critic of the German *Kunst-Blatt*, was disconcerted precisely by this mix of medievalism and modernity; Schorn found Juliet more like a Bacchante or a lascivious Phryne than Shakespeare's heroine, perhaps because she was based on the painter's young model and mistress, Carolina Zucchi. In this work Hayez depicts not the impetuosity of the kiss, but the sadness of the lovers' farewell, its solemnity underlined by a setting reduced to bare essentials. A chaste colour range gives the scene the detached air of a tragic moment in great literature rather than the direct experience of life. The change reflects the change in taste in the ten years between the two versions; the fervent Romanticism of the 1820s has been replaced by a more distilled treatment of the subject and a more controlled style.

MGM

PROVENANCE Conte Francesco Annoni, Milan, 1833; thence by descent

BIBLIOGRAPHY Milan 1833, pp. 72–73; Mazzocca 1994, no. 182

Fig. 52 Francesco Hayez, *The Last Kiss of Romeo and Juliet*, 1823, oil on canvas, 291 × 201.8 cm (114½ × 79½ in.), Villa Carlotta, Tremezzo, Como

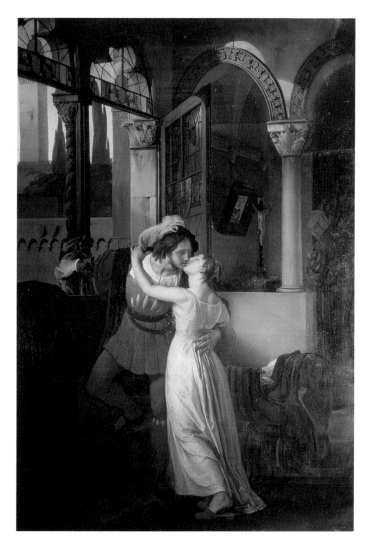

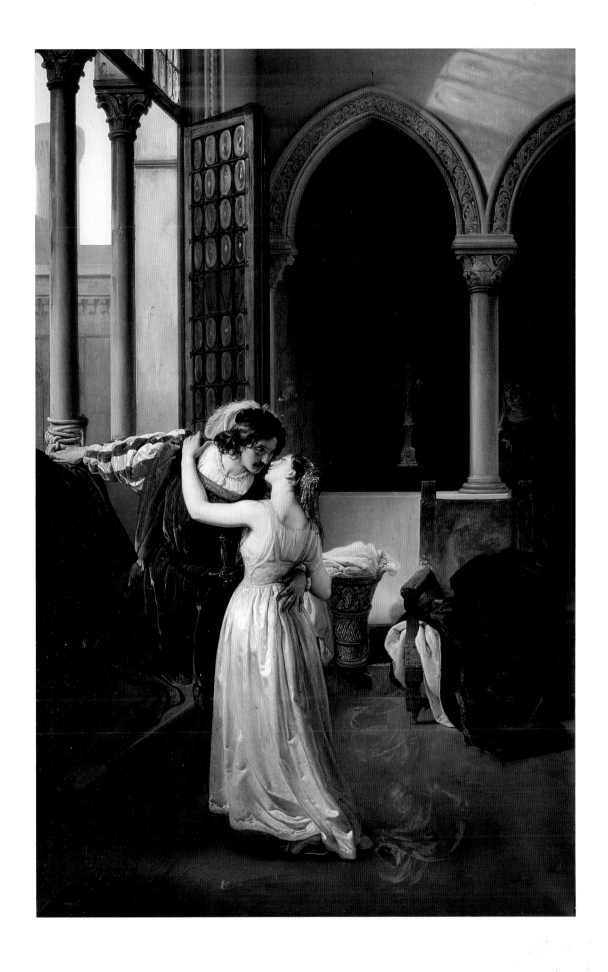

65

THÉODORE CHASSÉRIAU (1819–1856)
Macbeth and the Vision of the Kings (Macbeth, IV. i. 112–24)

Red wax seal of the Chassériau sale on the canvas
c. 1849–54
Oil on canvas
61 × 50 cm (24 × 19⅝ in.)
Musée des Beaux-Arts, Valenciennes Nord, inv. PY4 - RF 3919

In 1833–34, as a young man, Chassériau studied in the studio of Jean-Auguste-Dominique Ingres, where he learned an exact drawing technique that he soon put into practice as a fashionable portraitist and history painter. In 1844 he received one of his most important commissions, for a cycle of frescoes of allegorical subjects for the Cour de Comptes in Paris (destroyed by fire in 1871). The same year he engraved a series of plates of *Othello*, his first Shakespearean theme, inventive in the choice of subject and with dramatic contrasts of light and dark derived from Delacroix. Apart from *Othello*, Chassériau's favourite play was *Macbeth*. Drawings inspired by that tragedy (with others of *King Lear*) appear in a sketchbook of 1836–38, as well as two oil-paintings of approximately the same date as this painting – *Macbeth seeing the Ghost of Banquo* (Musée des Beaux-Arts, Reims), dated 1854, and *Macbeth and Banquo meeting the three Witches on the Heath* (Musée du Louvre, Paris), dated 1855. Both these were exhibited at the Bordeaux Salon of 1855, after the former picture had been refused by the Exposition Universelle of the same year. The renewed popularity of the play, which had been revived by an English company at the Théâtre Ventadour, was confirmed by Camille Corot's landscape with *Macbeth and the Witches* (Wallace Collection, London) painted the same year and exhibited at the Salon of 1859.

This painting depicts Macbeth's vision in the witches' cave of an unending procession of future Scottish kings, Banquo's descendants:

> What, will the line stretch on to th'crack of doom?
> Another yet? A seventh? I'll see no more.
> And yet the eighth appears, who bears a glass
> Which shows me many more …

In their monumental and spectral substance the figures show the influence of paintings by François Gérard (1770–1837) from Ossian and those of Anne-Louis Girodet (1767–1824) for Napoleon's house at Malmaison in 1801, as well as Ingres's *Ossian's Dream* of 1813 (Musée Ingres, Montauban), works that he could have come to know during his apprenticeship with Ingres. But, as M. Sandoz has pointed out, this oil sketch has "an exceptionally evocative power, which contrasts with the bland style of the Ossianic paintings". The intensity with which Chassériau paints the phantoms of his imagination owes something to his personal experience of seances held by his childhood friend Delphine Girardin, and his style has matured through contact with Delacroix. In his memoirs, Arsène Houssaye, the influential director

of the periodical *L'Artiste*, remembers him as a "determined believer – he followed in the footsteps of Mme de Girardin into the land of the dead; both left almost happy to quit this world or to be buried". Another adept of the occult, Mme Monnerot, writing to her son in November 1853, tells of chairs turning over at seances: "Théodore", she writes, "made the tables turn and speak, they said astonishing things to him … he is one of the fervent believers" (Paris, Strasbourg and New York 2002, pp. 66, 395).

The unfinished appearance of this painting adds to its effect, and possibly Chassériau left the canvas in this state deliberately, though one must not forget his precarious state of health at the time – he was to die two years later of consumption. He had already been accused of carelessness by the critic Théophile Gautier (1811–1872), usually his ardent supporter, when in 1852 he exhibited his *Desdemona preparing for bed* (Private Collection, Paris) at the Salon, a posthumous portrait of the singer Maria Malibran (1808–1836), where many parts were left looking like a sketch. Gautier (1852) pointed out Chassériau's "*élégance sculpturale*", but lamented that "unfortunately the painter has not given himself the trouble of completing the execution, having so successfully found the disposition and the principal lines of the forms". To our eyes it is precisely this expressive sketchiness of form and colour that gives this painting its suggestions of mystery and hallucination.
MGM

PROVENANCE Sale, Paris, 12 December 1854; sale, Chassériau, Paris; Baron Arthur Chassériau Collection, 1857; bequeathed to the Louvre, 1934; on deposit to its present location, 1937

BIBLIOGRAPHY Gautier 1852; Sandoz 1974, no. 238; Paris, Strasbourg and New York 2002, under nos. 201–02, pp. 66, 395

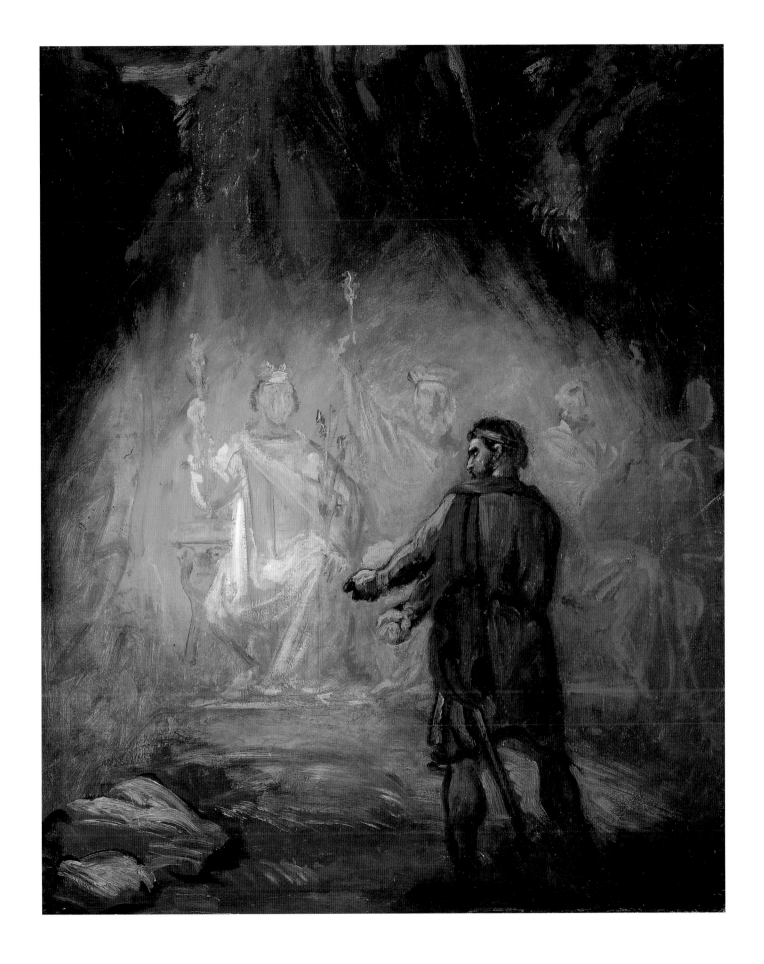

66

GUSTAVE MOREAU (1826–1898)
Hamlet and Laertes at the grave of Ophelia (Hamlet, V. i. 249–57)

Signed and dated *Moreau 1850*
1850
Oil on canvas
60 × 40 cm (23⅜ × 15¾ in.)
Musée Gustave Moreau, Paris, inv. N.862

Moreau enrolled at the Ecole des Beaux-Arts in 1846 in the studio of the Neo-classical painter François-Edouard Picot (1786–1868), but left three years later, having failed to win the Prix de Rome, although he was on the shortlist. The critic of *L'Artiste* wrote that "M. Moreau understands staging, but he lacks that intimate fervour that betrays itself with all those who love their art with real devotion" (5th series, III, 1849, no. 13, p. 208), while Etienne Delécluze remarked in the *Journal de Débats* (28 September 1849, p. 3): "M. Moreau has made a reasonably well conceived and executed work … this artist knows how to *make a painting*; but this is not enough; you must captivate and move your audience."

The tone of these criticisms encouraged the young painter, who was already fascinated by the works of Titian and Veronese he had copied in the Louvre, to abandon academic models in favour of the emotional expression and blazing colour he found in Delacroix and Chassériau, both devoted Shakespeareans (pls. 63, 65). Moreau soon formed a close friendship with Chassériau, in 1850 taking a studio next to his, near place Pigalle. The same year Moreau worked on his soulful self-portrait (Musée Gustave Moreau, Paris) and a series of small Shakespearean subjects, including a portrait of the adolescent Hamlet (Musée Gustave Moreau, Paris), more deranged than meditative, which he dedicated to his friend Alexandre Destouches. Thus Moreau announced his possession of what he later boasted to be his "*imagination à la Shakespeare, à la Dante*", that is, his own poetic inspiration (Moreau, *Ecrits complets*, p. 95).

Moreau painted two other incidents from the last act of *Hamlet*, the violent *Hamlet forcing the King to drink poison* (c. 1850; Musée Gustave Moreau, Paris), and this painting of the burial of Ophelia, where Hamlet, in the presence of the King and Queen, jumps into her grave and is assaulted by Laertes: "I prithee take thy fingers from my throat." The complex arrangement of figures here, compared with Delacroix's lithograph of 1843, derives from Moritz von Reztsch's lithograph of 1828, one of the few earlier illustrations of this incident. Moreau's Hamlet also appears to have some affinity with the recent interpretation of the role by the actor Philibert Rouvière, described by Baudelaire as "bitter, unhappy and violent, pushing anxiety as far as delinquency" (Baudelaire, *Oeuvres complètes*, p. 698).
MGM

PROVENANCE Artist's collection

BIBLIOGRAPHY Mathieu 1971, pp. 277–78; Mathieu 1976; Lacambre 1990, no. 862; Mathieu 1998, fig. p. 19

Fig. 53 After Moritz von Retszch (1779–1857), *The Funeral of Ophelia, c.* 1840, print, Cabinet des Estampes, Bibliothèque Nationale, Paris

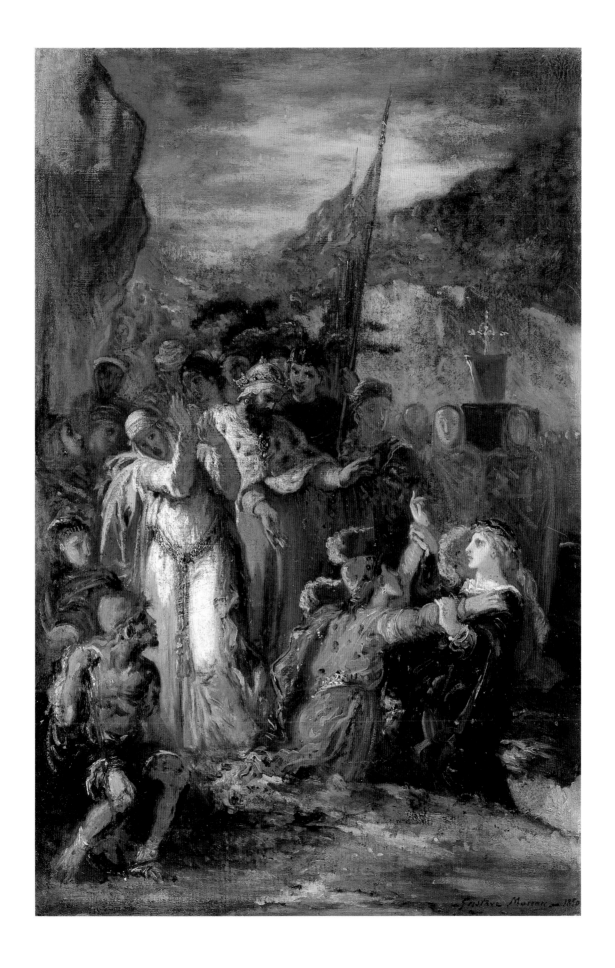

189

67
JOSEPH MALLORD WILLIAM TURNER (1775–1851)
Queen Mab's Cave (Romeo and Juliet, I. iv)

c. 1846
Oil on canvas
92.1 × 122.6 cm (36¼ × 48¼ in.)
Tate, London. Bequeathed by the artist 1856

This picture, the last of Turner's Shakespearean subjects, was exhibited by him at the British Institution in 1846 with the title given above and the quotations:

> Frisk it, frisk it by the Moonlight Beam
> > (A *Midsummer Night's Dream*)

> Thy Orgies, Mab, are manifold.
> > (MSS *Fallacies of Hope*)

The *Fallacies of Hope* purported to be a manuscript epic written by Turner himself, from which he frequently quoted, although it was almost certainly never a completed work. The reference to Shakespeare appears to be not to *A Midsummer Night's Dream* but to Mercutio's description of Queen Mab in *Romeo and Juliet* (I. iv), which includes the words "moonshine's watery beams". The picture does not otherwise follow Mercutio's description, evoking rather the "moonlight revels" and fairy dances of *A Midsummer Night's Dream* (II. i). Neither play suggests the cave or waterside setting. Martin Davies believes the layout of the British Institution catalogue with its suggestion of a Shakespearean quotation was a printer's mistake, and that the whole text should have been attributed to the *Fallacies of Hope*, but such a casual attitude to his sources would be typical of Turner's imagination and of his quoting from memory. In fact, the picture is a fantastic evocation of fairyland, with magic castle and Watteau-esque figures. Turner had already painted a Shakespearean tribute to Watteau in his *What You Will!*, exhibited at the Royal Academy in 1822 (Butlin and Joll 1984, no. 229), when his title was a typical play on words by Turner on Watteau's name; at the same time it was Shakespeare's alternative title for *Twelfth Night*. The picture may also have been in part a response by Turner to *The Enchanted Castle* by Francis Danby, first exhibited in 1825, the engraving of which was republished in 1841 at a time when Danby was trying to re-establish his reputation in London after a period of exile abroad.

The poet Alfred, Lord Tennyson went so far as to describe Turner as "the Shakespeare of landscape". A contemporary parallel, in his revolutionary Romanticism combined with respect for the forms and images of Classical antiquity, was the composer Hector Berlioz (1803–1869). Both illustrated Byron's *Childe Harold*: Turner in *Childe Harold's Pilgrimage – Italy* (RA 1832, now Tate, London; Butlin and Joll 1984, no. 342) and Berlioz in *Harold in Italy* (1834). Both were in thrall to the story of the Trojans, in particular the great love affair of Dido and Aeneas: Turner in a series of pictures from *Dido and Aeneas* (RA 1814, now Tate, London; Butlin and Joll 1984, no. 129) and *Dido Building Carthage* (RA 1814, now The National Gallery, London; Butlin and Joll 1984, no. 131) right up to his four final exhibits of 1850 (Butlin and Joll 1984, nos. 429–32), and Berlioz in his culminating masterpiece *The Trojans*, completed in 1858. Berlioz had already depicted Queen Mab in the scherzo of his *Romeo and Juliet* (1838), and Shakespeare's play also gave its subject to a further painting by Turner, *Juliet and her Nurse* (RA 1836, now Sra Amalia Lacroze de Fortabat, Argentina; Butlin and Joll 1984, no. 365), which, like *Queen Mab's Cave*, plays fast-and-loose with Shakespeare's text to place Juliet not in Verona but looking over the Piazza San Marco in Venice at night. As in all of Turner's subject pictures, fidelity to the facts or text was subject to reconstruction by his artistic imagination.
MB

PROVENANCE Bequeathed by the artist to the British nation, accepted 1846 and placed in The National Gallery, London; transferred to the Tate Gallery, 1954
BIBLIOGRAPHY Davies 1946, p. 152 no. 548; Butlin and Joll 1984, pp. 264–65 no. 420; Piggott in *Turner* 2001, pp. 290–91

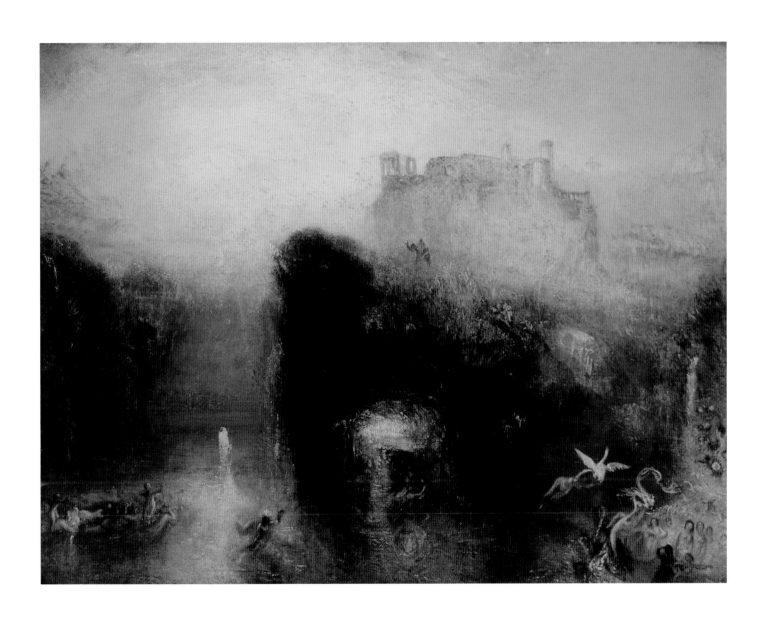

68
GUSTAVE MOREAU (1826–1898)
Lady Macbeth (Macbeth, V. i)

?1851–52
Oil on canvas
32 × 24 cm (12⅝ × 9⅜ in.)
Musée Gustave Moreau, Paris, no. 634

This study of Lady Macbeth, identified by Geneviève Lacambre, is unpublished. Although the summary handling, evoking form through vivid touches of colour, suggests it is a late work, its first treatment could date back to about 1852. A panel of *Macbeth and the Witches* (Private Collection, Paris) dates from 1853, confirming Moreau's interest in the play at this date. In his *Livre de notes*, or *Livre rouge*, which Moreau began in the early 1860s, he lists potential subjects for paintings alphabetically: Shakespearean subjects include the usual themes from *Romeo and Juliet*, *King Lear* and *Hamlet*, and also *Macbeth Rubbing his Bloodstained Hands* (Archive of the Musée Gustave Moreau, no. 500, p. 267). The sleepwalking scene in which Lady Macbeth tries to wash the blood from her hands, illustrated in this sketch, may have been suggested by the success of Delacroix's *Lady Macbeth Sleep-Walking* (Hosmer Collection, Montreal), shown at the 1851 Salon. That work was much admired for its expressive intensity, despite its small scale, and inspired Baudelaire's lines in *Les Fleurs du mal* (1857):

> *Ce qu'il faut à ce cœur profonde comme un abîme*
> *C'est vous, Lady Macbeth, âme puissante au crime,*
> *Rêve d'Eschyle éclos au climat des autans.*

For Paul Mantz it was the most moving of Delacroix's exhibited works: Lady Macbeth, lit by the candle she holds, advances with open eyes, burdened by her guilt even in sleep, and watched by the astonished doctor and lady-in-waiting. Théophile Gautier, who seems to have been given Delacroix's painting, described it thus: "Lady Macbeth a tiny figure moving on a miniature canvas, has more grandeur and energy than many enormous works: there is here something strange, gaunt, mad, something of the automaton about this night-walker" (Gautier, 'Salon de 1850–51', *La Presse*, 8 March 1851).

Moreau could have been inspired by the play, but his imagery, unlike Delacroix's, derived from Robert Smirke's print in *The Picturesque Beauties of Shakespeare* (1783), has more affinities with George Henry Harlow's *Sarah Siddons in the Scene of Lady Macbeth sleepwalking* (1814; fig. 43, p. 118), which adds weight to Lacambre's hypothesis that this is indeed Lady Macbeth. Mrs Siddons made her début in the role in 1785 and thereafter made it her war-horse; in the sleepwalking scene she appeared majestic and statuesque, wrapped in a white veil, lit obliquely by flickering candlelight. A member of the audience recalled: "The character of Lady Macbeth became a sort of exclusive possession of Mrs. Siddons. There was a mystery about it, which she alone seemed to have penetrated … .

Every audience appeared to wonder why the tragedy proceeded further when at the final exit of the Lady Macbeth its very *soul* was extracted" (Boaden 1827, pp. 264–65). Siddons had become a kind of visual archetype in the role, still able to stir Moreau's imagination decades later. MGM

PROVENANCE Artist's collection

BIBLIOGRAPHY Lacambre 1990, no. 634

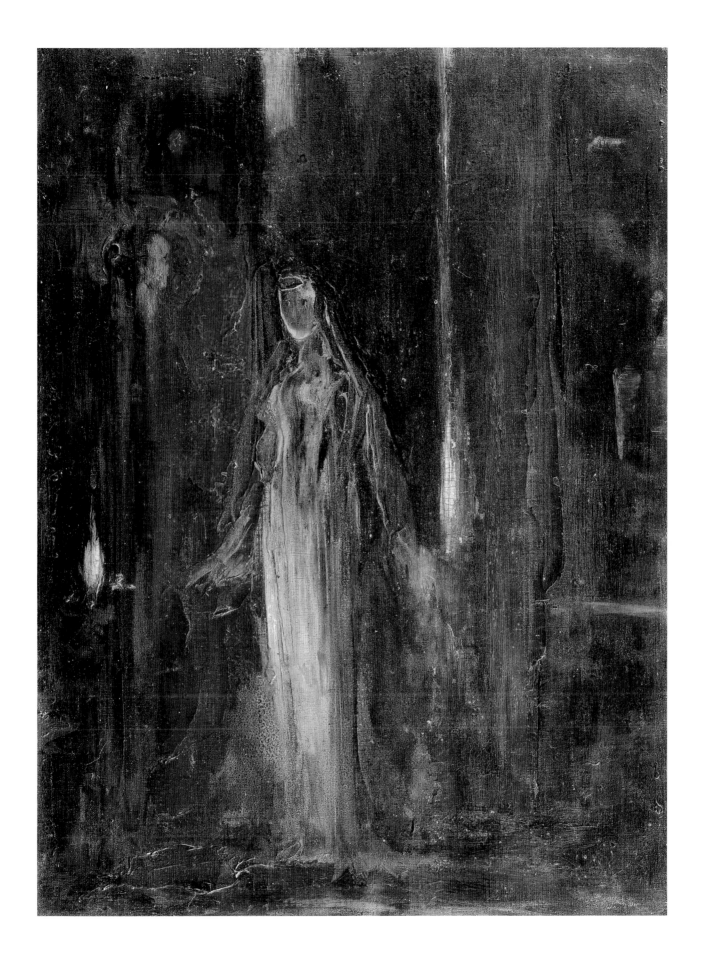

69

EUGÈNE DELACROIX (1798–1863)
The Death of Ophelia (Hamlet, IV. vii. 163–84)

Signed lower left *Eug Delacroix*
1853
Oil on canvas
23 × 30.5 cm (9 × 12 in.)
Musée du Louvre, Paris, inv. RF 1393

The death of Ophelia is narrated by Gertrude to Laertes. Its lyrical evocation is full of watery imagery – garlands interwoven like "weedy trophies", Ophelia's fall into the "weeping brook", her sliding "mermaid-like" below the surface to a "muddy death" – and was one of those passages that for many eighteenth-century commentators seemed to make Shakespeare's plays better suited to reading, to the 'theatre of the mind', than to performance.

Henry Fuseli was the first artist to illustrate this scene, in a drawing of the late 1770s made in Rome (The British Museum, London), in which he emulates Shakespeare's watery imagery, thereby challenging the current idea of 'poetic justice', which for Samuel Johnson meant that such pious, innocent heroines as Cordelia and Ophelia should not meet with untimely deaths. Fuseli models his Ophelia on Classical prototypes of nymphs and *Bacchanti* and suggests, with a single cursive touch, a metamorphosis confusing her opening dress with the water's current. His drawing was much imitated from the 1780s onwards: by, among others, Richard Westall (1765–1836) in a painting for the Boydell Gallery, and in a fine engraving by Robert Smirke for the first volume of *The Picturesque Beauties of Shakespeare* (1783), a work studied by Delacroix, perhaps during his London stay in 1825, the inspiration for some of his *Hamlet* lithographs of 1843.

Apart from Delacroix's lithograph, which is repeated here in reverse, this painting was preceded by two oil versions: a sketchy grisaille of 1838 (Neue Pinakothek, Munich) and a larger, more finished painting of 1844 (Reinhart Collection, Winterthur). Delacroix evidently wanted to translate his 1843 series of lithographs into oil-paintings, but there are other reasons for his renewed interest in *Hamlet* at this time: it was revived on the Parisian stage in Dumas's translation in 1846 and 1847, a production that also inspired a fine *Hamlet and Ophelia* by Ingres's pupil Henri Lehmann's (1814–1882), exhibited at the Salon of 1846 (untraced; known through Auguste Lemoine's lithograph). For Delacroix the choice of this moment derived from his close reading of the text: Smirke showed Ophelia standing, leaning against the branch that is about to break. Delacroix, like Fuseli before him, chose to depict Ophelia floating in the water; her abandoned figure appears to have been suggested by Nicolas Poussin's *Echo and Narcissus* (*c.* 1629–30; Musée du Louvre, Paris).

Delacroix repeatedly returned to the same subject, sometimes rediscovering the spontaneity of the first version in a much later one with a broader colour range, a habit he justified in his diary, after a conversation with the musician Manuel Garcia, brother of the singer

Maria Malibran, about the different ways in which actors and painters 'improvise'. The actor, once he has "got inside" the part, becomes more effective as he gets better and better at repeating the original effect, while "the painter has the same first passionate view of the subject. But his attempts to realize it are more transforming than the actor's. The more talent he has the more the quiet process of study will add beauties, not trying to follow his original idea as closely as possible, but rather adding to it by the warmth of his execution. Execution in painting must always have an element of improvisation in it, and it is chiefly in this that it differs from that of the actor. Execution in painting is only beautiful when the artist allows himself a certain freedom, to discover while making" (Delacroix, *Journal*, 27 January 1847, p. 124).
MGM

PROVENANCE Thomas, Paris, 1853; Marmontel; sale, Marmontel, 11 May 1868, no. 10; George Petit, 1885; Georges Thomy-Thiéry, January 1889; bequeathed by him to the Louvre, 1902

BIBLIOGRAPHY Dotson 1965, pp. 43, 56–60; Johnson 1986, no. 313

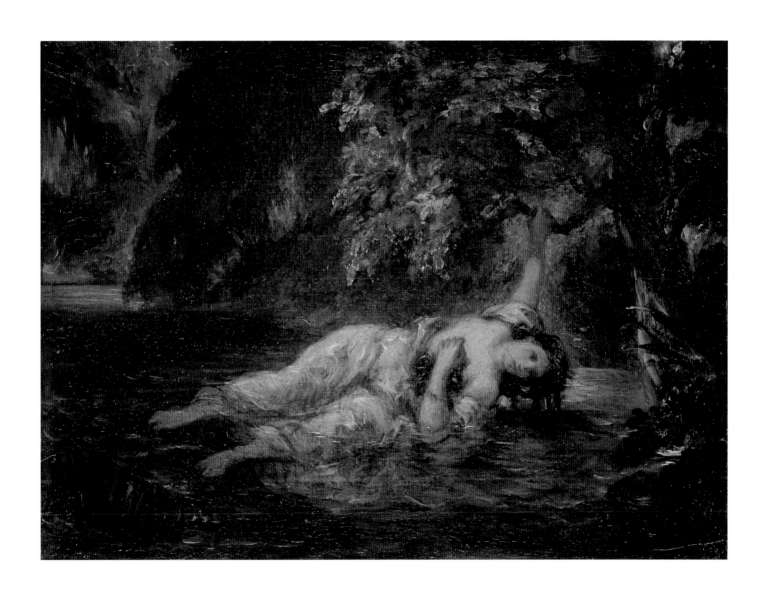

70

EUGÈNE DELACROIX (1798–1863)
Hamlet and Horatio in the Graveyard (Hamlet, V. i)

Signed and dated lower left *Eug.Delacroix/1859*
1859
Oil on canvas
29.5 × 36 cm (11⅝ × 14⅛ in.)
Musée du Louvre, Paris, inv. RF 1399

Of all Shakespeare's work this scene haunted Delacroix the most. His first depiction, *Hamlet Contemplating Yorick's Skull*, a lithograph of 1828 (Bibliothèque Nationale, Paris), was inspired by the album of engravings by the painters Achille Devéria and Louis Boulanger recording the Paris season of the Théâtre Anglais. Apart from a watercolour of the same date (Albertina, Vienna) and various drawings, the subject recurs in four oil-paintings dating from throughout Delacroix's career, each reinterpreting both the text and Delacroix's identification with Hamlet. The first was refused at the Salon in 1836 (fig. 48, p. 176); another version was exhibited in 1839 (fig. 5, p. 17) and was repeated in a lithograph of 1843; additionally there is an oil on paper of 1844 (recently reappeared in a private collection; Johnson 1986, no. L148); and this painting of 1859.

Revisiting the subject after a gap of fifteen years, Delacroix takes up the theme of his first work, the 1828 print, now reversed, with its composition spread out horizontally in such a way as to unite the two episodes, the grotesque conversation between the gravedigger and Hamlet, and the burial of Ophelia. In comparison with his early study, this painting is more architectural in structure, owing to the insertion of a second gravedigger linking the funeral cortège with the figures in the foreground, while many elements derive from Delacroix's oriental paintings – the vivid colour of the background, something between torchlight and the rosy light of dusk, and the simplified outline of the fortress, a memory of Moroccan architecture. Delacroix rings the changes with Shakespeare's text, having Ophelia's bier accompanied by a single priest, and introducing a masculine and restrained Hamlet in place of the beardless and vulnerable figure of his earlier work, while, in a strange role reversal, Horatio now becomes the tortured youth. This scene conveys less melancholy than his version of 1839, which was much admired; the critic Théophile Thoré said of that picture: "The expression on the face is sublime in its doleful concentration and recalls the poetic features of Liszt's inspired physiognomy … and what a dark execution in keeping with this gloomy philosophy! What a sad sky, veiled with heavy violet clouds; on the horizon a greenish streak flecked with grey, like the ashes of the steak" (Thoré, 'Salon de 1839', *Le Constitutionnel*, 16 March 1839).

This version was exhibited at the Salon of 1859 together with seven other paintings, and enjoyed a very different reception from the earlier one. Paul Mantz, normally a supporter of Delacroix (see pl. 63), wrote: "This is a painting of limited importance, the hastily mown aftercrop of a field which has given us such splendid harvests in the past." This judgement was repeated by Mathilde Stevens: "The execution is more timid and the impression produced is less striking, in spite of the Shakespearean breath which animates this little canvas." On the other hand, Edouard Cadol, in *L'Univers illustré*, found in its lack of balance, due to its rapid execution and skewed proportions, an affinity between the painter and Shakespeare, first noticed by Baudelaire at the Salon of 1846: "It is right to compare Delacroix with Shakespeare. Both have the same strength, the same impetuosity and the same faults" (Sérullaz 1998, p. 231). Only Zacharie Astruc was entirely enthusiastic. He was the spokesman of a younger generation of artists and critics, soon to champion the work of James Whistler and Edouard Manet:

> You all know this scene from *Hamlet*: it is the strongest of this athletic drama that ought to be as familiar to the general public as the air we breathe, as space, as the sky, as the immensity above us and the plants at our feet. It seems to me to be the abstract of the human soul in perfect harmony. There is nothing lacking in the moral and physical picture of his life. Lithography popularized the first Hamlet. This one seems to me more complete in its action. It goes far beyond in sentiment, in its more intimate philosophy, and in colour it is incomparable. To do justice to this painting one must point out everything: the incisive vigour of Hamlet, the powerful physique of the seated grave-digger, Horatio, the sunset, the towers seen in its rays as well as the tombstones – this beautiful green landscape background – and the monks whose demeanour is so exactly right. Nothing precious, overworked or slightly rendered. Everything is ample, everything is broadly outlined in the spirit of the idea. Shakespeare would not have drawn it otherwise. But look at the sky: it is sad, indecisive, and yet vibrating with a secret ardour! Is this not a reflection of the character of Hamlet? Those who can truly hear poetry translate it thus.

MGM

PROVENANCE Cachardy; his sale, 8 December 1862, no. 11; by 1873 in the possession of Baron Nathaniel de Rothschild and until at least 1885; Georges Thomy-Thiéry by 1902, by whom bequeathed to the Louvre

BIBLIOGRAPHY Astruc, *Les 14 stations du Salon 1859*, Paris 1859; Mantz, 'Le Salon 1859', *Gazette des Beaux Arts*, II, 1859, no. 9, p. 136; Stevens, *Impressions d'une femme au Salon 1859*, Paris 1859; Jullian 1975, pp. 245–51; Johnson 1986, no. 332; Guégan 1998, pp. 81–83; Paris and Philadelphia 1998–99, no. 93

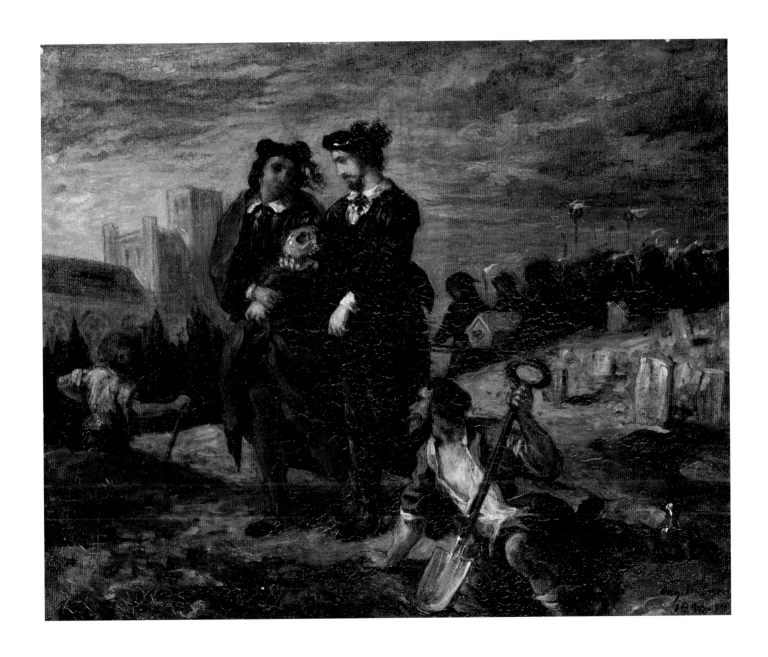

197

LIVERPOOL JOHN MOORES UNIVERSITY
LEARNING SERVICES

Anselm Feuerbach (1829–1880)
Romeo and Juliet (III. v. 11–25)

Signed and dated on the balcony to the left *AFeuerbach 1864*
1864
Oil on canvas
200 × 115 cm (78¾ × 45¼ in.)
Curt Elschner Foundation, Staatliche Sammlungen zur Kunst und Kulturgeschichte Thüringens, Thüringer Museum, Eisenach, inv. 17321/A2/261
Ferrara only

After training at the academies of Düsseldorf, Antwerp and Munich between 1845 and 1851, Feuerbach studied in Paris from 1852 to 1853 under Thomas Couture (1815–1879), who encouraged him to copy the paintings of Titian and Veronese in the Louvre and introduced him to Shakespeare, the inspiration for his own great success at the 1844 Salon, the *Love of Gold* (Musée des Augustins, Toulouse), taken from *Timon of Athens*. Between 1855 and 1873 Feuerbach lived in Venice and Rome, attracted by the past glories of ancient Rome and the Renaissance, a passion he shared with his friends the painters Arnold Böcklin and Hans von Marées. During 1863 and 1864 von Marées's patron, Count Adolf Friedrich Schack, commissioned from Feuerbach two paintings, possibly intended as a pair, *Paolo and Francesca* (Bayerischer Staatsgemälde Sammlungen, Schack Gallery, Munich), and this *Romeo and Juliet*, to be exhibited in a public gallery in his Munich house.

In keeping with his introverted temperament, Feuerbach avoided the passion and drama with which the subjects were associated in the Romantic era, from Hayez (pl. 64) to Delacroix (whose *Romeo and Juliet* excited hostility at the 1846 Salon because of the vulgarity of the embrace). Paolo and Francesca are absorbed in reading, while Romeo and Juliet, shown in the balcony scene, are transposed into a sort of melancholy idyll, recalling the desolate abandon of Romeo's words: "I have more care to stay than will to go: come death and welcome! Juliet wills it so!" In the first painting Schack congratulated Feuerbach on the chastity of his scene, but when the second painting arrived in Munich, on 4 November 1864, he expressed his disappointment to the artist's stepmother, Henrietta, who acted as a go-between for the two men (Allgeyer 1902):

> This couple show no trace of the fire and the passion, without which the farewell scene of Romeo and Juliet is unimaginable; Juliet (who has the same face as Francesca's though not so good) has nothing of the deeper expression of the soul, while Romeo is much too faint-hearted, almost sleepy. If you had been in Rome when he was at work on the painting, you would have given your Anselm no peace until he had interpreted this whole scene in a livelier way.

For Feuerbach, on the other hand, as he explained to his stepmother in a letter of 20 October 1864, "the virtue of this painting lies in the purity of its expression of the soul, and I know in advance that this will be generally overlooked". So strongly did he feel about this that he even thought of copying the painting, without telling Schack, for the more

sensitive English market (Kern and Uhde-Bernays 1911). This restraint suggests that Feuerbach may have found a model in the drawings by the Nazarene painter Peter Cornelius dating from 1813 (Thorwaldsen Museum, Copenhagen, and Städelsches Kunstinstitut, Frankfurt-am-Main). These were drawn in a neo-quattrocento style for an illustrated edition of Shakespeare's plays that was never published. In fact Feuerbach may have been concealing his own intense personal involvement with the scene: as with *Paolo and Francesca*, the two lovers have the features of the artist and his model, Nanna Risi, whose unhappy affair was breaking up at this time. There is a replica of the painting dated 1866, formerly in a private collection in Budapest. MGM

PROVENANCE Freiherr Adolf von Schack, Munich, 1864; Generalarzt Dr Solbrig, Munich; Moderne Galerie Thannhauser, Munich; Neue Galerie, Munich; Curt Elschner-Stiftung, Thüringer Museum, 1972

BIBLIOGRAPHY Allgeyer 1902, I, no. 420 and II, pp. 472–75; Kern and Uhde-Bernays 1911, II, pp. 125, 127–29; Ecker 1991, no. 395

Fig. 54 Peter Cornelius (1783–1867), *Scene from 'Romeo and Juliet'*, c. 1813, Thorvaldsens Museum, Copenhagen

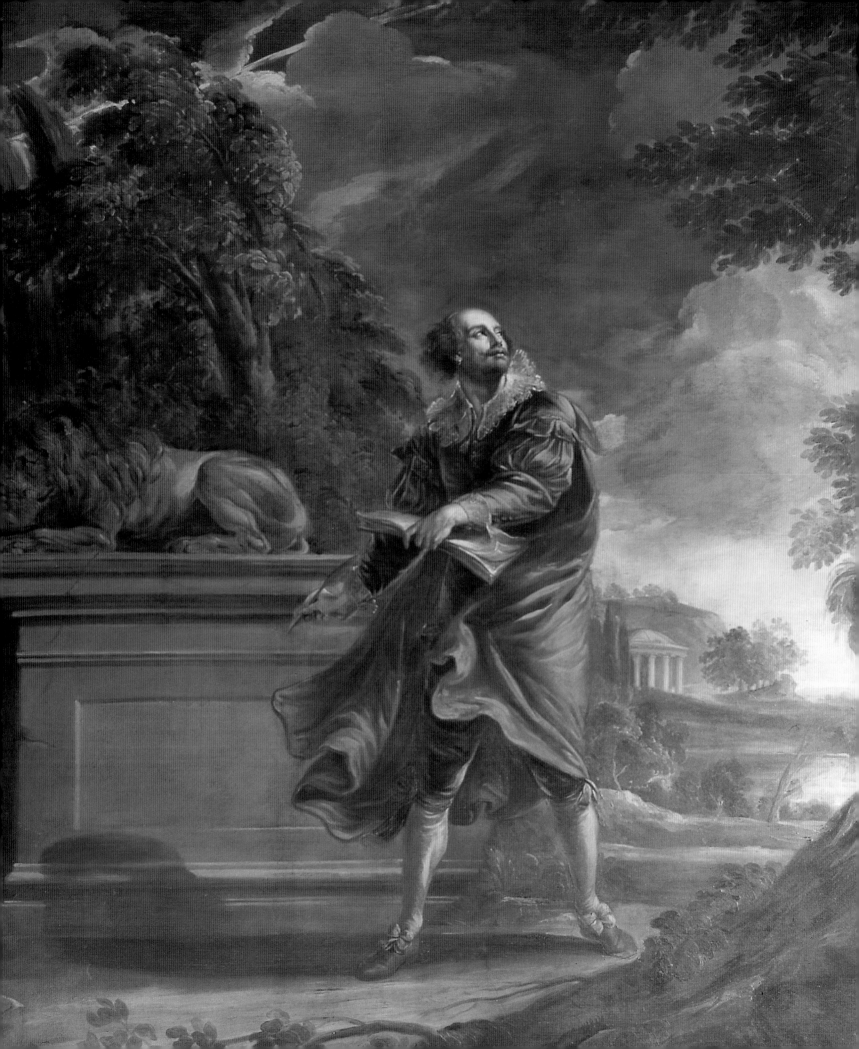

BARDOLATRY

JANE MARTINEAU

Garrick's Jubilee celebrations at Stratford-upon-Avon in 1769 elevated Shakespeare to the status of England's national saint. Although the term Bardolatry was invented much later by George Bernard Shaw, from the time of the Jubilee the cult of Shakespeare demanded many of the trappings of sanctity: an iconic likeness, places of pilgrimage, relics, and legendary anecdotes of his life.

THE ICON

Shakespeare, like his contemporaries, would have expected portraits to be lifelike; the sculpted monuments of the time were coloured for greater verisimilitude. But, whereas the image of Ben Jonson lives in his portraits, the only two authenticated likenesses of Shakespeare are decidedly second-rate. "Reader, Looke/ Not on his Picture, but his Booke", Jonson wisely admonished those confronted with the engraving of Shakespeare on the title page of the First Folio of 1623. Martin Droeshout the Younger (1601–after 1639) crudely portrayed Shakespeare as the archetypical egg-head (fig. 1, p. 8). The original from which the engraving is taken may have been drawn from life when Shakespeare was in his forties (his dress has been dated c. 1600–10). The engraving subsequently went through so many printings that even the meagre skill of the artist was obscured, but the inclusion of a portrait in the First Folio started a tradition; from Nicholas Rowe's edition of the *Works* in 1709, almost every new edition included a portrait.

The other early portrait, the memorial in Holy Trinity Church, Stratford-upon-Avon, is the work of Gerard Johnson the Younger, a sculptor of limited skill (see pl. 76), but presumably it was approved by Shakespeare's family. It emphasized two aspects of the poet: his scholarly status and his armorial bearings, which took Shakespeare so much trouble to obtain. Already in 1749 the monument was in a bad state when the actor–manager John Ward staged a benefit performance of *Othello* at Stratford to pay for its restoration. In 1793 the Shakespearean scholar Edmond Malone had the effigy whitewashed

in a misguided attempt to bestow on it Neo-classical decorum; its colours were restored only in 1861.

One other supposed portrait of Shakespeare, the Chandos portrait (National Portrait Gallery, London), entered the canon of 'reliable' likenesses in the early eighteenth century and was subsequently much copied. It is conceivably his portrait from life. To a present-day eye it is the most arresting and credible portrait, but the chance of finding positive proof of its identity is remote. These three portraits are the icons to which all other purported likenesses – mostly spurious – have been compared.

Such an elusive image of England's greatest writer was tantalizing to later generations. Two men did more to elevate Shakespeare than any others, and both identified with him: David Garrick seeing himself as his hero's descendant as actor–manager, and Sir Walter Scott assuming the role of Britain's second Bard. As well as his triumphs in the theatre, Garrick was largely responsible for the cult, the relics and the pilgrimage to Stratford-upon-Avon; Scott, through the example of his historical novels, spurred nineteenth-century painters to recreate Shakespeare's life.

Garrick's relationship was both reverent and intimate, as reproductions of Gainsborough's portrait of the actor with Shakespeare's bust, presented by Garrick to Stratford at the time of the Jubilee, suggest (see fig. 16, p. 33). Garrick attempted to persuade Gainsborough to paint a portrait of his idol between Tragedy and Comedy, but Gainsborough despaired at the task: "a Stupider Face I never beheld … I intend … to take the form from his Pictures & Statues just enough to preserve his likeness *past the doubt of all blockheads* … and supply a *Soul* from his Works – it is impossible that such a Mind, and Ray of Heaven, could shine, with such a Face & pair of Eyes … so as I said before damn *that*" (letter to Garrick, August 1768).

Garrick styled himself "Great Shakespeare's priest"; inevitably he needed a temple in which to worship his deity. Louis-François Roubiliac (1702–1762) carved a life-sized statue (1758; now The British Library, London) for Garrick's elegant Shakespeare temple designed by Robert Adam in the garden of his Thames-side villa at Hampton (fig. 56, p. 202). To help Roubiliac obtain a likeness, Sir Joshua Reynolds copied the Chandos portrait, and the sculptor made a second copy of

OPPOSITE Fig. 55 Giovanni Battista Cipriani (1727–1785), *Shakespeare striding through a storm-ridden landscape*, c. 1770, wall-painting commissioned by Henry Dawkins in 1766 for the music-room at Standlynch House, now Trafalgar Park, Wiltshire

Fig. 56 Johann Zoffany (1733–1810), *Mr and Mrs Garrick by the Shakespeare Temple*, 1762, oil on canvas, 99.7 × 125 cm (39¼ × 49⅛ in.), Yale Center for British Art, Paul Mellon Fund, New Haven CT

it himself (Government Art Collection, London), but Garrick himself is believed to have assumed the pose of the Bard standing at his desk in the throes of composition. Visitors were provided with chairs to contemplate the temple while tea was served.

Scott's devotion to Shakespeare encompassed more than literary admiration; as well as worshipping at the shrine in Warwickshire (see pl. 74), he rejoiced in sharing the initials 'WS', and persuaded the sculptors George Bullock and Francis Chantrey to compare his physiognomy to the Stratford bust. In Scott's works his heroes and heroines live alongside historical characters, and the daily lives of the famous are made real, Shakespeare's included; from the 1820s it became respectable for artists to paint historical genre scenes.

In 1824 James Boaden published his treatise on the portraits of Shakespeare. By that date many artists had attempted to provide a living image (see pls. 72, 73). Ford Madox Brown was only one of many who "carefully collated from the different known portraits, and more than any other from the bust at Stratford. The picture is an attempt to supply the want of a credible likeness of our national poet, as a historian recasts one tale, told long since by old chroniclers in many fragments" (1849; Manchester City Art Galleries).

To what use were such icons put? The Augustan poets, emulating their predecessors, decorated their libraries with portraits of famous writers; from the late seventeenth century the inclusion of Shakespeare became obligatory. For John Dryden, Shakespeare was the "Homer of our British poets"; he was presented with a copy of the Chandos portrait by Godfrey Kneller in 1689. The busts in Alexander Pope's library were by the Antwerp sculptor Peter Scheemakers the Younger (1691–1781); Pope, whose edition of the *Works* appeared in 1725, wrote: "I keep the pictures of Dryden, Milton, Shakespeare, etc, in my chamber, round about me, that the constant remembrance of 'em may keep me always humble." The largest collection belonged to Pope's patrons, the Earls of Oxford, whose supposed portrait of Shakespeare was the basis of many others (see pl. 72). In Lord Chesterfield's house in Mayfair (1750, demolished 1934) Shakespeare hung in pride of place in the library.

A proto-Romantic vision of Shakespeare decorated the music-room of Henry Dawkins at Standlynch House (now Trafalgar Park) in Wiltshire. Around 1770, Giovanni Battista Cipriani (1727–1785) painted the walls with a sweeping panoramic landscape in which demure ladies symbolize the Arts and Venus in her chariot, while on

another wall, wandering alone through a landscape wracked by storm, stalks Shakespeare in the grip of divine inspiration (fig. 55, p. 200). Holding folio and quill pen, wearing an earring, as in the Chandos portrait, wrapped in his cloak,

> The poet's eye, in a fine frenzy rolling,
> Doth glance from heaven to earth, from earth to heaven;
> And as imagination bodies forth
> The forms of things unknown, the poet's pen
> Turns them to shapes, and gives to airy nothing
> A local habitation and a name. (V. i. 12–17)

Theseus's lines from the last act of *A Midsummer Night's Dream* are inscribed on a scroll near his feet. On a more modest scale, the poet William Hayley (1745–1820), patron of Romney and Blake, coerced Blake into painting a pantheon of eighteen poets, including Shakespeare, in his library at Felpham, near Chichester. Walter Scott had a cast of the bust in Holy Trinity presiding over his new library at Abbotsford (see pl. 73).

The architect John Soane was another bardolator. In 1829 he designed a shrine, the Shakespeare Recess, on the landing of his house in Lincoln's Inn Fields, London, decorated with a cast of the Stratford bust and Henry Howard's painting of *The Vision of Shakespeare* among other paintings, including one of the more curious works of Shakespearean devotion. Clara Maria Leigh (1760s–1838), once married to the artist Francis Wheatley, painted a watercolour of *Flowers of Shakespeare* (RA 1835; fig. 57), which contains every bloom mentioned in his works.

By the early eighteenth century concern was growing over the absence of a public monument to Shakespeare in the capital. From the 1720s several new monuments were added in Poets' Corner in Westminster Abbey, among them those to Jonson and to Shakespeare's first biographer, Nicholas Rowe. A committee that included Lord Burlington, Alexander Pope and William Kent was established; to raise funds the managers of Covent Garden and Drury Lane staged benefit performances. The monument, designed by Kent and sculpted by Peter Scheemakers, was unveiled in January 1741; "The poet is attired in the dress of his time, natural free and easy", reported the *Daily Post*, but Pope greeted the monument with the doggerel: "After an hundred and thirty year's nap/ Enter Shakespeare with a loud Clap".

Shakespeare's image was adapted for theatre decoration. John Rich, manager of Covent Garden Theatre, had the Muses crowning Shakespeare painted over the stage (before 1733); around 1737 William Oram (died 1777) painted the heads of Shakespeare, Dryden, William Congreve and Thomas Betterton in Goodman's Fields, the theatre in which Garrick made his début; and the Crow Street

Fig. 57 Clara Maria Leigh (1760s–1838), *The Flowers of Shakespeare*, exhib. Royal Academy 1835, watercolour on paper, Courtesy of the Trustees of the Sir John Soane Museum, London

Theatre in Dublin had a drop-scene of the daunting subject of *Euterpe and Hercules conducting the infant Shakespeare to the Temple of Minerva* painted by Gaetano Marinari (*fl.* 1784–1834). While Shakespeare's image could be exploited as a mere sign of excellence – the publisher John Tonson had his head as his shop sign, and Samuel Wale (*c.* 1720–1786) painted a full-length figure of Shakespeare for a public house in Drury Lane – he was more often, as at Westminster Abbey, used as a patriotic symbol. Over the doorway of Boydell's Shakespeare Gallery at 52 Pall Mall was Thomas Banks's relief sculpture *Shakespeare between the Muse of Comedy and the Genius of Painting* (now in the garden at New Place, Stratford-upon-Avon).

Nineteenth-century monuments glorifying the arts invariably included Shakespeare. With Homer and Dante he forms a central triumvirate of writers on H.H. Armstead's and J.B. Philip's frieze on the Albert Memorial (1872); the financier Albert Grant provided Shakespeare with a monument in the heart of London's theatre district in 1874 when he paid £25,000 to create the garden and erect Shakespeare's statue in Leicester Square. In Stratford-upon-Avon a

new monument was unveiled in 1888; the work of the amateur sculptor Lord Ronald Gower (1845–1916), Shakespeare sits surrounded by the figments of his imagination: Hamlet, Falstaff, Henry V and Lady Macbeth. Gower was following the example of Gustave Doré's Parisian monument to Alexandre Dumas *père* (1885). In a speech at the unveiling Oscar Wilde said that this "poetic work" signalled "some new birth of art taking place in England". While this was wishful thinking, the monument still has popular appeal.

WORSHIP AND PILGRIMAGE

Devotion to Shakespeare takes many forms. The first visual homage was made by the writer Sir John Suckling, who chose to be painted by Anthony van Dyck standing out of doors reading *Hamlet* in an unwieldy folio edition (*c.* 1637–38; The Frick Collection, New York). According to Rowe, Suckling was "a professed admirer of Shakespeare's" and took his part against Jonson in conversation with William Davenant and Endymion Porter.

By the eighteenth century it became fashionable for actors to be portrayed with the bust of the bard: an early example is Francis Hayman's portrait of Hannah Pritchard (1750; Garrick Club, London, no. 696). Gainsborough made a masterly full-length portrait of the Irish actor James Quin seated beneath a miserable version of Shakespeare's bust (exhibited in 1763; National Gallery of Ireland, Dublin); when, a few years later, Gainsborough painted Garrick for Stratford-upon-Avon he integrated the portrait of the actor and the bust of the playwright, emphasizing Garrick's casual intimacy with his idol in his insouciant pose as he leans against the plinth. Garrick admonished his protégé William Powell: "Never let your Shakespeare be out of your hands … keep him about you as a charm". John Hamilton Mortimer painted Powell with his wife and daughters adorning Shakespeare's bust in an elegant landscape setting (1768; Garrick Club, London, no. 695). James Northcote had the infant prodigy Master Betty in the guise of Hamlet prancing beneath the bust (1805; pl. 40). Some sitters assumed Shakespearean characters: Reynolds painted Mrs Richard Lloyd carving her husband's name in a tree trunk in the manner of Rosalind in *As You Like It* (1776; Private Collection), and William Hayley had his son Thomas Alphonso, aged eleven, painted by Romney as *Robin Goodfellow in 'A Midsummer Night's Dream'* (Tate, London).

The rich could afford to people their houses with Shakespeare's characters. From 1843 to 1863 J.G. Lough (1798–1876) sculpted a series of Shakespearean characters and an elaborate frieze with Shakespeare in its centre for the staircase of Sir Matthew White Ridley's London house at 10 Carlton House (now Victoria and Albert Museum, London, and Blagdon, Northumberland). The engineer Isambard Kingdom Brunel's conceit was to have an Elizabethan-style dining-room adorned with paintings illustrating Shakespeare's plays (see pp. 219–20). Shakespeare and food again seem to have been associated

Fig. 58 Lord Ronald Gower (1845–1916), Shakespeare, from the Shakespeare Monument, 1888, bronze, Stratford-upon-Avon

in the creation of the monumental ornate sideboard featuring Shakespeare surrounded by numerous scenes from his plays carved by Thomas Tweedy and Gerrard Robinson (Shipley Art Gallery), exhibited at the International Exhibition in London in 1862.

Pilgrimage to Stratford-upon-Avon was well established by the time of the Jubilee; it affected visitors in different ways. Washington Irving was at least amused by the experience of being shown round the birthplace by the dreadful concierge Mrs Hornby, who displayed a motley collection of relics including the alleged sword with which Shakespeare played Hamlet and a box supposedly presented to him by the King of Spain, but Nathaniel Hawthorne was "conscious of not the slightest emotion … , nor any quickening of the imagination". In 1847 the house was bought by the Shakespeare Birthplace Committee after a public campaign in which Charles Dickens played a prominent role. Shakespeare's house, New Place, was bought in 1753 by the Revd Francis Gastrell; he was so vexed by visitors demanding to see Shakespeare's mulberry tree that in 1756 he chopped it down, capping this act of iconoclasm by demolishing the house in 1759. The monument in Holy Trinity was firmly established on the pilgrimage route (see pl. 74). In 1828 Benjamin Robert Haydon declared: "The most poetical imagination could not have imagined a burial place more worthy, more suitable, more English, more native for a poet than this."

In all cults fact merges with fiction. In Venice the fourteenth-century Palazzo Contarini Fasan on the Grand Canal was known in the nineteenth century as the house of Desdemona, and the palace of the Moro family in the Campo del Carmine is listed as Othello's house in guidebooks of the time. In Verona, a hat (*cappello*) sculpted on an arch in the courtyard of an inn on Via Cappello gave rise to the legend that the house had once belonged to the Capulet family; it was known as the house of Juliet before "the barbarian *Sacchespir* became known to the Italians"; her tomb, it was claimed, was in the cloister of the Capuchins. From the 1820s tourists arrived in droves; Heinrich Heine was there in 1828. Dickens, visiting Verona in November 1844, found the house "degenerated into a most miserable little inn … ankle deep in dirt". As to the tomb, he thought "it is better for Juliet to lie out of the track of tourists". The red Verona marble 'tomb', used as a water trough before being elevated to the status of a shrine, was plundered by Napoleon's former wife, Maria Luigia, Duchess of Parma, who had a necklace, bracelets and earrings made from its stone.

RECREATING THE LIFE

Each generation reinvents its heroes in its own spirit. Eighteenth-century painters liked to depict Shakespeare as the 'untutored child of nature' as in the versions of Angelica Kauffmann (see pl. 72), and Romney was another 'untutored genius' who identified with Shakespeare. His paintings of the infant Shakespeare (Stratford-upon-Avon and National Trust, Petworth House, West Sussex) were inspired by Thomas Gray's 'The Progress of Poesy', his most melodramatic image being a cartoon of *Nature unveiling herself to Shakespeare* (Walker Art Gallery, Liverpool); "To him the mighty Mother did unveil/ Her aweful face; the dauntless Child/ Stretch'd forth his little arms and smiled".

The actor–manager Charles Kemble, who dedicated his career to creating historically accurate productions of Shakespeare plays at Covent Garden Theatre (see pls. 46–48), also staged Charles A. Somerset's *Shakespeare's Early Days* in 1829, with himself in the lead. The scenery by the Grieve family (fig. 46, p. 152) is picturesque; the dialogue, archly archaizing. After being condemned by Sir Thomas Lucy for poaching, young Willy runs away to London where happily he meets the actor Richard Burbage, presents him with the manuscript of *Hamlet* and saves the Earl of Southampton from drowning. In the last act the queen hears the rousing news of the defeat of the Spanish Armada, presents Will with her portrait and commands Lucy to forgive the recreant.

Shakespeare and monarchy was a heady mixture for patriotic Victorian audiences; enthusiasm for the young Queen Victoria, who succeeded to the throne in 1837, generated a spate of paintings of Elizabeth I and the Bard. David Scott's *Queen Elizabeth Viewing the Performance of 'The Merry Wives of Windsor' in the Globe Theatre* (1840;

Theatre Museum, London) is typical in attempting an accurate recreation of the theatre while displaying a blithe disregard for historical fact. Queen Victoria frequently attended the public theatre; Queen Elizabeth would never have entered such a place. The stage is crowded with actors; anachronistically the female roles are played by women. Several generations of courtiers and all the literary crowd are there. A more historiographic approach was taken by Henry Wallis who, at the instigation of John Forster, recorded *The Room in which Shakespeare was Born* (RA 1854; untraced) and *In Shakespeare's House* (Victoria and Albert Museum, London; sketch Shakespeare Birthplace Trust).

As Victorian gentlemen frequented their West End clubs, so Shakespeare was assumed to have discussed literature with his confrères in the taverns off Cheapside (see pl. 75). His early escapades were also illustrated; Thomas Brooks's *Shakespeare before Lucy* (1862; Royal Shakespeare Company Collection, Stratford-upon-Avon) looks like the confrontation between a Victorian poacher and gamekeeper. Characteristically George Cruikshank reverted to the whimsical in *The First Appearance of William Shakespeare on the Stage … in 1564* (RA 1867; Yale Center for British Art, New Haven CT). Framed by a proscenium typical of a Victorian toy theatre, Shakespeare lies in his cradle surrounded by the characters he will create, transported safely to the nineteenth-century nursery.

Exhausted by such bardolatry, Max Beerbohm, in his essay 'On Shakespeare's Birthday' (1909), envisaged the devotees of Francis Bacon succeeding in proving their candidate's authorship of the plays. Then he could witness "the downfall of an idol to which for three centuries a whole world had been kneeling": he imagines the dissolution of all Shakespeare societies, the Leicester Square statue vandalized, and Anne Hathaway's cottage, shipped to New York by Mr J. Pierpont Morgan at a cost of £2,000,000, declared to be worthless.

SELECT BIBLIOGRAPHY

Shaw 1901; Beerbohm 1909; Manners and Williamson 1920, p. 142; Lenotti 1951; Halliday 1957; Boase 1960; Haydon, *Diary*, III, pp. 293–94; Piper 1964; Webster 1967; Strong 1969, I, pp. 279–83, no. 1; Croft-Murray 1970, II, pp. 185, 190; Buxton 1979; Schoenbaum 1981; Piper 1982; Altick 1985, pp. 142–50; Fowler 1986, pp. 23–38; Ward-Jackson 1987; Allwood 1988; Postle 1991; Schuckman 1991; Roscoe 1994; Faberman and McEvansoneya 1995; Dickens, *Pictures from Italy*, ed. Flint 1998, pp. 86–89, 199; Roscoe 1999, p. 203; Liverpool, London and San Marino CA 2002

LIVERPOOL JOHN MOORES UNIVERSITY
LEARNING SERVICES

72
ANGELICA KAUFFMANN (1741–1807)
Ideal Portrait of Shakespeare

Before 1781
Oil on canvas
136 × 94 cm (53½ × 37 in.)
From the Royal Shakespeare Company Collection with the permission of the Governors of the Royal Shakespeare Theatre, Stratford-upon-Avon, inv. 3

Angelica Kauffmann based her portrait of Shakespeare on George Vertue's engraved portrait made as the frontispiece for Alexander Pope's edition of Shakespeare (1723–25). This was published by Jacob Tonson, who used Shakespeare's head as his shop sign. Vertue's source was a miniature, believed to be of Shakespeare, in the collection of Robert Harley, 1st Earl of Oxford (1661–1724), the friend and patron of Pope and Vertue. Spielmann suggested (1913) that this painting may have been commissioned by Garrick or a publisher. Could this have been the model for Tonson's sign?

The portrait of Shakespeare is, at best, vapid. Kauffmann's compatriot Fuseli commented on the limitations of her facile, if immensely popular style: "The male and female characters of Angelica never vary in form, feature or expression from the favourite ideal of her own mind. Her heroes are all the man to whom she thought she could have submitted, though him, perhaps, she never found." Kauffmann married first an imposter posing as Count Horn and secondly in 1781 the painter Antonio Zucchi, returning with him to Italy that year.

The vignette of *Fame Decorating the Tomb of Shakespeare* beneath Shakespeare's bust was painted by Kauffmann in several versions (e.g. Burghley House, Lincs, oil on copper). It was engraved by Francesco Bartolozzi in 1782 with lines from John Gilbert Cooper's *The Tomb of Shakespeare: A Poetical Vision* (1755): "Here fancy stood (her dewy fingers cold)/ Decking with flow'rets fresh th'unsullied sod/ And bath'd with tears the sad sepulchral mold/ Her fav'rite Offspring's long and last abode." It and a pendant of *The Birth of Shakespeare* were painted for Lady Rushout of Northwick Park, daughter of Kauffmann's patron George Bowles.

Born in Switzerland and promoted by her father, Angelica Kauffmann had to decide between a career as a painter or singer. Travelling through Italy in 1763 she met Garrick in Naples; her portrait of the actor was exhibited in London in 1764 (now Burghley House, Lincs). She arrived in London in June 1766 and quickly established herself as a fashionable painter of portraits and historical and literary themes. In 1768 she was one of only two women admitted as founder members of the Royal Academy of Arts. Patronized by the royal family, admired by Garrick and Goldsmith, she flirted with Nathaniel Dance, Fuseli and Reynolds, and worked particularly successfully with Robert Adam, producing decorative paintings that complemented his architecture. In 1769 she, together with G.B. Cipriani and Dance, contributed scenery to Garrick's entertainment, *The Jubilee*, played at Drury Lane. Her portrait *Elizabeth Hartley as Hermione in 'The Winter's Tale'* (1774; Garrick Club, London,

no. 291), showing the actress in the statue scene that she played at Covent Garden in March 1774 and 1779, is stylistically close to this Shakespeare painting.

Kauffmann was living in Rome when Josiah Boydell invited her to contribute to his Shakespeare Gallery. She sent him two works: *Valentine Proteus, Sylvia and Julia in the Forest* from *Two Gentlemen of Verona* (1788; Wellesley College MA) and *Cressida and Diomed* from *Troilus and Cressida* (National Trust, Petworth House, West Sussex). This last scene she found hard to paint: *"es ist schwer aus einem Sujet das an sich selbsten nicht viel heist, etwas herauszubringen"* (it is difficult to make something out of a subject that does not say much to one), as she complained in a letter of 21 September 1788 to Goethe, who also professed a sentimental attachment to Angelica. She was paid 200 guineas per canvas, a low rate given that Benjamin West and Reynolds got 1000 guineas apiece, Romney 600 guineas and even Wright of Derby 300 guineas. In 1782 she painted ovals of *Miranda and Ferdinand* (Österreichische Galerie, Vienna) and *Pyramus and Thisbe* for the engraver James Birchall of London. A secretaire bookcase is decorated with two scenes of *Antony and Cleopatra* after her designs (*c.* 1786; Lady Lever Art Gallery, Birkenhead). JTM

PROVENANCE Presented to Stratford-upon-Avon by Mr Henry Graves, 1883

BIBLIOGRAPHY Spielmann 1913; Manners and Williamson 1924, p. 209; London 1955, nos. 10, 11; Stratford-upon-Avon 1970, pp. 5–6, no. 3; Rome 1998, pp. 102–03

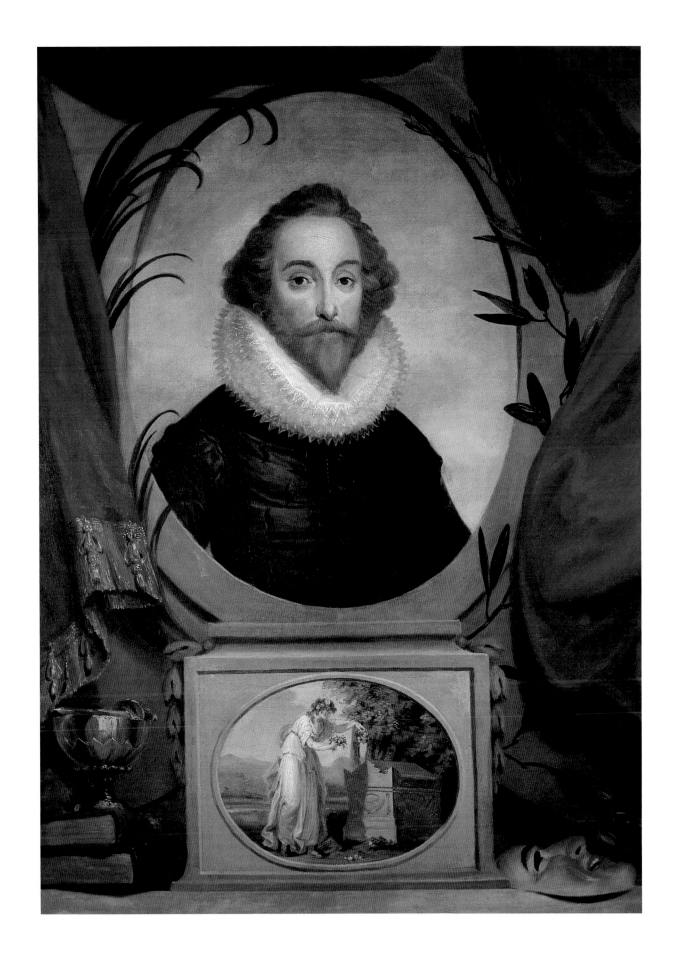

73
WILLIAM BLAKE (1757–1827)
Imaginary Portrait of Shakespeare

1800–03
Tempera over ink on canvas
41 × 79.5 cm (16⅛ × 31¼ in.)
Manchester City Galleries, inv. 1885.2

From September 1800 to September 1803 Blake lived in a cottage at Felpham near Chichester on the estate of the dilettante writer and poet William Hayley (1745–1820), who had built a new house, the Turret, there in 1797. Hayley was a generous patron to John Flaxman and George Romney, writing the latter's biography, and in 1786 at Boydell's dinner party had recommended Joseph Wright of Derby to contribute to the Shakespeare Gallery.

While Hayley evidently delighted in Blake's company, at first he seems to have employed him chiefly to engrave illustrations for his biography of the poet William Cowper, but in November 1800 he entrusted him with the task of decorating his library at the Turret with portraits of poets. Such schemes were in vogue with the Georgians: Alexander Pope had sculpted busts of his literary gods in his study; Hayley, with less cash, decided on grisaille paintings imitating stone busts, wreathed with garlands and flanked with illustrations from each writer's work. Their narrow format was presumably designed to fit above bookshelves.

Initially Cowper was to have been given pride of place, but after Thomas Alphonso, Hayley's illegitimate son, died in May 1800, the library became his memorial; his portrait hung over the fireplace with the rest arranged around in pairs. By 1803 there were portraits of eighteen poets, nine native, nine foreign. Hayley's selection was eccentric. Some are obvious choices – Homer, Demosthenes, Cicero, Dante, Tasso; those belonging to the English canon – Chaucer, Spenser, Shakespeare, Milton – would have appealed to Blake; Voltaire, whom Blake had read and hated, did not. Some – Alonso de Ercilla y Zuñiga (1533–1594) and Luiz vaz de Camoens (?1524–1580) – are downright eccentric, a testament to Hayley's voracious reading. Friedrich Gottlieb Klopstock, who died in 1803, was added at the last minute.

Blake had a profound love of Shakespeare and the English poets, and spent much of his time at Felpham writing his poem *Milton*. He based Shakespeare's head on the engraving by Droeshout in the First Folio. His bust is wreathed with convolvulus, while fronds of yew hang over the flanking scenes of Macbeth and the witches (on the right) and Banquo's ghost pointing to his successors ruling as kings of Scotland (left). Thomas Hayley had worked as apprentice to the sculptor John Flaxman, and these small scenes may have been based on his designs.
JTM

PROVENANCE William Hayley; his cousin Captain Godfrey, 1820; sold, *c.* 1840; William Russell, by 1863; sold Christie's, 5–6 December 1884; bought by Agnew's; purchased by Manchester City Art Gallery, 1885

BIBLIOGRAPHY Bishop 1951, pp. 250–83; Johnston 1969 pp. 3–5; Croft-Murray 1970, II, pp. 71–72, 171–72; Bindman 1977, pp. 132–34; Butlin 1981, II, pp. 297–302

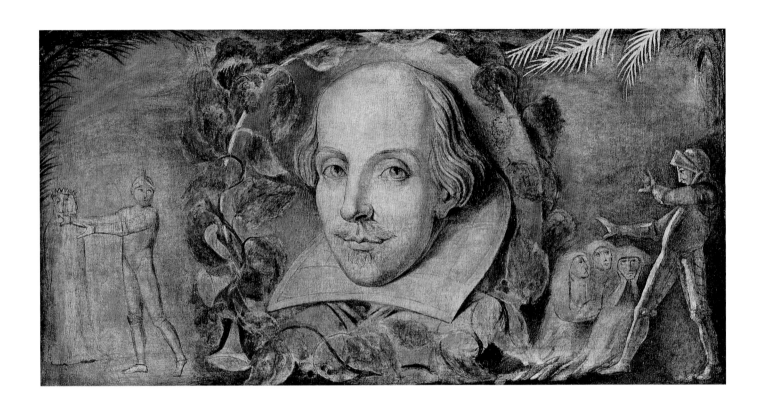

74

ATTRIB. DAVID ROBERTS (1796–1864)
Sir Walter Scott at Shakespeare's Tomb

?1840–45
Oil on canvas
99 × 73.6 cm (39 × 29 in.)
Shakespeare Birthplace Trust, Stratford-upon-Avon, inv. Strst.sbt.1969-11

In April 1828 Sir Walter Scott was in Stratford-upon-Avon and "visited the tomb of the mighty wizzard. It is in the bad taste of James the First's reign; but what a magic does the locality possess! There are stately monuments of forgotten families; but when you have seen Shakspeare's what care we for the rest?" The same day he went on to Charlecote Park, "the hall of Sir Thomas Lucy, the justice who rendered Warwickshire too hot for Shakspeare and drove him to London" (*Journal*, 8 April 1828). Scott had already visited Stratford in 1821; then he incised his name in the room in which Shakespeare was born. That year he alluded to the story of Shakespeare poaching deer in Charlecote Park in *Kenilworth* (II, chapter 5); too late, Lucy's descendant, whom Scott met in 1828, told him that the incident took place at another Lucy house.

The furniture designer and sculptor George Bullock (died 1819) took casts of Shakespeare's portrait-bust in Holy Trinity in 1814 at the instigation of the antiquary John Britton. Bullock was introduced to Scott by J.B.S. Morritt in 1816, and the same year presented Scott with one of the casts. Bullock also designed a pedestal for it. Scott wrote to Morritt: "now I have only to arrange a proper shrine for the Bard of Avon since you have fitted him with an altar worthy of himself. The figure came safe, and the more I look at it the more I feel that it must have resembled the Bard much more than any of the ordinary prints The forehead is more expanded, and has not a narrow, peaked, and priggish look inconsistent with the dignity of Shakespeare's character" (22 November 1816). In 1825 the bust was moved into the niche in Scott's new library at Abbotsford.

Scott's devotion to Shakespeare encompassed more than literary admiration; he identified with him, enjoying the fact that they shared the initials 'WS', and getting Bullock to take his life-cast to compare their physiognomies, which he did with the German phrenologist Dr Spurzheim. The sculptor Sir Francis Chantrey (1781–1841) also measured Gerard Johnson the Younger's bust of Shakespeare to demonstrate the similarity of the two bards' skulls. After Scott's death, Chantrey's bust of Scott replaced that of Shakespeare in the library.

In this painting, Scott stands lost in contemplation in the chancel of Holy Trinity, where Shakespeare lies buried. Light floods in the south windows and a wintry dawn is seen through the great east window. Johnson's bust of Shakespeare still bears the whitewash inflicted on it by Edmond Malone in 1793. The piece of carpet that usually covered Shakespeare's tomb slab in the chancel has been thrown on to a tomb chest. Brooding on the tomb in the 1820s, Scott may already have been planning his own burial place in the ruins of Dryburgh Abbey.

The painting was attributed to Sir William Allan (1782–1850) by Mr Hutchinson, which Francis Russell (1987) thought "plausible but not certain". What seems to be an early torn label on the back of the painting reads: "… Roberts RA 820." While Allan was one of Scott's favourite artists, a personal friend who painted him at Abbotsford several times, David Roberts (who worked as a scene-painter with Clarkson Stanfield early in his career and subsequently gained fame for his church interiors and landscapes of the Middle East) was also in his orbit. In 1831 Roberts went to Abbotsford to complete the series of drawings for *The Antiquities of Scotland*, which he etched himself. He also drew several rooms at Abbotsford, some of which were included in *Landscape Illustrations of the Waverley Novels*; a watercolour of *Abbotsford, the Hall* is in Glasgow Art Gallery. Around 1834 Roberts was invited to submit sketches for Scott's monument in Edinburgh; he made two drawings, one in the Egyptian, the other in the Gothic style, but his preferred scheme was thought too expensive, though in 1854 he designed four stained-glass windows for the Museum Room of the monument. He was in the Stratford area some time in or before 1842, when he painted *The Interior of the Church at Stanford-on-Avon* for Baroness Braye (Stanford Hall, collection of Lord Braye), and in Birmingham in October 1843. On either occasion he could have drawn the interior of Holy Trinity, adding Scott's figure as a posthumous tribute to the other bard. Krystyna Matyjaskiewicz has observed, in correspondence with the present writer, that Allan and Roberts were friends who, on at least one occasion in 1835, collaborated on a painting, with Roberts painting the background and Allan adding a view through a window. Could this be another case of collaboration?

JTM

PROVENANCE Anon. sale, Christie's, as Wilkie, 20 November 1968, no. 39; bought by Agnew's; acquired by the Trust from Agnew's, 1969 (31474), attrib. Sir William Allan

BIBLIOGRAPHY Britton 1840; Wainwright 1977; Russell 1987, p. 28, no. 15 (as attrib. to Allan); Christian in Tokyo *et al.* 1992–93, p. 162, no. 5 (as attrib. Allan)

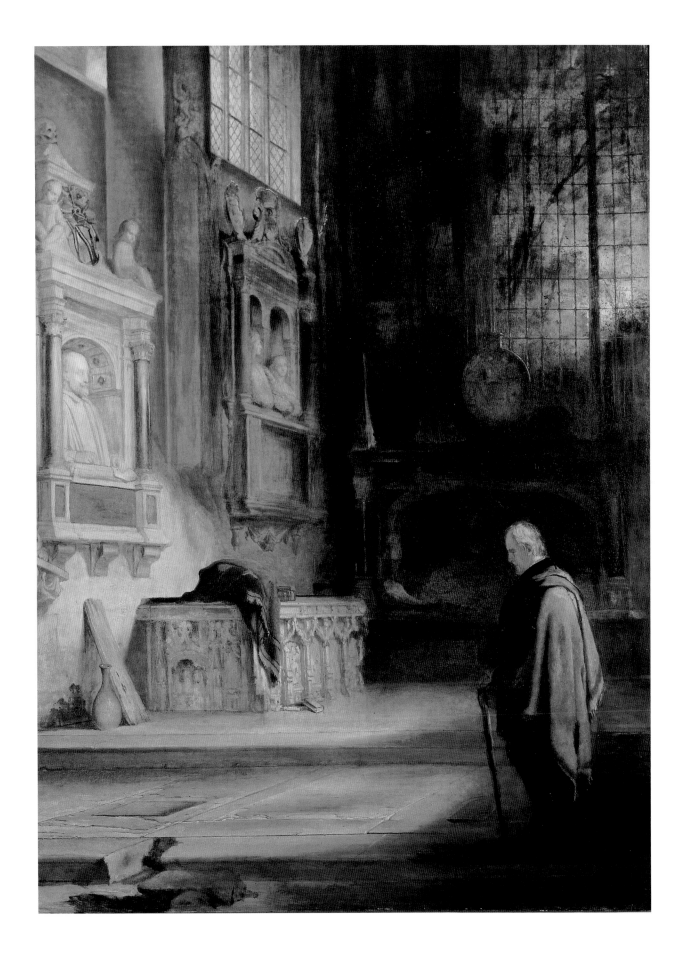

75
JOHN FAED (1819–1902)
Shakespeare and his Friends at the Mermaid Tavern

Signed and dated *J. Faed 1850*
1850
Oil on board laid on panel
38.1 × 46.7 cm (15 × 18⅜ in.)
Private Collection

The setting is the Mermaid Tavern on the corner of Bread Street and Friday Street, east of St Paul's Cathedral. Its proprietor was William Johnson, with whom Shakespeare bought a house in Blackfriars in March 1613. Books, pens, inkwells and papers are scattered over the table and floor. The Mermaid Club, also known as the Friday Street Club, is in session. This association is first mentioned in William Gifford's edition of *The Works of Ben Jonson* (1816). Gifford claimed the club was founded by Sir Walter Raleigh some time before his imprisonment in the Tower of London in 1603 and was frequented by Jonson, Shakespeare, Beaumont, Fletcher, Cotton, Carew, Martin, Donne and others.

The characters are identified by inscriptions on the frame; reading from the left they are: seated at the table, the antiquary and historian William Camden (1551–1623), author of *Britannia*; Thomas Sackville, 1st Earl of Dorset (1536–1608), Lord Chancellor to Elizabeth I and James I, but here in his capacity of playwright and poet; the playwright John Fletcher (1579–1625); and the statesman and writer Francis Bacon (1561–1626), the true author of Shakespeare's works according to Bacon's adherents; behind them stand the poet Joshua Sylvester (1563–1618); partly obliterated is the lawyer John Selden (1584–1654), friend of Jonson and Cotton; and the playwright Francis Beaumont (1584–1616). Seated opposite are the playwright Ben Jonson (1572–1637); the poet and courtier Thomas Carew (?1595–?1639); and the poet and divine John Donne (?1571–1631), who sits beside Shakespeare. Standing near the fireplace is the adventurer and poet Sir Walter Raleigh (?1552–1618); he leans on the shoulder of Shakespeare's patron Henry Wriothesley, 3rd Earl of Southampton (1573–1624); seated are the bibliophile Sir Robert Cotton (1571–1631); and the playwright Thomas Dekker (1570–1632), who had a hand in writing the play *Sir Thomas More*, on which it has been suggested Shakespeare may also have helped.

That such a heterogeneous group of statesmen, scholars, playwrights, actors and courtiers would have met in this way is unlikely, but beside the point. For Faed's generation this distinguished gathering elevated Shakespeare's status as a man of letters. Schoenbaum (1970) thought the Mermaid Club was Gifford's invention, but Duncan-Jones (2001) remarks that there is "plenty of contemporary evidence that such meetings happened". Shakespeare, presumably, visited his business partner's inn. Writing to Ben Jonson from the country, Beaumont remembered happy drinking days in London: "I lie, and dream of your full Mermaid wine … What things have we seen/ Done at the Mermaid! heard words that have been/ So nimble, and so full of subtle flame" (*Letter to Ben Jonson*). Jonson, too, conjured up "a pure cup of rich *Canary*-

wine,/ Which is the *Mermaids*, now, but shall be mine" (*Inviting a Friend to Supper*). John Keats, a passionate bardolator, wrote:

> Souls of poets dead and gone
> What Elysium have ye known
> Happy field or mossy cavern
> Choicer than the Mermaid Tavern?
> (*Lines on the Mermaid Tavern*)

This painting differs slightly from the large version (sold Sotheby's, 10 November 1998, lot 131, see Montgomery *et al*. 1985–86), which includes Samuel Daniel (1562–1619), author of *Hymen's Triumph*. It may be a preparatory model rather than a replica; Faed obviously had problems fitting so many literati around the table. The large version, exhibited at the Royal Scottish Academy in 1851, is said to have been made as a companion to *Sir Walter Scott and his Literary Friends at Abbotsford* by John's brother Thomas (Scottish National Portrait Gallery, Edinburgh).

The lives of famous artists and writers provided a rich source of subject-matter for many nineteenth-century painters. Even if the historical basis for their subjects was dubious, Faed and his contemporaries aimed at historical accuracy in portraiture, costume and setting, just as Charles Kean did in his theatre productions. To help him with such scenes, Faed was lent a trunk of historical costumes by Mr Tussaud of the waxworks, and the fireplace with its barley-sugar wooden columns is in high Victorian–Jacobean style. The characters are recognizable: for instance Bacon wears the high hat and ruff shown in his portrait by Paul van Somer, and Raleigh, with his trimmed beard and pearl earring, dressed in yellow doublet and red hose, resembles his portrait (both National Portrait Gallery, London).

Faed may also have had in mind his own drinking circle, called the Smashers' Club in Edinburgh. Shakespeare is said to have liked his drink, and according to one source even died of it: "Shakespear, Drayton and Ben Jonson had a merry meeting, and it seems drank too hard, for Shakespear died of a fever there contracted" (Revd John Ward, vicar of Stratford-upon-Avon, diary entry of 1661–63; Schoenbaum 1977).
JTM

PROVENANCE Christie's, London, sale, 4 November 1994, no. 77

BIBLIOGRAPHY Schoenbaum 1970, pp. 294–96; Schoenbaum 1977, p. 296; McKerrow 1982; Montgomery, New York and Chicago 1985–86, no. 23; Christie's sale catalogue, 4 November 1994, no. 77; Duncan-Jones 2001, p. 249

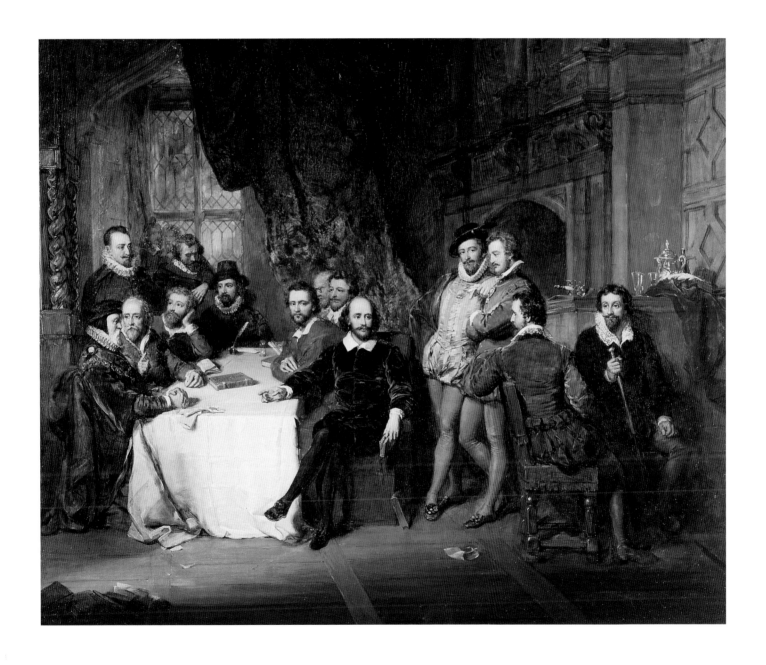

76

HENRY WALLIS (1830–1916)
A Sculptor's Workshop, Stratford-upon-Avon, 1617

Signed and dated on small maquette lower right *H Wallis 1857*
1857
Oil on canvas
39 × 53 cm (15⅜ × 21⅝ in.)
From the Royal Shakespeare Company Collection with the permission of the Governors of the Royal Shakespeare Theatre, Stratford-upon-Avon, inv. 113

On the banks of the River Avon a sculptor works on the bust for Shakespeare's monument in Holy Trinity Church, the tower and stone spire of which (added only in 1763) can be seen upstream. Ben Jonson holds Shakespeare's death mask for the sculptor to copy ("as a very intimate friend of the poet [he] would naturally have taken great interest in the monument and may have given suggestions on points of detail"; Wallis to Brassington). Three children play with toy farm animals, presumably also their father's work.

"The sculptor would have made a post-mortem mask of Shakespeare's head to work from", wrote Wallis. The inclusion of a death mask was topical: in 1849 the Kesselstadt Death Mask, said to be Shakespeare's and dated 1616, was 'found' – more probably fabricated – in Mainz and exhibited at The British Museum, causing great popular excitement.

"It is interesting to know that my supposed site of the workshop coincides with the spot on which the memorial has been built" (Wallis, *op. cit.*). The scene is, of course, apocryphal: Shakespeare's monument is the work of Gerard Johnson (or Gheerart Janssen) the Younger, the son of a Dutch sculptor of the same name who settled in England in the 1560s. It would have been carved in the family's workshop in Southwark (near the Globe Theatre) and transported to Stratford to be painted *in situ*. In 1857 whitewash still obscured the original colour of the effigy in Holy Trinity; it was repainted only in 1861, but Wallis knew it had once been coloured, since the small maquette of the whole monument shown in the foreground is polychromed.

Gerard Johnson Sr and his elder son, Nicholas, were responsible for the elaborate alabaster monument to the 1st Earl of Southampton, his wife and their son the 2nd Earl, in Titchfield Church, Hampshire, commissioned in 1592. On the base of the monument with its three full-length effigies, kneels the young Henry Wriothesley, 3rd Earl of Southampton, Shakespeare's patron, to whom he dedicated the poems *Venus and Adonis* (1593) and *The Rape of Lucrece* (1594). Shakespeare was probably staying at Titchfield to escape the plague in London in those years, and the new tomb would have been a remarkable object then, as it is now. Johnson the Younger also sculpted the tomb for Shakespeare's friend John Combe (died 1614), who left him £5 in his will; he too is buried in the chancel of Holy Trinity.

This is a small-scale replica of the painting, "about 4 ft long", that Wallis exhibited at the Royal Academy in 1857 (no. 458; untraced). Wallis trained at the Royal Academy Schools, and was elected an associate in 1871. He was patronized by John Forster (1812–1876), for whom he painted *In Shakespeare's House, Stratford-on-Avon* (RA 1854; now Victoria and Albert Museum, London), the year he also showed *The Room in which Shakespeare was Born* and *The Font in which Shakespeare was Christened* (both untraced). Evidently Wallis visited Stratford to further his painstaking efforts to recreate the town as it was in Shakespeare's day; such fieldwork signals his affiliation to the Pre-Raphaelites, with whom he sometimes exhibited.

Wallis illustrated scenes from Shakespeare's plays including *Antonio is released from Shylock's Bond* (sold Bonham's, 5 March 2002) and such literary subjects as *Dr Johnson at Cave's the Publishers* (RA 1854, no. 176) and *Shakespeare and Spenser* (RA 1865; photo Witt Library, Courtauld Institute of Art, London). His most famous work is *The Death of Chatterton* (1856; Tate, London), for which the writer George Meredith posed. In June 1857 Wallis eloped with Meredith's wife, Mary Ellen Peacock; after her death he travelled in the Near East and on the Continent and became an expert on Italian and oriental ceramics. He left his collection of ceramics to the Victoria and Albert Museum.

JTM

PROVENANCE Bought by the Shakespeare Memorial Gallery, 1910

BIBLIOGRAPHY Unpublished letter from Henry Wallis to William S. Brassington, 4 October 1910, Shakespeare Birthplace Trust, Stratford-upon-Avon; Esdaile 1952; Schoenbaum 1970, pp. 468–69; Williams 1977; Tokyo *et al.* 1992–93, p. 162, under no. 4

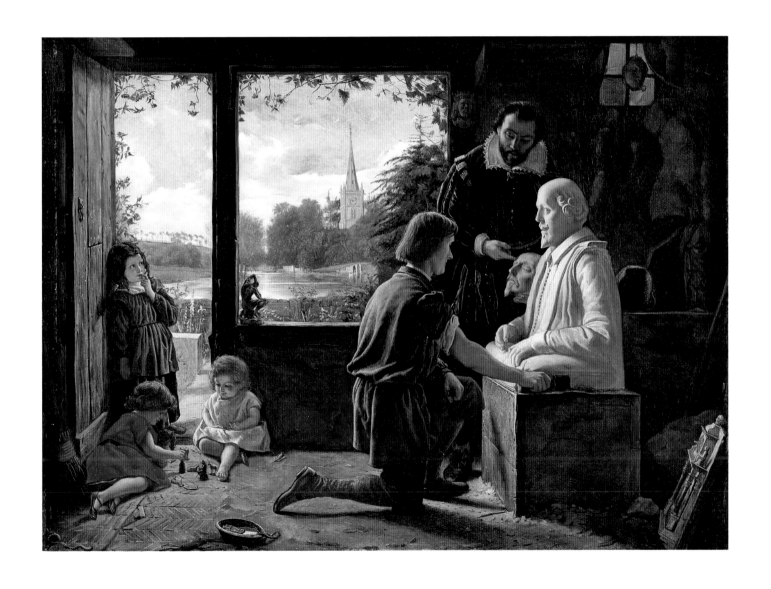

215

LIVERPOOL JOHN MOORES UNIVERSITY
LEARNING SERVICES

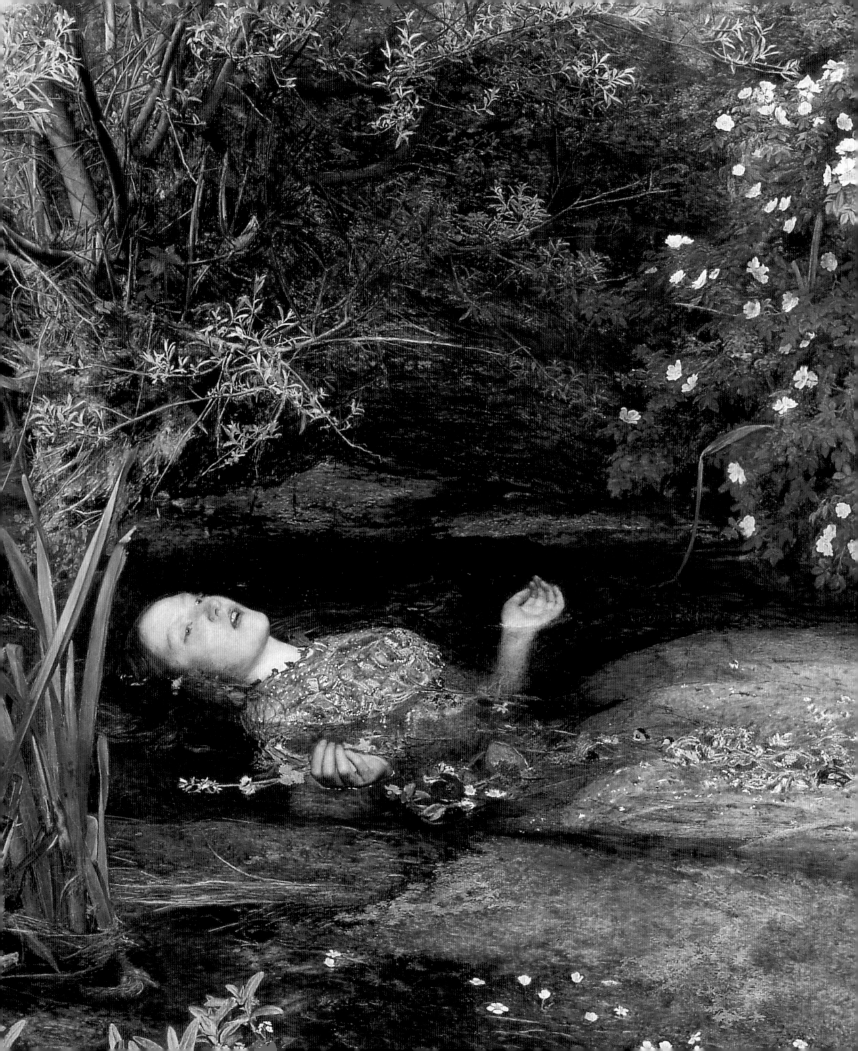

SHAKESPEARE IN VICTORIAN ART

John Christian

Queen Victoria came to the throne in 1837, and for most of her sixty-four-year reign literary subjects were enormously popular. Shakespeare claimed his full share of the limelight. When the Victorians inherited the tradition of illustrating his plays pictorially, it had already existed for nearly a century. Under their energetic stewardship it flourished with a new exuberance, until a reaction against literary themes of all kinds brought about its final eclipse.

To be precise, it was the Victorian middle classes who were responsible for this achievement. Affluent, well educated and intellectually curious, they were the patrons who liked literary subjects, leaving dynastic portraits and sporting scenes to the aristocracy. While Sir Edwin Landseer and Sir Francis Grant painted for the great landowners, the Pre-Raphaelites were supported by the ironmasters, stockbrokers and shipping magnates.

Inevitably, patronage shaped the tradition's development. It lost almost entirely the international character that had marked it during the Romantic, post-Napoleonic era, becoming more insular and even the context for attempts to define British identity. On the other hand, Shakespearean subjects had never been more diverse in conception, or more alarmingly varied in quality. Some of the genre's greatest masterpieces date from this period, but so does a degree of vulgarization that could only have occurred under a triumphant democracy. To such lengths did this process go that it even inspired a reaction in which artists deliberately set out to recapture the moral high ground, a phenomenon unique in the history of our subject.

The spirit of the age was not only reflected in what would now be called 'dumbing down'. Illustrations to Shakespeare, like so many more commercial commodities, were subject for the first time to mass production. It has been estimated that during the sixty or so years following the foundation of the Royal Academy in 1768, an average of five to ten Shakespearean subjects were shown there annually. The number doubled around 1830, and in the 1840s and 1850s some twenty examples was the norm. Illustrated editions of

Shakespeare's plays reveal a similar pattern. Setting aside the Boydell Shakespeare Gallery, only two such editions of real significance had appeared in the eighteenth century, Rowe's in 1709 and Hanmer's in 1744. But the 1850s produced no fewer than fifty, and there were as many as twenty even in the 1890s.

Shakespeare remained as central to theatrical life as he had been in the days of Garrick, the Kembles or Edmund Kean, who died in 1833, just four years short of the queen's accession. J.B. Priestley, in his masterly analysis of the 1850s, *Victoria's Heyday* (1972), went so far as to blame "the force and splendour of Shakespeare" for the abject poverty of contemporary drama. Given this ascendancy, it is hardly surprising that Shakespeare continued to inspire so many artists. It was one more illustration of the old Horatian adage "*ut pictura poesis*" (as painting is, so is poetry) that continued to hold such sway in the Victorian era.

The adage was particularly associated with the ideal of history painting in the Grand Manner that had tantalized artists and art theorists since the Renaissance. England had only taken the concept to heart in the eighteenth century, but it had then become inextricably linked with a matter of pressing concern, the attempt to found a national school of painting. It was inevitable that Shakespeare, the national poet *par excellence*, should play a crucial role in this exercise in self-awareness. Boydell made the point very forcibly when he wrote that "the great object" of his Shakespeare Gallery was "to advance art towards maturity, and establish an English School of Historical Painting".

The destruction of the old Palace of Westminster in 1834 provided an even greater opportunity of this kind, as that vociferous advocate of history painting, Benjamin Robert Haydon, immediately realized as he watched the building go up in flames. During the 1840s a series of competitions was held to find artists capable of painting murals in the new palace, and Shakespeare was one of the prescribed subjects, together with scenes from English history and the works of two poets second only to Shakespeare in eminence, Edmund Spenser and John Milton. Artists of all ages rushed to take part, and the ambitious and quixotic project often left its mark on the subsequent careers of the competitors. Several of those chosen to work at Westminster, including William Dyce (pls. 85, 88), Daniel Maclise

OPPOSITE Sir John Everett Millais (1829–1896), *Ophelia*, 1851–52, detail (fig. 61, p. 221)

Fig. 59 Richard Dadd (1817–1886), *Contradiction: Oberon and Titania*, 1854–58, oil on canvas, oval, 61 × 75.5 cm (24 × 29¾ in.), Collection Lord Lloyd-Webber

(pls. 77, 80), J.R. Herbert and G.F. Watts, made important contributions to Shakespearean iconography. So did many who merely entered the competitions – Joseph Severn, Noël Paton (pl. 83), Paul Falconer Poole, Richard Redgrave, Richard Dadd (fig. 59), David Scott (pl. 79), Ford Madox Brown and others.

The planners at Westminster saw Shakespeare painted on an epic scale dictated ultimately by the frescoes of Michelangelo and Raphael, but this was not how many, or indeed most, Victorians visualized the national poet. If at Westminster they inherited the grandiose dreams of the Augustan age, more often they were heirs to the intense and intimate vision of the Romantics – of John Keats 'spouting Shakespeare' by the hour in Haydon's studio; of Charles Lamb, whose popular *Tales from Shakespeare* (1807) sanitized the Bard and made him fit for home consumption; or of the landscape painter John Constable, who wrote

that Shakespeare "could make everything poetical" and was "always varied, never mannered". William Wordsworth, another ardent Shakespearean, was still very much alive, as were the artists Francis Danby and J.M.W. Turner (pl. 67), known chiefly as masters of Romantic landscape but each responsible for some idiosyncratic illustrations to Shakespeare's plays. Another survivor was the actor William Charles Macready. A true Romantic, moody and introspective in private life, moving audiences to tears on stage, he had acted in Paris at the height of the Shakespeare frenzy in the 1820s, helping to make devotees of Victor Hugo, Alexandre Dumas and Eugène Delacroix.

Exponents of the more intimate approach to Shakespeare tended to see him in terms of domestic genre, taking seventeenth-century Dutch painting and the Scottish artist David Wilkie as their models. One of the most prolific was Constable's friend and biographer

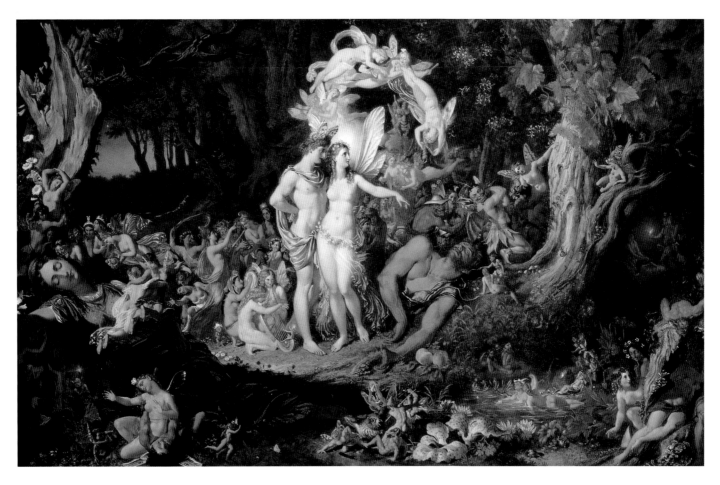

Fig. 60 Sir Joseph Noël Paton (1821–1901), *The Reconciliation of Oberon and Titania*, 1847, oil on canvas, 76.2 × 123.2 cm (30 × 48½ in.),
National Gallery of Scotland, Edinburgh

C.R. Leslie, an ardent theatre-goer since his student days, when he had seen the Kembles and other great thespians perform. Leslie's many Shakespearean subjects are nearly all taken from the comedies, and they have the same gentle humour as his illustrations to Cervantes, Molière or Laurence Sterne. He only strikes a more serious note when representing the woes of Queen Katharine in *Henry VIII*, a role in which his theatrical goddess, Mrs Siddons, had starred. Several Victorian artists (John Gilbert is the prime example) were attracted to this play, which gave them a golden opportunity to display their skills at historical reconstruction. Accuracy in matters of dress and setting was a guiding principle for Victorian painters of Shakespeare, just as it was for actor–managers of the day – Macready, Charles Kean (son of Edmund) and Henry Irving. They were not the first to aim at authenticity; signs of it are traceable as far back as Francis Hayman's illustrations to Shakespeare (see pl. 3). But the Victorians took the idea to extremes, totally rejecting the blithe disregard for historical truth that is so striking both in the Boydell Shakespeare and in images of the Garrick generation of actors on stage.

An approach similar to Leslie's was adopted by a group of somewhat younger artists who came to prominence in the 1840s. Calling themselves 'The Clique', they included Alfred Elmore, Augustus Egg, Henry Nelson O'Neil, and the most famous of all Victorian genre painters, William Powell Frith. Charles Dickens was also a member of this circle, and it is no coincidence that he was a dedicated amateur actor. Daniel Maclise, that assiduous Shakespearean so heavily committed at Westminster, was another intimate of the novelist, although he was too shy to join him on the boards.

In the late 1840s Leslie, Egg and Maclise, together with Edwin Landseer and Clarkson Stanfield (yet another friend of Dickens deeply involved with the theatre), contributed to a project that says much about the enlightened taste of the Victorian professional class, not to mention the ease with which it was still possible to reconcile what the novelist C.P. Snow would later call the "two cultures". The engineer Isambard Kingdom Brunel, famous for building the Great Western Railway and ocean-going steamships, commissioned seven artists to paint Shakespearean subjects for the dining-room at his London house in Duke Street, St James's. Many of these paintings

survive, the best known being Landseer's *Titania and Bottom* (National Gallery of Victoria, Melbourne), exhibited at the Royal Academy in 1851. As the foremost animal painter of the day, Landseer clearly relished the chance to depict the ass's head of the oafish weaver and some typically anthropomorphic hares, but the picture is chiefly remarkable as his only venture into the field of fairy painting.

This extraordinary phenomenon is relevant here because of the inspiration it consistently drew from two of Shakespeare's plays, *A Midsummer Night's Dream* and *The Tempest*. Its origins went back to Henry Fuseli and Sir Joshua Reynolds, but it was the Victorians who made it their own, revelling in the opportunities it offered to touch on such transgressive themes as malice, cruelty, sexual titillation and lust. It undoubtedly produced some masterpieces. Richard Dadd (1817–1886) was a member of 'The Clique' who went mad, murdered his father, and was incarcerated in Bethlem Hospital. There he painted *Contradiction: Oberon and Titania* (fig. 59, p. 218), a work of astonishing authenticity recording in minutest detail a vision that could only spring from a deeply disturbed mind. This, in Coleridge's famous distinction, is Imagination rather than Fancy. In contrast, Noël Paton's *The Quarrel* and *The Reconciliation of Oberon and Titania* (fig. 60, p. 219) are unashamedly products of Fancy, though fine examples for all that. Paton was so addicted to such subjects that critics accused him of being 'fairy mad'. His work is strongly tinged with German Romanticism, owing much to the Nazarenes and evoking thoughts of Weber's *Oberon* and Mendelssohn's *A Midsummer Night's Dream*. It is not surprising that the Edinburgh-based artist was admired by Queen Victoria, who made him her Limner for Scotland.

But this welcome touch of internationalism was by no means typical of Victorian fairy painting. George Cruikshank (pl. 87) and Robert Huskisson (pl. 81) were much more insular talents, while Dadd was one of those isolated eccentrics in which English art abounds. The same could be said of the most quintessentially Victorian of all these artists, John Anster Fitzgerald. He was at his best painting subjects of his own devising, full of fantastically attired fairies, robins, mice and malignant Bosch-like sprites, all seen as if caught in the brilliant limelight of a contemporary pantomime. He was a great devotee of the stage and famous for his impersonations of such long-dead thespians as J.P. Kemble, Macready and Kean, uttered in a rich Irish brogue. However, when he attempted an actual illustration to Shakespeare, the results were far less happy, epitomizing the depths of banality and kitsch to which the genre could sink.

There is another area of Shakespearean illustration in which the Victorians' genius for vulgarity found expression, namely the so-called 'keepsake' albums or 'books of beauty', annual collections of prose and verse embellished with engravings of simpering young women masquerading as characters in history or literature. The publisher Charles Heath specialized in these volumes and issued two devoted to Shakespeare's heroines, a *Shakespeare Gallery, Containing the Principal Female Characters in the Plays of the Great Poet* (1836–37), and *Heroines of Shakespeare* (1848). Leslie, Frith, Egg and T.F. Dicksee, a member of a dynasty of artists, were all regular contributors to these vapid but popular productions.

It was to counter the triviality of so much contemporary painting that the Pre-Raphaelite Brotherhood was founded in 1848. In his autobiography William Holman Hunt, one of the three leaders of the movement together with Sir John Everett Millais and Dante Gabriel Rossetti, specifically mentioned 'books of beauty' as examples of the "hackneyed conventionality" they so deplored. "Conventionality" was a matter of both style and content. The Brothers' determination to paint everything direct from nature was a reaction to the tired academic conventions on which so many artists relied, while in place of "trite and affected" subjects they looked for themes that were rich in moral significance, capable of conveying real feelings or making some meaningful social comment. The Bible was one obvious source, and Dante, Rossetti's speciality, another. But Shakespeare, understandably enough in view of the movement's many links with Romanticism, was hardly less important. When the PRB drew up a list of Immortals, he was one of only two who received three stars, the highest number that anyone achieved with the exception of Christ.

Millais's *Ophelia* (fig. 61, p. 221), exhibited at the Royal Academy in 1852, is probably the most celebrated Pre-Raphaelite account of a Shakespearean subject, but Hunt's *Valentine rescuing Silvia from Proteus*, from *The Two Gentlemen of Verona* (pl. 84), and *Claudio and Isabella*, from *Measure for Measure* (1850–53; Tate, London), are perhaps better indications of the movement's aims in that each shows figures experiencing some powerful inner conflict. Time and again the Pre-Raphaelites found a subject in Shakespeare that enabled them to strike this characteristic note of emotional intensity. Rossetti did so in drawings and watercolours illustrating *Hamlet*, Madox Brown in an ardent *Romeo and Juliet* and the edgy *Cordelia's Portion*. Brown was as obsessed by *King Lear* as Romney had been a century earlier. His paintings based on the play so impressed Henry Irving that he commissioned him to stage it in 1892.

Brown was one of many artists who, though never a member of the Brotherhood, were attracted by its ideals and worked in the Pre-Raphaelite style. These associates were often as keen Shakespeareans as the Brothers themselves. Walter Howell Deverell, who shared a studio with Rossetti in 1850–51, was too short-lived to produce many pictures, but those he did achieve were nearly all Shakespearean in theme. Yet another example was Arthur Hughes, well-known for such poignant evocations of emotional states as *April Love* (1856; Tate, London) and *Home from Sea* (1856–62; The Ashmolean Museum, Oxford). It was almost inevitable that he should paint the Shakespearean subject which perhaps appealed more than any to the Victorians, the madness and watery death of Ophelia; and indeed he produced a version the very same year as

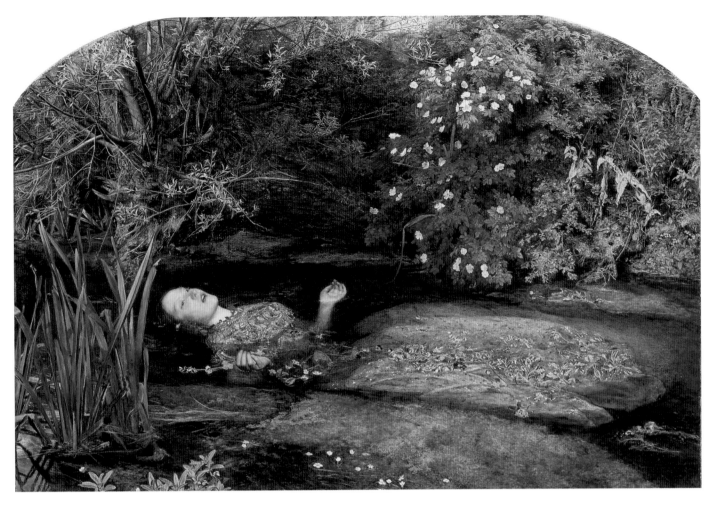

Fig. 61 Sir John Everett Millais (1829–1896), *Ophelia*, 1851–52, oil on canvas, 76.2 × 111.8 cm (30 × 44 in.), Tate, London

Millais (1852; Manchester City Art Gallery). Another of his most familiar pictures, *The Long Engagement* (*c.* 1854–59; Birmingham Museum and Art Gallery), began life as an illustration to *As You Like It*, only gradually developing into the angst-ridden genre scene we see today.

Perhaps more surprising was the appeal of Shakespeare to the Pre-Raphaelites' more academic contemporaries. Frederic Leighton, who, as president of the Royal Academy from 1878, came to dominate the Victorian art establishment, had a youthful penchant for scenes from *Romeo and Juliet* (pl. 86). His fellow Classicist Edward Poynter illustrated *Julius Caesar* (1883) and *A Midsummer Night's Dream* (1901), and even that resolute Aesthete Albert Moore painted a *Portia* (1885). Other notable Shakespearean images were produced by artists who sought to synthesize Pre-Raphaelite sensibility and academic form. J.W. Waterhouse painted a series of *Ophelias* and Frank Dicksee a characteristically lush *Romeo and Juliet*, basing it on one of his illustrations to two editions of the plays published by Cassells between 1883 and 1892.

By this time, however, partly due to the prevailing influence of French Realism, literary figure subjects had begun to lose the appeal they had held so long for the picture-conscious public. Artists who had made their name in this field turned increasingly to portraiture or landscape; some gave up altogether. Only a few battled on into the twentieth century, swimming valiantly against the tide of Modernism. None of these artists, sometimes today known by the Yeatsian sobriquet of 'last Romantics', was more persistent than Frank Cadogan Cowper, who died as late as 1958; and so far as the present subject is concerned, his *Titania Sleeps* (Private Collection), exhibited at the Royal Academy in 1928, represents the last gasp of a long, honourable, but by then moribund tradition. Technically the picture may be described as neo-Pre-Raphaelite, but the figure's dress is Art Deco, her *maquillage* and abandoned pose are pure Hollywood, and Walt Disney himself could hardly have improved on the watchful owl and rabbits.

SELECT BIBLIOGRAPHY

Salaman 1916; Boase 1947; Woodward 1950; Moelwyn Merchant 1959; Nottingham 1961; London 1964; Washington 1979–80; New Haven CT 1981; Montgomery, New York and Chicago 1986; Ashton 1990; London 1991; Tokyo *et al.* 1992–93; Faberman and McEvansoneya 1995; London *et al.* 1997–98

221

LIVERPOOL JOHN MOORES UNIVERSITY
LEARNING SERVICES

DANIEL MACLISE (1806–1870)
The Disenchantment of Bottom (A Midsummer Night's Dream, IV. i)

1832
Oil on canvas
127 × 101.6 cm (50 × 40 in.)
Wadsworth Atheneum Museum of Art, Hartford CT (Ella Gallup Sumner and Mary Catlin Sumner Collection Fund), inv. 1984–89
Ferrara only

Maclise was an Irishman, born in Cork, where he studied at the local art school before moving to London to attend the Royal Academy Schools in 1827. In the 1830s he published a series of caricatures of celebrated men of the day in *Fraser's Magazine* and began to make his name as a painter of literary and historical themes, winning a gold medal with *The Choice of Hercules* (Private Collection), which he entered for the Royal Academy's history painting competition in 1831. This and other early paintings are in a conventional academic idiom, but by the time he exhibited *A Scene from Undine* (The Royal Collection) in 1844 he had come under the influence of the Nazarenes. The picture was bought by Queen Victoria as a birthday present for Prince Albert, who liked its Germanic subject and style.

In 1845 Maclise was commissioned to paint one of the first murals in the House of Lords, *The Spirit of Chivalry*; the fact that Prince Albert was president of the royal commission in charge of the decoration of the new Palace of Westminster was no accident. Indeed, with the exception of William Dyce (see pls. 85, 88), another royal favourite who owed much to the Nazarenes, no one was to play a greater part in the decorative schemes at Westminster than Maclise. *The Spirit of Chivalry* was followed by *The Spirit of Justice*, and in 1858 he embarked on two vast murals in the Royal Gallery illustrating stirring subjects from recent history, *The Meeting of Wellington and Blücher at Waterloo* and *The Death of Nelson at Trafalgar*.

Maclise often drew inspiration from Shakespeare. He himself was a devotee of the theatre, and two of his closest friends, the novelist Charles Dickens (1812–1870) and the journalist and critic John Forster (1812–1876), were passionate amateur actors. In 1840 the three men visited Shakespeare's birthplace at Stratford-upon-Avon, which Forster, a great Shakespeare scholar and the proud possessor of a First Folio, was later instrumental in securing as a national monument to the Bard. Maclise had made his début at the Royal Academy in 1829 with a scene from *Twelfth Night*, and he returned to this play in 1840 for one of his most popular works (pl. 80). With it was shown another, very different, Shakespearean subject, the melodramatic *Banquet Scene in 'Macbeth'* (Guildhall Art Gallery, London), and these were followed two years later by *The Play Scene in 'Hamlet'* (Tate, London), which Dickens described as "a *tremendous* production. There are things in it which, in their powerful thought, exceed anything I have ever beheld in painting". All these paintings betray the strong influence of the theatre, the figures and backgrounds resembling actors on stage-sets.

Not surprisingly, Maclise was one of the artists who were approached by the engineer I.K. Brunel to paint a picture for the Shakespeare Room that he planned at his London house in the late 1840s. As a subject Maclise suggested the last scene in *As You Like It*, in which, as he put it, "most of the characters are brought together picturesquely in a woody landscape". Nothing came of this project beyond a preliminary sketch, but it found echoes in *The Wrestling Scene in 'As You Like It'* (formerly Forbes Collection, New York), which Maclise painted seven years later. Paintings inspired by *Othello* (1867), *Richard II* (1867) and *Macbeth* (1868) were among his last Royal Academy exhibits.

The Disenchantment of Bottom was shown at the Royal Academy in 1832. Oberon, taking pity on his wife Titania, has released her from her deluded infatuation with the "rude mechanical", and ordered Puck to remove his ass's head. Bottom wakes from his dream, seemingly with a cry of pain at his sudden return to reality, and still tormented by the fairies who have been the instruments of his cruel deception. Two, buzzing about his head, appear to sustain an illusion of the ass's ears of which he has just been denuded. W.J. O'Driscoll (1871) described the picture as "beautiful", but in fact it shows Maclise's imagination at its most bizarre, suggesting the influence of Fuseli in its exaggerated gestures, dramatic lighting, and arabesques of airborne fairies (see pl. 27).
JC

PROVENANCE Thomas Agnew, sold Christie's, 6 May 1871, lot 29, 9 guineas, to Mendoza; Albert Grant by 1875, sold Christie's, 27 April 1877, lot 50, 350 guineas, to Hilyard; John Farnworth; W.C. Quilter, MP, sold Christie's, 29 April 1893, lot 117, 110 guineas, to unknown buyer; The Hon. E.C. Guinness; bought by the Wadsworth Atheneum Museum of Art, 1984

BIBLIOGRAPHY O'Driscoll 1871, p. 45; Dafforne 1873, p. 7; London *et al.* 1997–98, no. 13

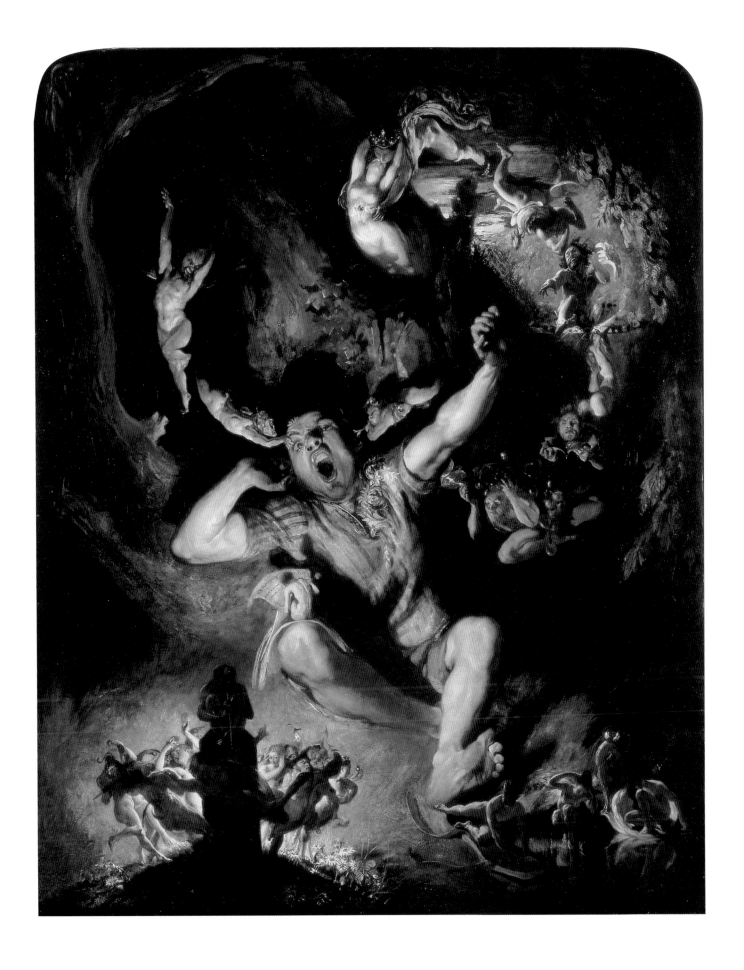

78

CHARLES ROBERT LESLIE (1794–1859)
Autolycus (The Winter's Tale, IV. iv)

1823–36
Oil on canvas
53.3 × 73.6 cm (21 × 29 in.)
Victoria and Albert Museum, London, inv. FA115

C.R. Leslie was born in London, the eldest son of American parents. When he was five the family moved to Philadelphia, but in 1811 he returned to London and entered the Royal Academy Schools. Apart from a six-month spell as drawing master at West Point Military Academy, New York State, he remained in England for the rest of his life. He was a close friend of the landscape painter John Constable (1776–1837), and published his biography in 1843. He had a long connection with the Royal Academy, becoming an associate in 1821, graduating to full membership in 1826, and serving as Professor of Painting from 1848 to 1852. His lectures were published as *A Handbook for Young Painters* in 1855.

Leslie is best known as a brilliant and prolific exponent of literary genre, painting numerous subjects from Shakespeare, Cervantes, Molière, Oliver Goldsmith, Laurence Sterne and Sir Walter Scott. His first Shakespearean subjects were not in fact genre scenes but essays in the Sublime. The outstanding example is the enormous *Murder of Rutland by Lord Clifford* (1815; Pennsylvania Academy of the Fine Arts, Philadelphia), a painting inspired by *3 Henry VI* for which the young Edwin Landseer posed as the hapless earl. The dramatic conception must reflect the experience of seeing Mrs Siddons and her brother John Philip Kemble, the two greatest tragedians of their day, on stage. In his autobiography, published posthumously in 1860, Leslie describes himself as "passionately fond of the theatre", and reveals how, as a young artist without much money, he would "practice the closest economy" in order to attend performances by the Kembles and their peers.

But from the 1820s on, Leslie preferred to paint 'domestic' subjects from plays such as *The Merry Wives of Windsor*, *The Taming of the Shrew*, *Twelfth Night* and *The Winter's Tale*. Relatively small in scale and characterized by what the *Athenaeum*'s art critic called "the wit of his pencil [and his] deep knowledge of human nature", these paintings owe much to the masters of seventeenth-century Dutch genre, and, like their prototypes, tended to appeal to middle-class patrons. Many were commissioned by John Sheepshanks (1784–1863), a wealthy cloth manufacturer who formed a large collection of contemporary British pictures and bequeathed them to the South Kensington (Victoria and Albert) Museum with the intention of forming the nucleus of a National Gallery of British Art. Another patron was I.K. Brunel, and in the late 1840s Leslie was one of the group of artists who painted pictures for Brunel's Shakespeare Room in his London house, his contribution being two scenes from *Henry VIII*.

Autolycus is generally regarded as one of Leslie's finest essays in Shakespearean genre. Commissioned by Sheepshanks, it was "sketched and partly painted" in 1823, but not completed and exhibited at the Royal Academy until 1836. The picture shows the rascally trinket-seller and ballad-monger peddling his wares to a group of credulous rustics. Autolycus's speech beginning "Here's another ballad, of a fish that appeared upon the coast on Wednesday" was quoted in the exhibition catalogue. The girls in the foreground are the shepherdesses Mopsa and Dorcas, and the eager youth to the left is probably the so-called 'clown' who is in love with Mopsa.

Leslie's friend John Constable gave him help with the picture, lending him studies of skies and a sketch of a mountain ash, which Leslie used for the tree on the right. Constable greatly admired the picture, describing it as "full of elegance and character". The lovers Florizel and Perdita are not included in the picture, even though they appear in the scene represented. A critic in the *Athenaeum* hinted that Leslie had found it beyond him to paint "the inimitable sweetness and simplicity of Perdita", and it was probably in response to this challenge that Leslie exhibited a companion-piece, *Florizel and Perdita* (Victoria and Albert Museum, London), at the Royal Academy the following year. Illustrating a slightly earlier incident in the play, the picture was also bought by John Sheepshanks.

The subject of Autolycus was also painted by Augustus Leopold Egg (1816–1863) in a picture exhibited at the Royal Academy in 1845 (Guildhall Art Gallery, London; see Tokyo *et al.* 1992–93, no. 52). Egg, like Leslie, was involved in the decoration of Brunel's Shakespeare Room.
JC

PROVENANCE Bought from the artist by John Sheepshanks; his gift to the South Kensington (now Victoria and Albert) Museum, 1857

BIBLIOGRAPHY *Athenaeum*, no. 446, 14 May 1836, p. 348; Leslie 1860, I, pp. li–liii; II, p. 230; London 1964, no. 46; Parkinson 1990, pp. 164–65 (with full bibliography)

79
DAVID SCOTT (1806–1849)
Puck fleeing before the Dawn (A Midsummer Night's Dream, V. i)

Signed and dated *DAVID SCOTT 1837*
1837
Oil on canvas
95.3 × 146 cm (37½ × 57½ in.)
National Gallery of Scotland, Edinburgh, inv. NG 992

Few British artists represent the Romantic movement more completely than David Scott. Born in Edinburgh, the oldest surviving child of Robert Scott, an engraver of stern Calvinistic faith, he was an exact contemporary and friend of his fellow Scot William Dyce (see pls. 85, 88). But whereas Dyce was to enjoy a relatively long career, receive the patronage of Prince Albert and play a major role in the decoration of the new Palace of Westminster, David Scott died at the age of forty-three, racked by ill health, religious doubt and an overwhelming sense of being misunderstood as an artist.

Having received his formal education at the High School in Edinburgh, Scott entered the Trustees' Academy to train as an artist at the age of fourteen. In 1828 he showed his first picture, prophetically entitled *The Hopes of Genius dispelled by Death*, at the Royal Institution in Edinburgh. He had already developed a powerful and histrionic style, inspired by engravings after Blake and Fuseli that he had known since boyhood, and further encouraged by the work of William Etty, John Martin (pl. 62) and Benjamin Robert Haydon which he saw when he visited London that year. In 1829 he was elected a member of the Royal Scottish Academy and exhibited there for the first time; the picture was an Ossianic subject that again demonstrated his commitment to the Romantic agenda.

In August 1832 Scott set out for further study in Rome, which he reached after visiting Milan, Venice and Florence. He took a studio and remained there until February 1834, working feverishly under the predictable influence of Michelangelo. Delacroix, whose work he saw in Paris on the way home, also impressed him deeply. Back in Edinburgh, he aspired to lead a Scottish revival of history painting in the Grand Manner, and was not altogether unsuccessful. Soon after his return, he was commissioned by the newly emancipated Roman Catholic community to paint an altarpiece, *The Descent from the Cross*, for St Patrick's Chapel in Lothian Street. Other pictures were bought by the Association for the Promotion of the Fine Arts. His illustrations to Coleridge's *Ancient Mariner* (1837) were much admired, and between 1839 and 1841 he published a series of articles on European painting in *Blackwood's Magazine*.

But Scott was a victim of his own temperament. His exaggerated style bewildered the critics, who accused him of having "the imagination of madness", while his morbid over-sensitivity caused him to pick quarrels and take offence where none was intended. His lack of success in the Westminster Hall competition of 1843, and his failure to gain the mastership of the Trustees' Academy the same year, further fuelled the sense of bitter disappointment that led to his death in March 1849. That his reputation survived at all was largely due to his younger brother, William Bell Scott (1811–1890), who published a *Memoir* of David in 1850.

It was almost inevitable that Shakespeare, who played so central a role in the attempt to create an English school of history painting, should also inspire the artist who sought to carry out a similar programme in Scotland. Scott exhibited a painting of *Oberon and Puck listening to the Mermaid's Song* at the Royal Scottish Academy in 1836, and *Queen Elizabeth viewing the 'Merry Wives of Windsor' in the Globe Theatre* (Theatre Museum, London), an essay in the same vein of Shakespearean genre as the painting by John Faed exhibited here (pl. 75), followed in 1841. A *Lear and Cordelia* by Scott is also recorded.

Puck fleeing before the Dawn was one of two Shakespearean themes that Scott showed at the Royal Scottish Academy in 1838, the other being *Ariel and Caliban* (National Gallery of Scotland, Edinburght). *Puck fleeing* was inspired by the imp's speech in the closing scene of *A Midsummer Night's Dream*:

> And we fairies, that do run
> By the triple Hecate's team,
> From the presence of the sun,
> Following darkness like a dream,
> Now are frolic.

The image is comparatively restrained for Scott, although this perhaps has more to do with the subject than his treatment. The artist has produced "a most original vision of Puck, curled up holding his knees, like a ball shot from a cannon, as he catapults himself through the night sky" (London *et al.* 1997–98). The energy expressed in this figure reflects Scott's longstanding enthusiasm for Michelangelo, Fuseli and Blake, while the feeling for colour and the texture of paint reminds us that, after some initial disappointment, he had succumbed to the charms of Venetian painting when he visited Venice en route for Rome in 1832.
JC

PROVENANCE James Campbell, 1901; by descent to W. McOran Campbell, sold Christie's, 2 July 1909, lot 112, 22 guineas, to Wallis for the National Gallery of Scotland

BIBLIOGRAPHY Scott 1850, p. 206; Brighton 1980, no. D79; Campbell 1990, p. 12; Tokyo *et al.* 1992–93, no. 42; London *et al.* 1997–98, no. 19; Wood 2000, pp. 68–69

227

LIVERPOOL JOHN MOORES UNIVERSITY
LEARNING SERVICES

DANIEL MACLISE (1806–1870)
Scene from 'Twelfth Night' (III. iv)

1840
Oil on canvas
73.7 × 124.5 cm (29 × 49 in.)
Tate, London. Presented by Robert Vernon 1847
Dulwich only

Malvolio, the pompous and overbearing steward to Olivia, a wealthy countess, appears before his mistress and her maid, Maria, in the garden of her house. He has been tricked by Maria into believing that Olivia is in love with him, and that she likes to see him cross-gartered and wearing yellow stockings to show off his shapely legs. Thus duped, he accosts her, kissing his hand to her extravagantly and insinuating that they might go to bed together, while she for her part is horrified to find a servant taking such liberties, and thinks he must have lost his wits. It is a scene of high comedy, but one not untouched by tragedy as we watch Malvolio making such a fool of himself.

Maclise had made his début at the Royal Academy in 1829 with a closely related scene from the play, *Malvolio affecting the Count*, but by all accounts the present picture, exhibited eleven years later, was a great improvement. "I can look at it for ever", wrote the actor W.C. Macready, whose portrait in the title role of Byron's poetic drama *Werner* (1822) was painted by Maclise (1849–50), "it is beauty, moral and physical, personified". Perhaps he identified with it so closely because of its resemblance to a group of actors on stage. Maclise was a devotee of the theatre, and the same effect is created in the dramatic *Banquet Scene in 'Macbeth'* (Guildhall Art Gallery, London), also exhibited in 1840, and *The Play Scene in 'Hamlet'* of 1842 (Tate, London). The paintings even have rounded upper corners, a fashion common to many Victorian pictures but here used to give an impression that we are looking through a proscenium arch.

Press comment on the *Scene from 'Twelfth Night'* was mixed. *The Times* agreed with Macready, calling it "a very fine picture, and very free from defect", but the *Athenaeum* was more critical. It thought the picture "less successful" than *The Banquet Scene in 'Macbeth'*, which it had praised highly. The conception of Malvolio did not quite suggest "the intoxicating moment when he believes greatness is about to be thrust upon him", and it might have been better if Olivia had shown "an involuntary sense of amusement at [her steward's] antic gestures, chequering her compassion for his frenzy". The picture's colouring, too, was too "chalky and feeble" for this fastidious writer. The best feature, in his view, was "the flowery riches" of the "old-fashioned garden, pencilled with that minute truth … which characterises the real artist, who knows that nothing is too trifling to be beneath his care".

There is indeed an almost Rococo airiness about the scene, in marked contrast both to the Fuselian chiaroscuro of the earlier *Disenchantment of Bottom* (pl. 77) and the rather ponderously Germanic style in which Maclise was working when he painted *The Wrestling Scene in 'As You Like It'* (formerly Forbes Collection, New York), exhibited at the Royal Academy in 1855.

Illustrations to *Twelfth Night* are not uncommon in British art. William Hamilton and J.H. Ramberg illustrated the play for the Boydell Shakespeare in the 1790s, and about the same time John Hoppner painted the actress Mrs Jordan in the role of Viola in which she starred at Drury Lane (Iveagh Bequest, Kenwood House, London). J.M.W. Turner exhibited a picture called *What You Will!* (Private Collection), the play's alternative title, at the Royal Academy in 1822 (Private Collection), and at least two Pre-Raphaelites found inspiration in the subject of Viola tormented by love for Orsino. The short-lived Walter Howell Deverell treated it in his masterpiece, exhibited at the National Institution in 1850 (formerly Forbes Collection, New York), and J.R. Spencer Stanhope, a representative of the later, 'Aesthetic', phase of the movement, painted the image of "patience on a monument, smiling at grief" (1884; Private Collection), which occurs in Viola's famous speech referring obliquely to her emotions.

Only Ramberg's contribution to the Boydell Shakespeare shows Malvolio cross-gartered before Olivia. There may have been other treatments – certainly *The Times* review of Maclise's version describes it as an "often-painted" subject; but they do not leap to mind, suggesting that they were not major examples of Shakespearean genre. Could it be that the subject, with its obvious sexual connotations, was considered a little vulgar? It is perhaps significant that there is not a single reference to Malvolio in Charles and Mary Lamb's *Tales from Shakespeare*, that chaste retelling of the plots of the plays to make them fit for home consumption.

Both the *Scene from 'Twelfth Night'* and *The Play Scene in 'Hamlet'* were bought direct from Maclise by Robert Vernon (1774–1849), a London horse-dealer and stable-keeper who made a fortune out of serving the aristocracy in the early nineteenth century. He gave his collection of modern British pictures to the nation in 1847, just as John Sheepshanks was to do a decade later (see pl. 78).
JC

PROVENANCE Bought from the artist by Robert Vernon, and given by him to the The National Gallery, London, 1847; subsequently transferred to the Tate Gallery

BIBLIOGRAPHY *The Times*, 6 May 1840, p. 6; *Athenaeum*, no. 654, 9 May 1840, p. 372; *Art-Union*, 1840, p. 74; O'Driscoll 1871, p. 66; W.C. Macready, *Diaries*, II, p. 53; Ormond 1968, p. 692; London and Dublin 1972, no. 76; London 1993, p. 69

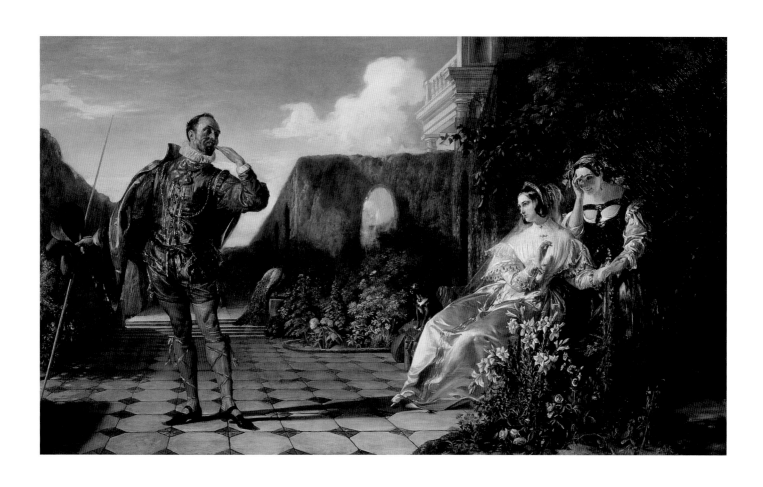

81

ROBERT HUSKISSON (1819–1861)
"Come unto these Yellow Sands" (The Tempest, I. ii. 375-81)

1847
Oil on panel
34.9 × 45.7 cm (13¾ × 18 in.)
Private Collection

Huskisson is regarded as one of the major exponents of Victorian fairy painting, although he was a far less substantial artist than either Richard Dadd or Noël Paton (pl. 83), and he lacked the fantastic and whimsical imagination of his slightly younger contemporary J.A. Fitzgerald. His career was established by Jeremy Maas (1969). He was born Robert Locking Huskinson (*sic*) at Langar, Nottinghamshire, the son of Henry Huskinson, a local portrait painter, but in 1839, when he was twenty, he moved to London with his younger brother Leonard, who was also a painter. Changing their name to Huskisson, the brothers exhibited at the Royal Academy, the British Institution and the Society of British Artists, but Robert ceased to exhibit in 1854, possibly for health reasons. He was still only forty-two when he died seven years later.

Huskisson belonged to the circle of Samuel Carter Hall (1800–1889), a prolific man of letters who not only produced innumerable books on every aspect of popular culture but edited the *Art Journal*, the leading (though deeply conservative) art magazine of the day. Mrs Hall, who was her husband's intellectual superior, was also a fertile author, many of their books being produced in tandem. The Halls owned examples of Huskisson's work and, together with Noël Paton, William Frost, Clarkson Stanfield, Thomas Creswick and others, he contributed illustrations to Mrs Hall's *Midsummer Eve: A Fairy Tale of Love* (1848).

Huskisson was also well known as a copyist, and carried out work of this kind for the great collector Lord Northwick (1769–1859). His picture of the Picture Gallery at Northwick's country house, Thirlestane House, Cheltenham (Yale Center for British Art, New Haven CT), was exhibited at the British Institution in 1847. William Powell Frith mentions Huskisson in his autobiography, writing that, although he had "painted some original pictures of considerable merit", he was "a very common man, entirely uneducated. I doubt if he could read or write; the very tone of his voice was dreadful".

The present picture, which belonged to the Halls, dates from 1847 and takes its title from Ariel's well-known song in *The Tempest*:

> Come unto these yellow sands,
> And then take hands;
> Curtsied when you have, and kiss'd,
> The wild waves whist,
> Foot it featly here and there,
> And, sweet sprites, the burden bear.
> Hark, hark!

The picture is indebted to one of the same subject by Richard Dadd (Private Collection), exhibited at the Royal Academy in 1842, but the main influence is undoubtedly the stage. The action is seen through a painted arch reminiscent of a proscenium arch in a theatre, with symbolic figures painted above in a manner still found in some theatres built or refurbished during the Victorian era. As for the 'actors', they fly around as if on wires and seem to be caught in the gaslight or limelight that revolutionized the early Victorian theatre, and were never more effectively employed than in the ballets and pantomimes in which fairies so often played a central role. We might almost be watching one of the so-called 'transformation scenes' that still conclude traditional pantomimes, in which all the resources of theatrical artistry combine to elicit gasps of wonder and delight from the audience. J.A. Fitzgerald's fairy subjects, painted a decade or more later than Huskisson's, are similarly inspired by the theatre, although the results are very different. JC

PROVENANCE Samuel Carter Hall, 1847

BIBLIOGRAPHY Maas 1969, p. 150; London *et al*. 1974–75, no. 248; London *et al*. 1997–98, no. 29; Wood 2000, pp. 72–73

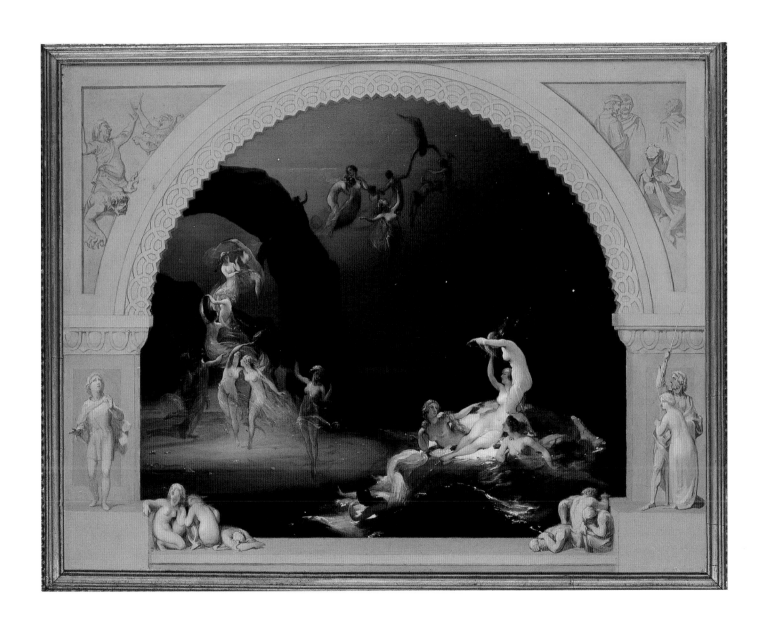

82

Sir John Everett Millais, P.R.A. (1829–1896)
Ferdinand lured by Ariel (The Tempest, I. ii. 387–402)

Signed and dated *J.E. Millais 1849*
1849–50
Oil on panel
64.8 × 50.8 cm (25½ × 20 in.)
The Makins Collection, Washington, DC

All three leading members of the Pre-Raphaelite Brotherhood – Dante Gabriel Rossetti, William Holman Hunt and John Everett Millais – made some vital contribution to the movement's astonishing success. If Rossetti was the man of ideas and vision and Hunt (pl. 84) the dogged seeker after material and spiritual truth, Millais was the brilliant technician with his finger very firmly on the pulse of public taste. Born in 1829, the son of affluent and indulgent parents, he was nineteen when the PRB was launched in 1848, intent on subverting academic conventions and embracing the ideal of truth to nature as expressed by Ruskin in *Modern Painters*. His early paintings adhere unflinchingly to this agenda, and were, not surprisingly, bitterly attacked by the critics, but by the early 1850s he was well on his way to becoming one of the most popular artists of the day. He ended his career a baronet and president of the Royal Academy.

Ferdinand lured by Ariel is one of the first pictures Millais painted according to strict Pre-Raphaelite principles. It was exhibited at the Royal Academy in 1850, together with the famous *Christ in the Carpenter's Shop* (Tate, London). The following quotation from *The Tempest* appeared in the catalogue:

> Ferdinand: Where should this music be? I' the air or the earth?
> Ariel: Full fathom five thy father lies;
> Of his bones are coral made;
> Those are pearls that were his eyes:
> Nothing of him that doth fade
> But doth suffer a sea-change
> Into something rich and strange.
> Sea-nymphs hourly ring his knell.

Ferdinand, the son of the King of Naples, having been shipwrecked on the island inhabited by Prospero and Miranda, is being led by Ariel to his master and mistress. Riding on the backs of strange bat-like creatures, the sprite gives him the deliberately misleading news that his father has been drowned, part of Prospero's plan to find a husband for his daughter and turn the tables on his old enemies.

Like so many early Pre-Raphaelite works, the picture was executed on a pure white ground to ensure the utmost brilliancy of colour, while almost every detail was painted from life. The background came first, being carried out in the summer of 1849 when Millais was staying with friends at Shotover Park, near Oxford. He took immense pains to treat it in as much detail as possible, describing it to Holman Hunt as

"ridiculously elaborate. I think you will find it very minute, yet not near enough so for nature. To paint it as it ought to be would take me a month a weed – as it is, I have done every blade of grass and leaf distinct".

On his return to London Millais painted the head of Ferdinand from F.G. Stephens, a fellow PRB. He then added the rest of the figure from a lay-figure. Ferdinand's dress was derived from a plate in Camille Bonnard's *Costumes Historiques* (1829–30), a source much used not only by Millais but by other Pre-Raphaelites. The picture was all but finished by December 1849, when Millais was at work on Ariel's bat-like attendants. According to William Michael Rossetti's diary, he intended "to make the spirits in the air half human and half like birds". They must be the only detail for which he did not have a model.

Like *The Carpenter's Shop*, which Dickens so notoriously vilified in *Household Words*, *Ferdinand* was severely criticized when it appeared at the Royal Academy. The *Athenaeum* thought it "better in the painting" than *The Carpenter's Shop*, but "yet more senseless in the conception, a scene built on the contrivances of the stage manager, but with very bad success". According to the *Art Journal*, it showed "a considerable vein of eccentricity", notably in depicting Ariel as "a hideous green gnome, [who] precipitates himself against Ferdinand with an action extremely ungraceful". For *The Times*, it was simply "a deplorable example of perverted taste".

Perhaps fortunately, the picture had been sold before the exhibition opened, although a potential buyer had been put off by the treatment of Ariel's attendants, complaining that the artist had not made them "more sylph-like". No doubt he was thinking of the coy and nubile variants that we find in the work of Huskisson or Paton, whose paintings included here (pls. 81, 83) are almost contemporary with Millais'.
JC

PROVENANCE Bought by Richard Ellison in 1850 for £150, and still his in 1854; James Wyatt, the well-known Oxford picture-dealer; Thomas Woolner, sold Christie's, 12 June 1875, lot 7, 300 guineas, to Allen; A.C. Allen; A.E. Makins by 1897, and thence by descent

BIBLIOGRAPHY *The Times*, 9 May 1850, p. 5; *Athenaeum*, no. 1179, 1 June 1850, p. 591, *Art Journal*, 1850, p. 175; Spielmann 1898, pp. 29, 101–02; Millais 1899, I, pp. 82–87; II, pp. 172, 467; Rossetti 1900, pp. 209, 232, 235, 247; Holman Hunt 1905, I, pp. 194, 205; Fish 1923, pp. 39, 42, 50; Ironside and Gere 1948, p. 41; Liverpool and London 1967, no. 22; Maas 1969, pp.148–49; London 1984, no. 24; Merlo 1984, pp. 78–79; Fleming 1998, pp. 55–57, 60, 61, 65, 170, 220, 268; Mancroff 2001, pp. 16, 52, 71, 75

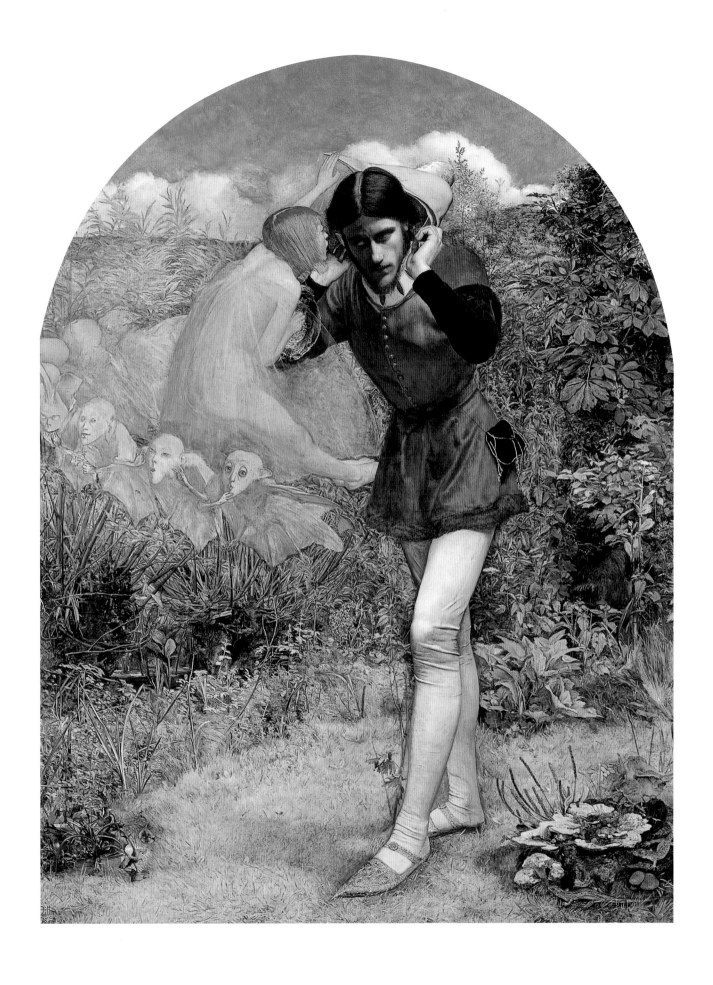

LIVERPOOL JOHN MOORES UNIVERSITY
LEARNING SERVICES

83

SIR JOSEPH NOËL PATON (1821–1901)
Elves and Fairies: A Scene from 'A Midsummer Night's Dream'

c. 1850
Oil on millboard
26.4 × 31.2 cm (10⅜ × 12¼ in.)
Yale Center for British Art, Paul Mellon Fund, New Haven CT, inv. B. 1975.5.6
Ferrara only

Paton was a Scottish painter of historical, religious, literary and allegorical themes. He was born in Dumfermline and began his career as a designer of textiles. In 1843 he went to London to study at the Royal Academy Schools, and there met John Everett Millais (see pl. 82), his junior by eight years. He did not join the Pre-Raphaelite Brotherhood, having returned to Scotland by the time it was founded in September 1848, but he remained on close terms with Millais and his work has a certain affinity with that of the Pre-Raphaelites.

Paton was an intellectual whose imagination was profoundly stirred by Celtic legends. He was also one of the greatest Victorian exponents of fairy painting, particularly during the early part of his career. His passion for fairy subjects was such that in 1850 the painter and photographer David Octavius Hill urged him to send "historical and sacred subjects" to the Royal Scottish Academy in order to refute the critics who were accusing him of being "fairy mad". In fact in later life Paton did turn increasingly to "sacred subjects", investing them with a rather sentimental piety that made them enormously popular. Queen Victoria herself was among his patrons and admirers. She appointed him her Limner for Scotland in 1866 and knighted him the following year.

Paton's two greatest fairy paintings are a pair of illustrations to *A Midsummer Night's Dream, The Quarrel of Oberon and Titania* and *The Reconciliation of Oberon and Titania* (fig. 60, p. 219), both in the National Gallery of Scotland, Edinburgh. The quarrel was over a changeling boy whom the queen of the fairies refused to give up to her husband, who wanted him for his page; it was only made up after Oberon, with the help of his henchman, Puck, had humiliated his wife by making her fall in love with Bottom, an oafish weaver and amateur actor, disguised as an ass. Paton's two paintings were executed in 1847, although the *Quarrel* was a large version of a picture he had exhibited at the Royal Scottish Academy, as his diploma work, in 1846. Illustrations to Shakespeare were among the subjects eligible for the competitions held in the 1840s to find artists capable of carrying out the decoration of the new Palace of Westminster, and Paton entered the *Reconciliation* for the competition of 1847. The picture gained him a premium of £300 and effectively established his reputation. The *Quarrel* was not exhibited at the Royal Scottish Academy until 1850, where it in turn caused a sensation. Lewis Carroll, the creator of *Alice's Adventures in Wonderland* and *Through the Looking Glass*, was among its admirers.

The present picture dates from about 1850, and is one of a number of smaller works that can be loosely related to Paton's two masterpieces.

The fairies and goblins are based on a group that appears at lower centre in the *Quarrel*, but Paton has made the goblins, if anything, more grotesque, while adding the figure of Puck, showing him larger than his fellow sprites but with such typical fairy attributes as pointed ears and butterfly-like wings. Puck also figures in the *Quarrel* but there he is seen in the train of his royal master, castigating an errant fairy in one of those slightly sadistic passages that are so characteristic of Victorian fairy painting.
JC

PROVENANCE James Coates; Lincoln Kirstein; American Shakespeare Theatre, Stratford CT, from which acquired by the Yale Center for British Art, 1975

BIBLIOGRAPHY Rhode Island 1979, no. 154; New Haven CT 1981, no. 99; Cormack 1985, pp. 176–77

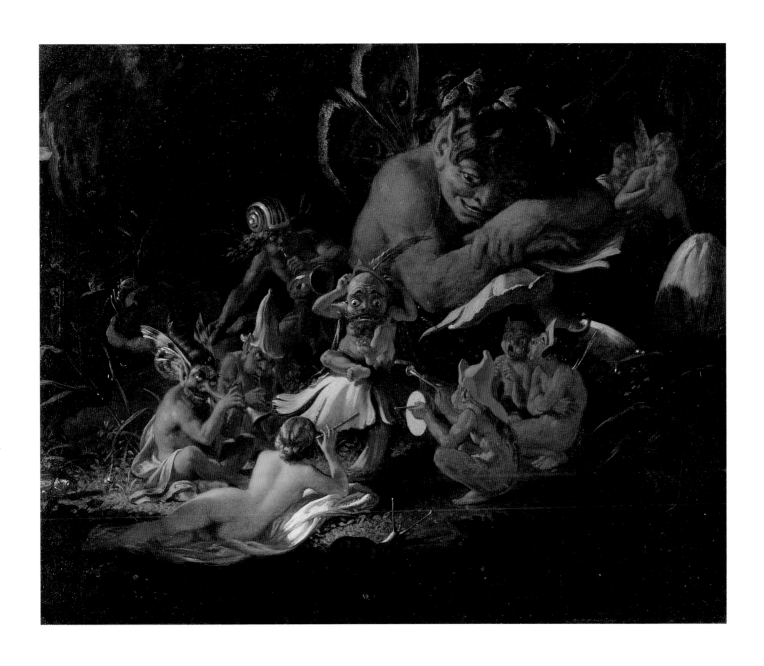

84
WILLIAM HOLMAN HUNT (1827–1910)
Valentine rescuing Silvia from Proteus (The Two Gentlemen of Verona, V. iv)

Inscribed by the artist *W. HOLMAN HUNT 1851 Kent*
1851
Oil on canvas
Arched top, 98.5 × 133.3 cm (38¾ × 52½ in.)
Birmingham Museums and Art Gallery, inv. 1887 P53

While Millais's technical facility and eye for a winning subject made Pre-Raphaelitism accessible (see pl. 82), Hunt ensured that its tenets prevailed by approaching them with the mind-set of an obsessive. His fanatical devotion to what he saw as the core values of Pre-Raphaelitism, the expression of metaphysical ideas through symbolism rooted in visual truth, soon focused on religious subjects, and in 1854 he set off on what was to prove the first of four visits to the East to paint biblical subjects on the very spot where they had occurred. The pictures that resulted from these visits brought him fame and wealth, but they seem laboured and prosaic beside a work such as *Valentine rescuing Silvia*, an early masterpiece exhibited within three years of the PRB's foundation. Ford Madox Brown described it soon after its completion as "without fault and beautiful to its minutest detail".

The subject is taken from the last scene of *The Two Gentlemen of Verona*. Relevant quotations from the play are inscribed on the frame in an attempt, typical of Hunt, to integrate text and image. Valentine, banished from Milan for paying court to the duke's daughter, Silvia, has just saved his lover from being raped by his false friend Proteus, whose machinations have already led to Valentine's banishment. Proteus, his treachery revealed, is overcome by guilt and remorse, while on the left his first love, Julia, who has followed him to Milan from Verona disguised as a page, looks on with dismay as Valentine not only assures him of his continued friendship but offers to resign Silvia to him as well. In the distance, the duke arrives with his retinue, an intimation that, in true Shakespearean fashion, all will soon end in general reconciliation.

Hunt loved to portray strong and conflicting emotions. He would do so again in a Shakespearean context in *Claudio and Isabella*, an illustration to *Measure for Measure* (1850–53; Tate, London). But seldom is the mixture so potent as in *Valentine rescuing Silvia*, in which lust, betrayal, shame, generosity, innocence, unrequited love and sexual jealousy all play a part. Short of the religious subjects to which Hunt would soon turn his attention, the Pre-Raphaelite ideal of painting themes replete with meaning could hardly be taken further.

The picture was painted comparatively quickly. After the furore caused by the Pre-Raphaelites' contributions to the Royal Academy of 1850, Millais's *Ferdinand lured by Ariel* (pl. 82) among them, Hunt was determined to send a major work in 1851, despite the short time at his disposal. Having sketched out the design, he took his canvas to Knole in Kent, and spent the autumn painting the woodland setting in the park. Two other PRBs, D.G. Rossetti and F.G. Stephens, were with him, similarly employed. Back in London, he completed the foreground in his studio, adding the dead leaves and the broken fungi indicative of the recent tussle between Silvia and her assailant. Only then did he set about the figures, whose poses were still not fully resolved. True to early Pre-Raphaelite practice, Hunt used non-professional models. Two young barristers, James Lennox Hannay and James Aspinal, sat respectively for Valentine and Proteus. Elizabeth Siddal, who had recently been discovered by W.H. Deverell and was to play such a major role in Pre-Raphaelite annals as muse and model, posed for Silvia.

Hunt designed the costumes of Silvia, Julia and Proteus himself, while Valentine's armour was lent to him by the popular genre painter William Powell Frith. A number of details were based on Camille Bonnard's *Costumes Historiques* (1829–30), the same book that Millais had used when devising a dress for his *Ferdinand* (pl. 82) a year earlier. For more general inspiration, Hunt seems to have been indebted to a picture based on the same play by Augustus Leopold Egg, *Launce's Substitute for Proteus's Dog* (Leicestershire Museum and Art Gallery). Egg's sole contribution to Brunel's Shakespeare Room, the picture was exhibited at the Royal Academy in 1849 and much admired by Hunt, who praised it as "sparkling and brilliant, like the wit of 'The Two Gentlemen of Verona' itself", in an essay on Egg that he published in 1863. Hunt's warm response to Egg's picture may explain why he alone of the Pre-Raphaelites illustrated this particular Shakespeare play.

The Pre-Raphaelite paintings exhibited at the Royal Academy in 1851 aroused as much hostility as those shown in 1850, but the tide was turning. In May Ruskin sent two letters to *The Times*, explaining the PRB's aims and defending their methods. "There has been nothing in art", he wrote, "so earnest or so complete as these pictures since the days of Albert Dürer", and he singled out two passages in *Valentine rescuing Silvia* – "the black sleeve of the Julia" and "the velvet on the breast and the chain mail of the Valentine" – as examples of "perfect truth, power and finish". Before the end of the year Hunt had not only sold the picture but seen it win a £50 prize at the Liverpool Academy.
JC

PROVENANCE Bought by Francis McCracken, November 1851; his sale, Christie's, 17 June 1854, lot 97, bought in; probably sold to the dealer D.T. White; Thomas Fairbairn by 1855; sold Christie's, 7 May 1887, lot 142; bought by the Birmingham Art Gallery for 1000 guineas

BIBLIOGRAPHY Cook and Wedderburn 1903–12, XI, pp. xlviii, 217; XIV, p. 226; Holman Hunt 1905, I, pp. 236–39, 246–51, 254–56, 280–82; II, pp. 344–49; Nottingham 1961, no. 65; Bennett 1963, pp. 486, 491; London 1964, no. 58; Liverpool and London 1969, no. 19; London 1984², no. 36; Alexandra 1995, p. 104, no. 17

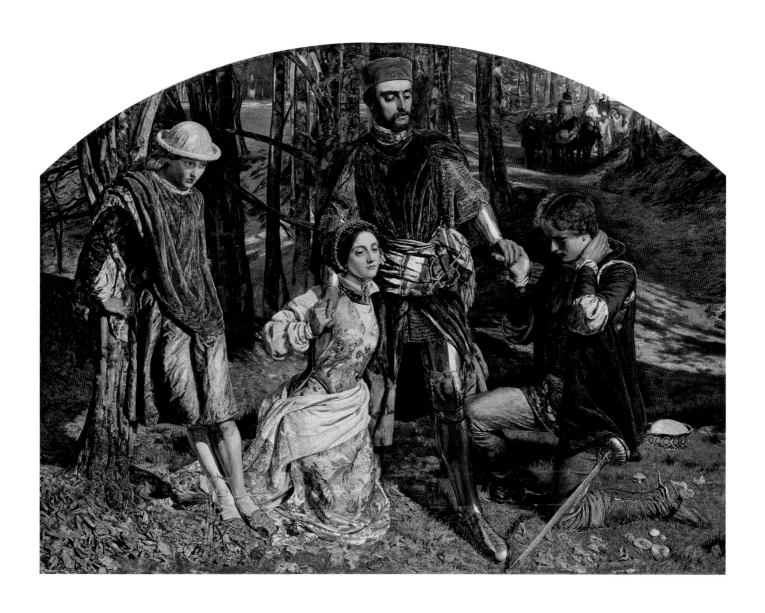

WILLIAM DYCE (1806–1864)
King Lear and the Fool in the Storm (King Lear, III. ii)

1851
Oil on canvas
136 × 173 cm (53⅛ × 68¼ in.)
National Gallery of Scotland, Edinburgh, inv. NG2585. Purchased with the aid of the National Art Collections Fund

Dyce was that very Victorian phenomenon, an artist who was also deeply involved in art education and administration. An exact contemporary of his fellow Scot David Scott (see pl. 79), he was born in Aberdeen where he studied medicine and theology. He was always to be something of a polymath, and science, music and church ritual remained lifelong interests. Having studied briefly at the Royal Academy Schools in London, he paid two visits to Rome (1825, 1827), where he made contact with the Nazarenes. However, when he returned to Scotland to practise as a portrait painter, first in Aberdeen and later in Edinburgh, he was still working in a conventional style indebted to Reynolds and Sir Thomas Lawrence.

Dyce moved to London in 1838 to become superintendent of the government-sponsored School of Design at Somerset House. He had been exhibiting at the Royal Academy since 1827, and was elected an associate in 1844 and a full member four years later. Meanwhile in 1843 the first competition had been held to find artists capable of decorating the new Palace of Westminster, and in 1845 Dyce was commissioned to paint an Anglo-Saxon subject, *The Baptism of Ethelbert*, in the House of Lords. By now he had adopted a quasi-Nazarene style that greatly appealed to Prince Albert, the president of the royal commission in charge of the project, and this trend was confirmed when he spent the winter of 1845–46 in Italy, studying early frescoes in order to prepare himself for the work at Westminster. In 1846 he was commissioned to paint a mural at Osborne House, the royal family's retreat on the Isle of Wight, and in 1848 he was assigned further work in the House of Lords, a series of Arthurian subjects in the Queen's Robing Room. These were still incomplete at his death sixteen years later.

Throughout his later career Dyce continued to be deeply involved in art education. He also advised on the management of The National Gallery, and served on the juries of the Great Exhibition (1851) and the International Exhibition (1862). So far as his own painting was concerned, the most important development was his association with the Pre-Raphaelites. The Brotherhood was formed in 1848, and the artists' first pictures were fiercely attacked by the critics. Dyce, however, was impressed. He urged John Ruskin to come to their defence, and within a few years Pre-Raphaelite principles had indeed gained widespread acceptance. Dyce himself was influenced, as we see in the well-known *Pegwell Bay* (Tate, London), exhibited at the Royal Academy in 1860.

King Lear and the Fool in the Storm appeared at the RA in 1851 (no. 77), the same year as Holman Hunt's *Valentine rescuing Silvia* (pl. 84). An appropriate quotation from *King Lear* accompanied it in the catalogue:

Fool: O nuncle, court holy-water in a dry house is better than this rain-water out o'door. Good nuncle, in, and ask thy daughters' blessing; here's a night pities neither wise man nor fool.

The picture had a mixed reception from the critics, *The Times* going so far as to describe it as "a deplorable failure". A more measured assessment was given by Ford Madox Brown, who was showing his great painting of *Chaucer at the Court of Edward III* (Art Gallery of New South Wales, Sydney) at the same exhibition. "Dyce has a picture that would be admirable," he told his friend Lowes Dickinson, "but for his misconception of King Lear and fool, which, in some measure, prevents it giving as much pleasure as it might; however, none but a fool or a critic would dislike the work". Brown was well qualified to judge an illustration to *King Lear*, a play that obsessed him and to which he turned time and again for inspiration. He had made a set of illustrations to it in 1844, and in 1851 he was still working on his painting *Lear and Cordelia* (Tate, London), exhibited in 1849 but not sold until 1854.

Dyce was not a great exponent of Shakespearean subjects. His only other ventures into this field seem to have been pl. 88 and a *Jessica* exhibited at the RA in 1843, a fairly insignificant work in the sentimental 'keepsake' style so popular at the time. It is possible that his interest in the theme of King Lear in the storm reflects the fact that Shakespeare's plays were among the subjects officially recognized as suitable for treatment in the Westminster decorative schemes. Certainly the picture dates from the period when he was working on the murals in the Queen's Robing Room, and is stylistically related to these paintings.
JC

PROVENANCE John Knowles to 1865; James Brand, sold Christie's, 10 March 1894, lot 86, 200 guineas, to Bonsor; anon. sale, Christie's, 3 November 1989, lot 145; Private Collection, London; bought by the National Gallery of Scotland, 1993

BIBLIOGRAPHY *The Times*, 3 May 1851, p. 8; *Art Journal*, 1851, p. 154; Poynton 1979, p. 199; Tokyo *et al.* 1992–93, no. 56

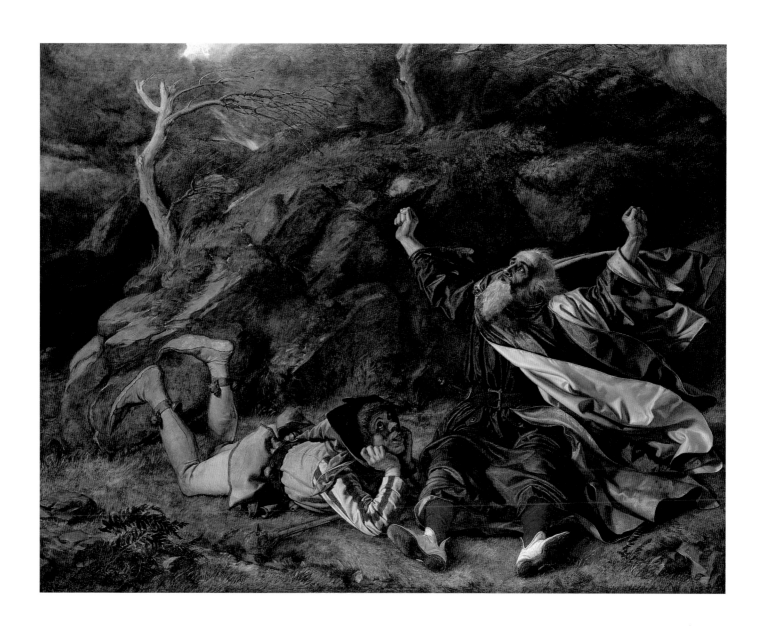

86
FREDERIC, LORD LEIGHTON, PRA (1830–1896)
The Reconciliation of the Montagues and the Capulets over the Dead Bodies of Romeo and Juliet (V. iii)

1853–55
Oil on canvas
177.8 × 231.1 cm (70 × 91 in.)
Agnes Scott College, Decatur GA
Ferrara only

The bodies of Romeo and Juliet, scions respectively of the two leading families of Verona, the Montagues and the Capulets, have been discovered in the Capulets' burial vault. Romeo has taken poison in the belief that Juliet is dead, while she, awakening from her death-like trance and finding his corpse by her side, has stabbed herself to death in despair. The body of Count Paris, whom Juliet's father had wished her to marry, lies slumped to the right; he has been killed by Romeo after accosting him as he attempted to enter the tomb.

Behind the lovers stand their fathers, Lords Montague and Capulet, bitterly aware that their family feud has precipitated the terrible tragedy and shaking hands in a belated gesture of reconciliation. Lady Capulet, heavily cloaked, has thrown herself on her daughter's body in a paroxysm of grief, while Friar Lawrence, who has acted as counsellor to the star-crossed lovers and suggested the solution to their plight that has so horribly miscarried, kneels to the left, invoking the mercy of heaven on all concerned. Between the two lords stands Escalus, Prince of Verona, speaking the words that point the moral of the play:

> See what a scourge is laid upon your hate,
> That heaven finds means to kill your joys with love!
> And I, for winking at your discords too,
> Have lost a brace of kinsmen. All are punish'd.

The painting is exactly contemporary with Leighton's best-known early work, *Cimabue's Celebrated Madonna is carried in Procession through the Streets of Florence* (The Royal Collection). Both highly ambitious in scale and conception, the pictures were his first major works to be exhibited, and were deliberately intended to launch him on the international stage. *Cimabue's Madonna* was shown at the Royal Academy in 1855 and did indeed bring him fame, causing a sensation and being bought by Queen Victoria. *The Reconciliation of the Montagues and the Capulets* appeared at the Exposition Universelles in Paris the same year. The pictures were painted in Rome, where Leighton had settled in 1852 at the age of twenty-one after a long apprenticeship that had included periods of study in nearly every European capital. As he later told the critic J. Comyns Carr, during this period he "treated none but subjects from the Italian Middle Ages, going to history, Dante, Boccaccio, and preferring in Shakespeare the Italian plays".

On his way to Rome in 1852 Leighton had visited Verona, the setting of *Romeo and Juliet*, and had probably seen 'Juliet's tomb', a well-known tourist attraction. Once he arrived, he soon made contacts that further encouraged his interest in "the Italian Middle Ages". Edward von Steinle, who had taught him in Frankfurt, had given him an introduction to Friedrich Overbeck, a founding father of the Nazarene movement, which had been launched in Rome in 1810 under the influence of the early Italian masters. He also associated with two young architects who were destined to play a large part in the English Gothic Revival, Alfred Waterhouse and William Burges. Burges designed vestments and candlesticks for *Cimabue's Madonna*.

But the crucial influences on Leighton in Rome resulted from his meeting with Adelaide Sartoris in February 1853. A charismatic and rather overpowering personality, Mrs Sartoris belonged to one of the most distinguished families in theatrical annals. Sarah Siddons and J.P. Kemble were her aunt and uncle. The actress Fanny Kemble was her sister, and before her marriage Adelaide herself had enjoyed a successful career as an opera singer, starring in the title role of *Norma*. Leighton became one of the most assiduous members of her intensely cultured circle. She introduced him to Robert Browning, another devotee of Italian historical subjects, while the Kemble connection goes far to explain the theatricality of *The Reconciliation*, which resembles the finale of a stage performance. Leighton not only heard Mrs Sartoris's famous Shakespeare recitations but took part in the charades and *tableaux-vivants* that she loved to organize. He also discussed *Romeo and Juliet* with Fanny Kemble, who later claimed that in order to "obtain a proper concept" for his picture he "induced [her] to read the passage to him from the immortal bard". Juliet had been one of Fanny's great roles, and she and her father, Charles Kemble, had done much to restore the play to the Shakespeare repertory.

Despite good reviews, the picture failed to sell when it was shown at the Exposition Universelle in 1855, or when it was brought to England and re-exhibited at the Manchester Institution in autumn 1856. Leighton therefore decided to include it in the exhibition of works by the Pre-Raphaelites and their contemporaries that toured America in 1857–58, visiting New York, Philadelphia and Boston. It finally found a private buyer in Philadelphia, and has remained in the United States ever since.
JC

PROVENANCE Bought by Mr Harrison of Philadelphia for £400, 1858; given to Agnes Scott College, 1963

BIBLIOGRAPHY Ormond 1975, *passim*; Newall 1990, pp. 12–15; Casteras 1990, p. 52; Stephenson 1999, pp. 229–31; 'Important British Art' sale, Christie's, London, 27 November 2002, lot 21 (with full bibliography)

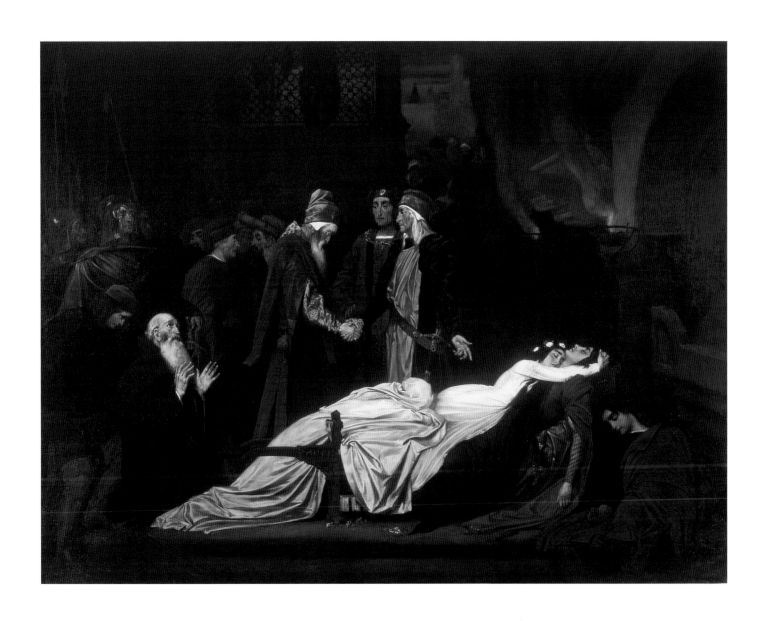

87
GEORGE CRUIKSHANK (1792–1878)
Herne's Oak (The Merry Wives of Windsor, V. v)

1857
Oil on canvas
91.4 × 121.9 cm (36 × 48 in.)
Yale Center for British Art, Paul Mellon Fund, New Haven CT, inv. B1975.5.24
Ferrara only

Cruikshank was essentially an illustrator. Both his father and his brother were caricaturists, and there is a strong element of caricature and satire in his accounts of political events and social customs. This approach made his work the ideal complement to that of another great caricaturist, Charles Dickens, whose novels he began to illustrate in 1836.

Fairy stories, which again lent themselves to grotesque treatment, were increasingly the focus of Cruikshank's imagination. His most famous illustrations of this kind were those he made for the Grimms' *Kinder- und Haus-Märchen* when they were translated under the title *German Popular Stories* in the 1820s. In 1850 he illustrated the second edition of Thomas Keightley's *Fairy Mythology*, and in 1853–54 he issued his own *Fairy Library*, a collection of traditional fairytales that he not only illustrated but rewrote to turn them into temperance tracts. Teetotalism had become an obsession with Cruikshank by this date. His campaigning, conducted largely through his work, reached a climax in the early 1860s, when he painted *The Worship of Bacchus* (Tate, London), an enormous panoramic indictment of the demon drink.

In the 1850s Cruikshank endeavoured to move beyond the limitations of book illustration, concentrating on oil-painting and exhibiting his pictures at the Royal Academy and the British Institution. The present example is probably the picture of this title that he showed at the British Institution in 1857, priced remarkably highly at £200. It shows the last scene in *The Merry Wives of Windsor*. The amorous Falstaff has been tricked into disguising himself as Herne the Hunter and meeting Mistress Page and Mistress Ford at Herne's Oak in Windsor Park. The ladies have now left him to his fate, and he is being tormented and scared out of his wits by their friends and children, disguised as fairies, goblins and satyrs. Anne Page stands at centre left, impersonating the Fairy Queen and encouraging the revellers with the words:

> Corrupt, corrupt, and tainted in desire!
> About him, fairies, sing a scornful rhyme;
> And, as you trip, still pinch him to your time.

Like so much of Cruikshank's later work, the picture has a moral dimension, reflecting his preoccupation with the evil effects of alcohol. As Sir Hugh Evans, one of Falstaff's tormentors, puts it, Falstaff has been "given to fornications, and to taverns, and sack and wine and metheglins, and to drinkings, and swearings and starings, pribbles and prabbles". He is now receiving his just deserts.
JC

PROVENANCE George D. Smith; Folger Shakespeare Library, Washington, DC, 1926; Lincoln Kirstein; American Shakespeare Theatre, Stratford CT, from which acquired by the Yale Center for British Art, 1975

BIBLIOGRAPHY *Athenaeum*, no. 1529, 14 February 1857, p. 218; *Art Journal*, 1857, p. 72; New Haven CT 1981, no. 38; Cormack 1985, pp. 74–75

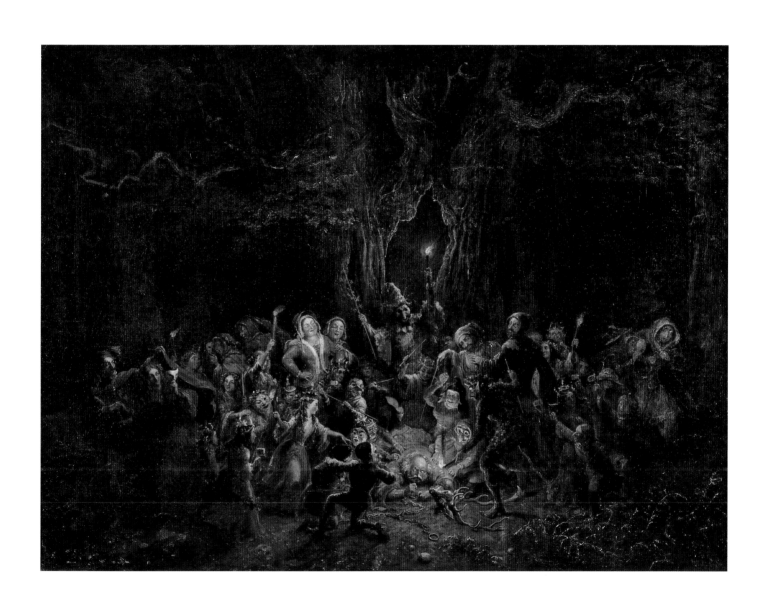

88
WILLIAM DYCE (1806–1864)
Henry VI at Towton (3 Henry VI, II. v)

1855–60
Oil on millboard
36.8 × 50.8 cm (14½ × 20 in.)
Guildhall Art Gallery, Corporation of London, inv. 661

Henry VI at Towton belongs to a group of pictures of figures in landscapes that Dyce painted in the late 1850s, often basing them on sketches made during summer holidays in Scotland, Wales, or, in the case of the famous *Pegwell Bay* (1859–60; Tate, London), Ramsgate, on the south-east coast of England. The battle of Towton, which was fought on 29 March 1461 at a hamlet near Tadcaster in Yorkshire, was a decisive event in the civil war, the so-called Wars of the Roses, that raged for much of the reign of Henry VI. It was lost by Henry, who led the Lancastrian (red rose) party, and won by Edward, Duke of York, head of the Yorkist (white rose) faction, who had already had himself proclaimed king as Edward IV. Henry fled to Scotland, and ten years later was murdered in the Tower of London.

Dyce shows Henry as he appears in Shakespeare's play. He has withdrawn from the field of battle and meditates on the harshness of his lot:

> Would I were dead, If God's good will were so!
> For what is in this world but grief and woe?
> O God! methinks it were a happy life
> To be no better than a homely swain

Dyce's interest in the subject is not hard to explain. A devout churchman with a keen interest in ecclesiology, church music and ritual, he would have been attracted to the figure of Henry VI, who was renowned for his piety and founded two great educational establishments, Eton College and King's College, Cambridge. A similar sympathy lies behind his picture of *George Herbert at Bemerton* (1861; Guildhall Art Gallery, London). Herbert, the early seventeenth-century divine who wrote some of the best-loved devotional poetry in the English language, represented many of the same values as Henry VI.
JC

PROVENANCE Sir John Pender; Charles Gassiot; Guildhall Art Gallery, 1902

BIBLIOGRAPHY Staley 1973, pp. 165–66; Poynton 1979, pp. 77, 156, 165, 175, 193; Tokyo *et al.* 1992–93, no. 57

BIBLIOGRAPHY

Ackroyd 1990
Peter Ackroyd, *Dickens*, London 1990

Adolphus 1839
John Adolphus, *Memoirs of John Bannister*, 2 vols., London 1839

Alexander 1977
David Alexander, 'Mezzotint Conversations after … Zoffany', *Antique Collector*, January 1977, pp. 64–67

Alexander 1992
David Alexander, 'Kauffman and the Print Market in Eighteenth-Century England', in W.W. Roworth, *Angelica Kauffman: A Continental Artist in Georgian England*, London 1992, pp. 8–9

Alexandra 1995
Vision of Love and Life: Pre-Raphaelite Art from the Birmingham Collection, England, exhib. cat., ed. Stephen Wildman, circulated by Art Services International, Alexandra VA 1995

Aliverti 1998
M.I. Aliverti, *La naissance de l'acteur moderne: L'acteur et son portrait au XVIIIe siècle*, Paris 1998

Allen 1986
Brian Allen, 'Francis Hayman and the Supper-Box Paintings for Vauxhall Gardens', in *The Rococo in England: A Symposium*, ed. Charles Hind, London 1986, pp. 113–33

Allgeyer 1902
J. Allgeyer, *Anselm Feuerbach*, 2nd edn, with the author's original letters, ed. C. Neumann, 2 vols., Berlin and Stuttgart 1902

Allwood 1988
Rosamond Allwood, 'Woodcarving: The "high art" of Victorian furniture making', *Antique Collecting*, XX, no. 10, March 1988, pp. 49–54

Altick 1985
Richard D. Altick, *Paintings from Books: Art and Literature in Britain, 1760–1900*, Columbus OH 1985

Anglesea 1971
Martyn Anglesea, 'David Garrick and the Visual Arts', unpublished MA thesis, University of Edinburgh 1971

Anon. 1762
Anon., *A Description of Vauxhall Gardens*, London 1762

Antal 1956, 1971
F. Antal, *Fuseli Studies*, London 1956; Italian edn *Studi su Fuseli*, Turin 1971

Argan 1960
G.C. Argan, 'Fuseli, Shakespeare's Painter', in *Il teatro di William Shakespeare*, trans. C. Vico Ludovici, 3 vols., Turin 1960, I, pp. XXIX–XLI

Ashton 1990
Geoffrey Ashton, *Shakespeare: His Life and Work in Paintings, Prints and Ephemera*, London 1990

Ashton 1997
Geoffrey Ashton, *Pictures in the Garrick Club*, ed. Kalman A. Burnim and Andrew Wilton, London 1997

Avery 1956
E. Avery, 'The Shakespeare Ladies Club', *Shakespeare Quarterly*, VII, spring 1956, pp. 153–58

Baltimore 1979
Théodore Chassériau: Illustration for Othello, exhib. cat. by J.M. Fisher, Baltimore Museum of Art, 1979

Bate 1986
Jonathan Bate, *Shakespeare and the English Romantic Imagination*, Oxford 1986

Bate 1989
Jonathan Bate, *Shakespearean Constitutions: Politics, Theatre, Criticism 1730–1830*, Oxford 1989

Bate 1992
Jonathan Bate, *The Romantics on Shakespeare*, London 1992

Bate 1997
Jonathan Bate, *The Genius of Shakespeare*, London 1997

Bate and Jackson 2001
Jonathan Bate and Russell Jackson (eds.), *The Oxford Illustrated History of Shakespeare on Stage*, Oxford 2001

Baudelaire, *Oeuvres complètes*
C. Baudelaire, *Oeuvres complètes*, ed. Y.G. Le Dantec, Paris 1950

Baugh 1990
Christopher Baugh, *Garrick and Loutherbourg*, Cambridge 1990

Baugh 1993
Christopher Baugh, 'Three Loutherbourg Designs', *Theatre Notebook*, XLVII, 2, 1993, pp. 96–103

Beckett 1949
R. Beckett, *Hogarth*, London 1949

Beerbohm 1909
Max Beerbohm, 'On Shakespeare's Birthday', *Yet Again*, London 1909

Belsey 2002
Hugh Belsey, *Gainsborough at Gainsborough's House*, London 2002

Bennett 1963
Mary Bennett, 'A Check List of Pre-Raphaelite Pictures exhibited at Liverpool 1846–67', *The Burlington Magazine*, CV, 1963, pp. 486–91

Bennett 1988
Shelley Bennett, *Thomas Stothard: The Mechanisms of Art Patronage in England circa 1800*, Columbia MO 1988

Berlioz, *Mémoires*
Mémoires de Hector Berlioz [Paris 1870], ed. and English trans. by David Cairns, London 1969

Bertelsen 1978
Lance Bertelsen, 'David Garrick and English Painting', *Eighteenth-Century Studies*, II, no. 3, spring 1978, pp. 308–24

Bindman 1970
D. Bindman (ed.), *William Blake: Catalogue of the Collection in the Fitzwilliam Museum, Cambridge*, Cambridge 1970

Bindman 1977
David Bindman, *Blake as an Artist*, Oxford 1977

Bindman 2000
David Bindman (intro.), *William Blake: The Complete Illuminated Books*, London 2000

Birmingham 1947
The Pre-Raphaelite Brotherhood, exhib. cat., Birmingham City Gallery, 1947

Birmingham 1951
City Museum Birmingham: Supplement III to the Catalogue of the Permanent Collection, Birmingham 1951

Bishop 1951
Morchard Bishop, *Blake's Hayley*, London 1951

Blinn 1982–88
Blinn, Hanjürgen, *Shakespeare-Rezeption: die Diskussion um Shakespeare in Deutschland*, 2 vols., Berlin 1982–88

Blunt 1959
A. Blunt, *The Art of William Blake*, New York and London 1959

Boaden 1825
James Boaden, *Memoirs of the Life of John Philip Kemble*, 2 vols., London 1825

Boaden 1827
James Boaden, *Memoirs of Mrs. Siddons, Interspersed with Anecdotes of Authors and Actors*, Philadelphia 1827

Boase 1947
T.S.R. Boase, 'Illustrations of Shakespeare's Plays in the Seventeenth and Eighteenth Centuries', *Journal of the Warburg and Courtauld Institutes*, X, 1947, pp. 83–108

Boase, 1955–56
T.S.R. Boase, 'An Extra-Illustrated Second Folio of Shakespeare', *British Museum Quarterly*, XX, 1955–56, pp. 4–8

Boase 1960
T.S.R. Boase, 'John Graham Lough: A Transitional Sculptor', *Journal of the Warburg and Courtauld Institutes*, XXIII, 1960, pp. 277–90

Booth 1981
Michael Booth, *Victorian Spectacular Theatre, 1850–1910*, London 1981

Bottrop 1996
The Boydell Shakespeare Gallery, exhib. cat., ed. Walter Pape and Frederick Barwick, Bottrop, Museum Bochum, 1996

Bragaglia 1973
L. Bragaglia, *Shakespeare in Italia: personaggi ed interpreti: vita scenica del teatro di Guglielmo Shakespeare in Italia 1792–1973*, Rome 1973

Bregenz 1968
A. Kauffmann und ihre Zeitgenossen, exhib. cat., Bregenz, 1968

Brewer 1997
J. Brewer, *The Pleasures of Imagination: English Culture in the Eighteenth Century*, London and New York 1997

Brewster and Jacobs 1997
Ben Brewster and Leah Jacobs, *Theatre to Cinema: Stage Pictorialism and the Early Feature Film*, Oxford 1997

Brighton 1980
Fairies, exhib. cat., Brighton Museum, 1980

Britton 1799
John Britton, *Sheridan and Kotzebue: The Enterprising Adventures of Pizarro*, London 1799

Britton 1840
John Britton, *Essays in the Merits and Characteristics of William Shakespeare*, London 1840

Brockwell 1915
Maurice Brockwell, *A Catalogue of Pictures and other Works of Art in the Collection of Lord St. Oswald at Nostell Priory*, London 1915

Brosch 1986
Shakespeare, Buch und Bühne, exhib. cat., ed. R. Brosch, J. Müller and G. Wagner, Berlin, Kunstbibliothek Berlin, Staatliche Museen Preussischer Kulturbesitz, 1986

Bruntjen 1985
Sven H.A. Bruntjen, *John Boydell, 1719–1804: A Study of Art Patronage and Publishing in Georgian London*, PhD diss., Stanford University 1974, New York and London 1985

Burnim 1958
Kalman A. Burnim, *Shakespeare Quarterly*, IX, no. 2, spring 1958, pp. 149–52

Burnim 1961
Kalman A. Burnim, *David Garrick, Director*, Pittsburg 1961

Butlin 1981
Martin Butlin, *The Paintings and Drawings of William Blake*, 2 vols., New Haven CT and London 1981

Butlin and Joll 1984
M. Butlin and E. Joll, *The Paintings of J.M.W. Turner*, 2nd edn, New Haven CT and London 1984

Buxton 1979
The Lamp of Memory: Scott and the Artist, exhib. cat. by Catherine Gordon and Nicholas Penny, Buxton Museum and Art Gallery, 1979

Cambridge 1977
Drawings by John Romney from the Fitzwilliam Museum, exhib. cat. by Patricia Jaffé, Cambridge, The Fitzwilliam Museum 1977

Cambridge 1997
Shakespeare and the Eighteenth Century, exhib. cat. by Jane Munro, Cambridge, The Fitzwilliam Museum, 1997

Campbell 1990
Mungo Campbell, *David Scott* (National Gallery of Scotland Scottish Masters series), Edinburgh 1990

Casteras 1990
Susan P. Casteras, *English Pre-Raphaelitism and its Reception in America in the Nineteenth Century*, London and Toronto 1990

Cedergreen Bech 1979
S. Cedergreen Bech, 'Nicolai Abildgaard', *Dansk biografisk Leksikon*, III, Copenhagen 1979, pp. 438–39

Chaloner Smith
J. Chaloner Smith, *British Mezzotint Portraits*, 4 vols., London 1878–83

Chateaubriand 1849–50
F.A.R. de Chateaubriand, *Mémoires d'outre-tombe*, 6 vols., Paris 1849–50

Cibber 1756
Theophilus Cibber, *Dissertations on Theatrical Subjects*, 2 vols., London 1756

Cole 1859
J.W. Cole, *The Life and Theatrical Times of Charles Kean, FSA*, 2 vols., London 1859

Cook and Wedderburn 1903–12
E.T. Cook and Alexander Wedderburn (eds.), *The Works of John Ruskin* (Library Edition), London 1903–12

Cormack 1985
Malcolm Cormack, *A Concise Catalogue of Paintings in the Yale Center for British Art*, New Haven CT 1985

Corti 1996
C. Corti, *Shakespeare illustrato*, Rome 1996

Coypel 1721
Antoine Coypel, *Discours prononcez dans les conférences de l'Académie royal de peinture et sculpture*, Paris 1721

Croker 1804
John Wilson Croker, *Familiar Enterprises to Frederick J-S Esq., on the Present State of the Irish Stage*, London 1804

Croft-Murray 1970
E. Croft-Murray, *Decorative Painting in England, 1537–1837*, II, *The Eighteenth and Nineteenth Centuries*, London 1970

Cross 2000
David A. Cross, *A Striking Likeness: The Life of George Romney*, Aldershot 2000

Dafforne 1873
James Dafforne, *Pictures by Daniel Maclise, RA*, London 1873

Davies 1946
M. Davies, *National Gallery Catalogues: British School*, London 1946

Davies 1783–84
Thomas Davies, *Dramatic Miscellanies*, London 1783–84

Davies 1780, 1808
Thomas Davies, *Memoirs of the Life of David Garrick* [London 1780], 2 vols., London 1808

Deelman 1964
Christian Deelman, *The Great Shakespeare Jubilee*, London 1964

Delacroix, *Correspondance*
Correspondance générale d'Eugène Delacroix, ed. A. Joubin, 5 vols., Paris 1935–38

Delacroix, *Journal*
Journal de Eugène Delacroix 1822–1863 [1932], ed. A. Joubin and R. Labourdette, Paris 1996

Deuchler 1999
F. Deuchler, '"Windsturm und Ungewitter", zu einem Bild von Johann Heinrich Füssli in der Fondazione Magnani Rocca', *Zeitschrift für schweizerische Archäologie und Kunstgeschichte*, LVI, no. 2, 1999, pp. 129–36

Dickens, *Pictures from Italy*, ed. Flint 1998
Charles Dickens, *Pictures from Italy*, 1846, ed. Kate Flint, Harmondsworth 1998

Dickens 1863
Charles Dickens, 'A New Stage Stride', *All the Year Round*, 31 October 1863

Dickens 1869
Charles Dickens, 'On Mr Fechter's Acting', *The Atlantic Monthly*, August 1869

Dobbs 1972
Brian Dobbs, *Drury Lane: Three Centuries of the Theatre Royal, 1663–1971*, London 1972

Dobson 1992
Michael Dobson, *The Making of the National Poet: Shakespeare, Adaptation and Authorship*, Oxford 1992

D'Oench 1999
Ellen G. D'Oench, 'Copper into Gold': Prints by John Raphael Smith 1751–1812, New Haven CT and London 1999

Donohue 1975
Joseph Donohue, *Theatre in the Age of Kean*, Oxford 1975, p. 59

Dotson 1965
E. Gordon-Dotson, 'English Shakespeare Illustration and Eugène Delacroix', in *Essays in Honor of Walter Friedländer*, New York 1965, pp. 40–61

Dotson 1973
E. Dotson, 'Shakespeare Illustrated 1770–1820', unpublished PhD diss., The Institute of Fine Arts, New York University, New York 1973

Downer 1966
Alan S. Downer, *The Eminent Tragedian: William Charles Macready*, Cambridge MA 1966

Duncan-Jones 2001
Katherine Duncan-Jones, *Ungentle Shakespeare: Scenes from his Life*, London 2001

Ecker 1991
J. Ecker, *Anselm Feuerbach, Leben und Werk, Kritischer Katalog der Gemälde, Ölskizzen und Ölstudien*, Munich 1991

Edinburgh 1957
National Gallery of Scotland: Catalogue of Paintings and Sculptures, Edinburgh 1957

Edinburgh 1960
National Gallery of Scotland: Catalogue of Scottish Drawings, Edinburgh 1960

Edinburgh and London 1986
Painting in Scotland: The Golden Age, exhib. cat. by D. Macmillan, Edinburgh and London 1986

Einberg and Egerton 1988
The Age of Hogarth: British Painters born 1675–1709, exhib. cat. by Elizabeth Einberg and Judy Egerton, London, Tate Gallery, 1988

Esdaile 1952
Katharine Esdaile, 'Some Fellow-Citizens of Shakespeare in Southwark', *Essays and Studies*, The English Association, ns, V, 1952, pp. 26–31

Faberman and McEvansoneya 1995
Hilarie Faberman and Philip McEvansoneya, 'Isambard Kingdom Brunel's "Shakespeare Room"', *The Burlington Magazine*, CXXXVII, 1995, pp. 108–18

Farington, *Diary*
The Diary of Joseph Farington, ed. Kenneth Garlick, Angus Macintyre and Kathryn Cave, 16 vols. (1793–1821), London and New Haven CT 1978–98

Fazio 1993
M. Fazio (ed.), *Il mito di Shakespeare e il teatro romantico*, Rome 1993

Fazio 1999
M. Fazio, *François-Joseph Talma, primo divo: Teatro e storia fra Rivoluzione, Impero e Restaurazione*, Milan 1999

Feaver 1971
William Feaver, *The Art of John Martin*, Oxford 1971

Fish 1923
Arthur Fish, *John Everett Millais*, London 1923

Fleming 1998
G.H. Fleming, *John Everett Millais: A Biography*, London 1998

Fowler 1986
James Fowler, 'David Scott's Queen Elizabeth Viewing the Performance of the "Merry Wives of Windsor" in the Globe Theatre (1840)', in *Shakespeare and the Victorian Stage*, ed. Richard Foulkes, Cambridge 1986, pp. 23–38

Freyer 1809
E. Freyer (ed.), *The Works of James Barry*, 2 vols., London 1809

Friedman 1976
Winifred H. Friedman, *Boydell's Shakespeare Gallery*, PhD diss., Harvard University 1974, New York 1976

Garrick 1744
David Garrick, *An Essay on Acting*, London 1744

Gautier 1852
T. Gautier, 'Salon de 1852', *La Presse*, 25 May 1852

The Gazetteer and New Daily Advertiser 1781
'A Continuation of the Remarks on the most Capital Paintings in the Royal Academy Exhibition', *The Gazetteer and New Daily Advertiser*, Saturday 2 May 1781, p. 1

Gooch and Thatcher 1991
B.N.S. Gooch and D. Thatcher (eds.), *A Shakespeare Music Catalogue*, Oxford 1991

Goodreau 1979
D.A. Goodreau, *Nathaniel Dance R.A., 1735–1811*, PhD diss., UCLA 1973, Ann Arbor MI 1979

Gowing 1953
L. Gowing, 'Hogarth, Hayman, and the Vauxhall Decorations', *The Burlington Magazine*, XCV, 1953, pp. 4–19

Graham Robertson 1931
Walford Graham Robertson, *Time Was*, London 1931

Guégan 1998
S. Guégan, *Delacroix: L'Enfer et l'atelier*, Paris 1998

Guise 1980
Hilary Guise, *Great Victorian Engravings*, London 1980

Habicht 1994
Werner Habicht, *Shakespeare and the German Imagination*, International Shakespeare Association, Occasional Paper 5, Hertford 1994

Haines 1925
C.M. Haines, *Shakespeare in France: Criticism, Voltaire to Victor Hugo*, London 1925

Hall 1934
Lillian A. Hall, *Catalogue of the Dramatic Portraits in the Theatre Collection of the Harvard College Library*, 4 vols., Cambridge MA 1934

LIVERPOOL JOHN MOORES UNIVERSITY
LEARNING SERVICES

Halliday 1957
F.E. Halliday, *The Cult of Shakespeare*, London 1957

Hamlyn 1978
Robin Hamlyn, 'An Irish Shakespeare Gallery',
The Burlington Magazine, CXX, 1978, pp. 515–29

Hammelmann 1958
Hanns Hammelmann, 'Shakespeare Illustration: The
earliest known originals', *Connoisseur*, CXLI, April 1958,
pp. 144–59

Hammelmann 1968
Hanns Hammelmann, 'Shakespeare's First Illustrators',
Notes on British Art, II, supplement to *Apollo*, LXXXVIII,
August 1968, pp. 1–4

Hammelmann 1975
Hanns Hammelmann, *Book Illustrators in Eighteenth-Century
England*, ed. T.S.R. Boase, New Haven CT and London
1975

Hammerschmidt-Hummel 1985
H. Hammerschmidt-Hummel, 'Johann Heinrich Füsslis
Illustrationen zu Shakespeares Macbeth unter
besonderer Berücksichtigung seiner Kunsttheorie',
Arcadia, XX, 1985, pp. 225–38

Hammerschmidt-Hummel 1990
H. Hammerschmidt-Hummel, 'Die Shakespeare-
Illustrationen des Frankfurter Malers Victor Müller im
Städelschen Kunstinstitut', *Akademie der Wissenschaften
und der Literatur*, VI, 1990, pp. 5–46

Hartnoll 1964
Phyllis Hartnoll (ed.), *Shakespeare in Music*, London 1964

Haydon, *Autobiography*
Benjamin Robert Haydon, *The Autobiography and Journals
of Benjamin Robert Haydon*, ed. M. Elwin, London 1950

Haydon, *Diaries*
Benjamin Robert Haydon, *Diaries*, ed. W.B. Pope, 5 vols.,
Cambridge MA 1963

Hazelton 1993
Nancy J. Doran Hazelton, 'The Tourist in the Audience:
Travel Pictures on the Nineteenth-century Stage',
Nineteenth Century Theatre, XX, 2, 1993, pp. 77–93

Hazlitt 1817
William Hazlitt, *Characters of Shakespeare's Plays*, London
1817

Heppner 1939–40
A. Heppner, 'The Popular Theatre of the Rederijkers in
the Works of Jan Steen and his Contemporaries', *Journal
of the Warburg and Courtauld Institutes*, III, 1939–40,
pp. 22–48

Hill 1753
Aaron Hill, *The Works of Aaron Hill*, 4 vols., London
1753

Hill 1755
John Hill, *The Actor*, London 1755

Highfill, Burnim and Langhans 1973–93
P.H. Highfill Jr, K.A. Burnim and E.A. Langhans,
*A Biographical Dictionary of Actors, Actresses, Musicians,
Dancers, Managers and Other Stage Personnel in London,
1660–1800*, 16 vols., Carbondale and Edwardsville IL
1973–93

Hogarth 1833
W. Hogarth, *Anecdotes of William Hogarth Written by
Himself* [London 1833], facsimile reprint London
1970

Holman Hunt 1905
W. Holman Hunt, *Pre-Raphaelitism and the Pre-Raphaelite
Brotherhood*, 2 vols., London 1905

Hotaling 1990
E.R. Hotaling: *Shakespeare and the Musical Stage: A Guide to
Sources, Studies and First Performances*, Boston 1990

Hume 1754
David Hume, *The History of Great Britain*, London 1754

Ingamells and Edgcumbe 2000
J. Ingamells and J. Edgcumbe (eds.), *Letters of Sir Joshua
Reynolds*, London 2000

Ingamells and Raines 1976–78
John Ingamells and Robert Raines, 'A Catalogue of the
Paintings, Drawings and Etchings of Philip Mercier',
The Walpole Society, XLVI, 1976–78

Ironside and Gere 1948
Robin Ironside and John Gere, *Pre-Raphaelite Painters*,
London 1948

Irwin 1966
D. Irwin, *English Neoclassical Art*, London 1966

Irwin 1975
D. and F. Irwin, *Scottish Painters at Home and Abroad
1700–1900*, London 1975

Jasinska 2001
A. Jasinska, 'Duch ojca Hamleta', *Opuscula Musealia*,
Zeszyty Naukowe Uniwersytetu Jagielloñskiego, no. 11,
2001, pp. 61–72

Joannides 1975
P. Joannides, 'Some English Themes in the Early
Works of Gros', *The Burlington Magazine*, CXVII, 1975,
pp. 774–85

Johnson 1981
L. Johnson, 'Delacroix, Dumas and Hamlet',
The Burlington Magazine, CXXIII, 1981, pp. 717–21

Johnson 1981–89
L. Johnson, *The Paintings of Eugène Delacroix: A Critical
Catalogue*, 6 vols., Oxford 1981–89

Johnston 1969
E. Johnston, 'Arguments towards a Conjectural
Arrangement of Blake's "Heads of the Poets"', in
For Friendship's Sake, exhib. cat., Manchester City Art
Gallery, 1969, pp. 3–5

Jullian 1975
R. Jullian, 'Delacroix et la scène d'Hamlet au cimetière',
Bulletin de la société de l'histoire de l'art français, 1975,
pp. 245–51

Kelly 1980
Linda Kelly, *The Kemble Era; John Philip Kemble, Sarah
Siddons and the London Stage*, London 1980

Kern and Uhde-Bernays 1911
G.J. Kern and H. Uhde-Bernays (eds.), *Anselm Feuerbachs
Briefen an seine Mutter*, 2 vols., Berlin 1911

Kerslake 1961
J. Kerslake, *Catalogue of Theatrical Portraits in London Public
Collections*, London 1961

Kirkman 1799
J.T. Kirkman, *Memoirs of the Life of Charles Macklin*, 2 vols.,
London 1799

Knowles 1831
J. Knowles, *The Life and Writings of Henry Fuseli*
[London 1831], 3 vols., New York 1982

Kragelund 1999
P. Kragelund, *Abildgaard, Kunstneren mellem oprørerne*,
2 vols., Copenhagen 1999

Lacambre 1990
G. Lacambre, *Peintures, cartons, aquarelles exposés dans les
galeries du Musée Gustave Moreau*, Paris 1990

Lacambre and Mathieu 1997
G. Lacambre and P.L. Mathieu, *Le Musée Gustave Moreau*,
Paris 1997

Lamb 1811
Charles Lamb, 'On the Tragedies of Shakespeare,
considered with reference to their fitness for stage
representation', 1811, in *The Works of Charles and Mary
Lamb*, ed. E.V. Lucas, London 1907

Lamb 1823
Charles Lamb, *On Some of the Old Actors*, London 1823

Lambourne 1994
Lionel Lambourne, 'Pugin and the Theatre', in *Pugin: A
Gothic Passion*, ed. Paul Atterbury and Clive Wainwright,
London 1994

Lawrence 1895
W.J. Lawrence, 'The Pioneers of Modern English Art',
The Magazine of Art, March 1895, p. 177

Leacroft 1973
R. Leacroft, *The Development of the English Playhouse*,
Ithaca NY 1973

Lennox 1753–54
Charlotte Lennox, *Shakespeare Illustrated*, 3 vols., London
1753–54

Lenotti 1951
Tullio Lenotti, 'Giulietta e Romeo nella storia, nella
leggenda, nell'arte', *Vita Veronese*, IV, 8 August 1951,
pp. 3–29

Leslie 1860
C.R. Leslie, *Autobiographical Recollections*, 2 vols., London
1860

Levey 1959
Michael Levey, 'Francesco Zuccarelli in England', *Italian
Studies*, XIV, 1959, pp. 1–20

LeWinter 1963
LeWinter, Oswald (ed.), *Shakespeare in Europe*, New York
1963

Lichtenberg 1938
Georg Christoph Lichtenberg, *Lichtenberg's Visits to
England*, Oxford 1938

Lichtenberg 1972
Georg Christoph Lichtenberg, *Schriften und Briefe*,
ed. W. Promies, Munich 1972

Little and Kahrl 1963
D.M. Little and G.M. Kahrl (eds.), *The Letters of David
Garrick*, 3 vols., Oxford 1963

Liverpool and London 1967
Millais PRB PRA, exhib. cat. by Mary Bennett, Liverpool,
Walker Art Gallery, and London, Royal Academy of Arts,
1967

Liverpool and London 1969
William Holman Hunt, exhib. cat., Liverpool, Walker Art
Gallery, and London, Victoria and Albert Museum,
1969

Liverpool, London and San Marino CA 2002
George Romney, 1734–1802, exhib. cat. by Alex Kidson,
Liverpool, Walker Art Gallery; London, National Portrait
Gallery; San Marino CA, The Huntington Library, 2002

London 1955
Exhibition of Paintings by Angelica Kauffmann, exhib. cat.,
London, Kenwood House, 1955

London 1960
Francis Hayman, exhib. cat. by Brian Allen, London,
Kenwood House, 1960

London 1964
*Shakespeare in Art: Paintings, Drawings and Engravings
Devoted to Shakespearean Subjects*, exhib. cat., intro.
by W. Moelwyn Merchant, London, Arts Council
of Great Britain, 1964

London 1971–72
Hogarth, exhib. cat. by Gert Schiff, London, Tate Gallery,
1971–72

London et al. 1974–75
The Late Richard Dadd, Arts Council of Great Britain,
exhib. cat. by Patricia Alderidge, London, Tate Gallery,
et al., 1974–75

London 1975[1]
Henry Fuseli, 1741–1825, exhib. cat. by Gert Schiff, London,
Tate Gallery, 1975

London 1975[2]
*The Georgian Playhouse: Actors, Artists, Audiences and
Architecture, 1730–1830*, exhib. cat. devised by Iain
Mackintosh assisted by Geoffrey Ashton, London,
Hayward Gallery, 1975

London 1977
Nathaniel Dance R.A., 1735–1811, exhib. cat. by
D.A. Goodreau, London, Kenwood House, 1977

London 1982
The Royal Opera House: A Retrospective, 1732–1982, exhib.
cat. by Iain Mackintosh and Geoffrey Ashton, London,
Royal Academy of Arts, 1982

London 1983
 James Barry: The Artist as Hero, exhib. cat. by W.L. Pressly, London, Tate Gallery, 1983
London 1984[1]
 Rococo: Art and Design in Hogarth's England, exhib. cat., ed. Michael Snodin, London, Victoria and Albert Museum, 1984
London 1984[2]
 The Pre-Raphaelites, exhib. cat. by Leslie Parris, London, Tate Gallery, 1984
London 1987
 Manners and Morals – Hogarth and British Painting 1700–1760, exhib. cat., London, Tate Gallery, 1987
London 1991
 The Painted Word, exhib. cat., ed. Peter Cannon-Brookes, London, Heim Gallery, 1991
London 1992
 The Swagger Portrait, exhib. cat. by Andrew Wilton, London, Tate Gallery, 1992
London 1993
 Robert Vernon's Gift, exhib. cat. by Robin Hamlyn, London, Tate Gallery, 1993
London 1994
 Theatre in the Age of Garrick: English Mezzotints from the Collection of the Hon. Christopher Lennox-Boyd, exhib. cat. by Christopher Lennox-Boyd, Guy Shaw and Sarah Halliwell, London, Courtauld Institute of Art, 1994
London 1997
 Dramatic Art: Theatrical Paintings from the Garrick Club, exhib. cat. by Desmond Shawe-Taylor, London, Dulwich Picture Gallery, 1997
London et al. 1997–98
 Victorian Fairy Painting, exhib. cat., ed. Jane Martineau, London, Royal Academy of Arts; Iowa City, University of Iowa Museum of Art; Toronto, Art Gallery of Ontario; New York, The Frick Collection, 1997–98
London and Dublin 1972
 Daniel Maclise, exhib. cat., London, National Portrait Gallery, and Dublin, National Gallery of Ireland, 1972
London and New York 2000–01
 William Blake, exhib. cat. by Robin Hamlyn and M. Phillips, London, Tate Britain, and New York, The Metropolitan Museum of Art, 2000–01
London, Paris and New York 1990
 Wright of Derby, exhib. cat. by Judy Egerton, London, Tate Gallery; Paris, Grand Palais; New York, The Metropolitan Museum of Art, 1990
Lynch 1953
 J. Lynch, Box, Pit and Gallery, Stage and Society in Johnson's London, Berkeley CA and Los Angeles 1953
Maas 1969
 Jeremy Maas, Victorian Painters, London 1969
Macandrew 1959–60
 H. Macandrew, 'Henry Fuseli and William Roscoe', Liverpool Libraries, Museums and Arts Committee Bulletin, VIII, Walker Art Gallery Number, Liverpool 1959–60
Mackintosh 1985
 Iain Mackintosh, 'David Garrick and Benjamin Wilson', Apollo, CXI, no. 279, May 1985, pp. 314–20
Macmillan 1970
 D. Macmillan, 'Alexander Runciman in Rome', The Burlington Magazine, CXII, 1970, pp. 23–30
Macmillan 1990
 D. Macmillan, Scottish Art 1460–1990, Edinburgh 1990
Macready, Diaries
 Diaries of William Charles Macready, ed. W. Toynbee, 2 vols., London 1912
Macready, Journal
 The Journal of William Charles Macready, ed. J.C. Trewin, London 1967

Macready, Reminiscences …
 Macready's Reminiscences, and Selections from his Diaries and Letters, ed. Frederick Pollock, 2 vols., London 1875
Mancroff 2001
 Debra N. Mancroff (ed.), John Everett Millais: Beyond the Pre-Raphaelite Brotherhood, New Haven CT 2001
Mander and Mitchenson 1955
 Raymond Mander and Joe Mitchenson, The Artist and the Theatre, London 1955
Manners and Williamson 1920
 V. Manners and G. Williamson, John Zoffany RA: His Life and Work, London 1920
Mannings and Postle 2000
 David Mannings and Martin Postle, Sir Joshua Reynolds: A Complete Catalogue of his Paintings, 2 vols., New Haven CT and London 2000
Mantz 1845
 'Lord Pilgrim' [P. Mantz], 'Exposition de l'Odéon', L'Artiste, 4th series, V, no. 4, 1845, p. 62
de Marly 1982
 Diana de Marly, Costume on the Stage 1600–1940, London 1982
Mason 1951
 E.C. Mason, The Mind of Henry Fuseli: Selections from his Writings with an Introductory Study, London 1951
Mason 1964
 E.C. Mason, 'Johann Heinrich Füssli und Shakespeare, in Shakespeare und die Schweiz', Jahrbuch der schweizerischen Gesellschaft für Theaterkultur, XXX, 1964, pp. 83–103
Mathieu 1971
 P.L. Mathieu, 'Documents inédits sur la jeunesse de Gustave Moreau 1826–1857', Bulletin de la société de l'histoire de l'art français, 1971, pp. 259–79
Mathieu 1976
 P.L. Mathieu, Gustave Moreau: sa vie, son œuvre, catalogue raisonné de l'œuvre achevée, Paris 1976
Mathieu 1998
 P.L. Mathieu, Gustave Moreau: monographie et nouveau catalogue de l'œuvre achevée, Paris 1998
Mazzocca 1994
 F. Mazzocca, Francesco Hayez: Catalogo ragionato, Milan 1994
McIntyre 1999
 Ian McIntyre, Garrick, London 1999
McKerrow 1982
 Mary McKerrow, The Faeds: A Biography, Canongate, Edinburgh 1982
Meisel 1983
 Martin Meisel, Realizations: Narrative, Pictorial and Theatrical Arts in Nineteenth-Century England, Princeton NJ 1983
Merlo 1984
 Carolyn Merlo, 'John Everett Millais and the Shakespearean Scene', Gazette des Beaux-Arts, 6th series, CIV, July–December 1984, pp. 78–79
Messina 1984
 M.G. Messina, 'Nota a Fuseli, Shakespeare's Painter', in Studi in onore di G.C. Argan, Rome, III, 1984, pp. 405–13
Millais 1899
 J.G. Millais, The Life and Letters of Sir John Everett Millais, 2 vols., London 1899
Millar 1969
 O. Millar, The Later Georgian Pictures in the Collection of Her Majesty The Queen, London 1969
Moelwyn Merchant 1958
 W. Moelwyn Merchant, 'Francis Hayman's Illustrations of Shakespeare', Shakespeare Quarterly, IX, 2, 1958, pp. 142–47
Moelwyn Merchant 1959
 W. Moelwyn Merchant, Shakespeare and the Artist, London 1959
Moelwyn Merchant 1964, 1973
 W. Moelwyn Merchant, 'Blake's Shakespeare', Apollo, LXXIX, 1964, pp. 320–24, reprinted in R.N. Essick (ed.),

The Visionary Hand: Essays for the Study of William Blake's Art and Aesthetics, Los Angeles 1973, pp. 247–52
Montagu 1994
 J. Montagu, The Expression of the Passions: The Origin and the Influence of Charles Le Brun's 'Conférence sur l'expression générale et particulière', New Haven CT and London 1994
Montgomery, New York and Chicago 1985–86
 A Brush with Shakespeare: The Bard in Painting 1780–1910, exhib. cat. by Ross Anderson, Montgomery AL, Museum of Fine Arts; New York, Public Library; Chicago, Public Library Cultural Center, 1985–86
Monval 1897
 G. Monval, Les collections de la Comédie française: catalogue historique et raisonné, Paris 1897
Moody 2000
 Jane Moody, Illegitimate Theatre: London Theatre, 1789–1840, Cambridge 2000
Moreau, Ecrits complets
 L'Assembleur de rêves, Ecrits complets de Gustave Moreau, ed. P.L. Mathieu, Fontfroide 1984
Morley 1891
 Henry Morley, The Journal of a London Playgoer from 1851 to 1866, London 1891
National Trust 1992
 National Trust, Stourhead List of Pictures, London 1992
Newall 1990
 Christopher Newall, The Art of Lord Leighton, Oxford and New York 1990
New Haven CT 1979
 The Fuseli Circle in Rome: Early Romantic Art of the 1770s, exhib. cat. by William L. Pressly, New Haven CT, Yale Center for British Art, 1979
New Haven CT 1981
 Shakespeare and British Art, exhib. cat. by Geoffrey Ashton, New Haven CT, Yale Center for British Art, 1981
New Haven CT and London 1987
 Francis Hayman, exhib. cat., ed. Brian Allen, New Haven CT, Yale Center for British Art, and London, Kenwood House, 1987
New York 1990
 Theatre on Paper, exhib. cat. by Alexander Schouvaloff, New York, The Drawing Center, 1990
Nicolson 1968
 Benedict Nicolson, Joseph Wright of Derby: Painter of Light, 2 vols., London 1968
Norris 1984
 Hilary Norris, 'A Directory of Victorian Scene Painters', Theatrephile, 1/2, 1984, pp. 38–52
Norwich 1996
 Art as Theatre: Shakespeare and Theatre in British Painting from Hogarth to Sargent, exhib. cat., Norwich Castle Museum, 1996
Nottingham 1961
 Shakespeare in Art: A Visual Approach to the Plays, exhib. cat. by W. Moelwyn Merchant et al., Nottingham, University Art Gallery, 1961
Nulli 1918
 S.A. Nulli, Shakespeare in Italia, Milan 1918
O'Connell 1991
 Sheila O'Connell, 'A Contract between George Harlow and William Cribb', Print Quarterly, VIII, 1991, pp. 48–49
Odell 1920–21
 George C.D. Odell, Shakespeare from Betterton to Irving, 2 vols., London 1920–21
O'Driscoll 1871
 W.J. O'Driscoll, A Memoir of Daniel Maclise, RA, London 1871
Oliver and Saunders 1965
 A. Oliver and J. Saunders, 'De Loutherbourg and Pizarro 1799', Theatre Notebook, XX, 1, 1965, pp. 30–33
Ormond 1968
 R. Ormond, 'Daniel Maclise', The Burlington Magazine, CX, 1968, pp. 685–93

Ormond 1975
Leonée and Richard Ormond, *Lord Leighton*, New Haven CT 1975

Oslo 1992
Fire Dansle Klassiker, Abildgaard, Juel, Eckersberg, Thorvaldsen, exhib. cat. by K. Monrad, Oslo, National Gallery of Norway, 1992

Paris 1980
La Comédie française 1680–1980, exhib. cat., ed. S. Chevalley, N. Guibert and J. Razgonnikoff, Paris, Bibliothèque Nationale, 1980

Paris and Philadelphia 1998–99
Delacroix, les dernières années, exhib. cat., ed. A. Serullaz, V. Pomarède and J. Rishel, Paris, Grand Palais, and Philadelphia Museum of Art, 1998–99

Paris, Strasbourg and New York 2002
Chassériau: un autre romantisme, exhib. cat. by S. Guégan, V. Pomarède and L.A. Prat, Paris, Grand Palais; Strasbourg, Musée des Beaux Arts; New York, The Metropolitan Museum of Art, 2002

Parkinson 1990
Ronald Parkinson, *Catalogue of British Oil Paintings 1820–1860*, London, Victoria and Albert Museum, 1990

Parma 1997
Füssli, pittore di Shakespeare, Pittura e teatro 1775–1825, exhib. cat., ed. F. Licht, S. Tosini Pizzetti and D.H. Weinglass, Mamiano di Traversetolo, Parma, Fondazione Magnani Rocca, 1997

Parma 2001
La tempesta del mio cor. Il gesto del melodramma dalle arti figurative al cinema, exhib. cat., ed. G. Godi and C. Sisi, Parma, Palazzo della Pilotta, 2001

Pasquin 1796
A. Pasquin [John Williams], *An Authentic History of the Professors of Painting, Sculpture and Architecture who have Practised in Ireland*, London 1796

Paulson 1971
Ronald Paulson, *Hogarth: His Life, Art and Times*, 2 vols., New Haven CT and London 1971

Paulson 1982
Ronald Paulson, *Book and Painting: Shakespeare, Milton and the Bible: Literary Texts and the Emergence of English Painting*, Knoxville TN 1982

Paulson 1991–93
R. Paulson, *Hogarth*, 3 vols., New Brunswick and Cambridge 1991–93

Pendred 1923
Mary L. Pendred, *John Martin Painter: His Life and Times*, London 1923

Pichois 1965
C. Pichois, 'Shakespeare inspirateur des artistes français', *Deutsche Shakespeare Gesellschaft West Jahrbuch*, Heidelberg 1965, pp. 264–78

Pickering 1755
Roger Pickering, *Reflections upon Theatrical Expression in Tragedy*, London 1755

Piper 1964
David Piper, *O Sweet Mr Shakespeare I'll have his Picture*, London, National Portrait Gallery, 1964

Piper 1982
David Piper, *The Image of the Poet: British Poets and their Portraits*, Oxford 1982

Pittard 1758
Joseph Pittard, *Observations on Mr. Garrick's Acting*, London 1758

Planché 1872
J.R. Planché, *The Recollections and Reflections of J.R. Planché*, London 1872

Postle 1991
Martin Postle, 'Gainsborough's "lost" picture of Shakespeare", *Apollo*, 1991, pp. 374–79

Powell 1986
Jocelyn Powell, *Restoration Theatre Production*, London 1986

Poynton 1979
Marcia Poynton, *William Dyce, 1806–1864: A Critical Biography*, Oxford 1979

Pressly 1981
William L. Pressly, *The Life and Art of James Barry*, New Haven CT and London 1981

Pressly 1993
William L. Pressly, *"As Imagination bodies forth". A Catalogue of Paintings in the Folger Shakespeare Library*, New Haven CT and London 1993

Pressly 2002
William L. Pressly, 'Romney's "Peculiar Powers for Historical and Ideal Painting"', in *Those Delightful Regions of Imagination: Essays on George Romney*, ed. A. Kidson, New Haven CT and London 2002, pp. 99–101

Price 1973
Cecil Price, *Theatre in the Age of Garrick*, Oxford 1973

Raines 1967
Robert Raines, *Marcellus Laroon*, London 1967

Redgrave 1981
Richard and Samuel Redgrave, *A Century of British Painters*, ed. R. Todd, Oxford 1981

Rhode Island 1979
Fantastic Illustration and Design in Britain, 1850–1930, exhib. cat. by Diana L. Johnson, Providence, Rhode Island School of Design, 1979

Richardson 1725
Jonathan Richardson, *An Essay on the Theory of Painting*, 2nd edn, London 1725

Roettgen 1993
Steffi Roettgen, *Anton Raphael Mengs 1728–1779 and his English Patrons*, London 1993

Rogerson 1953
B. Rogerson, 'The Art of Painting the Passions', *Journal of the History of Ideas*, XIV, no. 1, January 1953, p. 78

Rome 1998
Angelika Kauffmann e Roma, exhib. cat., Rome, Istituto Nazionale per la Grafica, Accademia di San Luca, 1998

Romney 1830
J. Romney, *Memoirs of the Life and Works of George Romney*, London 1830

Roscoe 1994
Ingrid Roscoe, 'The Monument to the Memory of Shakespeare', *Church Monuments*, IX, 1994, pp. 72–82

Roscoe 1999
Ingrid Roscoe, 'Peter Scheemakers', *The Walpole Society*, 61, 1999, pp. 162–204

Rosenfeld 1967
Sybil Rosenfeld, 'The Grieves' Shakespearean Scene Designs', *Shakespeare Survey*, XX, 1967, pp. 107–12

Rosenfeld 1969
Sybil Rosenfeld, 'The Grieve Family', *The Anatomy of an Illusion*, Amsterdam 1969

Rosenfeld 1973
Sybil Rosenfeld, *A Short History of Scene Design in Great Britain*, Oxford 1973

Rosenfeld 1978
Sybil Rosenfeld, *Temples of Thespis: Some Private Theatres and Theatricals in England and Wales, 1700–1820*, London 1978

Rosenfeld 1986
Sybil Rosenfeld, *Georgian Scene Painters and Scene Painting*, London 1986

Rossetti 1880
W. Rossetti, 'Annotated Lists of Blake's Painting, Drawings, and Engravings', in Alexander Gilchrist, *The Life of William Blake, Pictor Ignotus*, 2nd edn, London 1880

Rossetti 1900
W.M. Rossetti (ed.), *Pre-Raphaelite Diaries and Letters*, London 1900

Rowell 1981
George Rowell, *Theatre in the Age of Irving*, Oxford 1981

Russell 1987
Francis Russell, *Portraits of Sir Walter Scott*, London 1987

Salaman 1916
M.C. Salaman (ed.), *Shakespeare in Pictorial Art*, special number of *The Studio*, spring 1916

Sandoz 1974
M. Sandoz, *Théodore Chassériau: catalogue raisonné des peintures et estampes*, Paris 1974

San Marino CA 1985
English Narrative Drawings and Watercolours 1660–1880, exhib. cat. by Shelley Bennett, San Marino CA, The Huntington Library, 1985

Santaniello 1979
A.E. Santaniello (ed.), *The Boydell Shakespeare Prints*, New York 1979

Schiff 1973
G. Schiff, *Johann Heinrich Füssli 1741–1825, Oeuvrekatalog*, 2 vols., Zurich and Munich 1973

Schiff and Viotto 1977
G. Schiff, *L'opera completa di Füssli*, with critical catalogue by P. Viotto, Classici dell'Arte Rizzoli 91, Milan 1977

Schmidgall 1990
Gary Schmidgall, *Shakespeare and Opera*, Oxford 1990

Schoch 1998
Richard Schoch, *Shakespeare's Victorian Stage: Performing History in the Theatre of Charles Kean*, Cambridge 1998

Schoenbaum 1970
Samuel Schoenbaum, *Shakespeare's Lives*, Oxford and New York 1970

Schoenbaum 1977
Schoenbaum, *William Shakspeare: A Compact Documentary Life* [Oxford 1977], revised edn Oxford 1987

Schoenbaum 1981
Schoenbaum, *William Shakespeare: Records and Images*, London 1981

Schuckman 1991
C. Schuckman, 'The Engraver of the First Folio Portrait of William Shakespeare', *Print Quarterly*, VIII, 1991, pp. 40–43

Scott 1850
William Bell Scott, *Memoir of David Scott, RSA*, Edinburgh 1850

Scouten 1945
Arthur H. Scouten, 'Shakespeare's Plays in the Theatrical Repertory when Garrick came to London', *University of Texas Studies in English*, Austin TX 1945, pp. 257–58

Scouten 1956
Arthur H. Scouten, 'The Increase in Popularity of Shakespeare's Plays in the Eighteenth Century: a Caveat for Interpretors of Stage History', *Shakespeare Quarterly*, VII, spring 1956, p. 197

Scouten 1961
Arthur Scouten (ed.), *The London Stage 1660–1800*, Part 3: 1729–1747, 2 vols., Carbondale IL 1961

Serullaz and Bonnefoy 1993
A. Serullaz and Y. Bonnefoy, *Delacroix et Hamlet*, Paris 1993

Seward 1750
Thomas Seward, *The Works of Mr. Francis Beaumont and Mr. John Fletcher*, London 1750

Sgarbi 1984
V. Sgarbi, *Fondazione Magnani Rocca: Capolavori della pittura antica*, Parma 1984

Shaw 1901
George Bernard Shaw, *Plays for Puritans*, London 1901

Shebbeare 1755
Batista Angeloni (John Shebbeare), *Letters on the English Nation*, 2 vols., London 1755

Simon 1978
Robin Simon, 'Hogarth and the Popular Theatre', *Renaissance and Modern Studies*, XII, 1978, pp. 13–25

Simon 1979
Robin Simon, 'Hogarth's Shakespeare', *Apollo*, CIX, 1979, pp. 213–20

Skovgaard 1961
B. Skovgaard, *Maleren Abildgaard*, Gyldendal 1961

Smith 1829
J.T. Smith, *Nollekens and his Times*, 2 vols., London 1829

Smith 1986
Roger Smith, 'The Rise and Fall of the Art Union Print, *Print Quarterly*, III, 1986, pp. 95–108

Southern 1970
Richard Southern, *The Victorian Theatre: A Pictorial Survey*, Newton Abbot, Devon 1970

Speaight 1973
R. Speaight, *Shakespeare and the Stage: An Illustrated History of Shakespeare Performance*, London 1973

Spielmann 1898
M.H. Spielmann, *Millais and his Works*, London 1898

Spielmann 1913
M.H. Spielmann, 'The Welbeck Abbey or Harleian Miniature of Shakespeare: The James I Type', *Connoisseur*, XXXV, January 1913, pp. 3–13

Sprague 1945
A.C. Sprague, *Shakespeare and the Actors*, Cambridge MA 1945

de Staël 1807
A.L.G. de Staël-Holstein, *Corinne, ou l'Italie*, Paris 1807

de Staël 1810
A.L.G. de Staël-Holstein, *De l'Allemagne*, 4 vols., Paris 1810

Staley 1973
Allen Staley, *The Pre-Raphaelite Landscape*, Oxford 1973

Stephenson 1999
Andrew Stephenson, 'Leighton and the Shifting Repertoires of "Masculine" Artistic Identity in the Late Victorian Period', in *Frederic Leighton: Antiquity, Renaissance, Modernity*, ed. Tim Barringer and Elizabeth Prettejohn, Studies in British Art, 5, New Haven CT 1999

Stevens 1967
M. Stevens, *Walker Art Gallery: Old Master Drawings and Prints*, Liverpool 1967

Stone 1950
George W. Stone, 'David Garrick's Significance in the History of Shakespearean Criticism', *Publications of the Modern Language Association of America*, LXV, 1950, p. 186

Stone 1956
George W. Stone, 'Shakespeare's *Tempest* at Drury Lane during Garrick's Management', *Shakespeare Quarterly*, 7, 1956, pp. 1–7

Stone and Kahrl 1979
George W. Stone and G.M. Kahrl, *David Garrick: A Critical Biography*, Carbondale IL 1979

Stratford-upon-Avon 1970
Catalogue of Pictures and Sculptures: Royal Shakespeare Theatre Picture Gallery, 6th edn, Stratford-upon-Avon 1970

Stríbrný 2000
Stríbrný, Zdenek, *Shakespeare and Eastern Europe*, Oxford 2000

Strong 1969
Roy Strong, *Tudor and Jacobean Portraits: National Portrait Gallery*, 2 vols., London 1969

Studing 1993
R. Studing, *Shakespeare in American Painting: A Catalogue from the late XVIIIth Century to the Present*, London 1993

Stuebe 1979
Isabel Combs Stuebe, *The Life and Works of William Hodges*, PhD diss., New York University, New York and London 1979

Sudbury 1983
William Henry Bunbury, 1750–1811, exhib. cat. by John Reily, Sudbury, Suffolk, Gainsborough's House, 1983

Sunderland 1979
The Spectacular Career of Clarkson Stanfield (1793–1867), exhib. cat. by Pieter van der Merwe, Sunderland Museum and Art Gallery, 1979

Sunderland 1986
John Sunderland, 'John Hamilton Mortimer: His Life and Works', *The Walpole Society*, XII, 1986

Talma 1928
J.F. Talma, *Correspondance avec Mme de Staël, suivie de toute la correspondance leguée à la Bibliothéque Mazarine*, Paris 1928

Talma Vanhove 1836
Madame Veuve Talma [C. Vanhove], *Etudes sur l'art théâtral, suivies d'anédoctes inédites sur Talma et de la correspondance de Ducis avec cet artiste, depuis 1792 jusqu'en 1815*, Paris 1836

Taylor 1989
Gary Taylor, *Reinventing Shakespeare: A Cultural History from the Restoration to the Present*, London 1989

Taylor 1972
George Taylor, '"The Just Delineation of the Passions": Theories of Acting in the Age of Garrick', in *The Eighteenth-Century English Stage*, ed. Kenneth Richards and Peter Thomson, London 1972

Taylor 1989
George Taylor, *Players and Performances in the Victorian Theatre*, Manchester 1989

Terry 1908
Ellen Terry, *The Story of My Life*, London 1908

Terry, *Memoirs*
Ellen Terry's Memoirs, ed. Edith Craig and Christopher St John, London 1932

Terry, 'Studybook'
Ellen Terry, 'Studybook', archive at Smallhythe, Shattuck, Kent

Thomas and Hare 1989
David Thomas and Arnold Hare, *Restoration and Georgian England, 1660–1788*, Cambridge 1989

Tieghem 1947
Tieghem, Paul van, *Le préromantisme: études d'histoire littéraire européenne, v.3: La découverte de Shakespeare sur le continent*, Paris 1947

Tokyo et al. 1992–93
Shakespeare in Western Art, exhib. cat. by John Christian, Tokyo, Isetan Museum of Art; Ibaraki, Museum of Modern Art; Kintetsu Nara Hall; Takamatsu City Museum of Art, 1992–93

Tomory 1972
P. Tomory, *The Life and Art of Henry Fuseli*, London 1972

Trussler 1994
Simon Trussler, *The Cambridge Illustrated History of British Theatre*, Cambridge 1994

Turner 2001
Jan Piggott, 'William Shakespeare', in *The Oxford Companion to J.M.W. Turner*, ed. E. Joll, M. Butlin and L. Herrmann, Oxford 2001, pp. 290–91

Vertue, 'Notebooks'
George Vertue, 'Notebooks III', *The Walpole Society*, XXII, 1933–34, pp. 141–42

Vickers 1974–81
Vickers, Brian (ed.), *Shakespeare: The Critical Heritage 1623–1801*, 6 vols., London 1974–81

Villien 2001
B. Villien, *Talma, l'acteur favori de Napoléon I^er*, Paris 2001

Voltaire 1734
Voltaire, *Lettres écrites de Londres sur les Anglais*, Paris 1734

Wainwright 1977
Clive Wainwright, 'Walter Scott and the furnishing of Abbotsford; or the gabions of Jonathan Oldbuck Esq.', *Connoisseur*, CXCIV, 1977, pp. 3–15

Ward-Jackson 1987
Philip Ward-Jackson, 'Lord Ronald Gower, Gustave Doré and the Genesis of the Shakespeare Memorial at Stratford-upon-Avon', *Journal of the Warburg and Courtauld Institutes*, I, 1987, pp. 160–70

Wark 1973
Robert R. Wark, *Drawings for the Turner Shakespeare*, Los Angeles 1973

Washington, DC 1979
Robert Edge Pine: A British Portrait Painter in America 1784–1788, exhib. cat. by Robert G. Stewart, Washington, DC, Smithsonian Institution for the National Portrait Gallery, 1979

Washington, DC 1979–80
Shakespeare: The Globe and the World, handbook by Samuel Schoenbaum to a touring exhibition from the Folger Shakespeare Library, Washington, DC 1979–80

Washington, DC 1998
"Designs from Fancy": George Romney's Shakespeare's Drawings, exhib. cat. by Y. Romney Dixon, Washington, DC, Folger Shakespeare Library, 1998

Weaver 1981
William Weaver, 'Verdi, Shakespeare and the Italian Audience', in Nicholas John (ed.), *Otello*, London 1981, pp. 23–26

Webster 1967
Mary Webster, 'A Regency Flower Painter', *Country Life*, 18 May 1967, pp. 1246–48

Webster 1970
Mary Webster, *Francis Wheatley*, London 1970

Webster 1978, 1979
Mary Webster, *Hogarth* [Verona 1978], English edn 1979

Weinglass 1982
D.H. Weinglass (ed.), *The Collected English Letters of Henry Fuseli*, Millwood NY and Nedeln 1982

Weinglass 1994
David H. Weinglass, *Prints and Engraved Illustrations by and after Henry Fuseli: A Catalogue Raisonné*, Aldershot and Brookfield 1994

Wells 1969
W. Wells, 'William Blake's "Heads of the Poets"', in *For Friendship's Sake*, Manchester City Art Gallery, 1969

Wells 1997
Stanley Wells (ed.), *Shakespeare in the Theatre: An Anthology of Criticism*, Oxford 1997

West 1991
Shearer West, *The Image of the Actor: Verbal and Visual Representations in the Age of Garrick and Kemble*, London 1991

Wilkes 1759
Thomas Wilkes, *A General View of the Stage*, London 1759

Wilkinson 1790
Tate Wilkinson, *Memoirs of his own Life*, York 1790

Williams 1977
David Williams, *George Meredith: His Life and Lost Love*, London 1977

Williamson 1970
Jane Williamson, *Charles Kemble: Man of the Theatre*, Lincoln NE 1970

Wood 2000
Christopher Wood, *Fairies in Victorian Art*, Woodbridge 2000

Woodward 1950
John Woodward, 'Shakespeare and English Painting', *The Listener*, 15 June 1950, pp. 1017–18, 1030

Yonker 1969
Dolores B. Yonker, 'The Face as an Element of Style: Physiognomical Theory in Eighteenth-Century British Art', unpublished PhD diss., University of California 1969

York 1993
Affecting Moments: Prints of English Literature Made in the Age of Romantic Sensibility, exhib. cat. by David Alexander, University of York, 1993

Zebracka-Krupinska 1966
J. Zebracka-Krupinska, 'Nieznane obrazy Eugeniusza Delacroix w zbiorach Krakowskich', *Foliae Historiae Artium*, III, 1966, pp. 69–93

LENDERS AND PHOTOGRAPHIC CREDITS

We should like to thank the private collectors and the directors and staff of the following museums and galleries:

Birmingham Museums and Art Gallery pls. 13*, 84
Cambridge, The Fitzwilliam Museum pls. 15*, 16†, 18*, 19†
Cardiff, National Museums and Galleries of Wales pl. 39
Decatur GA, Agnes Scott College pl. 86*
Derby Museum and Art Gallery pl. 24
Dublin, The John Jefferson Smurfit Foundation pl. 10
Edinburgh, National Gallery of Scotland pls. 6, 8, 62, 79, 85
Eisenach, Thüringer Museum pl. 71*
Hartford CT, Wadsworth Atheneum Museum of Art pl. 77*
Her Majesty The Queen, The Royal Collection pl. 7
Kendal, Cumbria, Kendal Town Council (Abbot Hall Art Gallery) pl. 5
Kracow, Muzeum Uniwersytetu Jagielloñskiego pl. 63*
Liverpool, National Museums and Galleries on Merseyside, Walker Art Gallery pl. 9
London, The British Museum, Department of Prints and Drawings pls. 20–22
London, Garrick Club pls. 31, 34, 43
London, Guildhall Art Gallery pl. 88
London, Royal National Theatre (Maugham Collection) pl. 33
London, Sadler's Wells Theatre Collection pl. 44†
London, Tate pls. 3, 17, 42, 67, 80†
London, Theatre Museum pls. 32, 37–38
London, University of London Library pls. 46–48
London, Victoria and Albert Museum pls. 51–61, 78
Lytham St Annes, Lancashire, Fylde Borough Council pl. 11
Mamiano di Traversetolo, Parma, Fondazione Magnani Rocca pl. 29*
Manchester City Galleries pls. 36, 73
New Haven CT, Yale Center for British Art pls. 23*, 30*, 40*, 83*, 87*
Oslo, National Gallery of Norway pl. 14*
Paris, Musée Bibliothèque de la Comédie Française pl. 41*
Paris, Musée du Louvre pls. 69–70
Paris, Musée Gustave Moreau pls. 66, 68
Stratford-upon-Avon, Royal Shakespeare Company Collection pls. 4, 12, 26, 45, 49–50, 72, 76
Stratford-upon-Avon, Shakespeare Birthplace Trust pl. 74
Stratford-upon-Avon, Stratford Town Hall pl. 35
Valenciennes, Musée des Beaux-Arts pl. 65
Wakefield, Yorkshire, National Trust (Nostell Priory, The Winn Collection) pl. 2†
Washington, DC, The Makins Collection pl. 82
Zurich, Kunsthaus pl. 27

and other lenders who wish to remain anonymous (pls. 1, 25†, 28*, 64*, 75, 81)

[*] exhibited only at Palazzo dei Diamanti, Ferrara
[†] exhibited only at Dulwich Picture Gallery, London

Photographic Credits

Birmingham, Birmingham Museums and Art Gallery: pls. 13, 84
Cambridge, Cambridge University Library: figs. 41, 44
Cambridge, The Fitzwilliam Museum, University of Cambridge, Photographic Services: pls. 15–16, 18–19
Cardiff © National Museums and Galleries of Wales: pl. 39
Collection of David Alexander: figs. 6–11
Copenhagen © Thorvaldsens Museum / Photo: Olr Woldbye: fig. 54
Derby, Derby Museum and Art Gallery: pl. 24
Dublin, The John Jefferson Smurfit Foundation / Photo: Roy Hewson: pl. 10
Edinburgh © National Gallery of Scotland / Photo Antonia Reeve: pls. 6, 8, 62, 79, 85, figs. 28, 60
Eisenach, Thuringer Museum / Photo: Ulrich Kniese: pl. 71
Frankfurt-am-Main, Städelsches Kunstinstitut / Photo: Ursula Edelmann: fig. 48
Hartford CT, Wadsworth Antheneum Museum of Art: pl. 77
Kendal, Cumbria, © Abbot Hall Art Gallery: pl. 5, fig. 35
Krakow, Muzeum Uniwersytetu Jagielloñskiego / Photo: Janusz Kozina: pl. 63
Liverpool © Board of Trustees of the National Museums and Galleries on Merseyside (Walker Art Gallery): pl. 9, fig. 3
London, The Art Archive: pls. 31, 34, 43, fig. 43
London, The Bridgeman Art Library: pls. 75, 82, 88, fig. 42
London, The British Library: fig. 1
London, The British Museum: pls. 20–22, fig. 36
London, Christie's Images Ltd: pls. 11 (photo © 1999), 86, figs. 20 (photo © 2002) 59
London, Courtauld Institute of Fine Art, Conway Library: fig. 58
London, Courtauld Institute of Fine Art, Witt Library: fig. 51
London, National Trust Photographic Library / Photo: John Hammond: pl. 2
London, Royal National Theatre / Photo: V&A Picture Library: pl. 33
London, Sadler's Wells Theatre Collection / Photo: Oxford University Press: pl. 44
London, Sotheby's: pl. 28
London, © 2003 Tate / Photo: John Webb: pls. 3, 17, 42, 67, 80, figs. 19, 45, 61
London, © Trustees of the Sir John Soane Museum: figs. 39, 57, 58
London, Theatre Museum, V&A Picture Library: pls. 32, 37–38, figs. 12, 22
London, University of London Library: pls. 46–48, fig. 46
London, Victoria and Albert Museum, V&A Picture Library: pls. 51–61, 78, figs. 31, 37
Manchester, © Manchester City Galleries: pls. 36, 73
Massachusetts, USA, Harvard Theatre Collection: fig. 15
Milan, Civica Raccolta di Disegni e Stampe Bertarelli / Photo: Saporetti: figs. 24, 23
Milan, Private Collection / Photo: Studio Mari, Milan: pl. 64
Milan, © Giancarlo Costa: fig. 25
New Haven CT, Yale Center for British Art / Photo Richard Caspole: pls. 23, 30, 40, 83, 87, figs. 29, 56
Oslo, © Nasjonalgalleriet 2002 / Photo J. Lathion: pl. 14
Paris, Bibliothèque Nationale, Cabinet des Estampes: fig. 53
Paris, © Collections Comédie Française: pl. 41
Paris, Musée Gustave Moreau / Photo RMN – R.G. Ojeda: pls. 66, 68
Paris, Musée du Louvre / Photo RMN: Gérard Blot: pls. 69–70; R.M. Arnaudet: figs. 5, 49
Parma, Photo Amoretti: pl. 29, fig. 38
Randers, Randers Kunstmuseum / Photo: Poul Pedersen: fig. 34
Reims, © Musée des Beaux-Arts Reims, Photo Devleeshauwer: fig. 47
Stratford-upon-Avon, © Royal Shakespeare Company Collection: pls. 4, 12, 26, 45, 49–50, 72, 76, fig. 17
Stratford-upon-Avon, Stratford Town Council: pl. 35
Stratford-upon-Avon, © Shakespeare Birthplace Trust: pl. 74, fig. 2, 4
Sudbury, © The Trustees of Gainsborough's House / Photo: Associated Media: fig. 16
Tremezzo, Como, Ente Villa Carlotta, by permission of The Ministero dei Beni e le Attività Culturali. Reproduction prohibited: fig. 52
Valenciennes, Musée des Beaux-Artes / Photo RMN – R.G. Ojeda: pl. 65
Washington, DC, by permission of the Folger Shakespeare Library: figs. 13, 14, 26, 32
Wiltshire, Trafalgar Park / Photo: Associated Media: fig. 55
Windsor, The Royal Collection, © 2002 Her Majesty Queen Elizabeth II / Photo: SC: pl. 7
Zurich, Kunsthaus. All rights reserved / Photo © 2002: pl. 27, figs. 30, 33, 45

INDEX

LIVERPOOL JOHN MOORES UNIVERSITY
LEARNING SERVICES

LIVERPOOL JOHN MOORES UNIVERSITY
LEARNING SERVICES